Vincent van Gogh · The Complete Paintings

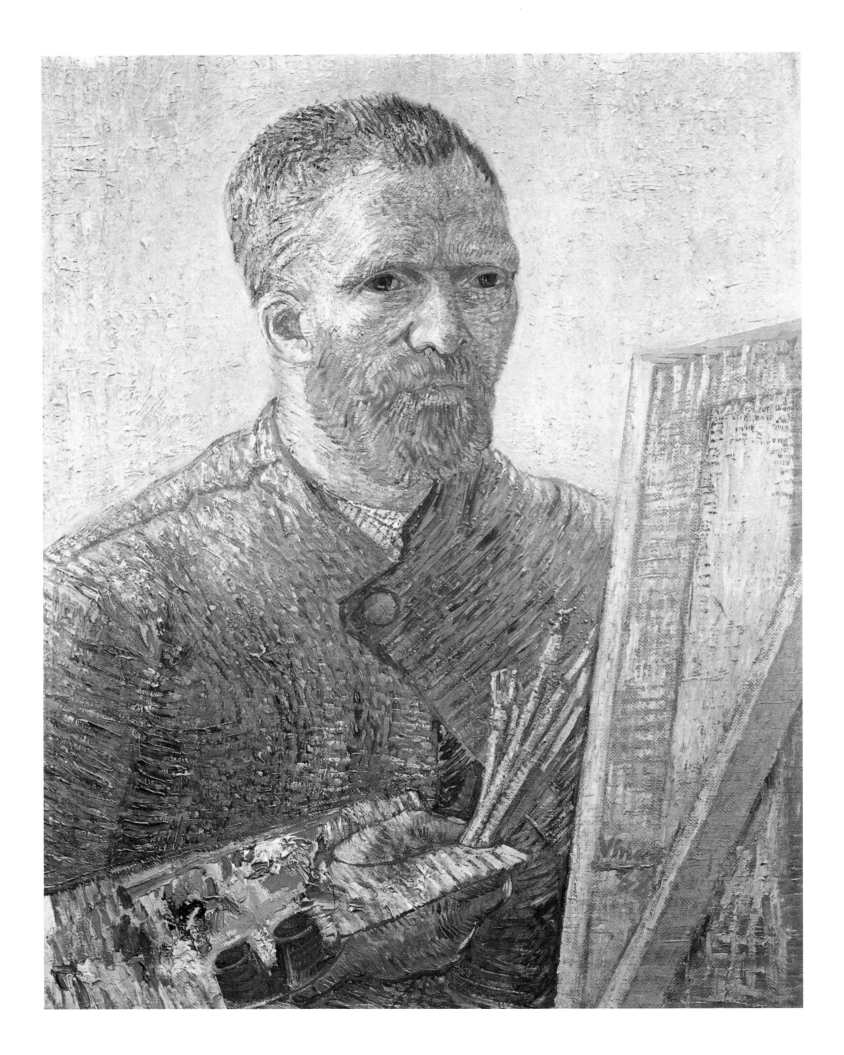

Ingo F. Walther/Rainer Metzger

Vincent van Gogh

The Complete Paintings

Volume I

Etten, April 1881 – Paris, February 1888

Benedikt Taschen

Front cover:
The Potato Eaters (Detail)
cf. p. 96

Frontispiece:
Self-Portrait in Front of the Easel
cf. p. 298

© 1990 Benedikt Taschen Verlag GmbH & Co. KG,
Balthasarstr. 79, D-5000 Köln 1
English translation: Michael Hulse
Cover design: Peter Feierabend, Berlin
Printed by: Neue Stalling, Oldenburg
Printed in Germany
ISBN 3-8228-0291-3

Contents

Deserted

Two chairs. Each of them dominating the painting it appears in. Positioned at an angle, touching the edges of the canvas, they have a monumental quality, and seem to be saying: "Go ahead, sit down." Both chairs are unoccupied. There are only one or two objects on them, waiting to be removed or picked up by the person they belong to. Both of these chairs dominate the pictures, filling the painted space, solid, palpable; yet they are intensely related to each other, too, like two panels of a diptych that achieve new unity in being brought together. Juxtaposed, the chairs will be looking at each other, as it were, offering an invitation to talk, to confide; or else, back to back, they will have turned away from each other, as if they had nothing more to say and existed in different worlds.

"Now, at any rate", wrote Vincent van Gogh to his brother Theo (Letter 563) in December 1888, when he painted the two chairs, "I can tell you that the latest two studies are most remarkable. One chair made of wood and extremely yellow wicker, up against the wall, on red tiles (by daylight). Then Gauguin's armchair, red and green, a nocturnal mood, the wall and floor similarly red and green, two novels and a candle on the seat. On canvas, the paint thickly applied." The curious subjects van Gogh was taking were furniture in his house at Arles and represented the daily meeting-place of van Gogh and his guest, Paul Gauguin. The two painters would sit talking about Art and the affairs of the world, debating, quarrelling, till things went up in their faces: Gauguin's sojourn was to be inseparably linked to the nervous breakdown from which van Gogh was never fully to recover. "A few days before we parted", van Gogh subsequently wrote to Albert-Emile Aurier (Letter 626a), describing the nocturnal painting of Gauguin's chair, "before illness forced me to enter a home, I tried to paint his empty chair."

The two paintings are his statement of the friendship of two artists. His own chair, simple and none too comfortable, with his dearly-loved pipe lying on it, stands for the artist himself. It is meant just as metaphorically as the more elegant, comfortable armchair where Gauguin liked to settle. Everyday things, purely functional objects, acquire

Self-Portrait
Paris, Spring 1887
Oil on cardboard, 42 x 33.7 cm
F 345, JH 1249
Chicago, The Art Institute of Chicago

symbolic power. The eye of love sees the mere thing as representing the man who uses it quite matter-of-factly. We may well be tempted to recall the pictorial tradition that provided van Gogh with his earliest artistic impressions. Dutch Calvinism sternly insisted on an iconographic ban that prohibited all images of the Holy Family except symbolic ones: the danger that the faithful might be distracted from their prayers by the beauty of the human form had to be avoided at all costs. Thus Christ could be represented by a 'vacant throne,' the symbol of judgement and power. It was enough to prompt responses of awe and devotion. Van Gogh's unoccupied chairs pay respect to a tendency to avoid representation of the human figure. Gauguin is there, seated in his armchair, even if we cannot see him – according to this formula.

The break in the two artists' friendship had become inevitable. When Gauguin decided to leave, he left the ruins of van Gogh's dreams of an artists' community in the South behind. "As you know, I have always considered it idiotic that painters live alone. It is always a loss if one is left to one's own devices", van Gogh had written to his brother (Letter 493), describing his longing for solidarity amongst painters. When he lost Gauguin, he also lost his overall perspective on Life. Thus we must see the two chairs as facing away from each other, expressing the irreconcilability of day and night – a polarity van Gogh establishes in the very colours used in the paintings.

Empty chairs had been a feature of van Gogh's thinking since childhood. The memories that crowd behind this single image are connected with deep mournfulness, with thoughts of the omnipresence of death. "After I had seen Pa off at the station, and had watched the train as long as it, or even only its smoke, was still in sight, and after I had returned to my room and Pa's chair was still drawn up to the table where the books and periodicals still lay from the day before, I felt as miserable as a child, even though I am well aware that we shall soon be seeing each other again." (Letter 118.) Irrational though the twenty-five-year-old's grief at the sight of the chair may seem, it was a constant tendency in van Gogh: to endow the most banal of objects with the properties of a memento mori. In 1885, when his father had died, van Gogh arranged his smoking tackle as a still life, simple yet laden with significance. It is no coincidence that a pipe and tobacco pouch are on his own wicker chair in the 1888 painting.

And we must not forget Charles Dickens, the English novelist, who (according to van Gogh) approved a pipe as a tried and tested prophylactic against suicide (Letter W11). Dickens's own vacant chair had been made famous by an illustration in *The Graphic*: "*Edwin Drood* was Dickens's last work", Vincent wrote to his brother (Letter 252), "and Luke Fields, who had got to know Dickens through doing the little illustrations, entered his room the day he died and saw his vacant chair. And that is how it came about that one of the old issues of *The Graphic*

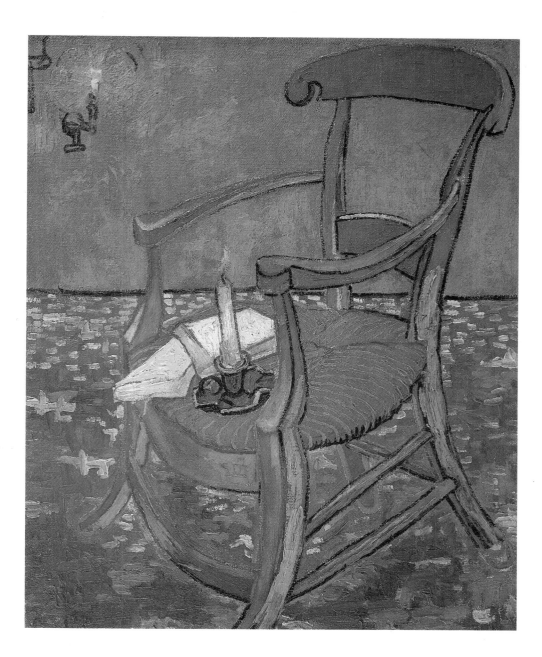

Paul Gauguin's Armchair
Arles, December 1888
Oil on canvas, 90.5 x 72.5 cm
F 499, JH 1636
Amsterdam, Rijksmuseum Vincent van
Gogh, Vincent van Gogh Foundation

carried the moving drawing, 'The Empty Chair'. Empty chairs – there
are a great many of them, more will be added to their number, and
sooner or later there will be nothing left ... but empty chairs."

Van Gogh's life's work as an artist remains ambivalent to a degree
that has not yet been fully recognized. His paintings are notable for their
immediacy, their sensuous impact. They draw their power from the
painter's affectionate openness towards all things, towards Man and
Nature. Still, the pleasure that he takes in a veritably naive identifica-
tion with the world is continually overshadowed by profound es-
chatological intuitions, by apprehensions of transience and death. The
hand that reaches out tenderly is retracted at the last moment because it
has too often been hurt. There can be no doubt that van Gogh learnt
from experience; indeed, his life precluded him taking a straight and
simple course. Yet van Gogh naturally remained a child of his age. He
grew up in a century when people for the first time saw their own
existence as everything, with no transcendental support system – a

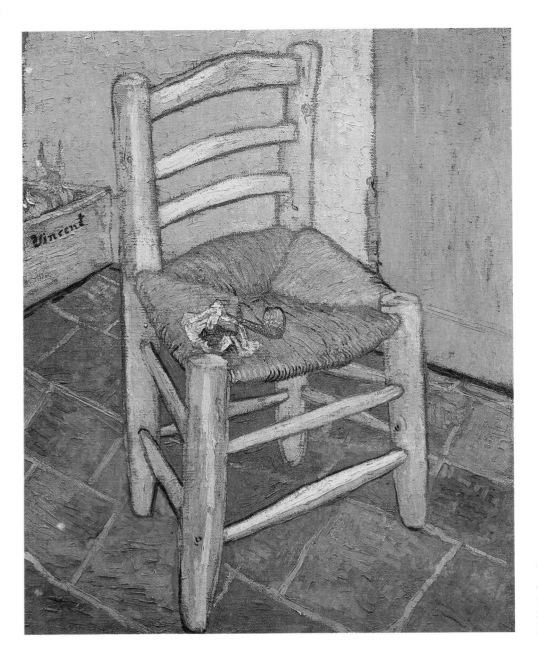

Vincent's Chair with His Pipe
Arles, December 1888
Oil on canvas, 93 x 73.5 cm
F 498, JH 1635
London, National Gallery

The Austrian art historian Hans Sedlmayr gives the title 'The vacant throne' to the final chapter of his essay in cultural criticism, *The Loss of the Centre [Verlust der Mitte]*. Sedlmayr writes: "It must be added that the artists have been among those who suffered the most in the 19th and 20th centuries, the very people whose task it has been to render the Fall of Man and of his world visible in their terrible visions. In the 19th century there was an altogether new type of suffering artist: the lonely, lost, despairing artist on the brink of insanity. It was a type that previously only occurred in isolated instances, if that. The 19th century artists, great and profound minds, often have the character of sacrificial victims, of victims who sacrifice themselves. From Hölderlin, Goya, Friedrich, Runge and Kleist through Daumier, Stifter, Nietzsche and Dostoyevsky to van Gogh, Strindberg and Trakl there was a line of solidarity in suffering at the hands of the times. All of them suffered from the fact that God was remote, and 'dead', and Man debased."

Van Gogh's chairs constitute a metaphor of the crisis of the entire century, a metaphor that corresponds to the somewhat forced pathos of Sedlmayr's account. We cannot grasp van Gogh's own *via dolorosa*, through to his fits of madness and final suicide, in isolation from the century he lived in. Van Gogh's ailment was the *maladie du siècle*, the self-fulfilling *Weltschmerz*, that Sedlmayr attempts to explain by the loss of belief in God. In his *History of Modern Culture [Kulturgeschichte der Neuzeit]*, Egon Friedell (albeit in rather more specific terms) moves in the same direction: "It has been claimed, frequently and emphatically, that our existence may have become more quotidian and grey but is the more rational, but this is a mistake. The 19th century was the inhuman century *par excellence*; the triumph of technology mechanized our lives totally, rendering us stupid; the worship of Mammon has irredeemably impoverished mankind, without exception; and a world without God is not only the least moral but also the least comfortable that can be conceived. As he enters the Present, modern man reaches the inmost circle of hell along his absurd and necessary path of suffering."

Thus it is only consistent if we write the history of van Gogh's art and life, less in a personal than in a historical sense. The causes for his failure in life, and for the subsequent rapid (all the more rapid) success of his cultural counterworld, need not be sought in the untouchable torments of a solitary visionary. Quite the contrary: the reason lies in van Gogh's tireless ambition for recognition, even if only in the image society had fashioned and could accept, the image of the outsider, the isolated genius. If ever there was a genius against his own will, it was Vincent van Gogh.

THIS EDITION. This two-volume edition of Vincent van Gogh's complete paintings is not intended to replace the two catalogues of his work that have long been available. Though its approach to chronological sequence is rather muddled, the indispensable catalogue for research purposes remains Jacob-Baart de la Faille's *The Works of Vincent van Gogh*, published in 1928, revised edition 1970. Jan Hulsker's *The Complete van Gogh* (1980) continued de la Faille's work and made vital corrections. Catalogue numbers in these two publications are keyed **F** or **JH** in the picture captions.

Unlike the available catalogues, this edition seeks to offer colour reproductions of as many as possible of the approximately 870 paintings by van Gogh (the exact number varies owing to a number of disputed attributions). The present authors believe there is little point in reproducing van Gogh in black and white. It is the first time the entirety of van Gogh's work as a painter has been accessible to the public on this scale, and the authors hope the book will also be of service to scholars. Information on the titles, dates, measurements and ownership of paintings is as up-to-date as possible.

It was impossible to reproduce every work in colour because some have been burnt or their whereabouts are unknown, others are in anonymous private hands, and in some cases permission to reproduce in colour was refused. This edition nevertheless reproduces over 83% of van Gogh's paintings in colour, many for the first time. The paintings are arranged in chronological order, with occasional departures for technical or aesthetic reasons. The chapters of the text are also chronologically conceived, though the text and illustrations may be far apart because of the sheer number of illustrations. To assist the reader, marginal titles include information on the place and date of painting. In Volume II, all the paintings are from three periods: Arles, Saint-Rémy and Auvers.

The text was a joint effort, though Rainer Metzger did by far the lion's share, for which I am grateful. We hope that by offering a catalogue and monograph within the same covers we are doing a service both to scholars and to the general public, and that the book will be a pleasure to read and look at. I.F.W.

Man Digging
The Hague, August 1882
Oil on paper on panel, 30 x 29 cm
F 12, JH 185
Private collection
(Christie's Auction, London, 5. 12. 1978)

The Making of an Artist
1853-1883

The Family
1853-1875

Carpenter's Workshop, Seen from the Artist's Studio
The Hague, May 1882
Pencil, pen, brush, heightened with white, 28.5 x 47 cm
F 939, JH 150
Otterlo, Rijksmuseum Kröller-Müller

Vincent van Gogh was the son of a Dutch pastor, Theodorus van Gogh, and his wife, Anna Cornelia. Their first son was still-born; a year later to the day, on 30 March 1853, another boy saw the light of day. This healthy son was given the names of the still-born first, Vincent Willem, after his two grandfathers. So Vincent van Gogh's very first day of life was an ominous one. This curious fact need not have disturbed the parents too much, but ever since a veritable army of analysts have been responding to the lasting fascination of a child that was born on the anniversary of its death, as it were. And it may well be that Vincent's taste for the paradoxical grew out of this remarkable coincidence.

His family lived a quiet life in the modest vicarage at Zundert near Breda, in Dutch Brabant. Theodorus's father had been a pastor too; indeed, so had generations of the van Goghs. They were not strict Calvinists in belief, but adherents of the Groninger party, a liberal branch of the Dutch Reformed Church. Vincent was profoundly influenced by the hard-working and pious atmosphere of his parental home;

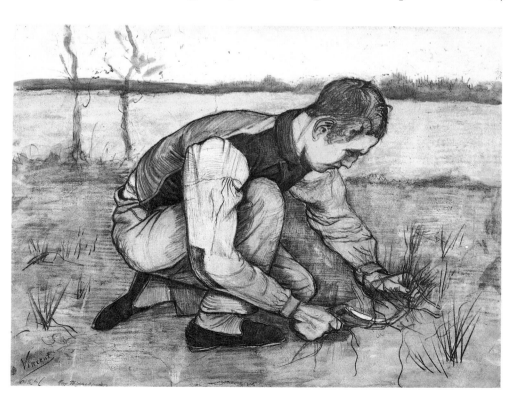

Boy Cutting Grass with a Sickle
Etten, October 1881
Black chalk, watercolour, 47 x 61 cm
F 851, JH 61
Otterlo, Rijksmuseum Kröller-Müller

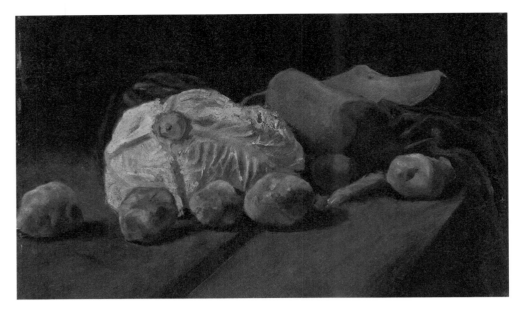

Still Life with Cabbage and Clogs
Etten, December 1881
Oil on paper on panel, 34.5 x 55 cm
F 1, JH 81
Amsterdam, Rijksmuseum Vincent van
Gogh, Vincent van Gogh Foundation

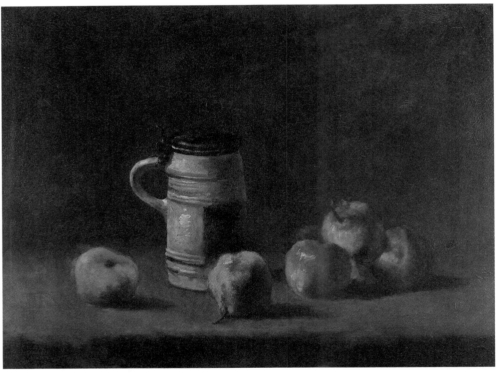

Still Life with Beer Mug and Fruit
Etten, December 1881
Oil on canvas, 44.5 x 57.5 cm
F 1a, JH 82
Wuppertal, Von der Heydt-Museum

and the eruptive violence with which he expressed himself strikes us as a necessary strategy for ridding himself of the cosy image of the world that was imposed on him in childhood.

Theodorus and Anna Cornelia van Gogh had six children. Vincent, the first-born, was followed by Anna Cornelia (born 1855), Theo (born 1857), Elisabetha Huberta (born 1859), Willemina Jacoba (born 1862) and finally Cornelis Vincent (born 1867). During his lifetime, Vincent was to keep up close relations with only two of his siblings: Willemina, to whom some twenty letters dating from late in his life were addressed, and Theo, his financial support, father confessor and viewer of his pictures. The childhood and youth of the siblings seem to have been much what we would expect in a *petit bourgeois* household, and later, after a fit of madness, Vincent was to long for the unruffled happiness of

Beach at Scheveningen in Calm Weather
The Hague, August 1882
Oil on paper on panel, 35.5 x 49.5 cm
F 2, JH 173
Private collection

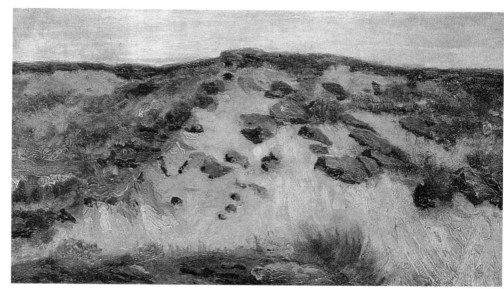

Dunes
The Hague, August 1882
Oil on panel, 36 x 58.5 cm
F 2a, JH 176
Amsterdam, Private collection

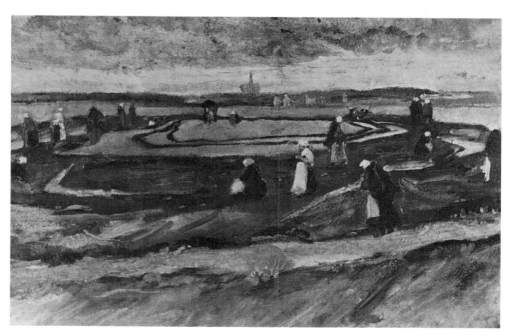

Women Mending Nets in the Dunes
The Hague, August 1882
Oil on paper on panel, 42 x 62.5 cm
F 7, JH 178
Private collection
(Mak van Waay Auction, Amsterdam,
15. 4. 1975)

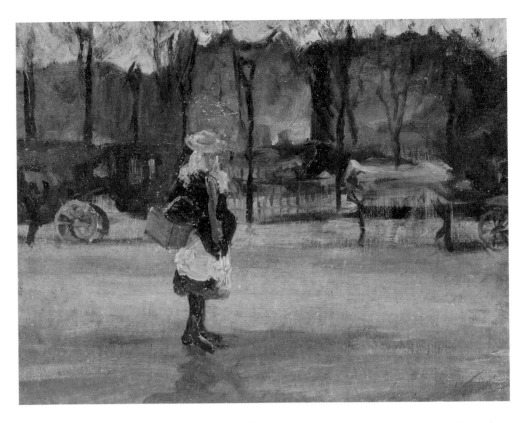

A Girl in the Street, Two Coaches in the Background
The Hague, August 1882
Oil on canvas on panel, 42 x 53 cm
F 13, JH 179
Winterthur, Collection L. Jäggli-Hahnloser

his Zundert home: "During my illness I saw every room in the Zundert house, every path, every plant in the garden, the surroundings, the fields, the neighbours, the graveyard, the church, our kitchen garden at the back – down to the magpie nest in a tall acacia in the graveyard." (Letter 573.) In the last year of his life, longing for his childhood home never relaxed its grip on Vincent van Gogh.

Vincent's father had no fewer than ten brothers and sisters. Vincent's uncles, who lived in various parts of the Netherlands, emphasized their authority over their nephew. Four of them played an especially influential role. Hendrick Vincent van Gogh, "Uncle Hein", was an art dealer in Brussels; it was under him that Theo first ventured into the wider

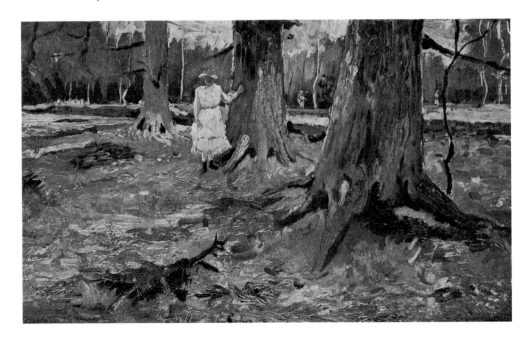

Girl in White in the Woods
The Hague, August 1882
Oil on canvas, 39 x 59 cm
F 8, JH 182
Otterlo, Rijksmuseum Kröller-Müller

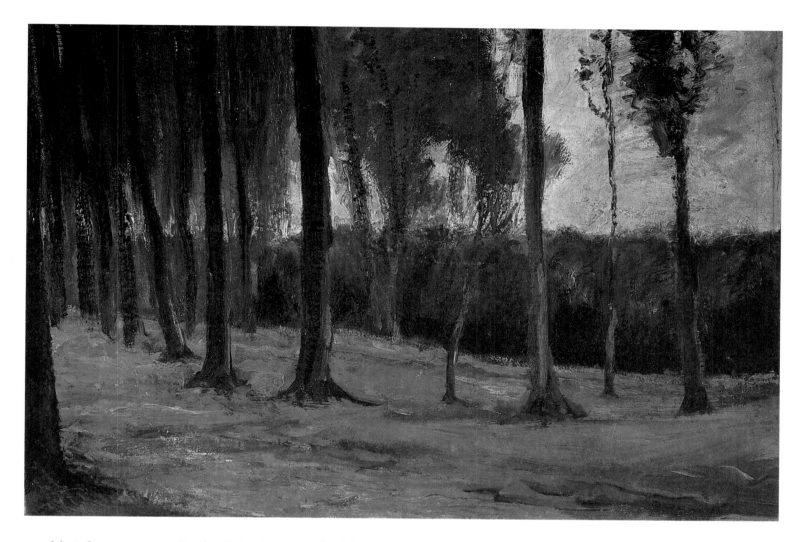

world. Johannes van Gogh, "Uncle Jan", had been made an admiral; Vincent was to live at his home in Amsterdam for the best part of a year. Cornelis Marinus van Gogh, "Uncle Cor", was also an art dealer, and thus active in the field that (along with the pulpit) was the other traditional profession of the van Goghs. Indeed, Vincent van Gogh, "Uncle Cent", was also an art dealer; he was the young Vincent's godfather. He had made the most impressive career for himself, working his way up in The Hague from the most modest of beginnings and ultimately incorporating his shop into the gallery chain of the Paris art publisher Goupil & Cie. There the young Vincent was to make his own first contacts with paintings and drawings.

The family had found a respectable station in society, and the constant pressure to conform which was brought to bear upon Vincent must have felt all the more burdensome when his own career as an art dealer soon proved to have been a false start. In due course, the resigned twenty-four-year-old was to write to his brother (Letter 98): "When I consider the past – when I consider the future, all the well-nigh insuperable difficulties, the vast and arduous toil which I feel no taste for and which I, wicked I, would like to avoid, when I think of the eyes of so many people, gazing at me – people who will know what the reason was if I am unsuccessful, people who will not level the customary re-

Edge of a Wood
The Hague, August 1882
Oil on canvas on panel, 34.5 x 49 cm
F 192, JH 184
Otterlo, Rijksmuseum Kröller-Müller

Two Women in the Woods
The Hague, August 1882
Oil on paper on panel, 35 x 24.5 cm
F 1665, JH 181. Paris, Private collection

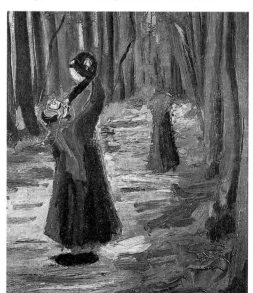

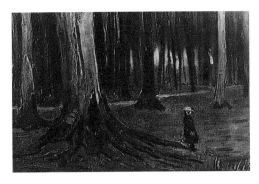

Girl in the Woods
The Hague, August 1882
Oil on panel, 35 x 47 cm
F 8a, JH 180
Netherlands, Private collection

Dunes with Figures
The Hague, August 1882
Oil on canvas on panel, 24 x 32 cm
F 3, JH 186
Berne (Switzerland), Private collection

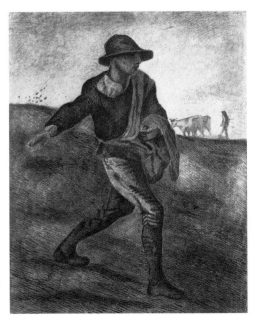

The Sower
The Hague, December 1882
Pencil, brush, Indian ink, 61 x 40 cm
F 852, JH 275
Amsterdam, P. and N. de Boer Foundation

proaches because, tried and tested in all things good and decent, in all that is refined gold, they will say by means of their expressions: We helped you, we were a light to you on your way – we did what we could for you; did you sincerely want it? What is our reward? Where is the fruit of our labour?"

When Vincent joined the branch of Goupil & Cie in The Hague as an apprentice in 1869, at the age of sixteen, there seemed no obstacle to the kind of career the family council would have wished him. Goupil was one of the leading firms in Europe and had recently begun its conquest of America. The house specialized in the reproduction of printed graphics, and leading engravers and painters worked for it. By 1869 the firm had seven branches. Uncle Cent was a partner in it. From 1873, the firm was also Theo van Gogh's employer. Vincent was subsequently remembered as a friendly, dependable employee; the reference written in 1873 by Mr. Tersteg (manager of the branch in The Hague) was a paean of praise. When he was transferred to London in summer 1873, the move was doubtless meant as a reward. It was that transfer that finally set the stone rolling.

Till then, statements such as "Theo, I must seriously advise you to smoke a pipe, it does you good when you're in a bad mood, as is often the case with me" (Letter 5) had been secret confidences. The inescapable loneliness Vincent was soon to experience in London was to accompany him his whole life long. He had fallen from the broad lap of his big family, and now nothing more kept him in the self-sufficiency of a predestined path in Life. The tone of his letters to Theo became noticeably more melancholy. His appeals to the common fraternal spirit were quintessentially expressed in the image of a walk taken together: "How I would like to have you here some time; what fine times we spent together in The Hague, I think so often of our walk along the Rijswijk road, where we drank milk after the rain near the mill... For me, the Rijswijk road is connected with memories that are perhaps the loveliest of all the memories I have." (Letter 10) The cosiness of an idyllic walk was to accompany Vincent van Gogh's life as an artist and became one of his recurrent themes.

Van Gogh's Other Art
The Letters

Beach at Scheveningen in Stormy Weather
The Hague, August 1882
Oil on canvas on cardboard, 34.5 x 51 cm
F 4, JH 187
Amsterdam, Stedelijk Museum (on loan)

"But we must write each other plenty of letters", Vincent van Gogh baldly proposed to his brother Theo on 13 December 1872 (Letter 2). From this acorn, within two brief decades, there grew a mighty oak of correspondence which many have praised as a work of art in its own right. Over 800 of the letters have been preserved, thanks above all to Theo van Gogh's industrious collector instincts. The letters to Theo were the more important; it was to Theo that Vincent's first letter was written, and his last, too; indeed, over three quarters of the letters were addressed to Theo. In 1914–1915, Theo's widow (i.e. Vincent's sister-in-

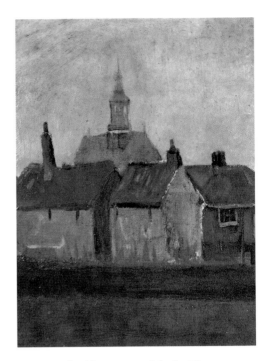

Cluster of Old Houses with the New Church in The Hague
The Hague, August 1882
Oil on canvas on cardboard, 34 x 25 cm
F 204, JH 190
Whereabouts unknown
(Sotheby's Auction, 20. 11. 1968)

law) Jo van Gogh-Bonger first published the material that was in her hands: 652 letters in all. The numbering that was given to the letters has been retained to this day, but in the meantime other written material has been added at the appropriate chronological point (marked with a small letter). Emile Bernard, one of van Gogh's closest painter friends, published the letters addressed to himself in 1911: these have their own numbering and carry a capital B. In 1937 the correspondence between van Gogh and Anton van Rappard was made available to the public in an expanded edition of the letters: the letters to Rappard have a capital R before the number. And then in 1954 Vincent's letters to his sister Willelmina appeared in print: these bear a capital W. To mark the centenary of van Gogh's birth, a first complete edition of the writings was published between 1952 and 1954; this edition added replies to Vincent written by Theo and his wife, all marked with a capital T.

"It is almost as if when writing I did not encounter the same difficulty as I do when painting. In order to do things to my own satisfaction, the work requires far less deliberation when I put something down on paper than it does if I aim at complete satisfaction in my painting. We spend our whole lives in unconscious exercise of the art of expressing our thoughts with the help of words... We ought to write letters that demand our whole attention and on which our fate may depend every day. It is for such reasons that men of significance invariably write well, especially when dealing with matters they have a thorough knowledge of." Thus Eugène Delacroix, Vincent van Gogh's great paragon, in a diary entry on the close ties between writing and painting, and the opportunities writing affords an artist for occasional ease or self-scrutiny. In art history, the link between writing and the visual arts has

Fisherman on the Beach
The Hague, August 1882
Oil on canvas on panel, 51 x 33.5 cm
F 5, JH 188
Otterlo, Rijksmuseum Kröller-Müller

Fisherman's Wife on the Beach
The Hague, August 1882
Oil on canvas on panel, 52 x 34 cm
F 6, JH 189
Otterlo, Rijksmuseum Kröller-Müller

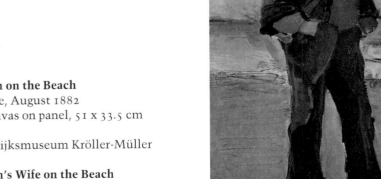
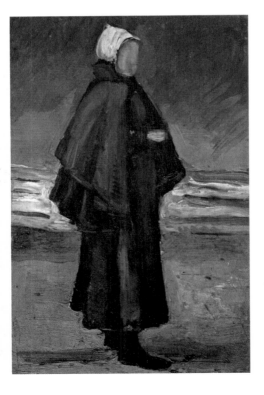

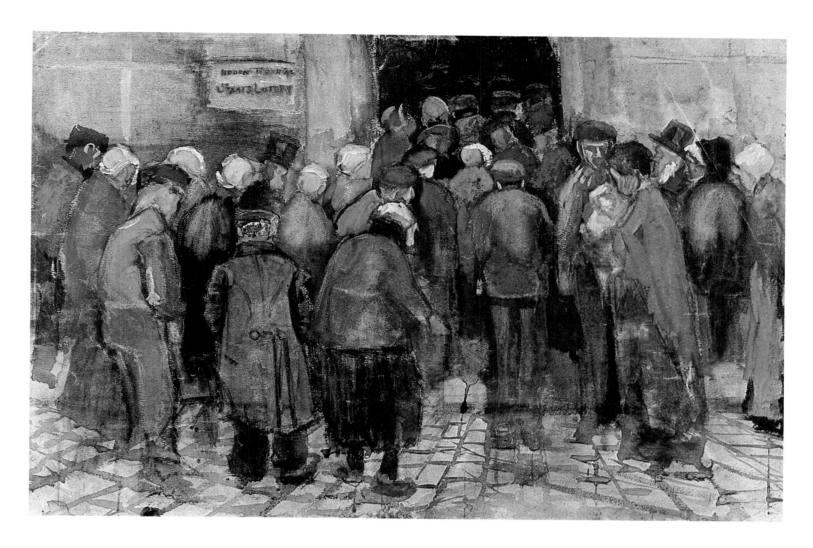

a sturdy tradition: the ancient idea of *ut pictura poesis* (as in painting, so in poetry) has kept a firm grip on art and the ways artists have thought down the centuries.

Van Gogh's own correspondence breathes the spirit of that idea, seeking to bridge the gap between Art and Reality through sheer vividness of description. "A female figure in a black woollen dress is lying before me; I am certain that if you had her for a day or so you would be reconciled to the technique." (Letter 195.) Does not this comment on a drawing read as if he were writing of a real person close to him? "A flock of doves goes sailing by across the red tiled roofs, between the black smoking chimneys. Beyond is an infinity of soft, delicate green, mile upon mile of flat pasture land and a grey sky – as tranquil and peaceful as in Corot or van Goyen." (Letter 219.) When van Gogh looks at a real landscape, is it not as if he were considering a painted one?

We are reminded of the literature of his contemporaries – of Emile Zola, for instance, who subjected his eye to the schooling of Art. "It was not until after seven", we read in his novel *La Bête Humaine* (1890), "that Jacques finally saw the panes growing brighter and taking on a milky white colour. Gradually, through the whole room, an indefinable light spread, in which the furniture seemed to swim, as it were. The stove rose out of the waters, as did the cupboard, the sideboard." Zola is

The State Lottery Office
The Hague, September 1882
Watercolour, 38 x 57 cm
F 970, JH 222
Amsterdam, Rijksmuseum Vincent van
Gogh, Vincent van Gogh Foundation

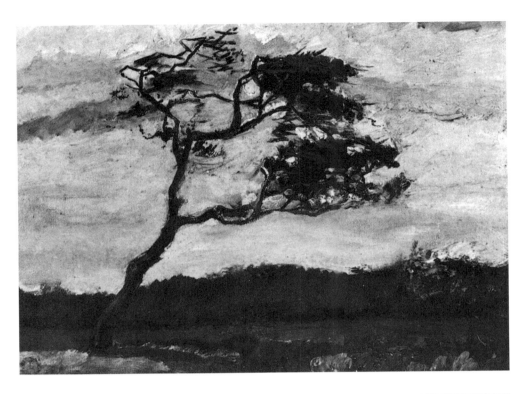

A Wind-Beaten Tree
The Hague, August 1883
Oil on canvas, 35 x 47 cm
F 10, JH 384
Whereabouts unknown

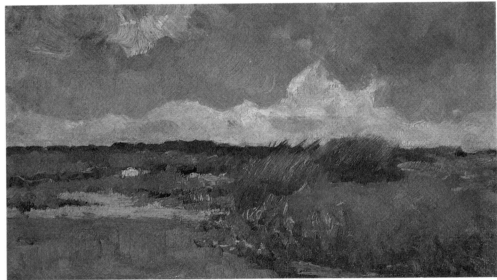

Marshy Landscape
The Hague, August 1883
Oil on canvas, 25 x 45.5 cm
No F Number, JH 394
Private collection
(Koller Auction, Zurich, 12. 11. 1976)

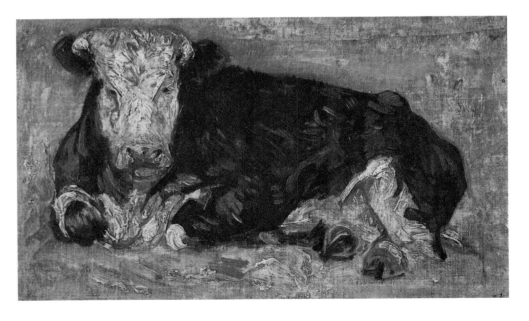

Lying Cow
The Hague, August 1883
Oil on canvas, 19 x 47.5 cm
F 1C, JH 389. Whereabouts unknown
(Sotheby's Auction, 11. 11. 1959)

Lying Cow
The Hague, August 1883
Oil on canvas, 30 x 50 cm
F 1b, JH 388. Whereabouts unknown

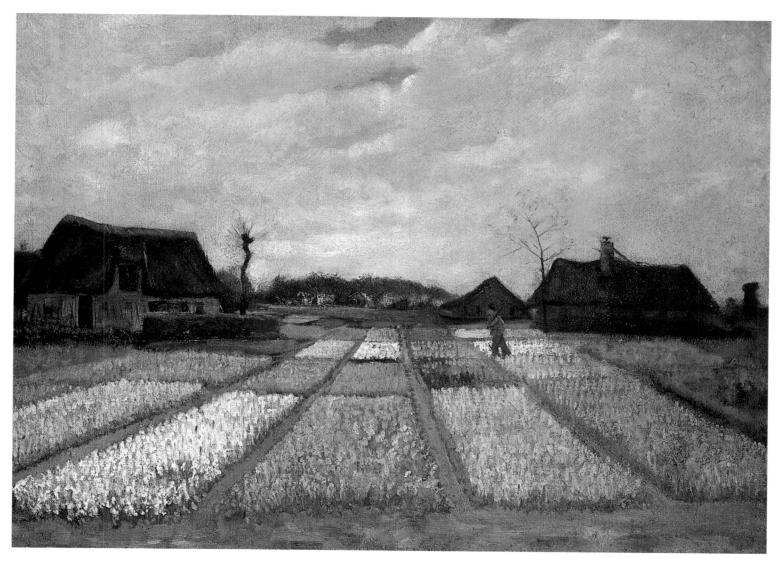

describing an interior that is as real as an interior in an Impressionist painting. In van Gogh's own playing with the nuances of natural and artificial description we can clearly detect his aim to give the language of his letters a flexibility and immediacy beyond statements of personal involvement, to take his bearings from the eloquence of writers such as Zola. It is that eloquence that gives van Gogh's letters the literary value widely ascribed to them.

And then, of course, van Gogh's letters provide a running commentary on his paintings. Almost every one of his works is referred to in some way, be it the subject, the choice of colours, or the circumstances that led to its being painted. Van Gogh's painting and letter-writing are two sides of the same coin. They are parallel forms of an almost uncontainable passion for self-expression.

Delacroix emphasized the value of letter-writing as an accompaniment to artistic creation and as an apt means of appreciating and describing one's own works. Delacroix himself repeatedly wrote other kinds of texts, too; he kept a diary, wrote newspaper articles, and was even the author of books. Van Gogh, on the other hand, limited his endeavours as a writer almost entirely to his correspondence. His fixa-

Bulb Fields
The Hague, April 1883
Oil on canvas on panel, 48 x 65 cm
F 186, JH 361
Washington, National Gallery of Art,
Collection Mr. and Mrs. Paul Mellon

The Sower (Study)
The Hague, August 1883
Oil on panel, 19 x 27.5 cm
F 11, JH 392
Whereabouts unknown

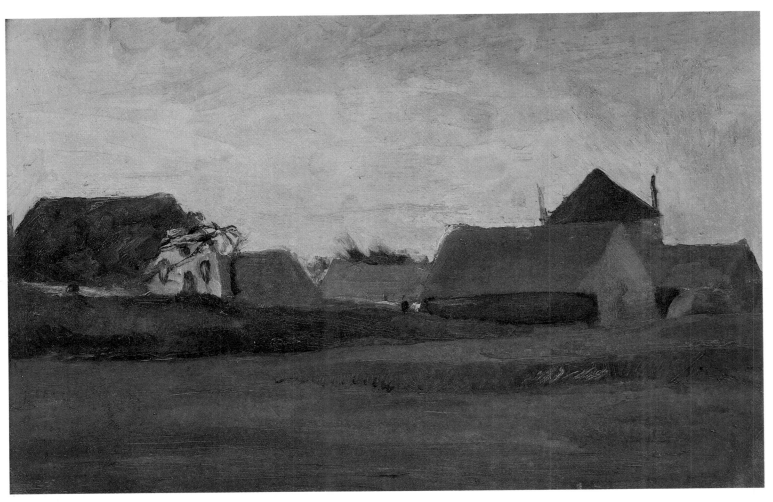

**Farmhouses in Loosduinen near The Hague
at Twilight**
The Hague, August 1883
Oil on canvas on panel, 33 x 50 cm
F 16, JH 391
Utrecht, Centraal Museum
(on loan from the van Baaren Museum
Foundation, Utrecht)

Three Figures near a Canal with Windmill
The Hague, August 1883 (?)
Medium and dimensions unknown
F 1666, JH 383
Whereabouts unknown

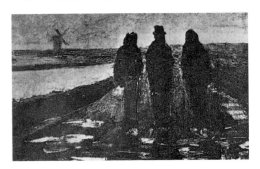

tion on his brother will have been an important reason for this. This fixation had the effect of focussing Vincent's attention on one person at the expense of others, thoughout his life. It was to Theo that he wrote most of his letters, including those in which he criticizes himself most severely and opens himself up most profoundly. And it was to Theo that Vincent's pictures were addressed, too: Theo was his artistic brother's public. To view the letters as a handy commentary on the paintings will thus not do. It was only in his parallel activities of writing and painting, both of them addressed to a single person, Theo, that Vincent van Gogh saw significance in his own existence. Only there did he see himself as active, useful, and productive of things of value. And this is why his confessions (it is the aptest word for his paintings and letters alike) are so highly charged with emotion.

Van Gogh signed his works with a simple Christian name: Vincent. One reason why he did so was that he was seeking to put distance between himself and his origins in a family of careerists and *petit bourgeois* piety: "I ask you quite openly", he wrote to Theo (Letter 345a) at a time when he was living at home, chafing at his parents' cast-iron moral attitudes, "how do we relate to each other – are you a 'van Gogh' too? For me you have always been 'Theo'. I myself am different in character from the other members of the family, and really I am not a 'van Gogh' at all." What mattered was not one's descent, not the loudly

Landscape with Dunes
The Hague, August 1883
Oil on panel, 33.5 x 48.5 cm
F 15a, JH 393
Private collection
(Sotheby's Auction, London, 4. 12. 1968)

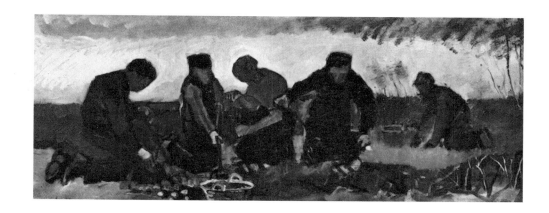

Potato Digging (Five Figures)
The Hague, August 1883
Oil on canvas, 39.5 x 94.5 cm
F 9, JH 385
New York, Collection Julian J. Raskin

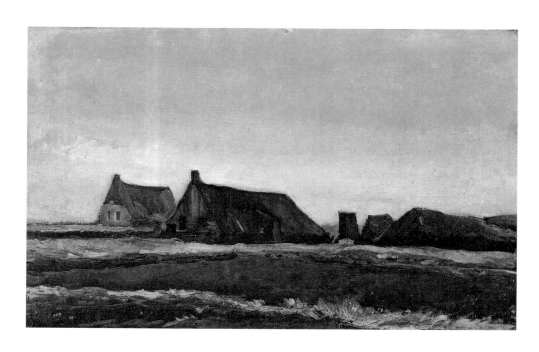

Farmhouses
The Hague, September 1883
Oil on canvas, 35 x 55.5 cm
F 17, JH 395
Amsterdam, Rijksmuseum Vincent van
Gogh, Vincent van Gogh Foundation

Cows in the Meadow
The Hague, August 1883
Oil on canvas on panel, 31.5 x 44 cm
F 15, JH 387
Private collection

The Heath with a Wheelbarrow
The Hague, September 1883
Watercolour, 24 x 35 cm
F 1100, JH 400
Cleveland, The Cleveland Museum of Art

proclaimed membership of some family of high social standing, but the individual pure and simple. And for the individual, the Christian name did good service. Vincent signed his paintings as he signed his letters. It was his way of declaring them the work of a man revealing his inmost self. In February 1884, when he hit upon the idea of thanking Theo for his financial and emotional support by dedicating his entire artistic output to him, his oeuvre definitively acquired the same private character as the letters. And the simple signature, Vincent, expressly attests a modesty that only recognises artistic obligations towards his brother Theo.

"Now I have nothing and am wretched, put forth from the face of Goodness, and I love my wretchedness and shudder at what is most sublime in my eyes. I have one hope, a hope for that unhappy brother of Poetry: madness. With all her charms, Poetry cannot ever give me what I have experienced in Life. Her love is no substitute. So perhaps it will be friendship, perhaps her brother; he is infinite, he comes between us and the world and never quits our side till we are with the gods." Thus the German Romantic Clemens Brentano, in a metaphorically complex passage that links the brother with madness. Vincent van Gogh's correspondence is resigned in tone, and its melancholy is the seedbed of a kind of greatness – in his view of himself; and the nature of the corres-

Farmhouses among Trees
The Hague, September 1883
Oil on canvas on panel, 28.5 x 39.5 cm
F 18, JH 397
Private collection
(Christie's Auction, London, 31. 3. 1987)

pondence becomes strikingly clear if it is compared with the correspondence of that fated generation of German Romantic writers. In Letter 345, for example, van Gogh adopts a tone that is arrestingly similar to that of Brentano's lament: "Life is a terrible reality, and we ourselves are running straight into infinity; what is, is – and whether we take things harder or not so hard does not affect the nature of things in the slightest... When I was younger I inclined more than I do now to think it was a matter of coincidences, of insignificant things, of misunderstandings. But as I grow older I am increasingly changing my mind and seeing profounder reasons. Life is 'a strange business', brother." Following his thoughts on infinity, and on the woes caused by Time, the simple word 'brother' seems laden with cryptic significance beyond a mere address to a relative. It is as if van Gogh's deep sense of loneliness saw the sole chance of solace in his brother – much as another German writer, Heinrich von Kleist, longed "to be understood, if only on occasion, by one other human soul."

We have the impression that van Gogh's entire will to live is being focussed on the addressee of his letter; at the same time, it is his need to express himself to that person which establishes his will to live in the

Peat Boat with Two Figures
Drente, October 1883
Oil on canvas on panel, 37 x 55.5 cm
F 21, JH 415
Netherlands, Private collection

Footbridge across a Ditch
The Hague, August 1883
Oil on canvas on panel, 60 x 45.8 cm
F 189, JH 386
Private collection
(Christie's Auction, London 3. 7. 1973)

first place. The addressee is the point to which all his melancholy, but also all his confessional courage, tends. It is a precarious balancing act, since the writer becomes existentially dependent on his sense of the reader's interest; and out of that balance arises the desire for the two to become one. "That is why I long for you so much", wrote Brentano, "so that you and I together may abjure belief in everything ordinary and prosaic, so that I can write whatever occurs to me without any concern for criticism or the demands of the age. You will be so kind as to have my stuff printed above your own name; because as soon as you have made me happy I shall no longer wish to have a name, and what is yours will be mine." There is a distinct similarity in the way Vincent van Gogh viewed his relations with Theo (Letter 538): "Now I feel that my pictures are not yet good enough to compensate for the advantages I have enjoyed through you. But believe me, if one day they should be good enough, you will have been as much their creator as I, because the two of us are making them together."

Brentano's flirtation with madness, and Kleist's suicide, were attempts to bridge the gap between Literature and Life. In the intensity of his own struggles, van Gogh was to outdo them both. It would be wrong to exaggerate the similarities between his correspondence and that of the German Romantics; there was nothing conscious or imitative in the affinity. Still, it serves to highlight an important (arguably the most important) tradition in the artist: Vincent van Gogh was a thorough Romantic in terms of his emotional world and his lack of inhibition in living it to the full. And the comparison with Kleist and Brentano also underlines the close ties between van Gogh's art and his letter-writing. Both means of expression articulated the artist's entire personality, and were catalyzed by his tendency to relate exclusively to his brother Theo.

The Religious Maniac
1875-1880

Two Peasant Women in the Peat Field
Drente, October 1883
Oil on canvas, 27.5 x 36.5 cm
F 19, JH 409
Amsterdam, Rijksmuseum Vincent van Gogh, Vincent van Gogh Foundation

"Who sees that once our first life, the life of youth and young manhood, the life of worldly pleasure and vanity, has withered away, as wither away it must – and it will do so, just as the blossoms fall from the trees – who sees that then a new life is ours, in all its strength, a life filled with love of Christ and with a sadness that causes sorrow to no one, a divine sadness?" Most of the products of van Gogh's pen up to 1880 read like this passage from Letter 82a, dating from November 1876. He had

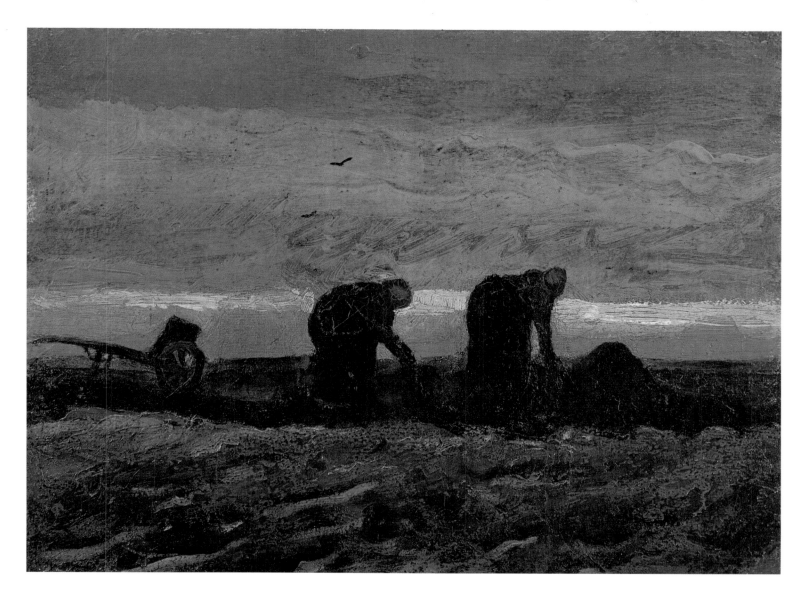

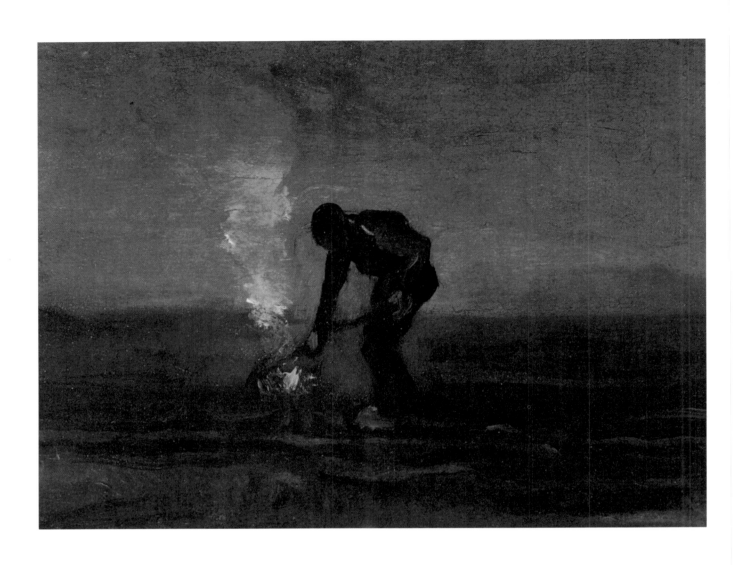

Peasant Burning Weeds
Drente, October 1883
Oil on panel, 30.5 x 39.5 cm
F 20, JH 417
Private collection
(Christie's Auction, New York, 12. 5. 1987)

Landscape with a Church at Twilight
Drente, October 1883
Oil on cardboard on panel, 36 x 53 cm
F 188, JH 413
Private collection
(Christie's Auction, London, 3. 7. 1973)

Farmhouse with Peat Stacks
Drente, October-November 1883
Oil on canvas, 37.5 x 55.5 cm
F 22, JH 421
Amsterdam, Rijksmuseum Vincent van
Gogh, Vincent van Gogh Foundation

A Wood Auction
Nuenen, December 1883
Watercolour, 33.5 x 44.5 cm
F 1113, JH 438
Amsterdam, Rijksmuseum Vincent van
Gogh, Vincent van Gogh Foundation

The Old Tower of Nuenen with a Ploughman
Nuenen, February 1884
Oil on canvas, 34.5 x 42 cm
F 34, JH 459
Otterlo, Rijksmuseum Kröller-Müller

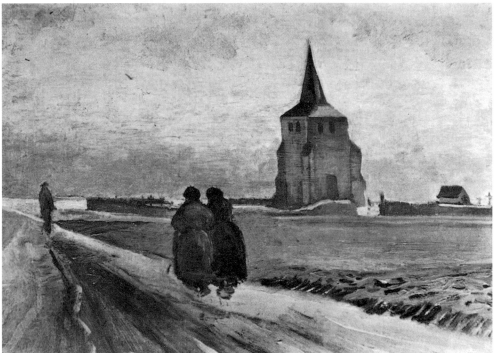

The Old Tower of Nuenen with People Walking
Nuenen, February 1884
Oil on canvas on panel, 33.5 x 44 cm
F 184, JH 458
Private collection

developed what can only be described as a religious mania, and it involved excessive mortification of the flesh: van Gogh cudgelled his back, went around wearing only a shirt in winter, and slept on the stone floor beside his bed. It was as if he wanted to catch up on his forefathers' piety – and was doing it at double the normal pace.

Vincent lacked experience with women, and one unfortunate love seems to have given him a considerable jolt. Six months previously he had nursed a secret love for Eugenie Loyer, the daughter of his landlady in London; and when at last he dared to tell his adored young woman of

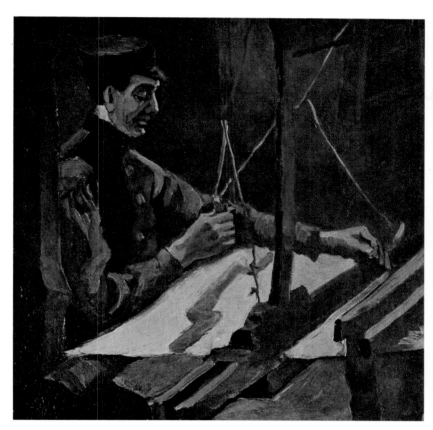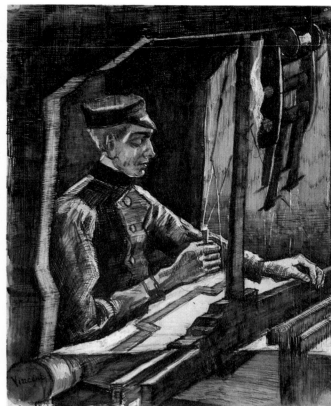

his feelings he proved to be too late – another man had got there first. Thwarted relations with women were to devastate Vincent's emotional life at later periods too. At the time of his rejection, about the end of 1873, van Gogh's behaviour underwent a complete change. Hitherto an open, entertaining and liberal-minded man, he became an eccentric, taciturn loner who substituted late-night Bible reading for contact with his fellow-beings. He now reviewed all the books he had previously read so voraciously to check their usefulness for pious purposes. In the tone of a preacher he instructed Theo (Letter 36a): "Do not read Michelet or any other book but the Bible till we meet again at Christmas."

It was of no avail when Uncle Cent arranged for his nephew to be transferred to Goupil's Paris headquarters: by spring 1876, Vincent van Gogh's career as an art dealer was at an end. Fractious advice to purchasers, suggesting they buy cheaper art, doubtless did credit to his love of truth but scarcely helped the company's turnover. After he had been dismissed, Vincent returned to England, to Ramsgate and Isleworth (near London), not far from the scene of his first love. There he worked as an assistant teacher, for a pittance, and gave full rein to his missionary tendencies. Gradually, he came to feel he had a vocation to be a clergyman like his forefathers; at this period in his life, he saw his father, Theodorus van Gogh, as an important role model.

Uncle Cent next found Vincent a job in a Dordrecht bookshop. But what had once been Vincent's pronounced taste for books was now no more than blinkered Biblical fanaticism; and he would sit in the book-

Weaver Facing Right (Half-Figure)
Nuenen, January 1884
Oil on canvas, 48 x 46 cm
F 26, JH 450
Berne, Collection H. R. Hahnloser

Weaver Facing Right (Half-Figure)
Nuenen, January-February 1884
Pen, washed with bistre, heightened with white, 26 x 21 cm
F 1122, JH 454
Amsterdam, Rijksmuseum Vincent van Gogh, Vincent van Gogh Foundation

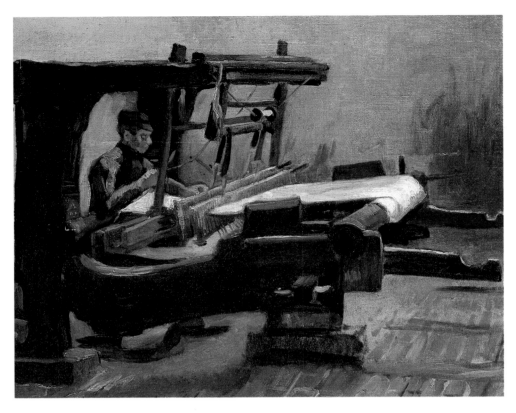

Weaver Facing Right
Nuenen, February 1884
Oil on canvas on panel, 37 x 45 cm
F 162, JH 457
Private collection
(Sotheby's Auction, London, 5. 12. 1983)

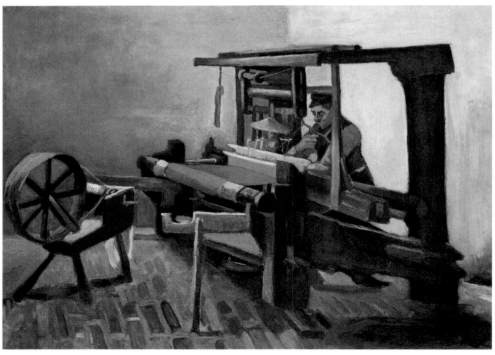

Weaver Facing Left, with Spinning Wheel
Nuenen, March 1884
Oil on canvas, 61 x 85 cm
F 29, JH 471
Boston, Museum of Fine Arts

shop store-room translating the Dutch version of Holy Scripture into English, French and German. (Van Gogh had a considerable gift for languages.) In spring 1877, Vincent went to stay with his Uncle Jan in Amsterdam, where he prepared for theology studies by tackling Latin and Greek, taking maths lessons, and generally trying to fill the gaps he felt his apprenticeship period had punched in his education. Vincent's plans to study came to nothing, and he broke off his preparations before risking failure in the entrance examinations: but at least he was taking pleasure in a variety of reading again, and he drew maps based on his

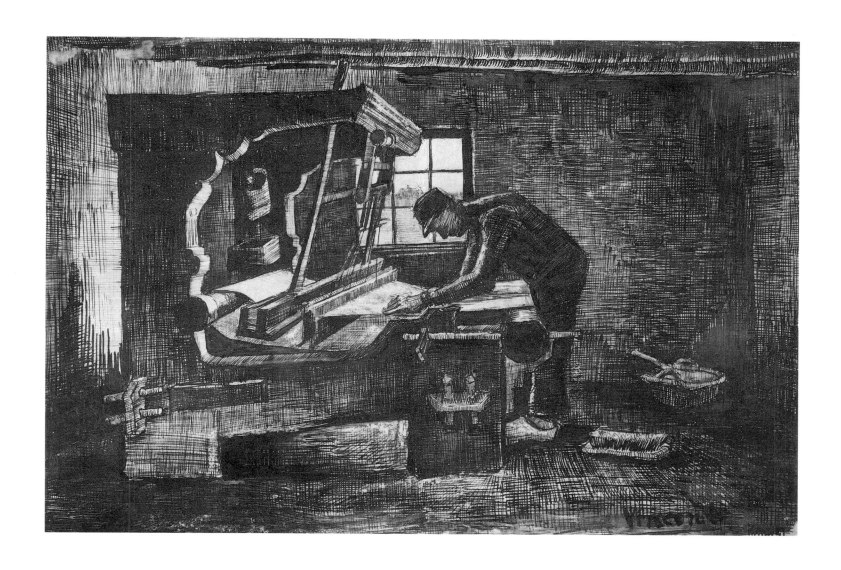

Weaver Standing in Front of a Loom
Nuenen, May 1884
Pencil, pen, heightened with white,
27 x 40 cm
F 1134, JH 481
Otterlo, Rijksmuseum Kröller-Müller

Weaver Arranging Threads
Nuenen, April-May 1884
Oil on canvas on panel, 41 x 57 cm
F 35, JH 478
Otterlo, Rijksmuseum Kröller-Müller

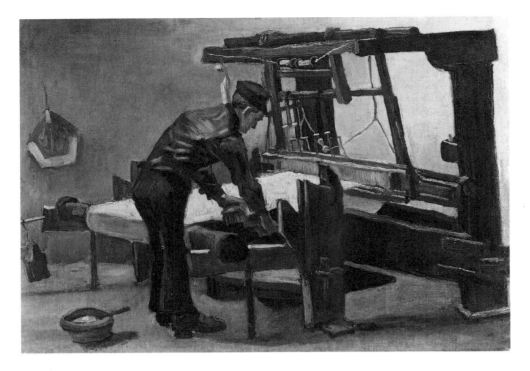

Weaver Standing in Front of a Loom
Nuenen, May 1884
Oil on canvas, 55 x 79 cm
F 33, JH 489
Private collection

Weaver Arranging Threads
Nuenen, May 1884
Oil on panel, 19 x 41 cm
F 32, JH 480
Private collection
(Sotheby's Auction, London, 2. 4. 1979)

reading, too – locations of major importance in the French Revolution (after Jules Michelet's study) or the travels of St. Paul, for instance.

Van Gogh's heady piety was based on the imitating Christ. With a humility that was veritably Franciscan, he neglected his appearance in the attempt to discover those inner values which alone constitute true holiness. He took Thomas à Kempis's devotional work *The Imitation of Christ* as his text, and identified with St. Paul. He adapted his motto at this time from St. Paul's Second Epistle to the Corinthians: "in sorrow yet ever joyful." Repeatedly he glossed the words in letters written during this period. St. Paul's characteristic thought of struggles in this world for salvation in the next was re-interpreted by van Gogh in universally applicable style as a paradox – a paradox that applied to his own state of mind, which trod an ill-defined line between melancholy and remorse, lovesickness and humility, world-weariness and sadness, in a word: between a quite commonplace inability to cope with everyday life and a Christian rejection of worldly preoccupations.

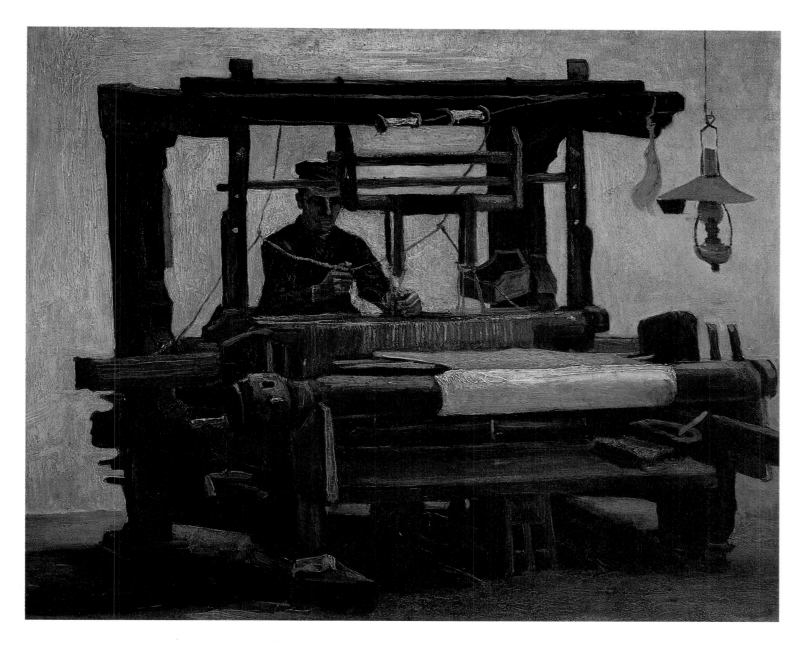

"There will only be a little rest ahead once one has done a couple of years' worth of work and senses that one is on the right track", Vincent wrote to Theo from Amsterdam (Letter 97). In point of fact, his own restlessness – both in terms of geographic location and within himself – was worse than ever. The more he sought religion as an escape from himself, the more his behaviour took on a compulsive character; repeatedly his father felt it necessary to fetch his difficult son home for a spell of peace and quiet. At last the family council agreed that Vincent should try his hand as a lay preacher (since this required active humanity rather than theological expertise). And Vincent's Samaritan instincts were presently to come into their own in the Borinage, an impoverished Belgian mining district.

In happy anticipation, Vincent again compared himself to the apostle (Letter 126): "Before he began his life of preaching, St. Paul [...] spent three years in Arabia. If I might be active for three years or thereabouts, in all tranquillity, in a region like that, I should not return without

Weaver, Seen from the Front
Nuenen, May 1884
Oil on canvas, 70 x 85 cm
F 30, JH 479
Otterlo, Rijksmuseum Kröller-Müller

Landscape with Pollard Willows
Nuenen, April 1884
Oil on canvas on panel, 43 x 58 cm
F 31, JH 477
Whereabouts unknown

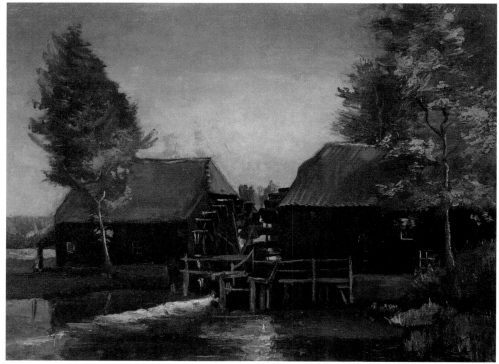

Water Mill at Kollen near Nuenen
Nuenen, May 1884
Oil on canvas on cardboard, 57.5 x 78 cm
F 48a, JH 488
United States, Private collection
(Sotheby's Auction, 6. 4. 1967)

having something to say that would indeed be worth listening to." Van Gogh's compulsive sense of being assessed in accordance with basic criteria evolved by his own tireless labours had invariably been the impulse that spurred him on, daily, to new efforts. In the Borinage, his self-sacrificing spirit once again got rather carried away; the Evangelical Committee opted not to renew Vincent's contract, claiming that he had rather overdone his zeal. He had given his clothing to the needy like St. Martin, had lived in a tumbledown hut like St. Francis, and had existed on a diet of bread and water, as demanded by the strictest of spiritual exercises. In van Gogh's view, loving one's neighbour could know no

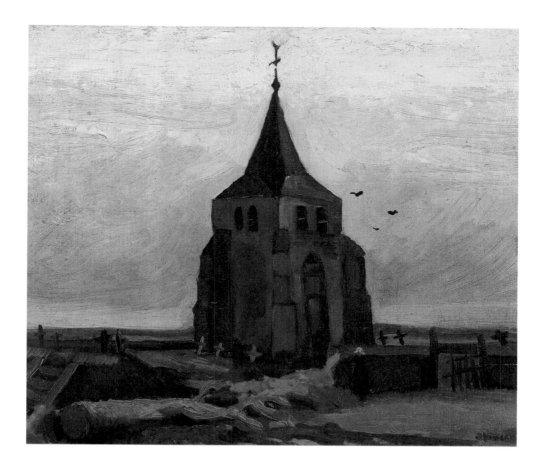

The Old Church Tower at Nuenen
Nuenen, May 1884
Oil on canvas on panel, 47.5 x 55 cm
F 88, JH 490
Zurich, Collection E. G. Bührle

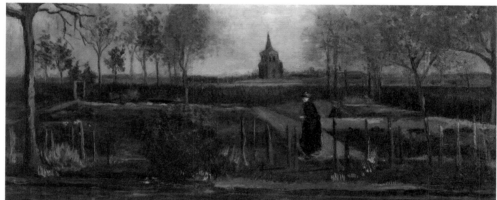

The Parsonage Garden at Nuenen
Nuenen, May 1884
Oil on paper on panel, 25 x 57 cm
F 185, JH 484
Groningen, Groninger Museum voor Stad
en Lande (on loan)

limits. He found his reward in the solidarity of the miners and the proof that they accepted him. Decades later, a legend was still being told locally to the effect that a Dutch lay preacher had guided the most notorious alcoholic in the district back to Mother Church.

Vincent touched rock bottom in the Borinage. He had found that the life of a preacher really suited him no better than that of an art dealer; now he was living without any income among the poorest of the poor, a standing reproach to the middle classes. Even Theo was daunted. From October 1879 to July 1880 their correspondence was interrupted, and it was not till Vincent finally accepted one of his brother's postal money orders that the silence was broken. In his reply, Vincent van Gogh proved to be a changed man, stripped of illusions, his head cleared, and with a new vocation – Art.

"No beginning but in God"
Van Gogh and Religion

Vincent van Gogh's brief apprenticeship in the world of art dealing gave him an early familiarity with paintings. But if we did not bear in mind the crucial part played by the years of religious mania in his subsequent development as an artist, our grasp of his work would remain superficial – indeed, it would be impossible to interpret it. His faith, his personal religion, acted as the catalyst of his creative impulses, and supplied a source of symbols, motifs and meanings that he was to draw on time and again. The harshest criticism of the notion of faith prevalent in Vincent's parental home must remain the fact that it provided the background to his own craving for security, purification and deep feeling – in a word, his own individual brand of piety.

In 1890 P. C. Görlitz, who shared van Gogh's lodgings in Dordrecht, was to recall: "In some respects he was extremely modest, extremely reticent. One day – we had known each other for a month – he asked me, smiling irresistibly as usual: 'Görlitz, you might do me an awfully big favour, if you like.' I replied: 'What is it? Do tell me.' 'Well, the room is really yours, and I'd like your permission to stick one or two Biblical scenes up on the wallpaper.' Of course I immediately gave my consent,

Weaver, Interior with Three Small Windows
Nuenen, July 1884
Oil on canvas, 61 x 93 cm
F 37, JH 501
Otterlo, Rijksmuseum Kröller-Müller

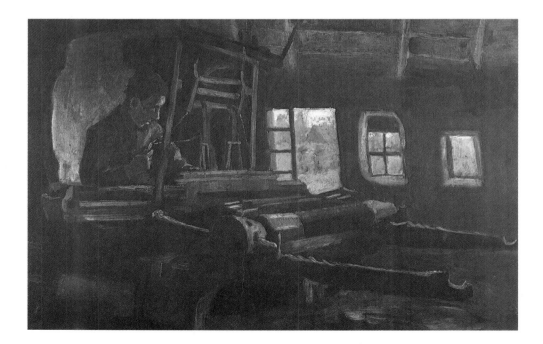

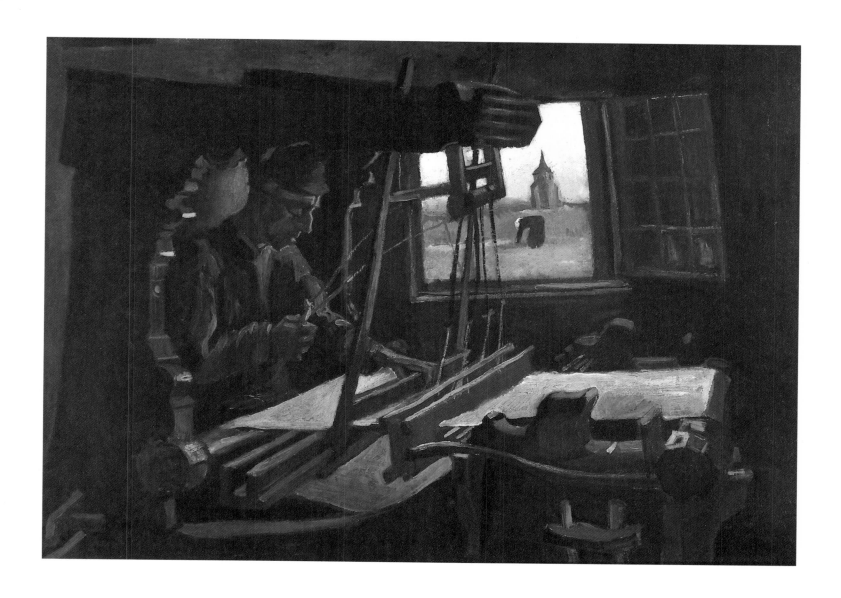

Weaver near an Open Window
Nuenen, July 1884
Oil on canvas, 67.7 x 93.2 cm
F 24, JH 500
Munich, Bayerische Staatsgemälde-
sammlungen, Neue Pinakothek

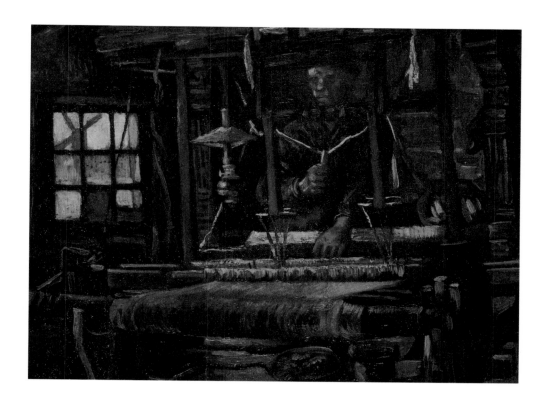

Weaver, Seen from the Front
Nuenen, July 1884
Oil on canvas on panel, 47 x 61.3 cm
F 27, JH 503
Rotterdam, Museum Boymans-van
Beuningen

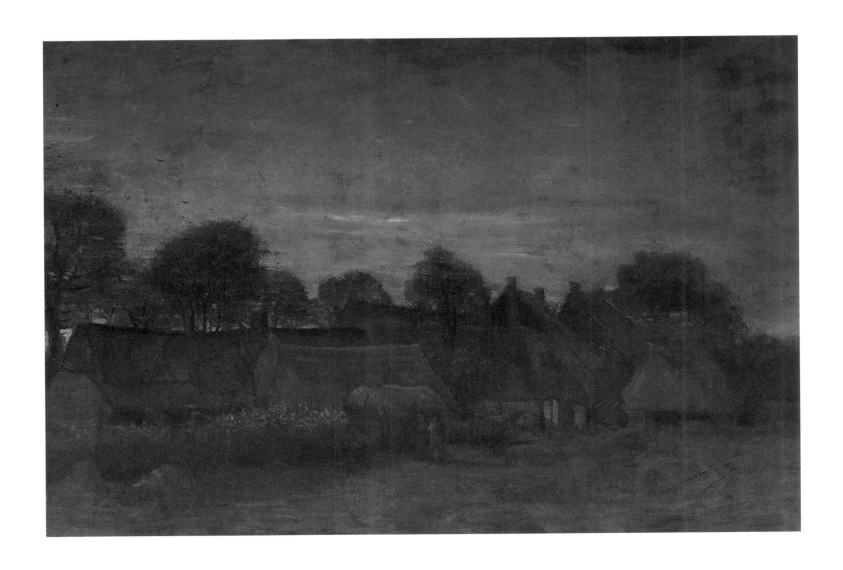

Village at Sunset
Nuenen, Summer 1884
Oil on paper on cardboard, 57 x 82 cm
F 190, JH 492
Amsterdam, Stedelijk Museum
(on loan from the Rijksmuseum)

New-Born Calf Lying on Straw
Nuenen, July 1884
Oil on canvas, 31 x 43.5 cm
No F Number, no JH Number
Private collection

Cart with Red and White Ox
Nuenen, July 1884
Oil on canvas on panel, 57 x 82.5 cm
F 38, JH 504
Otterlo, Rijksmuseum Kröller-Müller

The Old Tower in the Fields
Nuenen, July 1884
Oil on canvas on cardboard, 35 x 47 cm
F 40, JH 507
Private collection
(Sotheby's Auction, London, 10. 12. 1969)

and he went to work at feverish speed. An hour later, the whole room was decorated with Biblical pictures and Ecce Homo scenes, and van Gogh had written beneath every head of Christ: 'in sorrow, yet ever joyful'."

To van Gogh, Jesus Christ was the personification *par excellence* of his own view of the world. That view was based on the paradox of suffering that is welcome, sorrow that pleases; and pictures were a means of illustrating and backing up this view. When van Gogh considered the works of art he saw, he was not applying technical or compositional standards, or assessing colour values; his criteria were not aesthetic. Instead, he was after expression of his own view of the world. His approach to art was distinctly literary in character: he expected pictures to tell stories that he could identify with. He demanded concrete visual presentations of spiritual values, in such a way as to assist his own desire for orientation. Naturally enough, Vincent took to drawing his own Biblical scenes: "Last week", he wrote in May 1877 (Letter 97), "I got as far as Genesis 23, where Abraham buries Sarah in the cave of the field of Machpelah, the plot he has bought, and without really thinking about it I drew a little sketch of how I imagine the place." Van Gogh drew the landscape purely because of its Biblical interest. Gener-

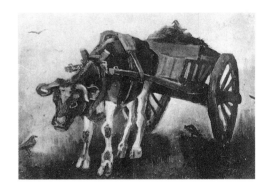

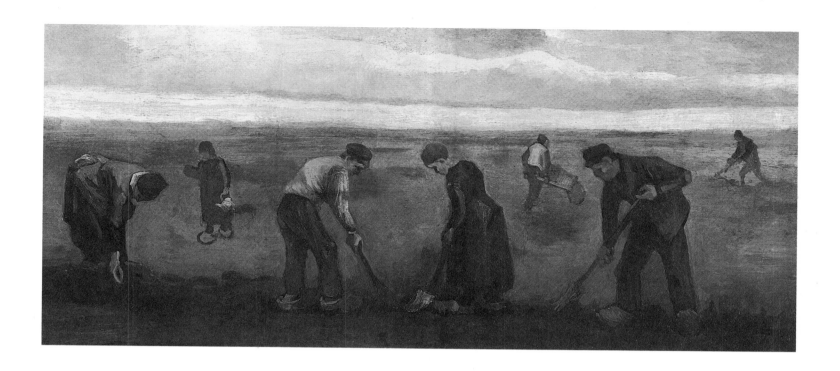

Farmers Planting Potatoes
Nuenen, August-September 1884
Oil on canvas, 66 x 149 cm
F 41, JH 513
Otterlo, Rijksmuseum Kröller-Müller

Spinning Wheel
Nuenen, Summer 1884
Oil on canvas, 34 x 44 cm
F 175, JH 497
Amsterdam, Rijksmuseum Vincent van
Gogh, Vincent van Gogh Foundation

ally speaking, his work is notable for the close inter-relations of every-day appearances (of objects, landscape) and the profounder, more fundamental levels of meaning they conceal.

At the end of October 1876, van Gogh preached for the first time, at Isleworth (England). This sermon (included as number 79a in the Letters) is of particular interest because many of the subjects that loom large in his paintings are referred to in it, motifs that are at the centre of his thinking and which (in words or on canvas, as categories of perception) he emphasizes time and again. In the passage which closes this sermon, Vincent (without ever having held a brush) arranges his motifs exactly as if they were all together in a single painting:

"I once saw a beautiful picture: it was a landscape, in the evening. Far in the distance, on the right, hills, blue in the evening mist. Above the hills, a glorious sunset, with the grey clouds edged with silver and gold and purple. The landscape is flatland or heath, covered with grass; the grass-stalks are yellow because it was autumn. A road crosses the landscape, leading to a high mountain far, far away; on the summit of the mountain, a city, lit by the glow of the setting sun. Along the road goes a pilgrim, his staff in his hand. He has been on his way for a very long time and is very tired. And then he encounters a woman, or a figure in black, reminiscent of St. Paul's phrase: 'in sorrow, yet ever joyful'. This angel of God has been stationed there to keep up the spirits of pilgrims and answer their questions. And the pilgrim asks: 'Does the road wind uphill all the way?' To which comes the reply: 'Yes, to the very end.' And he asks another question: 'Will the day's journey take the whole long day?' And the reply is: 'From morn to night, my friend.' And the pilgrim goes on, in sorrow, yet ever joyful."

The landscape with a setting sun (F720, JH1728), the flatland stretch-

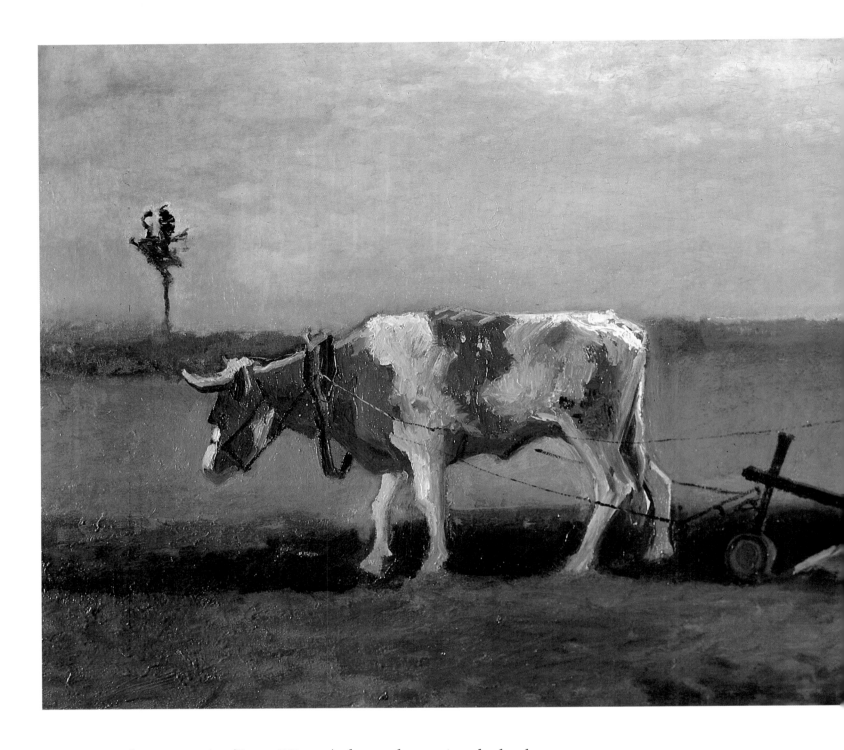

ing away to the mountains (F412, JH1440), the track crossing the land-
scape (F407, JH1440), the solitary wanderer (F448, JH1491), and the
black figure (F481, JH1604) were to be seen again, time after time, when
van Gogh put up his easel in various places. They are details seen closely
and affectionately, but they also have representative or symbolic status;
they are both immediate realities and timeless types. What van Gogh
sees with his own eyes leads him back to projections envisioned in
youth; and at the same time those projections guide the painter in his
quest for motifs worthy of representation on canvas.

 The contorted quality of van Gogh's ways of establishing a motif in
his permanent repertoire can be effectively illustrated if we take a closer
look at that figure in black. In Paris, he had often visited the Louvre.

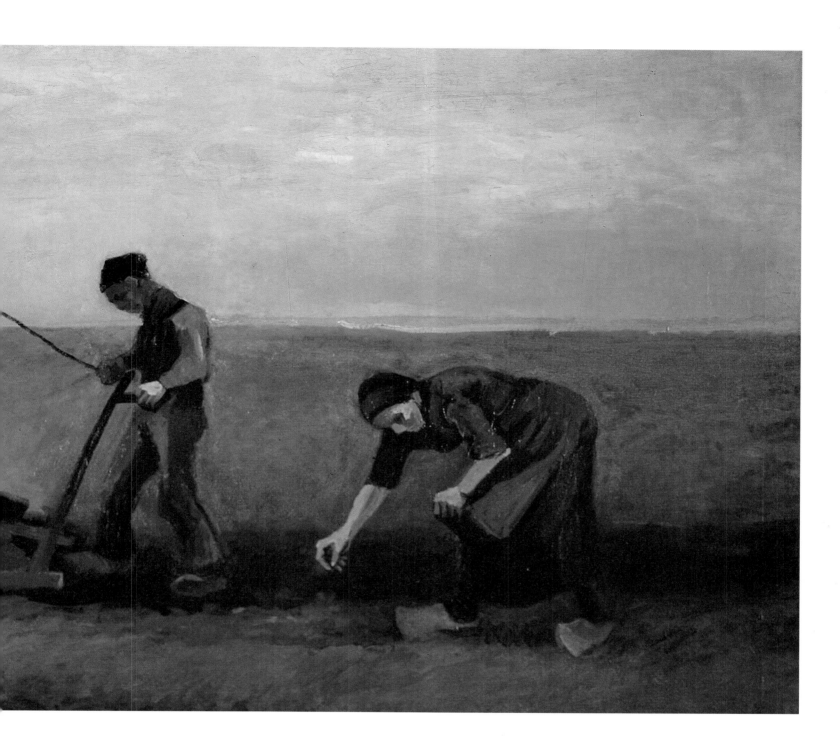

Potato Planting
Nuenen, September 1884
Oil on canvas, 70.5 x 170 cm
F 172, JH 514
Wuppertal, Von der Heydt-Museum

Doubtless he will have remembered a work then attributed to the rather bloodless Baroque painter Philippe de Champaigne, showing a halflength figure of an elderly woman dressed entirely in black, gazing sadly out of the picture. In Michelet's book *L'Amour* van Gogh would have found this description of the picture: "From here I can see a lady, in thoughtful mood, walking in a garden which, though sheltered, is not very extensive and where the blooms have withered early... She reminds me of a lady by Philippe de Champaigne who captured my heart: so honest and upright, clever enough but simple, unequal to the world's devious machinations." There is more to come. Van Gogh thought highly of Michelet's writings; but one more step needed to be taken in his mind before the lady in black could become a constant theme in his

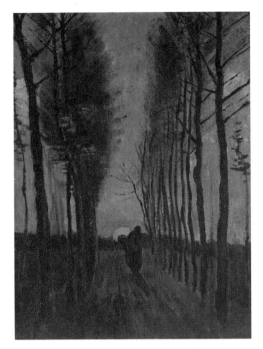

Avenue of Poplars at Sunset
Nuenen, October 1884
Oil on canvas, 45.5 x 32.5 cm
F 123, JH 518
Otterlo, Rijksmuseum Kröller-Müller

Avenue of Poplars in Autumn
Nuenen, October 1884
Oil on canvas on panel, 98.5 x 66 cm
F 122, JH 522
Amsterdam, Rijksmuseum Vincent van
Gogh, Vincent van Gogh Foundation

art. "I am sending you a French Bible", he wrote to his brother (Letter 31), and *The Imitation of Christ*. It was probably the favourite book of that woman de Champaigne painted; in the Louvre there is a picture of her daughter, a nun, also by de Champaigne; *The Imitation of Christ* is on the chair beside her."

We know nothing about the anonymous lady's reading habits, or anything about her daughter; and the book beside the nun in Philippe de Champaigne's votive painting is certainly not Thomas à Kempi's work. Van Gogh had simply fabricated a link between things that had touched his heart and which he felt simply had to be connected. Favourite books, a painting that made a powerful impression, and an all-embracing desire for religious devotion fused to form a complex of thought that can only be described as syncretist. From childhood on, Vincent had absorbed culture, reading voraciously and acquiring pictures, and now his faith was out to subsume his diverse knowledge under an overall world-view. The simple yet complex motto remained: "in sorrow, yet ever joyful."

"Only he can be an artist who has a religion of his own, an original way of viewing the infinite." Thus Friedrich Schlegel, requiring a religious dimension in an artist. In purely biographical terms, van Gogh lived up to this requirement more completely than most artists. His art's ability to touch the hem of the Eternal was not the result of any determination to fit romantic images of the Artist; rather, it derived from a profound and genuine longing for the sheltered security of religious faith. He painted his works for the sake of that moment when, through devotion to the tiniest detail, the artist experiences a sense of total order: the very small and the omnipotently vast could only be grasped from one and the same standpoint. Deeply religious, van Gogh believed that that point lay in God.

The rare moments when he found confirmation of his convictions in the act of painting distinguish van Gogh from genuinely Romantic painting, which could only conceive its image of God in terms of a polarity: on the one hand, an omnipotent Creator dwelling hidden away within Nature, and on the other Man, trembling, conceding his frailty. A passage from Letter 242 reads like van Gogh's altogether deliberate counter-statement to the quest for a spiritual transfiguration in Nature that we see in a Caspar David Friedrich or a Turner: "How much good walking out to the desolate seashore and gazing out at the grey-green sea with the long white crests on its waves can do a man who is downcast and dejected! But if one should have a need for something great, something infinite, something one can perceive God in, there is no need to go far in quest; it seems to me that I have seen something deeper, more infinite, more eternal than the ocean in the expression in a small child's eyes when it awakens early in the morning and yells or laughs on finding the dear sun shining upon its cradle. If ever a 'beam shines down from above', that may be where it is to be found." In terms of the intensity of

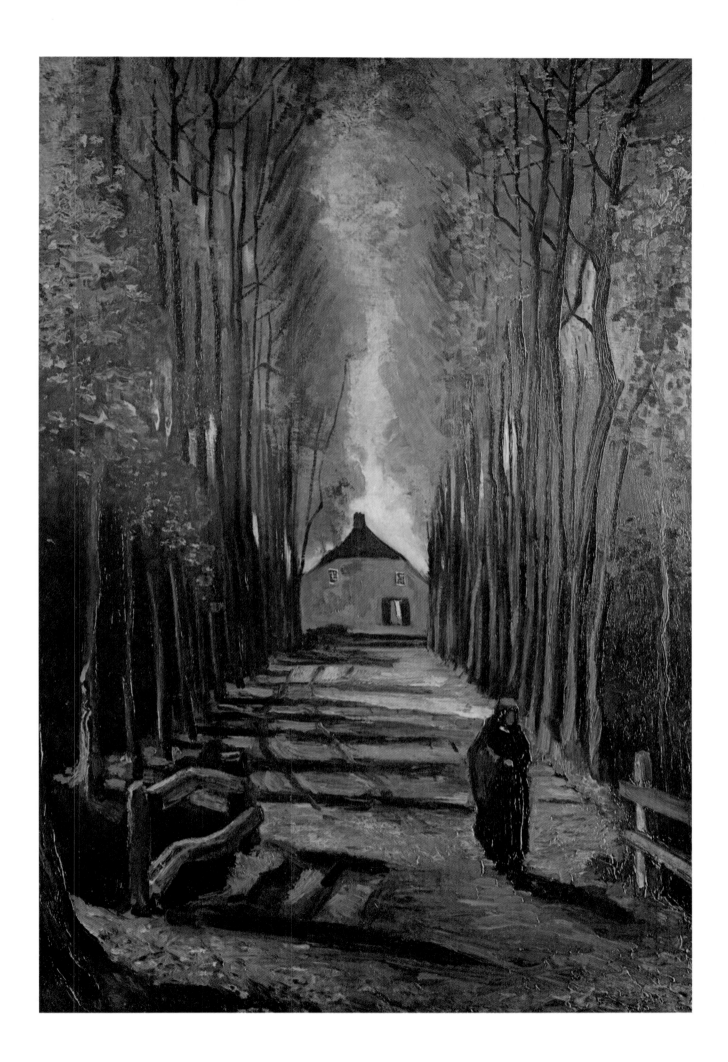

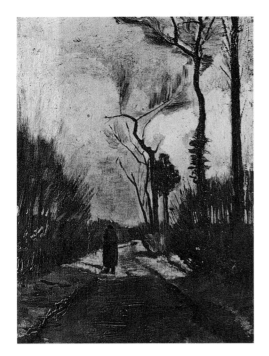

Lane in Autumn
Nuenen, October 1884
Oil on canvas on panel, 46 x 35 cm
F 120, JH 519
Fribourg (Switzerland), Private collection

Chapel at Nuenen with Churchgoers
Nuenen, October 1884
Oil on canvas, 41.5 x 32 cm ·
F 25, JH 521
Amsterdam, Rijksmuseum Vincent van
Gogh, Vincent van Gogh Foundation

his dejection, van Gogh was surely the equal of the Romantics; yet it was his trust in all living things, a trust we might almost call desperate, that distinguished his feel for Life from theirs. In van Gogh, an instinctive trust in God was forever at odds with his knowledge and experience of individual alienation and isolation.

"And now, when each one of us returns to everyday life, to everyday duties, let us not forget that things are not what they seem to be, that God is using the things of everyday life to instruct us in higher things, that our life is a pilgrimage and we are strangers on this earth, but also that we have a God, a Father, who offers shelter and protection to strangers." The conclusion of van Gogh's Isleworth sermon was hardly unusual for its kind, yet it is interesting if we take his subsequent career as a painter into account. These words might almost serve as an illustration to paintings such as that of van Gogh's boots (p. 201) or the chairs in his house at Arles. These things are not only what they seem; vivid and real, they yet direct our attention to something profounder, something all-comprehending, which lies beyond. In such works, van Gogh is close to allegory, which was adopted for specifically Christian purposes in order to relate all real phenomena to God. "Other speech" (the etymological meaning of Greek "allegory") was necessary if the distinction between the worldly and the heavenly realm was to be preserved and revealed. Suffering and redemption, death and salvation, frailty and exaltation are indivisibly conjoined in allegory and can be associated with realities of different kinds at one and the same moment. Allegory was always Christendom's most powerful rhetorical resource; it afforded both comfort and consolation.

There is allegorical thought in van Gogh's Isleworth sermon, in the image of the stranger. This was borrowed from *The Imitation of Christ* by Thomas à Kempis, his favourite reading at the time. "Be thou always as a stranger and a guest on this earth", we read, "and consider the things of this world as matters that concern thee not. Keep thy heart free and always directed upward unto God; for here on earth thou hast no permanent home." The greater the torment and the more inescapable the loneliness, the more Man is prepared to open himself to God and sue for redemption. God offers shelter and protection to strangers (in van Gogh's paraphrase of this passage). Again and again – and with greater urgency towards the end of his life – van Gogh was to quote the image of the stranger. The metaphor embraced his own misfortunes – his persistent lack of success, his inability to relate to people, his sickness – and offered the consolation of a better world. That hope for consolation was in fact the true mainspring of his art. It is palpable in those few moments of identification with existence which he felt when confronted with the sheer life in his chosen subjects, and it is palpable in his trust in a reward, later, somewhere, at some time: "What we need is no less than the Infinite and Miraculous", he wrote in Letter 121, "and Man does

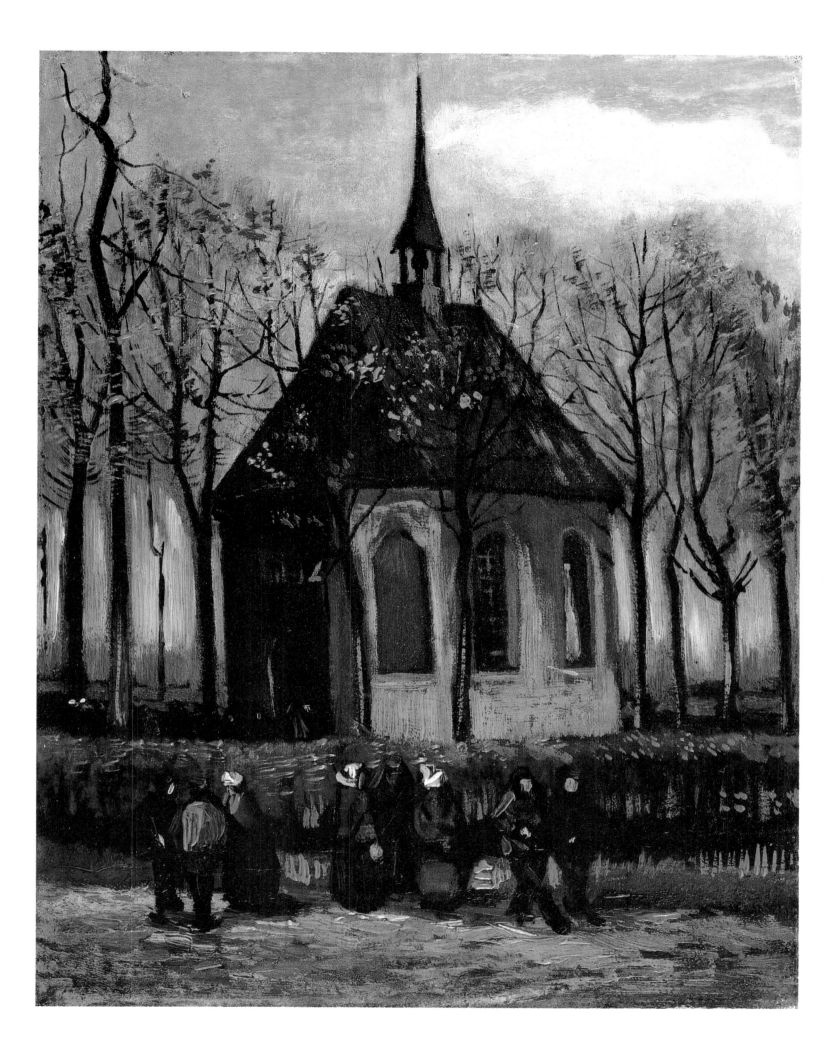

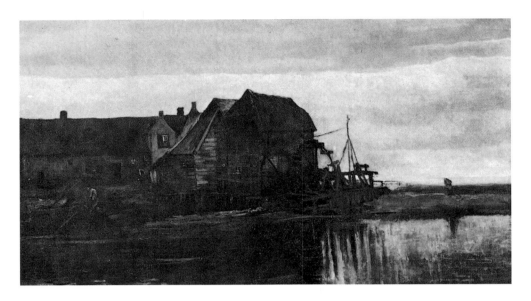

Water Mill at Gennep
Nuenen, November 1884
Oil on canvas on carboard, 87 x 151 cm
F 125, JH 525
Whereabouts unknown

well to be content with nothing less and not to feel secure until he has attained it." Van Gogh did not feel secure, nor could he, given the dimensions of the happiness he had proposed to himself: he would not have been the only one who found that in the stodgy middle-class reality of the 19th century it was all too much. Relying on his belief, he placed his trust in transcendence; we are at liberty to interpret his transcendental beliefs as a hope of paradise, of immortality, or simply of some kind of meaningful existence in the future. Doubtless van Gogh began by thinking of the Christian heaven, where he hoped for a reward. Later, with a trying life as an artist behind him, he occasionally indulged in promising himself significance for the art of the future, along the lines of this diary entry by Delacroix: "One must hope that the great men who were despised or persecuted in their own lifetimes will one day be

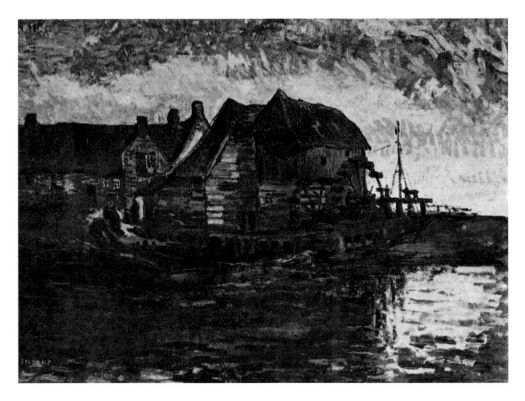

Water Mill at Gennep
Nuenen, November 1884
Oil on cardboard, 75 x 100 cm
F 47, JH 526
New York, Private collection

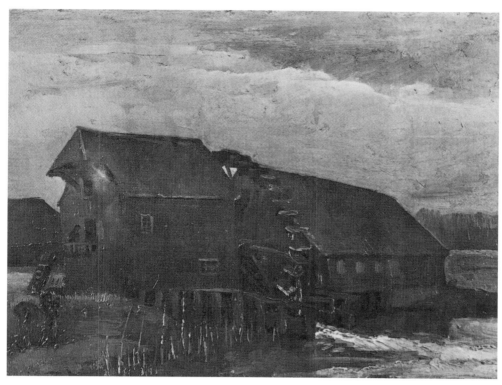

Water Mill at Opwetten
Nuenen, November 1884
Oil on canvas on panel, 45 x 58 cm
F 48, JH 527
Private collection
(Sotheby's Auction, London, 30. 3. 1966)

granted the reward that was denied them on earth when they enter into a sphere where they enjoy a happiness of which we have no conception, part of which is the happiness of looking down to witness the fairness and justice with which Posterity remembers them."

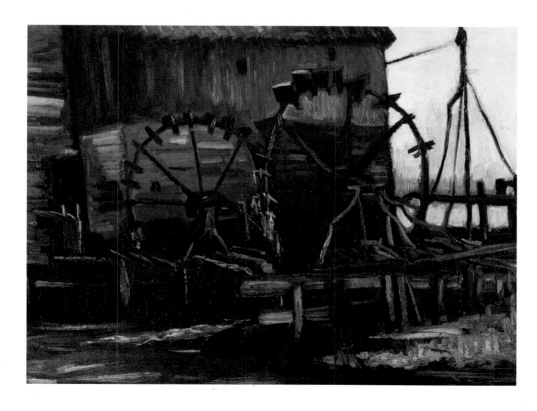

Water Mill at Gennep
Nuenen, November 1884
Oil on canvas, 60 x 78.5 cm
F 46, JH 524
Private collection

First Steps as an Artist
1880-1881

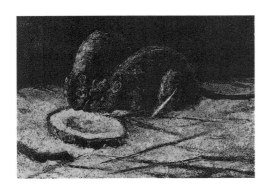

Two Rats
Nuenen, November 1884
Oil on panel, 29.5 x 41.5 cm
F 177, JH 543
Private collection
(Christie's Auction, New York, 19. 5. 1981)

Letter 133, the letter with which Vincent van Gogh resumed contact with his brother after months of silence, highlights the painter's significance as an artist with words. At infrequent intervals, perhaps once a year, his constant state of wrangling uncertainty issued in a perfectly dispassionate, almost cynical description and critique of himself and his current situation. Van Gogh's letter from the Borinage (the Belgian coal-mining district), written in July 1880, was the first in this series of level-headed analyses. Before he could make these disillusioned assessments of his ill-organized life, though, he had to put self-sacrificing toil on behalf of others behind him to an increasing extent: his early religious spirit, involving an evangelical imitation of Christ that was expressed in caring for his neighbours, was of no help in overcoming his unceasing discontent with himself and his life in general. Once he started to view the tenets of faith in a more abstract sense, as a way of seeing the world,

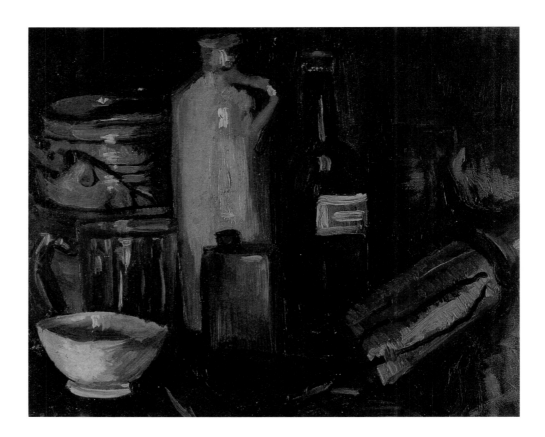

Still Life with Pots, Jar and Bottles
Nuenen, November 1884
Oil on canvas, 29.5 x 39.5 cm
F 178r, JH 528
The Hague, Haags Gemeentemuseum

a new approach to Art became possible. Hitherto he had actively practised his faith and had seen pictures as a support for it, narrating the process of redemption; but now the pattern was reversed, and the working artist set out to create pictures representing the certainty of redemption. In this process, religion served as a kind of pledge that he empowered himself to redeem at any time.

"Once I was in another environment", van Gogh told his brother in the same letter, "an environment of pictures and works of art, [...] an intense, passionate feeling for that environment overcame me, a feeling that came close to rapture. Nor do I regret it. And now, far from home, I am often homesick for that homeland of pictures [...] Instead of yielding to my homesickness I told myself that home, the fatherland, is everywhere. Instead of succumbing to despair I decided on active melan-

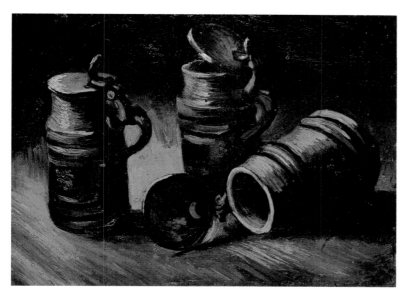 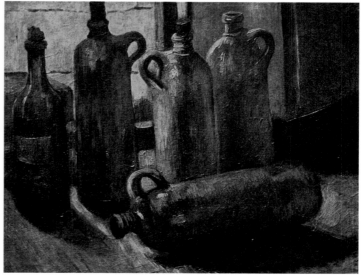

choly, insofar as being active was in my power; or, to put it differently, I put a melancholy that hopes and strives and seeks before a despairing melancholy of gloomy inaction." This passage provides us with a key phrase in his view of himself as an artist: "active melancholy". In the times to come it was to keep van Gogh going, ceaselessly, confronting his *weltschmerz* with the utopian notion of alleviating action. His art, his homeland of pictures, always kept its sights on both the impossibility and the hope of consigning his sufferings to oblivion through action.

"Now, I equally believe", he continued in the same letter, "that everything that is truly good and beautiful in Man and Man's works, everything of a moral, inner, spiritual, sublime beauty, all derives from God... Try to understand what the great artists, the serious masters, are ultimately saying in their finest works – God is in it. One will have expressed it in a book, another in a painting. So Art is worship, or divine service, inasmuch as it places Beauty (which is the same thing as Goodness) in the heart of Man." After years of fairly ill-considered religious enthusiasm, van Gogh had achieved a position where Art and

Still Life with Three Beer Mugs
Nuenen, November 1884
Oil on canvas, 32 x 43 cm
F 49, JH 534
Amsterdam, Rijksmuseum Vincent van Gogh, Vincent van Gogh Foundation

Still Life with Five Bottles
Nuenen, November 1884
Oil on canvas, 46.5 x 56 cm
F 56, JH 530
Vienna, Neue Galerie
in der Stallburg

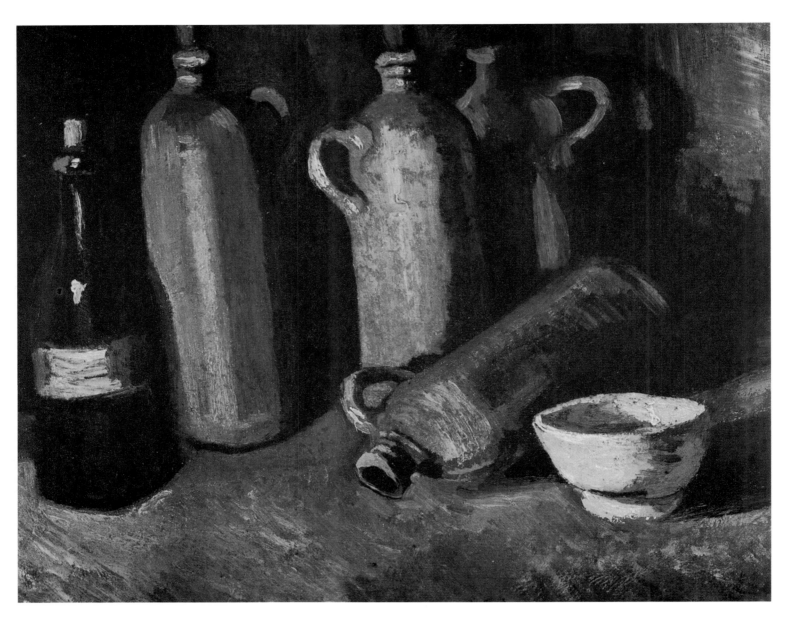

Religion, if they imposed moral obligations, were in fact one and the same thing.

It was because of this degree of abstraction in his thinking that van Gogh devoted himself to painting. It was widely agreed that Art enjoyed universal validity; and van Gogh not only wanted to do something for mankind, he also wanted recognition for what he was doing. Hitherto he had been "an idler in spite of myself; sometimes people in this position do not know themselves what they might be capable of, yet they feel instinctively: I *am* capable of something, my existence *does* mean something!" We should view van Gogh's new activity as an artist as an offer he was making to his family, in particular to Theo, to re-establish trust in each other after the months of indifference: "I am writing to you about all this because I believe you would rather I did something good than nothing at all, and this may perhaps be an occasion for restoring the fellow-feeling and heartfelt harmony between the two of us, an occasion for us to be of use to each other."

It implies no disparagement of van Gogh's artistic work if we point

Still Life with Four Stone Bottles, Flask and White Cup
Nuenen, November 1884
Oil on canvas, 33 x 41 cm
F 50, JH 529
Otterlo, Rijksmuseum Kröller-Müller

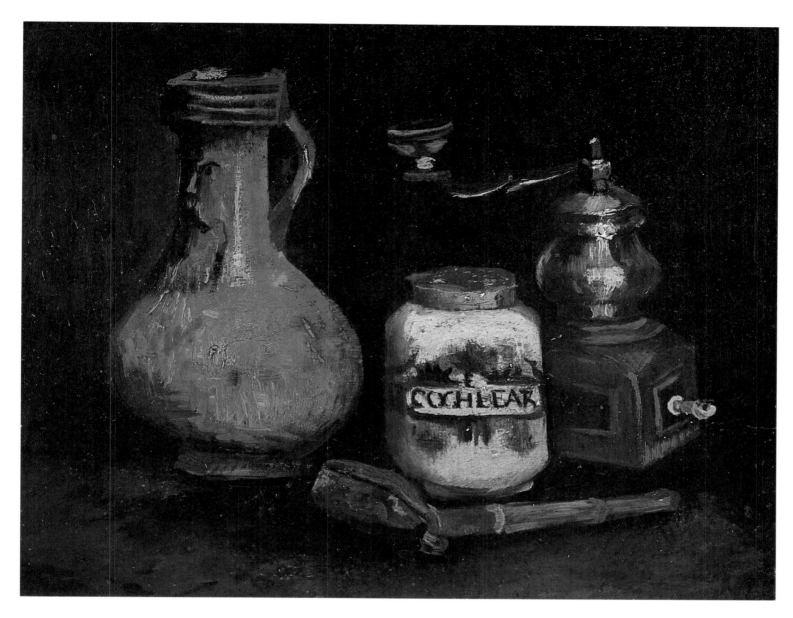

Still Life with Coffee Mill, Pipe Case and Jug
Nuenen, November 1884
Oil on panel, 34 x 43 cm
F 52, JH 535
Otterlo, Rijksmuseum Kröller-Müller

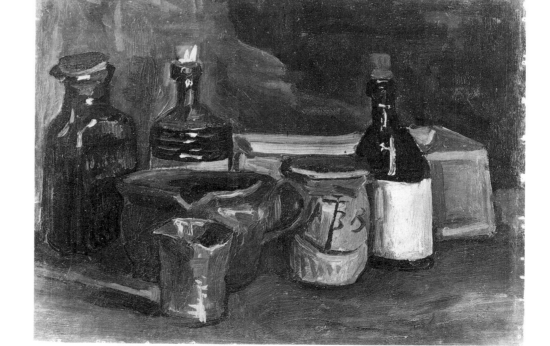

Still Life with Pottery, Bottles and a Box
Nuenen, November 1884
Oil on canvas, 31 x 42 cm
F 61r, JH 533
Amsterdam, Rijksmuseum Vincent van
Gogh, Vincent van Gogh Foundation

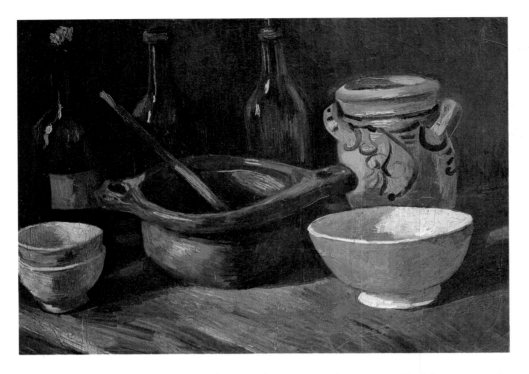

Still Life with Three Bottles and Earthenware Vessel
Nuenen, Winter 1884/85
Oil on canvas, 39.5 x 56 cm
F 53, JH 538
Amsterdam, Rijksmuseum Vincent van Gogh, Vincent van Gogh Foundation

out that there were material considerations that impelled him to take his decision for Art. From this time on, Theo was punctual in sending off his postal money orders; and Vincent depended on the clout of the art dealers in the family.

In October 1880 van Gogh went to Brussels, to start on his training in Art. He matriculated at the Academy: "Once I have mastered drawing or watercolours or etching, I can return to mining and weaving country and shall be better at working from Nature than I am now. But first I have to acquire an amount of skill" (Letter 137). A model student, he copied pictures and practised drawing exercises. He suppressed the

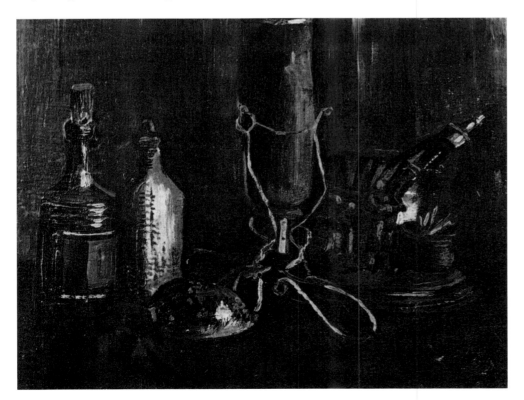

Still Life with Bottles and a Cowrie Shell
Nuenen, November 1884
Oil on canvas on panel, 30.5 x 40 cm
F 64, JH 537
Whereabouts unknown
(Sotheby's Auction, London, 3. 7. 1968)

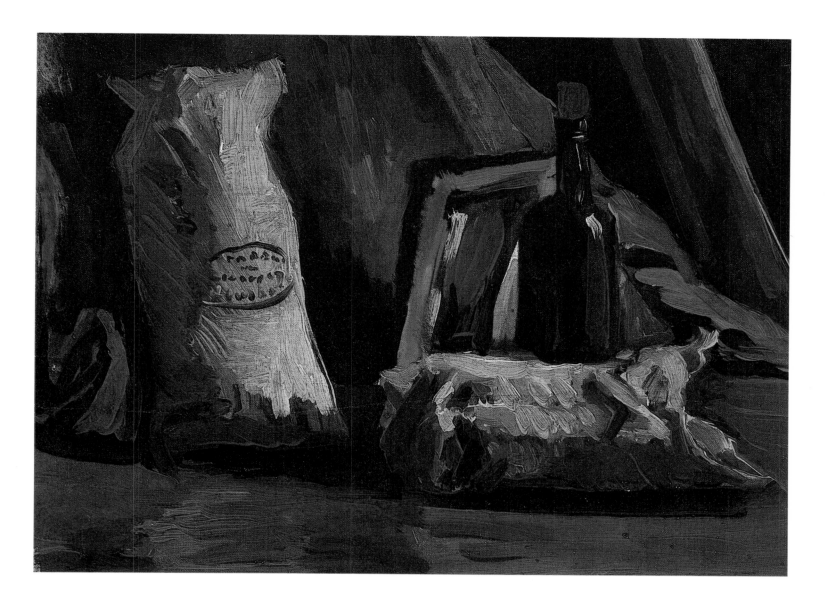

irresistible urge to go out into Nature. And he even sent his first works home, "to Pa, so that he can see I'm doing something" (Letter 138). Anton Mauve, his mother's brother-in-law and one of the best-known Dutch painters of the day, helped Vincent, introducing him to ways of handling paint and giving him essential advice. Van Gogh believed he had now discovered his true vocation, a path which might in due course earn him honour and financial rewards, and his family and relatives, tradition-minded as they were, approved. In April 1881 Vincent even went to Etten, to his parents' home, where Theodorus van Gogh was now the incumbent of the parish; and now that everything seemed to be working out he was welcomed with open arms.

Things turned out much as they had previously done, though. The career in art dealing, under the wing of his uncles, had ended in dismissal. His life as a pastor, which met his father's hopes, had come to grief in the slums of the Borinage. And now his artistic calling, approved by the whole family, presently turned out a disaster: some six months later, Vincent was thrown out of the house, and the Rev. van Gogh seemingly even decided to disown his son. All the plans van Gogh had obediently

Still Life with Two Sacks and a Bottle
Nuenen, November 1884
Oil on canvas on panel, 31.7 x 42 cm
F 55, JH 532
Private collection
(Koller Auction, Zurich, 25.-26. 5. 1984)

framed came to nothing. They were plans based on conventional bourgeois ideas of success, and they brought home to Vincent that this kind of tepid conformity was not for him. In Etten he realised that his conception of Art was not the same as society's; and inevitably he became an outsider again, even in the very province which luxury and aestheticism had marked out as the province of outsiders.

Vincent was in love. The lady in question was no other than his cousin Kee, recently widowed. She had a young son, and Vincent, with his weakness for children, soon acquired a passion for the boy's mother, too. The entire family were embarrassed by his advances, and found his protestations of love indecent, impious and lacking in sensitivity towards a woman in mourning. Vincent countered the reproaches with the sheer intensity of his feelings, disregarding the rules of convention.

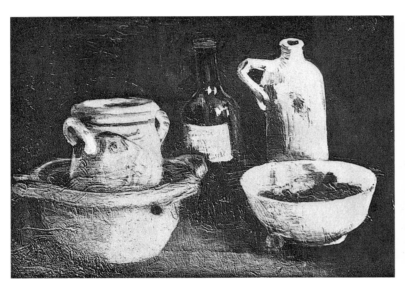 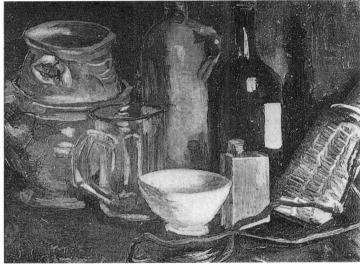

Vincent freely expressed his emotions to Theo. Writing to his new friend Rappard in Brussels, on the other hand, he was secretive about his love, and claimed that his affections were all enlisted in the service of Art: "Though you may not know it", he said (in Letter R4), "this Academy is a loved one who actually prevents a more serious, warmer, more fruitful love from awakening within you. — Let that lover go her way, and fall head over heels in love with the lady your heart truly loves, Dame Nature or Réalité. I too have fallen in love, head over heels, with a Dame Nature or Réalité, and since then I have been feeling happy although she is putting up tough resistance." Writing to Theo at the same time (Letter 157), he was less ambiguous: "Fall in love, and there you are, to your amazement you notice that there is another force that impels us to action: feeling." And he felt that his new devotion had a positive influence on his art: "To my chagrin, there always remains an element of hardness and severity in my drawings, and I believe that she (that is to say, her influence) is needed if they are to become softer." Kee's influence would supposedly purify his art and endow it with the flexibility it needed for the vital confrontation with Nature.

Still Life with Pottery and Two Bottles
Nuenen, November 1884
Oil on canvas, 40 x 56 cm
F 57, JH 539
Private collection

Still Life with Pottery, Beer Glass and Bottle
Nuenen, November 1884
Oil on canvas on panel, 31 x 41 cm
F 58, JH 531
United States, Private collection

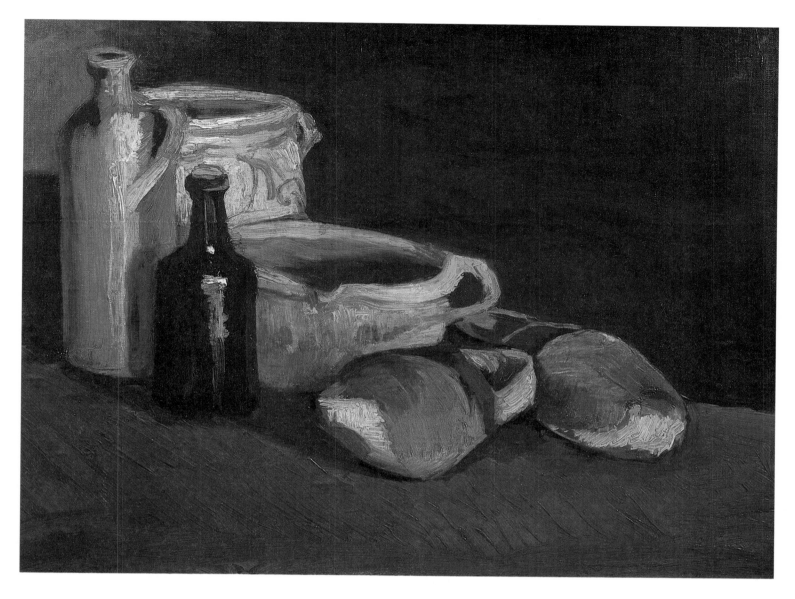

Once again we perceive van Gogh's tendency to syncretism. He had a twofold vision of his cousin – as a prim and proper clergyman's daughter rejecting his advances because the family elders expected her to do so, and as a woman he loved and intended to fight for. He projected everything he hated and loved into her. Kee became a personification of conventions and freedom alike, of the academic form of Establishment Art and of the openness of Nature, of the moral double standards of the middle class and of the immediacy of emotional life. And when Kee refused to listen to him, he wanted to thrust the propriety of his upbringing, the ridiculous rules of good behaviour away from him. It was in this connection that van Gogh first mentioned the concept that all his artistic efforts were to be devoted to and which art historians still identify him with: "May your profession be a modern one", he urged Theo (in Letter 160), "and may you help your wife to attain a modern soul, free her of the awful prejudices that shackle her." Modernity and emancipation were already inseparable in van Gogh's mind; and his emphatic calls for freedom were to be matched by the dazzling evolution of his art.

Still Life with Clogs and Pots
Nuenen, November 1884
Oil on canvas on panel, 42 x 54 cm
F 54, JH 536
Utrecht, Centraal Museum
(on loan from the van Baaren Museum
Foundation, Utrecht)

Vase with Honesty
Nuenen, Autumn 1884
Oil on canvas, 42.5 x 31.5 cm
F 76, JH 542
Amsterdam, Rijksmuseum Vincent van
Gogh, Vincent van Gogh Foundation

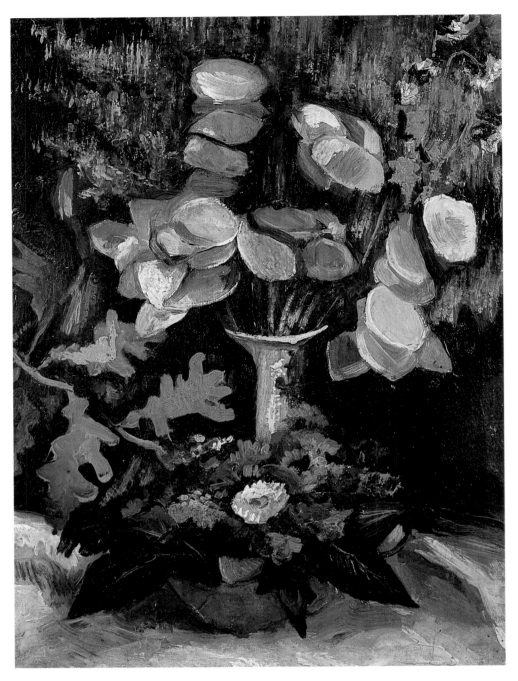

Vase with Dead Leaves
Nuenen, November 1884
Oil on canvas on panel, 41.5 x 31 cm
F 200, JH 541
Private collection
(Sotheby's Auction, London, 21. 4. 1971)

But he still had a long way to go. Van Gogh's first two paintings were completed at the end of 1881, under Mauve's guidance: *Still Life with Cabbage and Clogs* (p. 16) and *Still Life with Beer Mug and Fruit* (p. 16). Vincent's first steps as a painter were hesitant, tentative; he chose inanimate subjects, as he had been taught at the Academy, and tried to establish three-dimensionality and effects of light in a casual arrangement of the objects he had picked. The background remained a non-spatial brown; this approach was not a particularly good idea, since it afforded the individual items no optical purchase. But van Gogh had made a start. And in the rustic simplicity with which he took so obdurate a subject as clogs for granted we sense a foretaste of the scenes of peasant life that van Gogh was to paint in the years ahead.

Van Gogh's Early Models

Still Life with Paintbrushes in a Pot
Nuenen, November 1884
Oil on canvas on panel, 31.5 x 41.5 cm
F 60, JH 540
Private collection
(Christie's Auction, London, 26. 6. 1989)

In a distinctly new way, Vincent van Gogh's art was a product of the industrial era. The 19th century had embraced the ideal of industrial progress with enthusiasm. The multiplication of things was seen as the foundation of a better world. And works of the visual arts became subject to the process of reproduction too. Art was stored in museums, accessible to the public, and private homes had prints and books so that quiet hours of leisure could also be spent in the pursuit of Art. What the museums hoarded were paintings that had the aura of originals; and

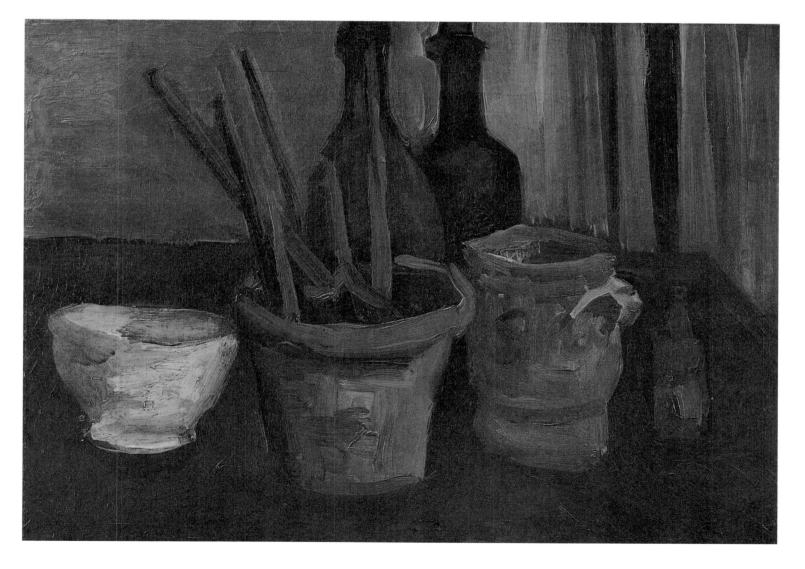

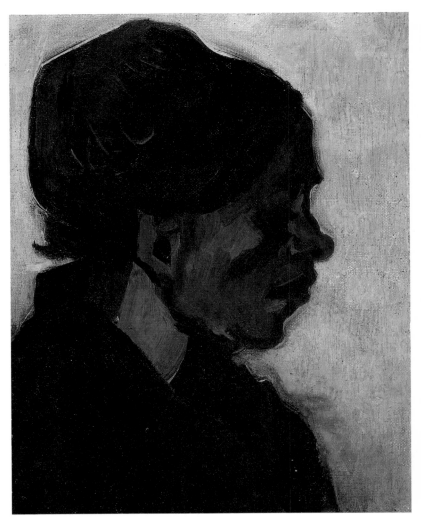

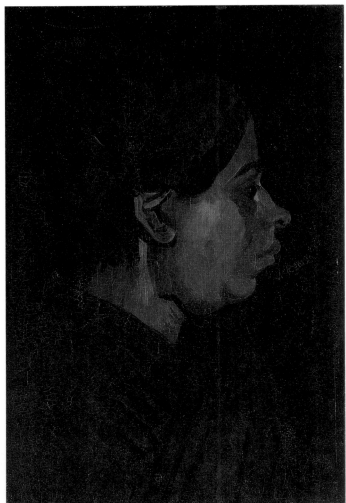

these in turn served as the prototypes for mass reproduction of a new commodity – pictures. Art began to seem banal and everyday. To a greater extent than any painter before him, van Gogh underwent his training as an artist by looking at reproductions. It was as if the auto-didact needed to school his eye on the smooth impersonality of mass-produced printwork if his vision was to discover the living and universal qualities in Man and Nature.

Goupil, van Gogh's earlier employer, was the leading name in art reproduction. Definite as van Gogh was about severing ties with his past, he continued to take pleasure in the reproductions Goupil published. Confident of his ability to acquire artistic skill from prints and drawing schools, he soon quit the Brussels Academy, although it was free (which had been his only reason for matriculating there in the first place). In his view it was enough if he diligently copied reproductions and then let the fruits of his labour ripen in the warm glow of Nature. Van Gogh's tutor was Charles Bargues. Bargues's *Cours de dessin* and *Exercises au fusain* (two volumes of drawing exercises for study at home, published by Goupil) took the place of the Academy in van Gogh's training. The *Cours* included sixty nudes – of increasing technical difficulty – which the student was supposed to copy. The *Exercises* came in two parts: first there were seventy pages of sketches from

Head of a Brabant Peasant Woman with Dark Cap
Nuenen, January 1885
Oil on canvas on panel, 26 x 20 cm
F 153, JH 587
Otterlo, Rijksmuseum Kröller-Müller

Head of a Peasant Woman with Dark Cap
Nuenen, January 1885
Oil on canvas on panel, 37.5 x 24.5 cm
F 135, JH 585
Cincinnati, The Cincinnati Art Museum

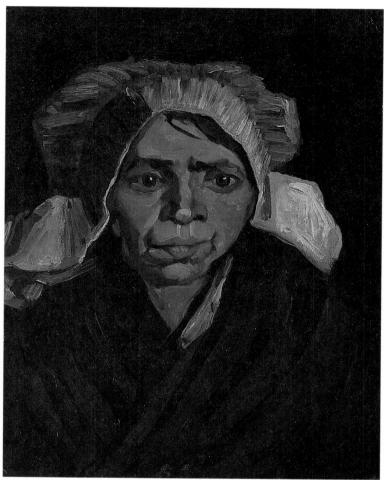

Peasant Woman, Head (unfinished)
Nuenen, December 1884
Oil on canvas on panel, 47.5 x 34.5 cm
F 159, not listed in JH
Amsterdam, Rijksmuseum Vincent van
Gogh, Vincent van Gogh Foundation
(Attribution disputed)

Head of a Peasant Woman with White Cap
Nuenen, December 1884
Oil on canvas, 43.5 x 37 cm
F 146a, JH 565
Private collection
(Koller Auction, Zurich, 8. 11. 1974)

plaster models to be mastered, and then the student went on to drawing from famous paintings. Van Gogh tackled both sections repeatedly; indeed, he had amused himself in this way every day during his Borinage sojourn. In summer 1881 he went to work on them for a final time, and did not have recourse to them again till 1890, shortly before his death.

The engravings of contemporary works of art (which van Gogh also copied) made a lasting impression. Time and again he asked Theo to send him new Goupil publications. His liking for the social romanticism of a Jean-François Millet or Jules Breton matched the fashionable taste of the day; Paris society had started to value this work highly some ten years earlier. They were paintings that gave a true-to-life account of the hard facts of everyday farming or factory life while at the same time misting them over in idyllic light (sunsets, and so forth). Millet's *Angélus* (Paris, Musée d'Orsay) was the perfect example of this kind of work. It showed a farmer and his wife, forgetful of their poverty, hearing the bells of the angelus ringing from a distant belfry and pausing for silent prayer. Paintings such as this must have met van Gogh's need for an art that included religious devotion; indeed, when he was still living in the Borinage he had gone to see Jules Breton, to talk to the famous artist.

But van Gogh was not only out to copy these painters' works. They

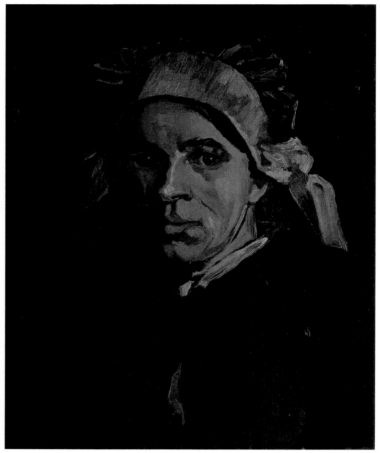

Head of a Young Peasant with Pipe
Nuenen, Winter 1884/85
Oil on canvas, 38 x 30 cm
F 164, JH 558
Amsterdam, Rijksmuseum Vincent van
Gogh, Vincent van Gogh Foundation

Head of a Peasant Woman with White Cap
Nuenen, December 1884
Oil on canvas on panel, 42 x 34 cm
F 156, JH 569
Amsterdam, Rijksmuseum Vincent van
Gogh, Vincent van Gogh Foundation

Head of a Peasant Woman with White Cap
Nuenen, December 1884
Oil on canvas on panel, 40.5 x 30.5 cm
F 144, JH 561
Montreal, Collection Mrs. Olive Hosmer

Head of a Peasant with Cap
Nuenen, December 1884
Oil on canvas, 39 x 30 cm
F 160a, JH 563
Private collection
(Sotheby's Auction, London, 1. 7. 1970)

Head of a Peasant Woman
Nuenen, December 1884
Oil on canvas on panel, 40 x 32.5 cm
F 132, JH 574
Private collection
(Christie's Auction, London, 6.–10. 12. 1968)

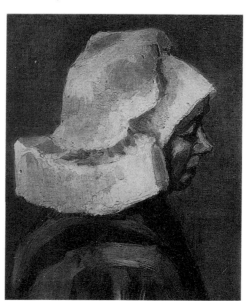

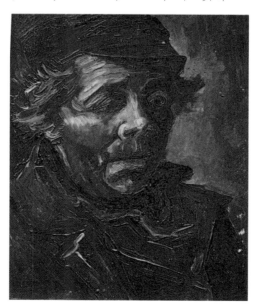

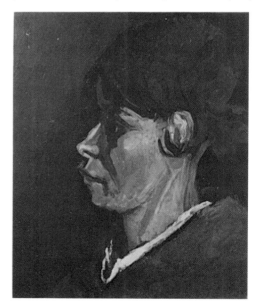

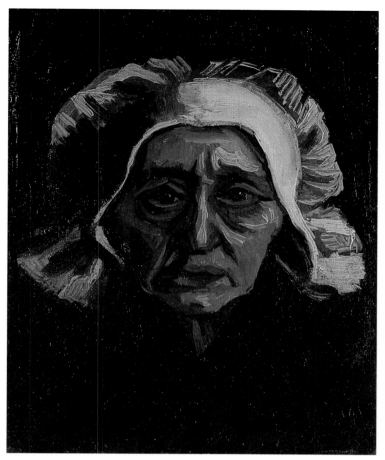

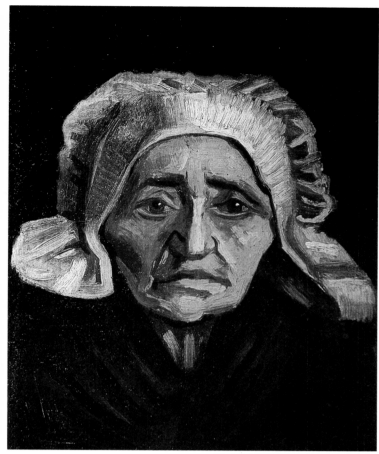

Head of an Old Peasant Woman with White Cap
Nuenen, December 1884
Oil on canvas, 36.5 x 29.5 cm
F 75, JH 550
Wuppertal, Von der Heydt-Museum

Head of an Old Peasant Woman with White Cap
Nuenen, December 1884
Oil on canvas on cardboard, 33 x 26 cm
F 146, JH 551. Private collection
(Sotheby's Auction, London, 30. 6. 1981)

Head of a Peasant Woman with Dark Cap
Nuenen, January 1885
Oil on canvas on panel, 39.5 x 30 cm
F 133, JH 584
Private collection

Head of a Peasant with Cap
Nuenen, January 1885
Oil on canvas, 35.5 x 26 cm
F 169a, JH 583
Collection Stavros S. Niarchos

Head of a Peasant Woman with Dark Cap
Nuenen, January 1885
Oil on canvas on panel, 25 x 19 cm
F 153a, JH 586
New York, Private collection

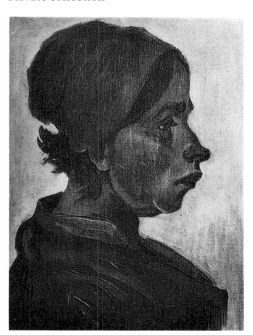

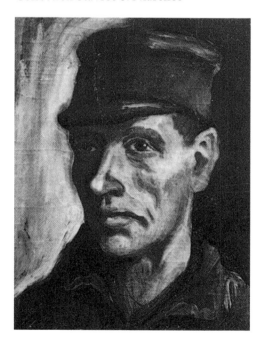

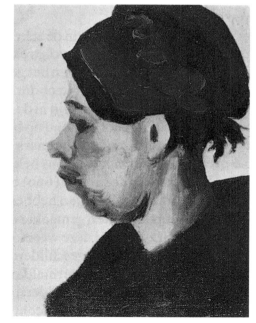

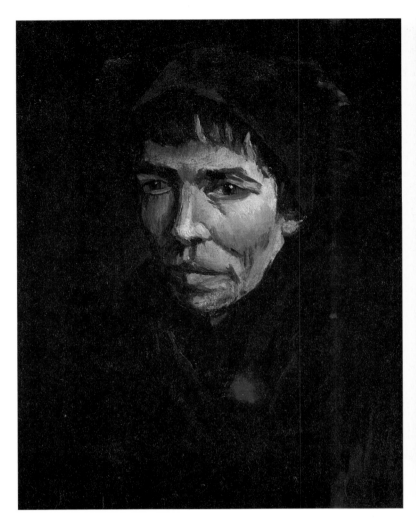
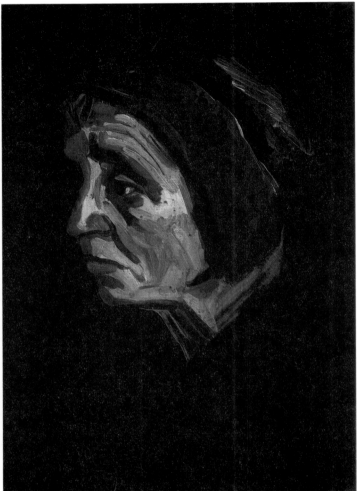

also served as models in his own life. He was given to quoting from Alfred Sensier's biography of Millet, and appropriated some of Millet's statements as a creed of his own: "I am noting down a few phrases from Sensier's *Millet* for you", he wrote to Theo (Letter 180), "phrases that impressed and affected me greatly, sayings of Millet's: Art is a fight – in Art you have to risk your very life. You have to work like a nigger: I would sooner say nothing at all than express myself feebly." These comments, put into Millet's mouth by his biographer, van Gogh took as the guidelines of his own life. And he gave them authenticity, just as he gave life to the routine lines produced in the copyist's act by applying the technique to Nature. It was as if the full vitality of his own perception only came into its own once the things he saw had become lifeless, as it were. Reproduction was almost the *sine qua non* for van Gogh's passion for appropriation.

Along with Bargues's exercises and the reproductions of Millet and Breton, a third body of graphic work influenced van Gogh's early drawings. It was an age of reproductions, and since mid-century (particularly in England) there had been a number of publications, most of them illustrated periodicals, that ran pictures showing scenes of everyday life, often with a sociocritical slant. Van Gogh had a subscription to the best-known of these periodicals, *The Graphic*. The illustrations included a

Head of a Peasant Woman with Dark Cap
Nuenen, January 1885
Oil on canvas, 40.6 x 31.7 cm
F 1667, JH 629
Private collection
(Christie's Auction, London, 28. 3. 1988)

Head of an Old Peasant Woman with Dark Cap
Nuenen, January 1885
Oil on canvas on panel, 36 x 25.5 cm
F 151, JH 649
Otterlo, Rijksmuseum Kröller-Müller

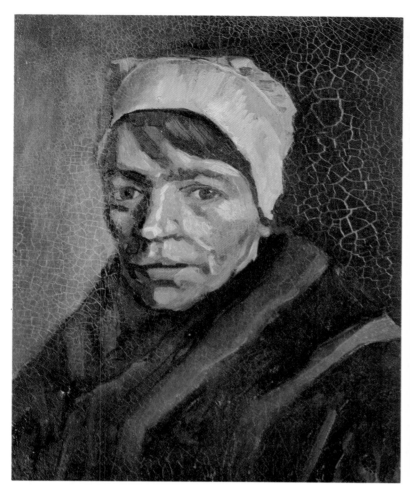
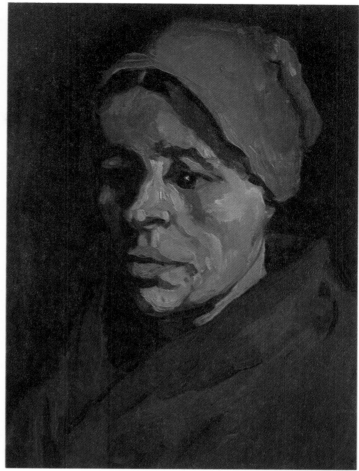

Head of a Peasant Woman with White Cap
Nuenen, January 1885
Oil on canvas, 38 x 30 cm
F 65, JH 627
Whereabouts unknown

Head of a Peasant Woman with Brownish Cap
Nuenen, January 1885
Oil on canvas, 40 x 30 cm
F 154, JH 608
Otterlo, Rijksmuseum Kröller-Müller

large number of human figures; and many of the unadorned, realistic reports made their mark on his own art. Fildes's drawing of Charles Dickens's empty chair is the most familiar example. An illustration by Helen Paterson was to prompt a painting now in The Hague, *Girl in White in the Woods* (p. 18). And the paintings of peasants done in Nuenen were closely related to William Small's portraits of working people. Van Gogh could envisage a career as a periodicals illustrator for himself: "Without presuming to suggest I could do as well as the people I have named, I do hope that if I work hard at drawing these working people and so forth I shall become more or less capable of doing illustrations for magazines or books" (Letter 140).

Only one copy dating from van Gogh's early years (and documented by references in the letters) survives: a drawing done of etcher Paul-Edmé Le Rat's reproduction of a painting by Millet. This version of *The Sower* (p. 20) is given the number 1 in Jan Hulsker's complete catalogue of van Gogh's works. Van Gogh clearly took meticulous pains to mimic the etching's style and flow – his own lines follow the lines of the needle. But in Etten van Gogh was already to put this faithful imitation, this impersonal devotion to a model, behind him.

"The first thing I have to do is find a room that's big enough, so that I can get the necessary distance. The moment he looked at my studies,

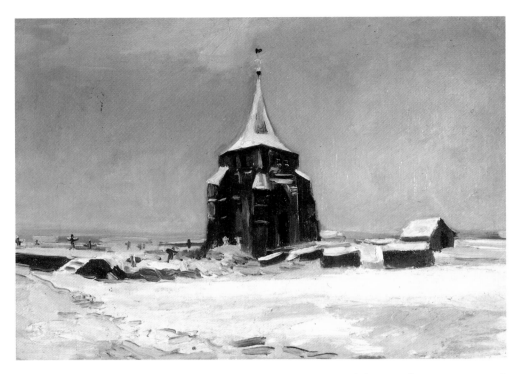

The Old Cemetery Tower at Nuenen in the Snow
Nuenen, January 1885
Oil on canvas on cardboard, 30 x 41.5 cm
F 87, JH 600
Collection Stavros S. Niarchos

Mauve told me: 'You're too close to the model.'" What van Gogh described (in Letter 164) as a problem of restricted space was to be a typical feature of his work in general: closeness to his subject. This closeness is certainly a quite literal question of physical proximity; but it is also an emotional closeness that results from an immediacy of identification with all things. Van Gogh acquired his draughtsmanship skills by schooling himself on the stereotyped objectiveness of illustrations, and in consequence his early drawings were on the dull side in terms of line and flow, with his contours tidily framing motifs he could not organically fit into the background; but nevertheless, from the very beginning those early works emanate that pleasure van Gogh must have taken in dealing with his subjects. However poor the quality of the drawings, they always have an intense note of solidarity which derives not so much from the handling of the pencil as from the perspective of van Gogh's approach. The rough love of detail, which is incapable of

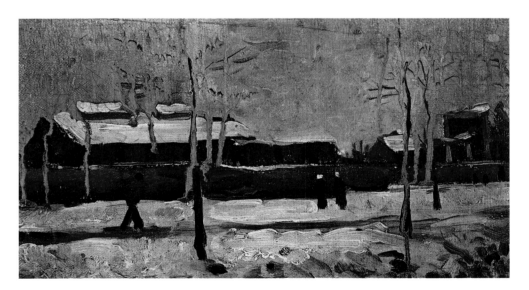

The Old Station at Eindhoven
Nuenen, January 1885
Oil on canvas, 13.5 x 24 cm
F 67a, JH 602
Private collection
(Sotheby's Auction, London, 26. 6. 1984)

reproducing tactile, material, three-dimensional effects, is balanced out from the very start by a quality that could be termed conceptual. Before committing his vision to paper, van Gogh would always evolve a sense of his subject that had a great deal of longing, sympathy and trust in it. In Letter 195 he himself left an account of this: "I have tried to endow the landscape with the same feeling as the figure. Taking firm root in the earth, frantically and passionately, as it were, and still being half torn

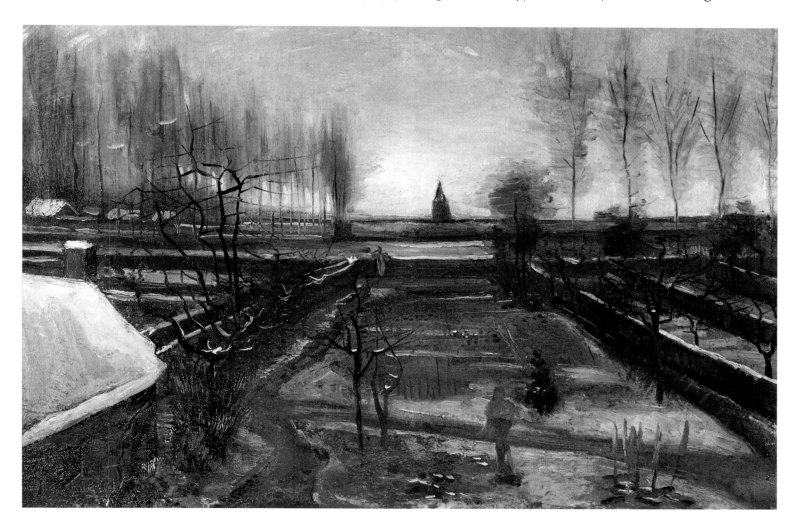

The Parsonage Garden at Nuenen in the Snow
Nuenen, January 1885
Oil on canvas on panel, 53 x 78 cm
F 67, JH 604
Los Angeles, The Armand Hammer Museum of Art

away by the storms. In both the white figure of the woman and the black, gnarled roots I wanted to express some of the struggle of life. Or, to be more exact: because I was trying to be faithful to the natural world before me, without philosophizing, in both cases, almost in spite of everything, something of that great struggle entered in."

In his contemplation of individual motifs there is always a sense of the fate of all life, which the artist shares in. "Something of that great struggle" comes to the fore, in all its inclusive totality. There can be no doubt about the links of this way of thinking to religious mania, on the one hand, and on the other to Romantic intensity of feeling. But it is also perfectly possible that van Gogh's particular problems with artistic technique, his lack of any thorough training, and indeed (to put it bluntly) his lack of talent, played a part too. In the process of copying,

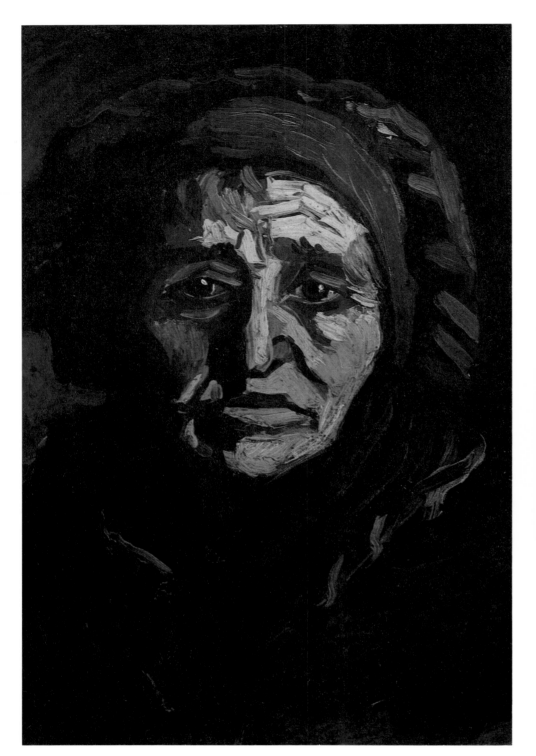

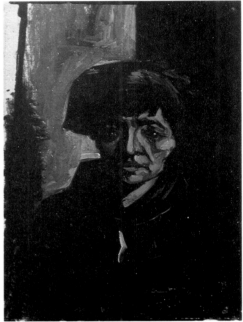

Head of a Peasant Woman with Greenish Lace Cap
Nuenen, February-March 1885
Oil on canvas, 38 x 28.5 cm
F 74, JH 648
Otterlo, Rijksmuseum Kröller-Müller

Head of a Peasant Woman with Dark Cap
Nuenen, December 1884
Oil on canvas on panel, 35 x 26 cm
F 136a, JH 548
Japan, Private collection
(Christie's Auction, New York, 15. 5. 1985)

van Gogh appropriated all his subjects complete with contexts. He found them in total, finished units which had to be grasped overall if he was to give deeper attention to the details. He was plainly unskilled, and this absence of skill made it impossible for him to take a descriptive approach to things; but this absence was compensated by an expressive vigour that enhanced all his shapes and forms and made sheer energy into an aesthetic quality. In every new work, van Gogh laid bare the roots of his creativity.

Family Life
The Hague 1882-1883

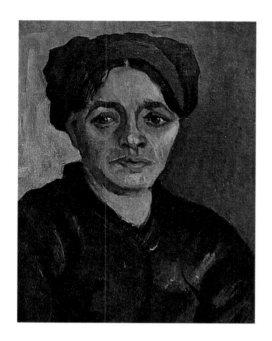

Head of a Peasant Woman with Dark Cap
Nuenen, January 1885
Oil on canvas, 40 x 30.5 cm
F 137, JH 593
Whereabouts unknown

The first two still lifes van Gogh painted (p. 16) were done in Mauve's studio in The Hague. This old city to win became Vincent's base when he travelled to Amsterdam to make a last attempt Kee. When Kee rejected him, he turned to any other woman who would have him – and found one. Van Gogh records the encounter; in Letter 164, which can be read (in its assured and distanced view of himself) as an 1881 pendant to Letter 133 from the Borinage: "Retribution comes if one lives without a woman for too long. And I do not believe that what some people call God, others the Supreme Being, and still others Nature, is both irrational and merciless. In a word, I came to this conclusion: Just for once I shall see if I can't find myself a woman. And, dear God, I didn't need to look far." Nature, both rational and merciful (the combination of rationality and humane qualities is characteristic of van Gogh's way of seeing things), supplied van Gogh with a woman. She earned a poor living as a prostitute.

Christine Clasina Maria Hoornik, known as Sien, was older than Vincent (like Kee); she had a daughter and was expecting a second child. "It is not the first time that I've been unable to resist the feeling of attraction and love towards those women in particular whom the pastors damn so vehemently, condemning and despising them from on high in their pulpits." Vincent himself brought all his powers of sympathy to bear on Sien. Solidarity with this ill-treated woman meant more to him than observing conventions that forbade contact with fallen women: "If one wakes early and is not alone, one sees a fellow human being beside one, it makes the whole world so much more of a livable place. Far more livable than the devotional books and whitewashed church walls the pastors are so in love with."

There had been a violent family quarrel, and following it Vincent had left the parental home at Etten (on Christmas Day, 1881) and moved to The Hague. The city was the centre of the art world, which meant so much to him, and he was close to Sien, too. Time after time, at the festival that marks the birth of Christ, van Gogh took decisions that changed his life. It was Christmas that prompted him to hand in his notice at Goupil's – he returned home when trade was at its briskest. And later, when his life with Gauguin in Arles was deteriorating, the

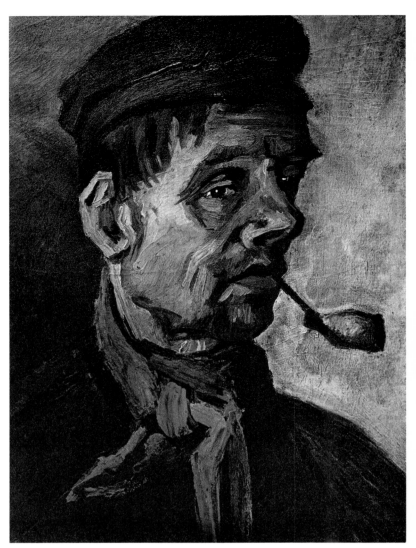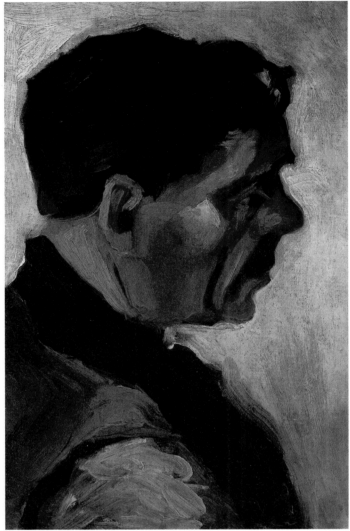

crisis was to be reached when he mutilated himself at Christmas. In The Hague he attempted to re-establish the festive tranquillity of the day with his new family: "A strong, powerful emotion visits a man's spirit when he sits beside the woman he loves, with an infant child in the cradle next to them. Even if she was in hospital and I sitting beside her where she lay – it would still always be the eternal poetry of Christmas night, with the infant in the manger, as the old Dutch painters portrayed it, and Millet and Breton – with a light nevertheless in the darkness, a brightness amidst the dark night" (Letter 213). Once again, van Gogh's innate goodness and sentimentality colours his vision; a hospital room becomes a stable in Bethlehem, and the new-born child acquires a divine sublimity.

The woman he loves is seen with an artist's eye, too: "Never before have I had so good a helper", he wrote to Rappard (Letter R8), "as this ugly??? faded woman. To me, she is beautiful, and I find in her the very things I need; life has passed her by, and she has been marked by suffering and misfortune. If the earth has not been ploughed, one cannot grow anything in it. She has been ploughed – and for that reason I find more in her than in a whole heap of the unploughed." Sien's

Head of a Peasant with a Pipe
Nuenen, January 1885
Oil on canvas, 44 x 32 cm
F 169, JH 633
Otterlo, Rijksmuseum Kröller-Müller

Head of a Peasant
Nuenen, February-March 1885
Oil on canvas, 47 x 30 cm
F 168, JH 632
Otterlo, Rijksmuseum Kröller-Müller

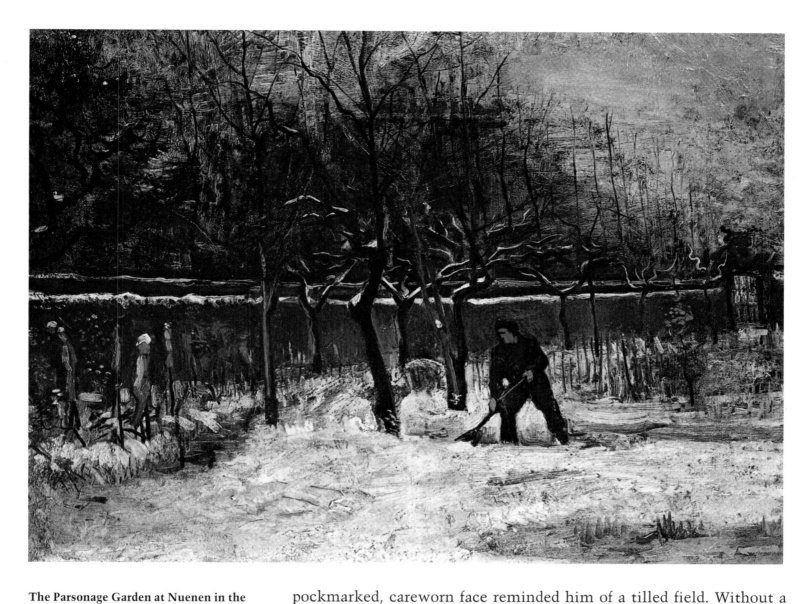

**The Parsonage Garden at Nuenen in the
Snow**
Nuenen, January 1885
Oil on canvas on panel, 51 x 77 cm
F 194, JH 603
Pasadena (Cal.), Norton Simon Museum
of Art

pockmarked, careworn face reminded him of a tilled field. Without a
trace of irony, van Gogh adapted her face to the Biblical metaphor of
sowing and reaping, the same metaphor as he used to describe his own
painting. Sien became his muse. She had no mythological beauty to
offer him; but her incorruptible vitality was more than sufficient com-
pensation for any lack of literary or historical status.

The help he had hoped for from his relatives was not forthcoming.
They preferred to keep the good-for-nothing of the family at arm's
length now that he was living with a prostitute and her two illegitimate
children. (Van Gogh never learnt that Sien in fact had four children.) Van
Gogh's response was a greater dedication to his work than ever. Now,
with models at his disposal, he was finally able to indulge his view of
himself as a figure painter. In summer 1882 he and his family moved to a
larger apartment. Now he even had a studio. "To return quite specifi-
cally to the subject of Art", he wrote to his brother in Letter 215, "from
time to time I feel a great desire to go back to painting. The studio is
much more spacious, the light is better, I am well able to keep paint etc.
without making too much of a dirty mess. And so I have promptly made
a new start with watercolours." And in August 1882 he produced a

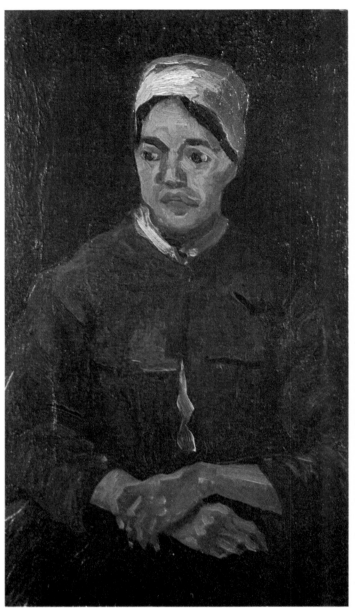
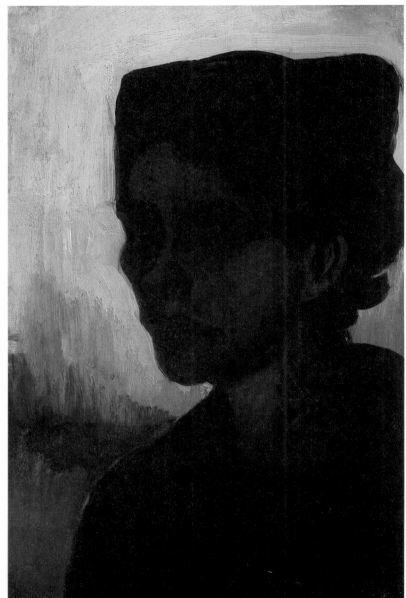

series of oil paintings, fourteen of which (out of a total that must have been double that figure) have survived.

Mauve was a member of the 1880 Movement, a Dutch school of *plein air* painters centred on The Hague, a school that were trying to reconcile the approach of the Barbizon painters with the landscape tradition of the baroque Golden Age. Théodore Rousseau had founded an artists' colony around the middle of the century in the woods at Fontainebleau. Tired of the busy Parisian bustle, these artists were out to reform landscape painting, which was in an ailing condition, crushed by the dogmas of the academies. Painters such as Charles-François Daubigny and Camille Corot took to setting up their easels in the open, hoping to capture the fleeting play of light, the life and atmospherics of their subjects, to restore to those subjects a certain lightness and directness, indeed joyfulness. The Barbizon School's programme was influential, and artists' associations that spurned the cities were appearing everywhere by the end of the century. Mauve's group in The Hague – including painters

Peasant Woman, Seated (Half-Figure)
Nuenen, February 1885
Oil on canvas on panel, 46 x 27 cm
F 127, JH 651
Private collection
(Sotheby's Auction, 26. 5. 1976)

Head of a Young Peasant Woman with Dark Cap
Nuenen, February-March 1885
Oil on canvas, 39 x 26 cm
F 150, JH 650
Otterlo, Rijksmuseum Kröller-Müller

such as Jozef Israëls, the brothers Jacob Henricus and Matthijs Maris, and Johannes Bosboom – practised a Barbizon escapism on Dutch soil. But in addition they were drawing upon a second tradition, a line that had achieved the sheer élan of liberation even in times of prescriptive rules laid down by the pontificating Guardians of Art: this was the line of 17th century Dutch landscape art. In the works of Jacob van Ruisdael or Meindert Hobbema, communion with Nature had always been valued above all things. And the artists of The Hague aimed to combine the direct approach of the Barbizon painters with the close attention to the motif that was characteristic of the Dutch old masters.

Van Gogh closely resembled them in his choice of subjects. He too was attracted to the outskirts of The Hague, a transitional area that was neither city nor countryside, where the light was dimmer, the air freer, the motifs lighter of heart, and the mood unclouded by the full melancholy of rural parts. In the main, he painted sea scenes: views of the beach at Scheveningen and of the subjects that presented themselves there, such as dunes, fishermen, boats, and crashing waves. But this coincidence of subject matter represents the only common ground between van Gogh and the 1880 Movement, as two examples will show.

"Otherwise, the scenery is very simple on the whole", wrote van Gogh in Letter 307, describing the vicinity, "flat and level, with

Peasant Woman Sweeping the Floor
Nuenen, February-March 1885
Oil on canvas on panel, 41 x 27 cm
F 152, JH 656
Otterlo, Rijksmuseum Kröller-Müller

Peasant Woman Sewing
Nuenen, February 1885
Oil on canvas, 42.5 x 33 cm
F 126a, JH 655
Schweinfurt, Collection Georg Schäfer

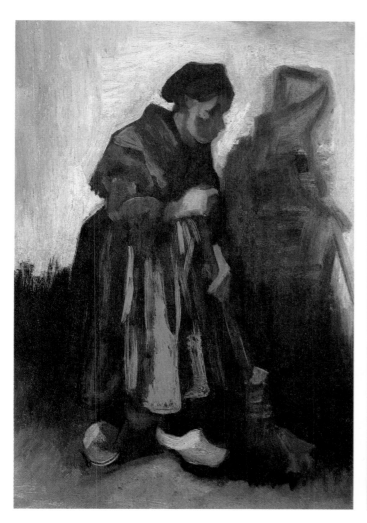
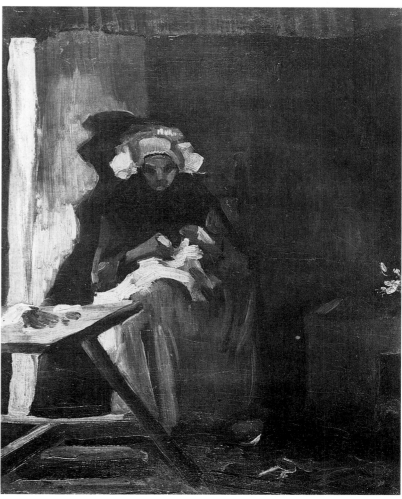

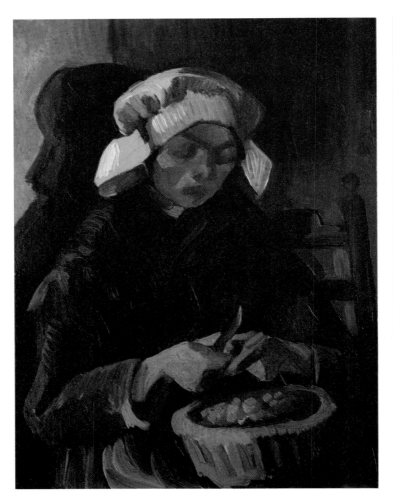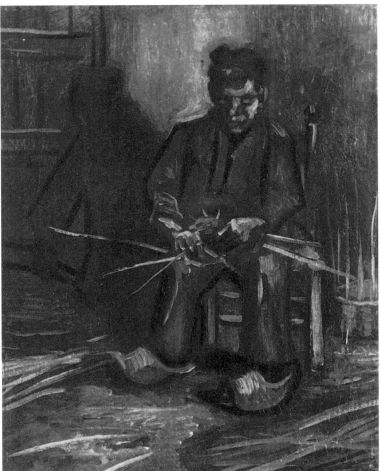

weather-beaten dunes, and at best waves. I think that if we were there together the area would create a mood in which we would have no doubts about my work but would sense for certain what we must aim for." In the dunes he used as subjects, as in all things, van Gogh was seeking consolation, an opening for communication, an option on some kind of identification. To a far greater extent than the enlightened artists of his time he withdrew into Nature, searching for its anthropomorphic side, the image of himself and of the gloomy frame of mind he was in. That is why his dunes look so monumentally close (p. 17). "Theo, I am definitely not a landscape painter; if I paint landscapes, there will always be something figural in them" (Letter 182). Landscape was a model for van Gogh. He did not want it to be unapproachable and remotely beautiful; he wanted it open, harmonizing with the painter's situation by virtue of its capacity for symbolic expression. In this, van Gogh was far closer to a Ruisdael, with his religiously motivated approach to Nature, than to the disillusioned snapshot scenes of a Mauve.

"I have been in Scheveningen frequently and have brought two small seascapes home with me. There is a great deal of sand in the first – but when it came to the second, with a storm blowing and the sea coming right up to the dunes, I had to scrape it totally clear twice because it was completely caked in sand. The storm was so rough that I could hardly

Peasant Woman Peeling Potatoes
Nuenen, February 1885
Oil on canvas on panel, 43 x 31 cm
F 145, JH 653
Private collection

Peasant Making a Basket
Nuenen, February 1885
Oil on canvas, 41 x 35 cm
F 171, JH 658
Switzerland, Private collection

PAGE 81, LEFT:
Peasant Sitting at a Table
Nuenen, March-April 1885
Oil on canvas, 44 x 32.5 cm
F 167, JH 689
Otterlo, Rijksmuseum Kröller-Müller

PAGE 81, RIGHT:
Peasant Woman at the Spinning Wheel
Nuenen, February-March 1885
Oil on canvas, 41 x 32.5 cm
F 36, JH 698
Amsterdam, Rijksmuseum Vincent van Gogh, Vincent van Gogh Foundation

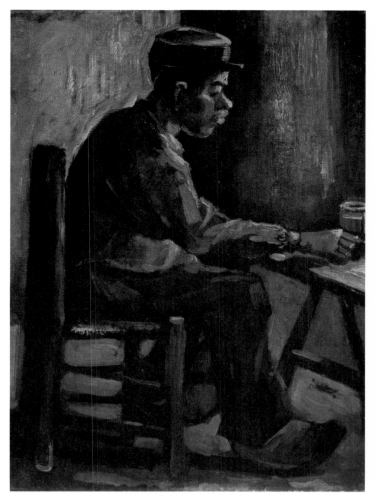

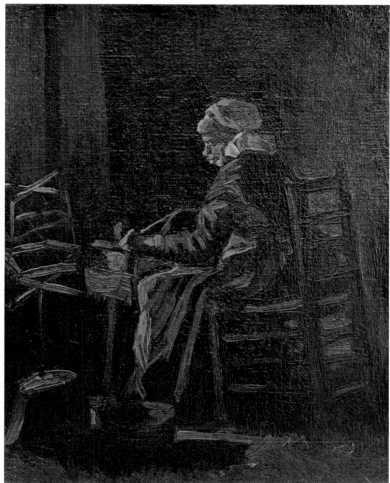

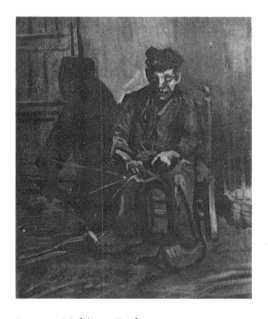

Peasant Making a Basket
Nuenen, February 1885
Oil on canvas, 41 x 33 cm
F 171a, JH 657
Whereabouts unknown

stand, and could see next to nothing because of the blowing sand." Here (in Letter 226) van Gogh is describing the creation of his two seashore scenes (pp. 20 and 21) in the teeth of the raging elements. The reckless streaks of thick paint and the impetuous lacerations of the surface convey a well-nigh palpable sense of the beach and the dunes. The painter's material (paint and canvas) and Nature's material (fine sand) are mixed, and the artist is plainly conniving at the process in the interests of authenticity. We are doubly close: close to the motif, and close to the process of creation. Van Gogh admits us to his struggle to produce the work. The distinguished craftsmanship of the 1880 Movement, the ideas of perfection and presentable finish cherished by the artists of The Hague, would have been altogether at odds with so crude a surface – it would have been seen as beneath an artist's dignity.

In the same letter, van Gogh wrote: "If in the course of time they were to see more often than they do now the trials and tribulations I go through with my work, how I am forever scraping off and making alterations – how I sternly compare with Nature and then make another change, so that they can no longer make out this spot or that figure exactly – it would always remain disappointing to them, they would not be able to grasp that painting can't be done just so, right away, and they would repeatedly conclude 'that I don't really understand what I'm

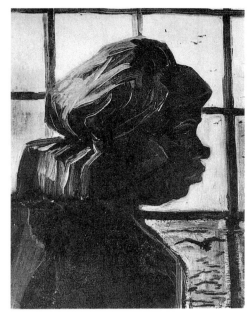 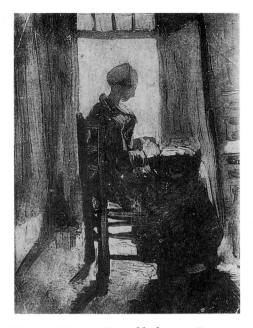

Peasant Woman, Seen against the Window
Nuenen, March 1885
Oil on canvas on cardboard, 41 x 32 cm
F 70, JH 715
Netherlands, Private collection

Peasant Woman Seated before an Open Door, Peeling Potatoes
Nuenen, March 1885
Oil on canvas on panel, 36.5 x 25 cm
F 73, JH 717
Epalinges (Switzerland), Collection Doyer

Head of a Peasant Woman against a Window
Nuenen, February-March, 1885
Oil on canvas, 38.5 x 31 cm
F 70a, JH 716
Amsterdam, Rijksmuseum Vincent van Gogh, Vincent van Gogh Foundation

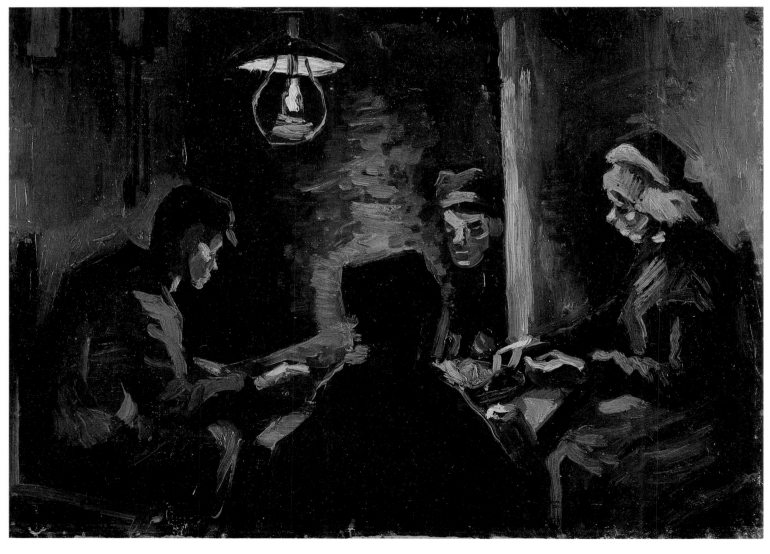

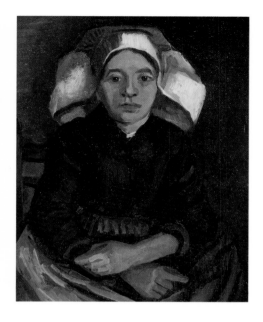

Head of Peasant Woman with Dark Cap
Nuenen, February 1885
Oil on canvas, 32 x 24.5 cm
F 138, JH 644
Private collection
(Sotheby's Auction, New York, 21. 4. 1979)

Peasant Woman Peeling Potatoes
Nuenen, February 1885
Oil on canvas, 41 x 31.5 cm
F 365r, JH 654
New York, The Metropolitan Museum of Art

Peasant Woman, Seated, with White Cap
Nuenen, December 1884
Oil on canvas on panel, 36 x 26 cm
F 143, JH 546
Whereabouts unknown

LEFT:
Four Peasants at a Meal (First Study for
'The Potato Eaters')
Nuenen, February-March 1885
Oil on canvas, 33 x 41 cm
F 77r, JH 686
Amsterdam, Rijksmuseum Vincent van
Gogh, Vincent van Gogh Foundation

doing' and that real painters go about their work quite differently." Van Gogh's "they" is society as a whole, with its fixed categories of correctness and ability. Van Gogh knew all too well that he did not fit these categories, either as an artist or as a man. His impetuous and temperamental character was inevitably expressed in these paintings – but so too was his lack of solid talent. Every brushstroke had to be a stroke of genius – and this vehemence undermined what might have been tidy painterly work.

By now van Gogh had four mouths to feed. With customary missionary zeal he had succeeded in dissuading Sien from continuing her life as a prostitute; but this moral success had a financial side effect, since she no longer earned any money. Theo's monthly allowance hardly sufficed now, and Vincent's appeals for extra funds became ever more urgent. His new and enthusiastic devotion to painting soon had to take a back seat: "For fourteen days now I have painted from early in the morning till late in the evening, and if I go on like that it will be too expensive as long as I am not selling anything" (Letter 227). In typical fashion he had got himself into a paradoxical situation: the harder he worked, the less money he had. "I cannot live any more thriftily than we are already doing; we have cut down on whatever we could cut down on, but there is always more work to do, especially these last few weeks, and I can hardly cope – that is, with the costs involved" (Letter 259). The family was literally going hungry. The spartan fare had its effect on the quality of van Gogh's work, and his hope of ever making money as an artist began to recede. It was a vicious circle of poverty, with lethargy and resignation waiting at the centre: "Essentially I have a constitution strong enough to take it", he explained to his brother (in Letter 304), "if only I hadn't had to go hungry so long; but that is how it has always been, time after time – either going hungry or working less – and whenever it was possible I've chosen the former, and now I am too weak.

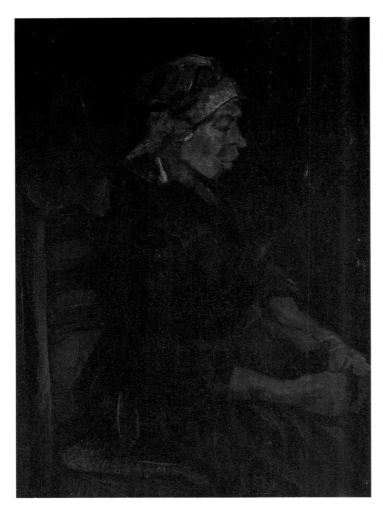 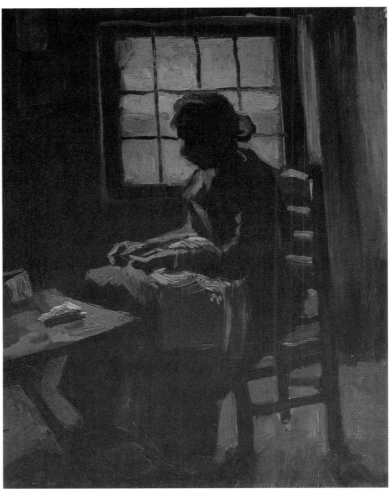

Peasant Woman, Seated, with White Cap
Nuenen, March 1885
Oil on paper on panel, 36 x 27 cm
F 144a, JH 704
s'-Hertogenbosch, Noordbrabants Museum
(on loan)

**Peasant Woman Sewing in Front of a
Window**
Nuenen, February-March 1885
Oil on canvas, 43 x 34 cm
F 71, JH 719
Amsterdam, Rijksmuseum Vincent van
Gogh, Vincent van Gogh Foundation

How can I cope? The effects are clearly to be seen in my work, and I am
worried about how I am to go on."

Van Gogh clutched all the more desperately at one single straw —
success as an illustrator. He had used English periodical illustrations to
extend his own draughtsmanship skills, and now he hoped to produce
the kind of figural representation of everyday scenes that was in demand
in the illustrated magazines. After his brief excursion into painting
(lasting a bare month) he returned to drawings and watercolours. He
took his subjects as he found them in the streets, made hasty sketches,
and then assembled the details in larger compositions. The group por-
traits he was now doing were broad in perspective, showed various
kinds of people, and had a quality of narrative, journalistic accuracy:
they are unique in van Gogh's oeuvre. He did not see them as works in
their own right but as studies, steps along the way to the artistic
perfection he was aiming at. Watercolours such as *The State Lottery
Office* (p. 23), done in autumn 1882, are struggling with multiple prob-
lems: the difficulty of making a whole out of the individual figures, of
making the figures relate to each other without simply bunching them
up, and of presenting the people as an anonymous mass yet simultane-
ously as individuals whose situation is understood. Van Gogh nicely
expressed this problematic area with the word *moutonner* (literally:

Peasant Woman with Child on Her Lap
Nuenen, March 1885
Oil on canvas on cardboard, 43 x 34 cm
F 149, JH 690
Private collection

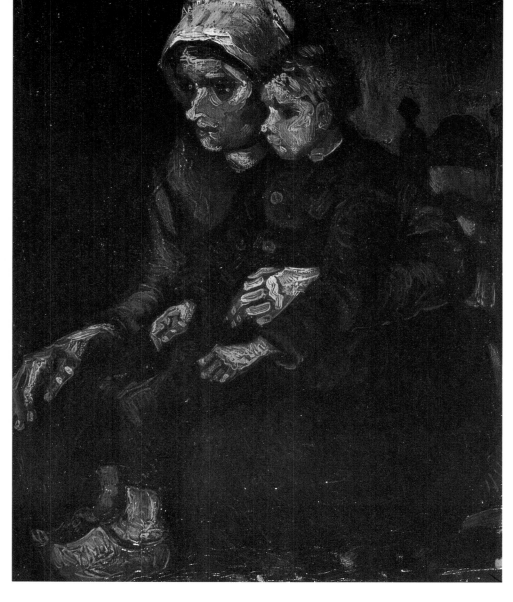

Head of a Peasant Woman with Dark Cap
Nuenen, March 1885
Oil on canvas on panel, 40 x 30 cm
F 136, JH 683
Whereabouts unknown

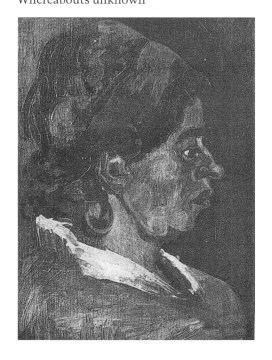

sheep-herding): "But how hard it is to put life and movement into it, to have the figures in their proper places yet distinct from each other! It is the great problem of *moutonner*; groups of figures that do constitute a whole, true, but their heads and shoulders are peeping past each other, while in the foreground the legs of the foremost figures are plainly seen, and above them the skirts and trousers come out in a confused mess that has nevertheless been drawn, for all that" (Letter 231).

Van Gogh was soon to flee the problem, without managing to solve it. He made a hurried return to his close-ups of individual people; and subsequent scenes, including several figures, were quite frankly indebted to those pictures of individuals in which he invested so much empathy. His figures are seen on a narrow foreground strip against a broad horizon, with only the land and the sky between them, each one isolated in silhouette, likelier to be absorbed in some silent task than interacting with the other people in the scene. In this respect, *Potato Digging, Five Figures* (p. 27) recapitulates van Gogh's art of his Hague

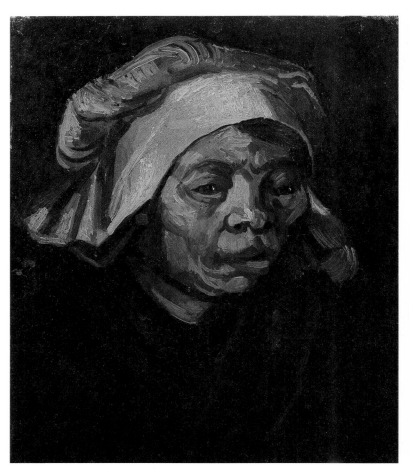 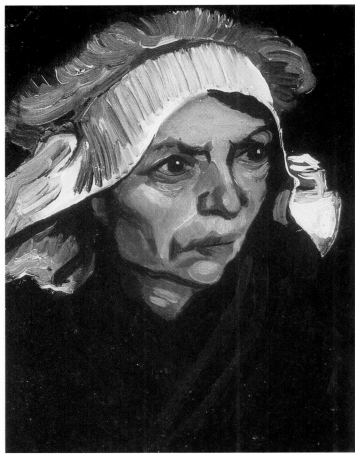

phase. The crudely sketched rustic figures hardly overlap at all; their gestures, the devotion to their work, silently absorbed in digging, are conceived in a spirit of the individual, not the group. Their different movements represent the sequence of separate actions in potato digging rather than an actual scene in the field. Van Gogh was to use this kind of multi-figural picture again; this digging scene, done in late summer 1883, was the first in a series of similar works he produced in Holland.

"Last year", he wrote in Letter 308, describing his new approach to figural representation, "I repeatedly tried to paint figure studies, but the way they turned out back then drove me to despair... At that time it threw me totally if my sketch was no longer clear during the painting, and I would have to spend a lot of time redoing the sketch, which meant quite simply that if I could only have the model for a short while nothing whatsoever was produced. But now I don't care at all if the drawing disappears; I do it with the brush right away, and this creates enough form, so that my study is of use to me." So the group portraits, such as the potato diggers, resulted from a new approach to the subject. Instead of drawing laborious sketches and then transferring them to canvas, in oil, van Gogh was now doing his initial sketches in oil straight off. The details were now turning out more vivid, direct, and above all perma-nent. And this more intense kind of figure study also resulted in a more additive style of composition (compared with the watercolours); the sketch could be directly incorporated into the final work, and the

Head of a Peasant Woman with White Cap
Nuenen, Winter 1884/85
Oil on canvas on triplex board, 42 x 34.5 cm
F 80a, JH 682
Amsterdam, Rijksmuseum Vincent van
Gogh, Vincent van Gogh Foundation

Head of a Peasant Woman with White Cap
Nuenen, March 1885
Oil on canvas on panel, 41 x 31.5 cm
F 80, JH 681
Zurich, Collection E. G. Bührle

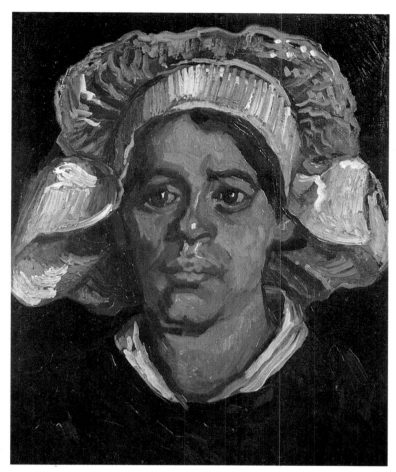 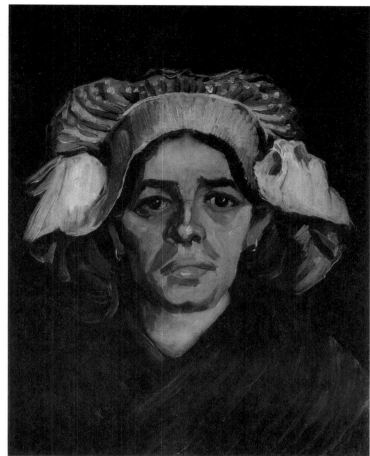

Head of a Peasant Woman with White Cap
Nuenen, March-April 1885
Oil on canvas, 44 x 36 cm
F 85, JH 693
Otterlo, Rijksmuseum Kröller-Müller

Head of a Peasant Woman with White Cap
Nuenen, March 1885
Oil on canvas, 43 x 33.5 cm
F 130, JH 692
Amsterdam, Rijksmuseum Vincent van
Gogh, Vincent van Gogh Foundation

painter scarcely needed to rework it any more. For a whole year, financial worries had kept van Gogh from painting. In summer 1883 he ventured to paint again, and in addition to *Potato Digging, Five Figures* produced landscapes in the main. The remoteness of the viewpoint in these landscapes was likewise a product of his close study of detached illustration styles in the magazines. Van Gogh also used an invention of his own, a perspective frame of the kind often devised during the Renaissance. "It consists of two long bars", wrote van Gogh (Letter 223), "to which the frame is attached by means of wooden pegs, either in a vertical or horizontal format. This provides a view of a beach or meadow or field as through a window. The verticals and horizontals of the frame, plus the diagonals and the cross-over, or a subdivision into square sectors, afford a number of fixed points that make it possible to do an exact drawing with lines and proportions." Painting always needs a means of establishing a fixed and effective standpoint; van Gogh's frame was perhaps a banal version of this, but at least it was portable, and it was a highly functional answer to the demands of *plein air* painting.

Driven into the ground, this frame henceforth provided van Gogh with that grid of lines which we can increasingly discern in his landscapes from this time onwards. If we compare the *Landscape with Dunes* (p. 27), painted in September, 1883, with the close view done a year earlier (p. 17), the change in van Gogh's view of the subject is immediately apparent. In the later picture, a horizon divides the work

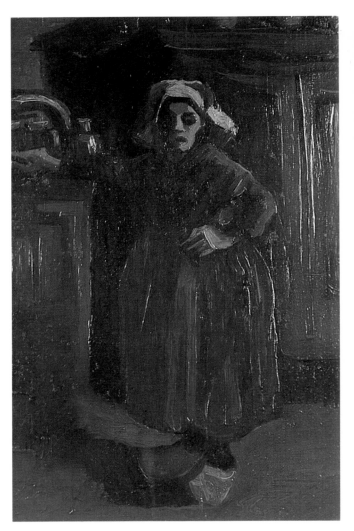

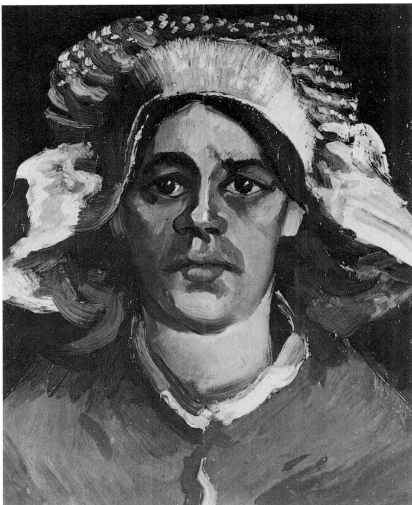

into two sections, the lower of which is further subdivided by diagonals. Perceiving lines with a new sensitivity thanks to his frame, he chose an angle on his landscape that was evidently the window view afforded by his gadget. Van Gogh's artistic resources had been increased. His dialogue with Nature could now be expressed as effectively in a broad landscape panorama as in a monumental close-up of a single motif. He was now better able to achieve nuanced articulation of feelings of exposure and loneliness, and feelings of harmony and sympathy: the period at The Hague provided van Gogh not only with the ability to handle a number of figures but also with a grip on perspective.

While his art was developing promisingly, his private life boded ill for the future. The financial problems remained undiminished, and Vincent, growing ever more confident of his artistic vocation, made no attempt to curb his expenses for the sake of Sien and the children. Faced with sheer necessity, Sien returned to her old work. Van Gogh, needless to say, was appalled that she had gone back to prostitution. A big-hearted man, he felt responsible for his loved ones. But their lives, however much he might long for security and trust, were too different. That summer Theo, the only one who had steadfastly stood by them, had visited his protégés and had been horrified by the conditions they

Peasant Woman Standing Indoors
Nuenen, March 1885
Oil on canvas on panel, 41 x 26 cm
F 128, JH 697
Belgrade, Narodni Muzej

Head of a Peasant Woman with White Cap
Nuenen, March 1885
Oil on canvas on panel, 41 x 32.5 cm
F 1668, JH 691
Private collection

Head of a Young Peasant in a Peaked Cap
Nuenen, March 1885
Oil on canvas, 39 x 30.5 cm
F 163, JH 687
Brussels, Musée Royaux des Beaux-Arts
de Belgique

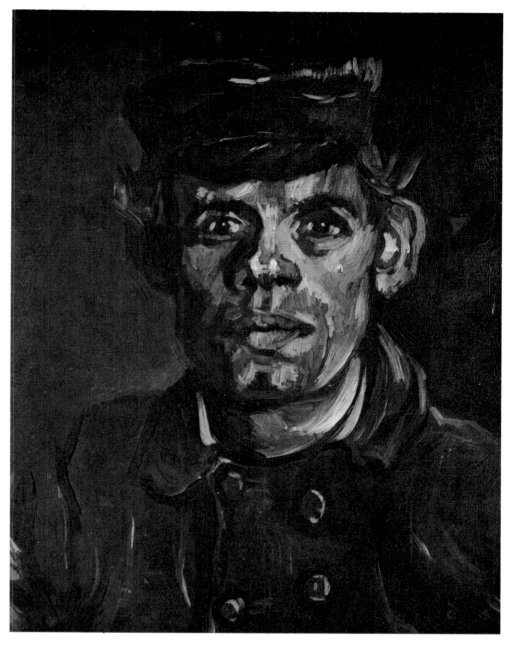

Head of a Young Peasant in a Peaked Cap
Nuenen, March 1885
Oil on panel, 44.5 x 33.5 cm
F 165, JH 688
Kansas City (Mo.), The Nelson-Atkins
Museum of Fine Art

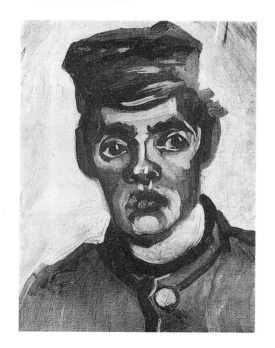

lived in. Circumspectly he had tried to prompt his brother to take the inevitable decision: a separation would clearly be Vincent's only chance of devoting himself to his art. The painter and the head of the family were at war within him. Van Gogh was going to have to do without the woman he loved – and living with the consequences of this decision was not easy in the years ahead. From now on, all of van Gogh's intensity was focussed on a single object: his paintings. In them, he seized the world all the more firmly, the more mercilessly it evaded him. Suffering pathos in person, henceforth he was an artist pure and simple. In September he moved to Drente, a region of Holland that had preserved a plain and melancholy mood since time immemorial; like a wounded animal, he went into hiding, alone.

Art and Responsibility
Commitments for the Future

The twenty months van Gogh had spent with a woman were not without consequences. With his plans for family life in ruins and his future (he believed) gloomy, he felt he was in a corner; but the fact of it was that his oppressive sense of responsibility for every living creature under the sun underwent a change during his time with Sien. It was as if van Gogh had needed the family experience as a focus for his devotional impulses – and now he was better able to master his over-generous tendencies. Now he directed them towards his art, and concentrated in his paintings the energy he had hitherto been scattering. The way he

Head of a Peasant Woman with Dark Cap
Nuenen, March-April 1885
Oil on canvas, 43.5 x 30 cm
F 69, JH 724
Amsterdam, Rijksmuseum Vincent van Gogh, Vincent van Gogh Foundation

Head of a Peasant Woman with Dark Cap
Nuenen, April 1885
Oil on canvas, 42 x 34 cm
F 269r, JH 725
Amsterdam, Rijksmuseum Vincent van Gogh, Vincent van Gogh Foundation

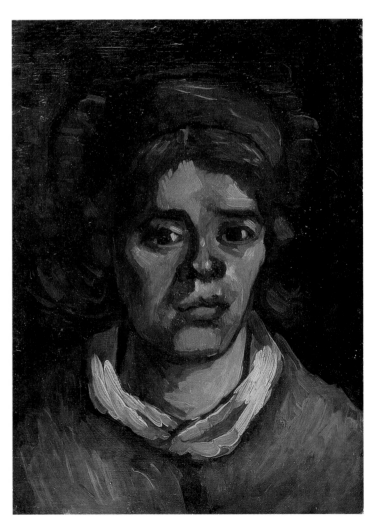
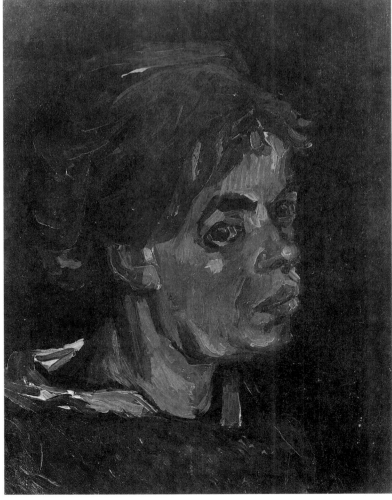

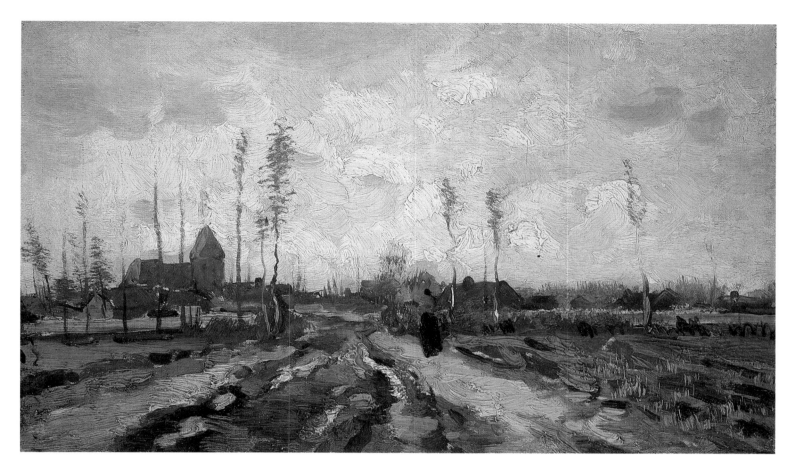

Landscape with Church and Farms
Nuenen, April 1885
Oil on canvas, 22 x 37 cm
F 185a, JH 761
Los Angeles, Los Angeles County
Museum of Art

saw himself as an artist became clearer too: poverty prompted him to develop a concept of art for the underprivileged. His daily toil at his art brought home to him the toughness but also the dignity of the crafts-man's life. Under constant pressure to earn money, his life came to resemble that of a pieceworker. And van Gogh now felt that his life as an artist would be lived in a spirit of solidarity with the working classes, with the craftsman's ethic and with speed of production an end in itself.

"There are some things we feel to be good and true", he wrote to his brother (Letter 259), "even if much remains inexplicable and obscure from a rational, calculating point of view. And although in the society we live in actions of this kind are considered foolish or crazy or I don't know what – there is not much to be said about it when hidden forces of attraction and love have awoken within us... He who has preserved his belief in a God will occasionally hear the quiet voice of conscience, and at such times it is good to obey it with the naivety of a child." This was Vincent's gloss on a statement by Victor Hugo that he had taken as his motto: "Conscience is higher than Reason." The inner qualities of Man, the loyalty of his feelings, the intensity of his affection, precede his rational capacities – and that is the yardstick of Art, too.

In this we see van Gogh's affinity to John Ruskin, the English art critic and social reformer. 'Soul' is the hallmark of Man and his works. Ruskin, writing in a spirit that anticipated van Gogh, had said that a work of beauty was created not by the art of an hour, of a lifetime, of a century, but by uncounted souls in mutual endeavour. And in looking at

Peasant Woman Taking her Meal
Nuenen, February-March 1885
Oil on canvas, 42 x 29 cm
F 72, JH 718
Otterlo, Rijksmuseum Kröller-Müller

Peasant Woman Darning Stockings
Nuenen, March 1885
Oil on canvas on panel, 28.5 x 18.5 cm
F 157, JH 712
Whereabouts unknown

a painting (Ruskin had also insisted) we must have a discipline, understanding, and natural heart-felt emotion to equal that of the original creator. The paramount thing was to elevate the purity of the spirit, this unexpressed harmony that makes each man his fellow man's neighbour at the deepest level of feeling, above all else. Paintings serve as a vehicle rather than a focal point: the genuine human dignity of the creating artist will not leave those who behold the work unmoved.

Both Ruskin and van Gogh sang the praises of craftsmanship: "so long as men work *as* men, putting their heart into what they do, and doing their best", Ruskin had writen in *The Seven Lamps of Architecture,* "it matters not how bad workmen they may be, there will be that in the handling which is above all price". Van Gogh expressed this thought as follows (Letter 185): "Work you have slaved over, work you have tried to put your character and feelings into, can give pleasure and sell." Authenticity of expression was more important than consummate skill; virtuoso technique would tend to overshadow the simple humility of the act of creation. For van Gogh, with his difficulties in handling a brush and drawing a line, thoughts of this nature plainly suggested themselves. And van Gogh had more than enough of that vitality that demanded expression: "What my head and heart are full of must come out, in drawings and pictures" (Letter 166).

Like Ruskin, van Gogh did not see craftsmanship only in terms of reliability of production. The productive craftsman totally absorbed in his work, devoting all his physical and mental energy to it, would be aware of the hardship and the dignity of his existence in equal measure. To restore that dignity to those who were caught up in the machinery of industry and became mere anonymous ciphers as they went about their

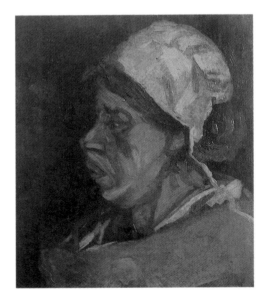

Head of a Peasant Woman with White Cap
Nuenen, March 1885
Oil on canvas on panel, 41 x 35 cm
F 131, JH 685
Private collection
(Sotheby's Auction, London, 5. 12. 1979)

labours was the lofty aim of van Gogh's own toil. "I wish very much that people who wish me well would finally realise that what I do or don't do springs from a deep feeling of love and a need for love", he wrote (in Letter 197); "for I sense that my work lies deep in the heart of the people, that I have to keep to everyday things and delve deep into life and forge ahead through many trials and tribulations." More than any artist before him, van Gogh saw his art as a way of expressing solidarity with his fellow-beings, who (he was profoundly convinced) were all equal. In a word, van Gogh's art was on the side of democracy.

Not that he was out waving banners. Sticking his tongue out at the *bourgeoisie* in self-important style, as the self-appointed king of the democrats Gustave Courbet did, was not for van Gogh. He sided with the weak, the underprivileged, and the have-nots through instinctive affection rather than for political reasons. If van Gogh was a partisan of any kind, he was contemplative, not programmatic. He had known the deprivations of poverty all too well himself – and had also been fully aware of the sublime feelings a mere glimpse into a mean hovel could prompt. Van Gogh was uninterested in the socialist utopias of his time and tended more to the position once stated by the German writer Georg

Head of a Peasant Woman with Red Cap
Nuenen, April 1885
Oil on canvas, 43 x 30 cm
F 160, JH 722
Amsterdam, Rijksmuseum Vincent van Gogh, Vincent van Gogh Foundation

Head of a Peasant Woman with Dark Cap
Nuenen, March 1885
Oil on canvas on panel, 38.5 x 26.5 cm
F 134, JH 684
Paris, Musée d'Orsay

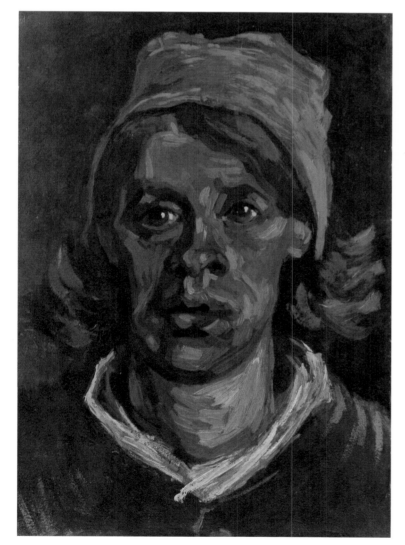

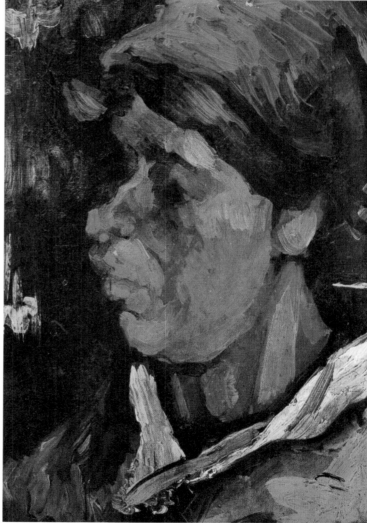

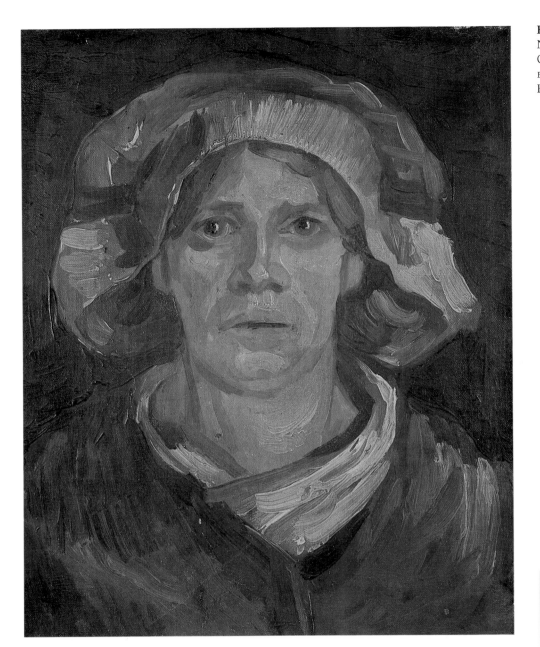

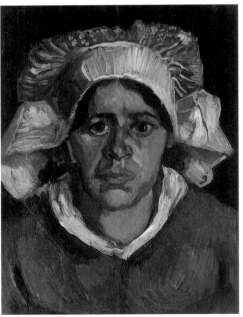

Head of a Peasant Woman with White Cap
Nuenen, March 1885
Oil on panel, 41 x 31.5 cm
F 81, JH 695
Berne, Kunstmuseum Bern

Büchner: "One should try it, immerse oneself in the life of the lowest of the low, reproduce his every gesture and twitch, his innuendoes, the whole subtle and scarcely noticeable play of his features... No man should appear too lowly or ugly for one. Only then can one understand mankind."

In The Hague van Gogh left an aesthetic credo on record, in Letter 309. There, with the prospect of seeing his plans to start a family crumble, he put his thoughts on the art he wanted to produce into clear form. As always, he had his theory ready far before he created the work to match. The thoughts expressed in Letter 309 may well be the profoundest anywhere in his correspondence and deserve quoting at some length. They deal with the artist's responsibility to work with the future in mind (though van Gogh cannot say precisely where his commitments lie). If we bear the events of the preceding months in mind, the task van Gogh was setting himself becomes a little clearer: his hopes of private

Head of a Peasant Woman with White Cap
Nuenen, March 1885
Oil on canvas on panel, 47 x 34.5 cm
F 85a, JH 694
Private collection
(Sotheby's Auction, New York, 14. 11. 1984)

Head of a Peasant Woman with White Cap
Nuenen, April 1885
Oil on canvas on cardboard, 47.5 x 35.5 cm
F 140, JH 745
Edinburgh, National Gallery of Scotland

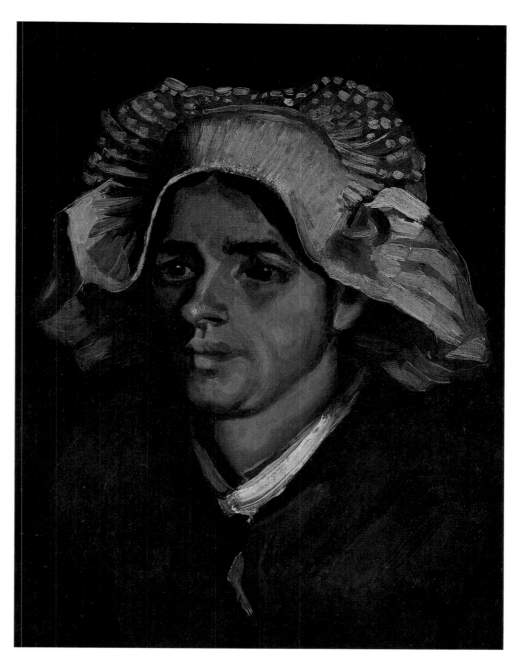

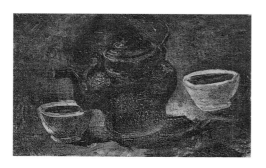

Still Life with Copper Coffeepot and Two White Bowls
Nuenen, April 1885
Oil on panel, 23 x 34 cm
F 202, JH 738
Private collection

happiness and family contentment had come to nothing, and if his scope and range in life had become somewhat unclear, equally he was now intent on extending them. He was not out to love his neighbour, whether in a religious or paternalistic way; but he definitely planned the tireless production of paintings. Now, like Ruskin, van Gogh saw Art as a process of purification that could produce visions of an altered and better world. His work was now placed at the service of immutable utopianism – though without ever ceasing to pay an almost despairing attention to the here and now of everyday reality. And for all its prevarications, his work was powered by his own irrepressible needs, unbounded, scarcely articulated.

This extract from Letter 309 (written in summer 1883) reads prophetically in view of the stubborn consistency with which van Gogh made his expectations of life dependent on what he would create as an artist: "I not only began drawing relatively late, but in addition I may well not

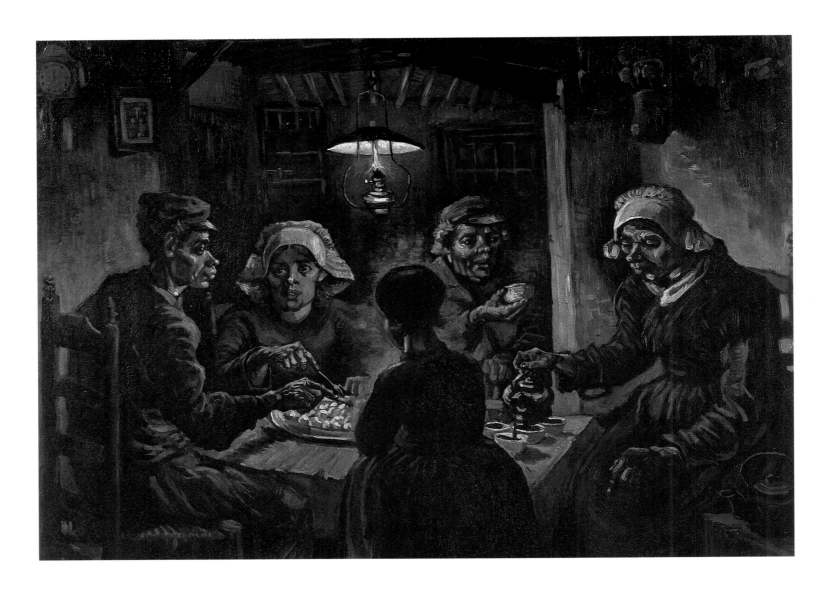

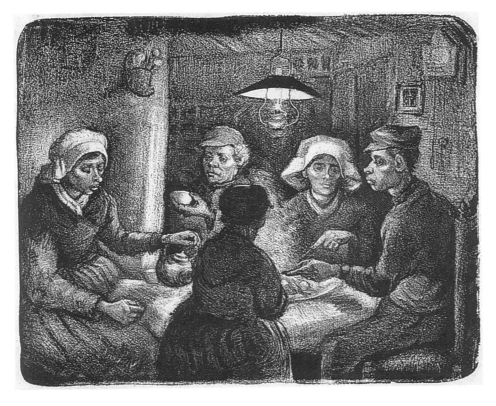

The Potato Eaters
Nuenen, April 1885
Oil on canvas, 81.5 x 114.5 cm
F 82, JH 764
Amsterdam, Rijksmuseum Vincent van
Gogh, Vincent van Gogh Foundation

The Potato Eaters
Nuenen, April 1885
Lithograph, 26.5 x 30.5 cm
F 1661, JH 737

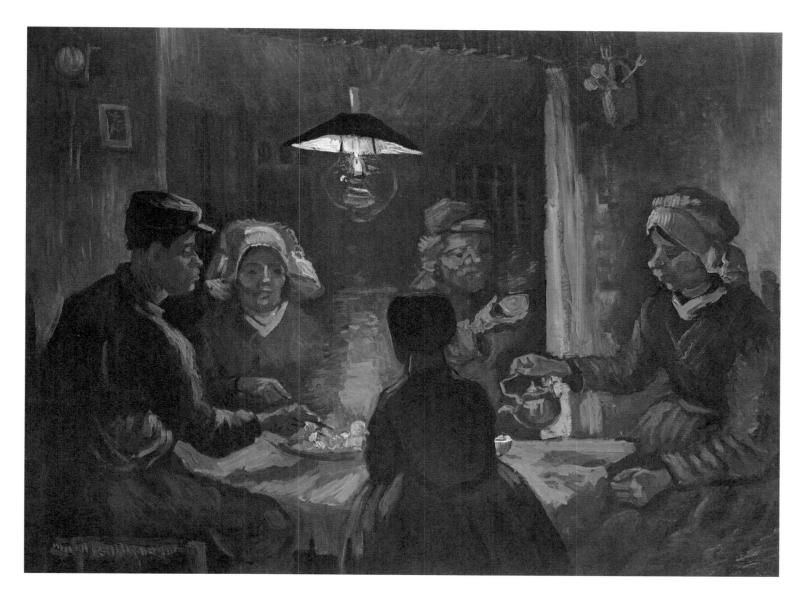

The Potato Eaters
Nuenen, April 1885
Oil on canvas on panel, 72 x 93 cm
F 78, JH 734
Otterlo, Rijksmuseum Kröller-Müller

have so very many years of life ahead of me... As far as the time that remains for my work is concerned, I believe that without being premature I can assume that this body of mine will still keep going, despite everything, for a certain number of years yet – say, between six and ten. I feel all the more able to assume this since at present there is not yet a proper 'despite everything' in my life... I do not intend to spare myself or pay much heed to moods or problems – it is a matter of some indifference to me whether I have a longer or a shorter life, and in any case physical mollycoddling such as a doctor can accomplish up to a point is not to my taste.

"So I am continuing in my life of ignorance, though there is one thing I do know: within a few years I must accomplish work of a certain order; I do not need to be in too much of a hurry, because no good comes of that – but I must go on working calmly and quietly, with as great a regularity and composure as possible, and as much to the point as possible; the world is my concern only insofar as I have a certain debt and obligation, so to speak – because I have been wandering about this world these thirty years – to leave a certain something in memory of me behind,

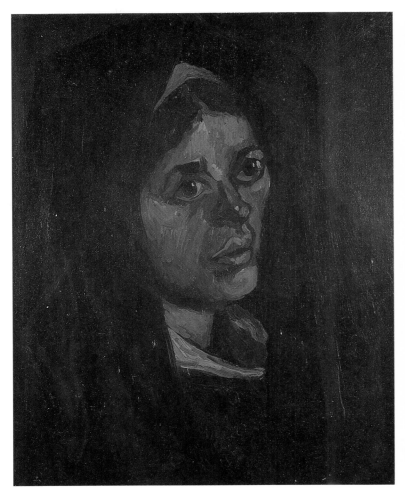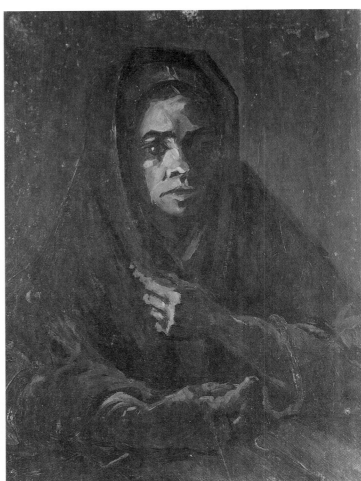

Head of a Peasant Woman in a Green Shawl
Nuenen, May 1885
Oil on canvas, 45 x 35 cm
F 155, JH 787
Lyon, Musée des Beaux-Arts

Head of a Peasant Woman in a Green Shawl
Nuenen, May-June 1885
Oil on canvas, 45.5 x 33 cm
F 161, JH 788
Amsterdam, Rijksmuseum Vincent van
Gogh, Vincent van Gogh Foundation

drawings or paintings, out of gratitude – not made in order to gratify some fashion or other but to express an honest human feeling. That work, then, is my objective ... And that is how I see myself – as a man who must produce something with a heart and love in it, within a few years, and who must produce it by willpower ... Something has to be created in these years; this thought is my guiding light whenever I draw up plans for my work. So now that yearning to work to the full extent of my powers will be rather more comprehensible to you, as will a certain resolve to work with simple means. And perhaps you can also understand that I do not view my studies as existing in their own right but rather always have my mind on my work as a whole."

No Soul, No Self
Drente 1883

Head of a Peasant Woman with White Cap
Nuenen, May 1885
Oil on canvas, 43.5 x 35.5 cm
F 388r, JH 782
Amsterdam, Rijksmuseum Vincent van
Gogh, Vincent van Gogh Foundation

Head of a Peasant with Hat
Nuenen, May-June 1885
Oil on canvas, 41.5 x 31.5 cm
F 179r, JH 786
Amsterdam, Rijksmuseum Vincent van
Gogh, Vincent van Gogh Foundation

In autumn 1883 in Drente, van Gogh painted practically nothing but peasants' cottages (cf. pp. 27 and 33). Like these squat, windswept cottages with slant roofs, scattered about the vast flatlands, van Gogh felt small; the cottages offered him a metaphor of his own need for an anonymity and concealment in which he could evade responsibilities. He would hardly have approached his subjects, tiny mounds in the mire, embedded into the marshes, he preferred to contemplate them in his imagination, these brown, earthy clods lying camouflaged on the plain. The artist envied them the mimetic skill with which they blended in. His flight into solitude left its mark, though, and van Gogh became more melancholy than ever.

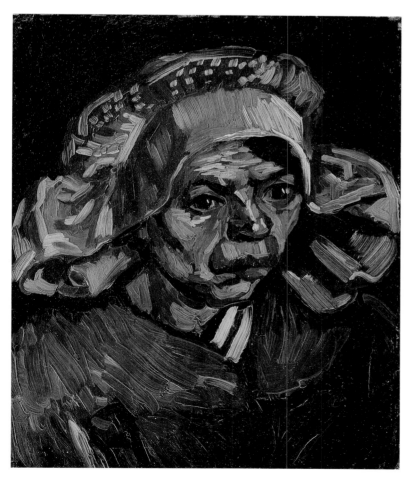
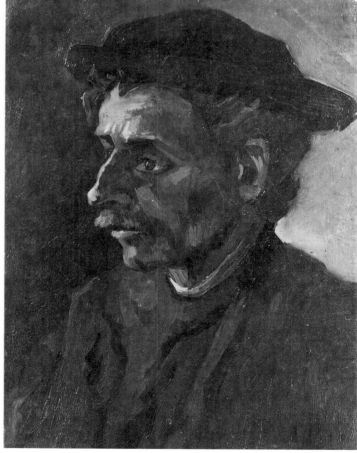

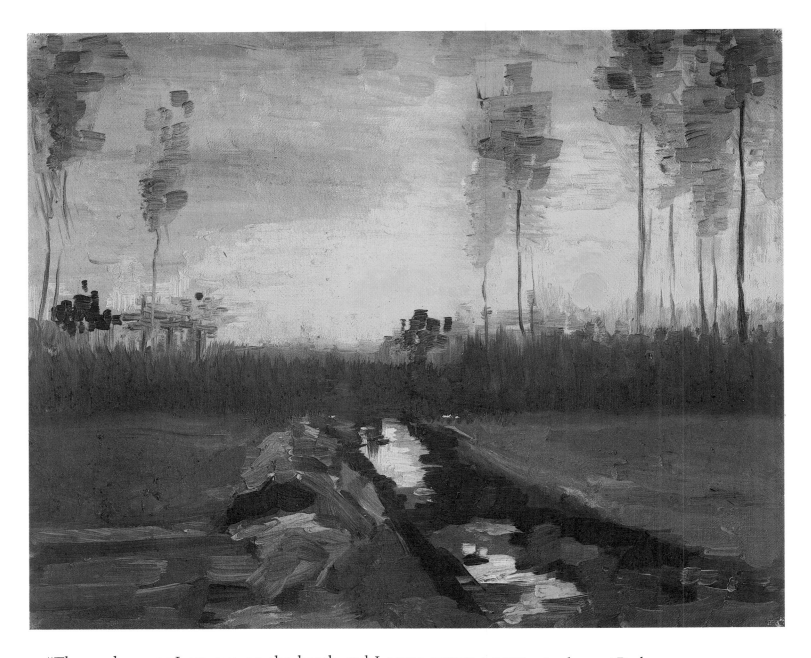

"Theo, whenever I am out on the heath and I come across a poor woman with a child in her arms or at her breast, the tears come to my eyes. It is her that I see; their weakness and sluttishness seem only to heighten the resemblance", wrote Vincent in the very first letter he wrote from his new solitude (Letter 324). He had wanted to escape from his responsibilities; but flight had only left his conscience uneasier than ever. He saw himself as a traitor towards both Sien and the children and his own ideals. In Drente, van Gogh was trying out escapism, and testing his ability to enter Nature in quest of oblivion. The watchwords he insisted on when writing to Theo were "simplicity and truth", and – working desperately hard – he tried to project these values onto the countryside, in the hope that ideas he had evolved in The Hague, in the city bustle, would be upheld in the rural remoteness of Drente. "Recently I had a talk to the man I am lodging with, who is a farmer himself", he wrote to his parents (Letter 334). "We started talking quite by chance, because he happened to ask what London was like, he had

Landscape at Dusk
Nuenen, April 1885
Oil on canvas on cardboard, 35 x 43 cm
F 191, JH 762
Lugano-Castagnola, Fondazione
Thyssen-Bornemisza

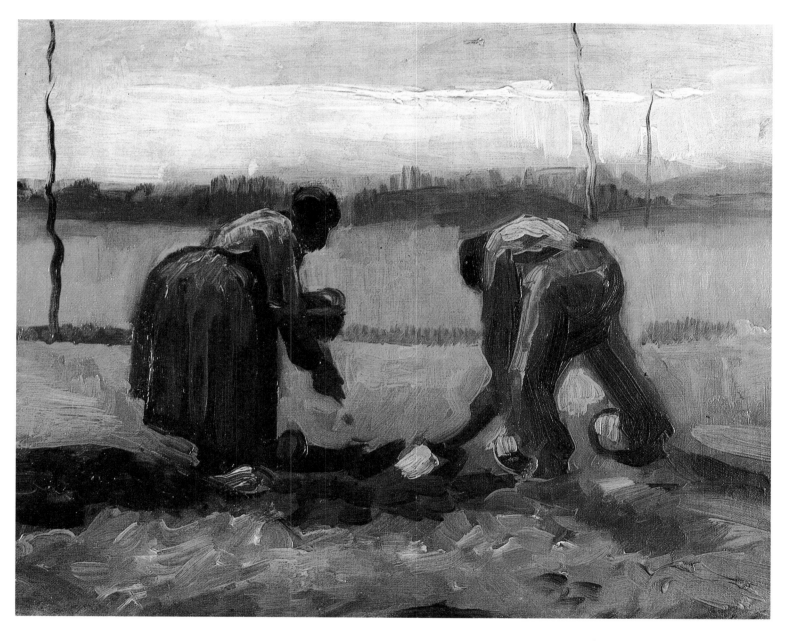

Peasant and Peasant Woman Planting Potatoes
Nuenen, April 1885
Oil on canvas, 33 x 41 cm
F 129a, JH 727
Zurich, Kunsthaus Zürich

heard so much about it; I told him that a simple farmer who did his work and thought while he was about his work was the man of true education in my eyes, that was how it had always been and would always remain." How much real disappointment and sought-after justification lay behind van Gogh's belief in the superiority of country people! Affection for peasants was a way of taking revenge on Sien. Still, those few pictures of people lifting potatoes or digging peat focus on his own gloomy frame of mind rather than on the country folk. Unlike *Potato Digging, Five Figures* (p. 27), which he did back in The Hague, *Two Peasant Women in the Peat Field* (p. 31) scarcely attempts any solidarity with the farming people's arduous labours. The massive blocks of colour that serve as the women's silhouettes have a self-referential function in the more or less decorative way that the two figures appear in sequential rapport. They are aesthetic means of linking the ground to the streaky, cloudy sky, and as they bend beneath the burden of Life they seem to wish to become invisible, much as the painter did at the time. The unity of description

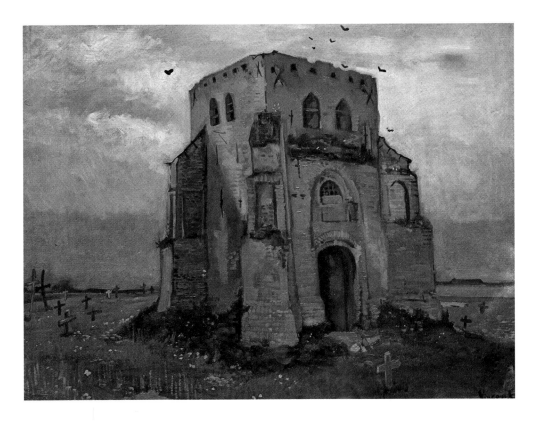

The Old Cemetery Tower at Nuenen
Nuenen, May 1885
Oil on canvas, 63 x 79 cm
F 84, JH 772
Amsterdam, Rijksmuseum Vincent van
Gogh, Vincent van Gogh Foundation

and commentary, of level-headed narrative of an event and subjective response on the part of the artist, has been dispersed by the urge to forget. Even in his early work, van Gogh was inimitably skilled at representing the fate of Man in familiar, everyday dress. The things and people in his paintings inevitably had a mood of melancholy and pity; in the act of painting, the artist's emotional world acquired independence – and objectivity, in that it could clearly be seen in the object of contemplation. The paintings van Gogh did at Drente were tautological, though. Melancholy gained the upper hand and submerged the works in the unfocussed atmospherics of a wholly personal mood. The

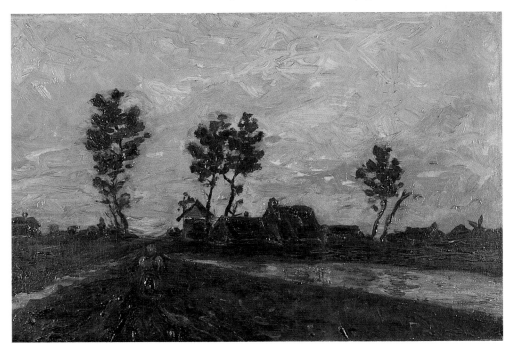

Landscape at Sunset
Nuenen, April 1885
Oil on canvas, 27.5 x 41.5 cm
F 79, JH 763
Switzerland, Private collection

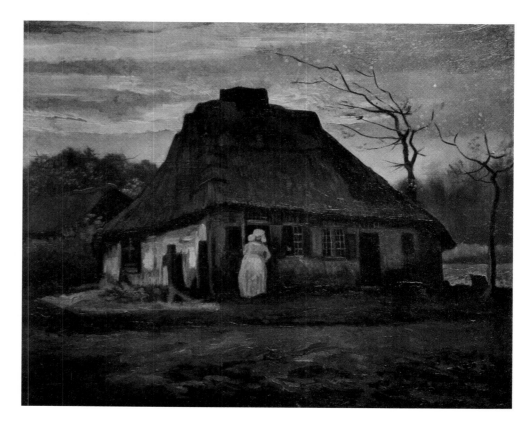

Cottage at Nightfall
Nuenen, May 1885
Oil on canvas, 65.5 x 79 cm
F 83, JH 777
Amsterdam, Rijksmuseum Vincent van
Gogh, Vincent van Gogh Foundation

Head of a Peasant Woman
Nuenen, May 1885
Oil on canvas, 40.5 x 34 cm
F 86, JH 785
Otterlo, Rijksmuseum Kröller-Müller

subjects van Gogh tackled had no autonomy; quite the contrary – this sadness had an unworldly quality. Vincent was doing his best to be a Romantic, but in reality he was not a mood painter; and whenever his pictures struck intense emotional notes it was only because the emotion was vitally present in the subjects. In Drente, however, the intensity of purely subjective sadness was his sole subject. Van Gogh was all too aware of the problem. "The weather has been dismal and rainy", he wrote in Letter 328, seeking refuge in irony at his own expense, "and when I go up to the loft I've set up in everything is remarkably gloomy; the light, entering by a single glass tile, falls on an empty paint-box, a bundle of brushes the hair of which is practically useless now, in a word: it is all so wondrously bleak that it fortunately has its funny side too, and if one doesn't want to cry about it one can be amused."

Van Gogh did not need to be isolated from the world in order to feel lonely. And Romantic, emotional bombast did nothing to further his art. The three months he spent in Drente encouraged him to recognise these two facts. The time of year when he tended to take decisions, the period before Christmas, again saw van Gogh driven to act; and in December 1883 the prodigal son returned home – this time to Nuenen in Brabant, where his father had a new living. Vincent's apprenticeship lay behind him now. He had shed his religious mania and selfless love of his neighbour, and had turned his back on the dream of family life and infatuation with isolation alike; in the process he had acquired a robust sense of autonomy that was to be the seedbed of an art independent of the facts of everyday life. Shortly, in Nuenen, he was to plan the first of his masterpieces. The first of the classic 'van Goghs'.

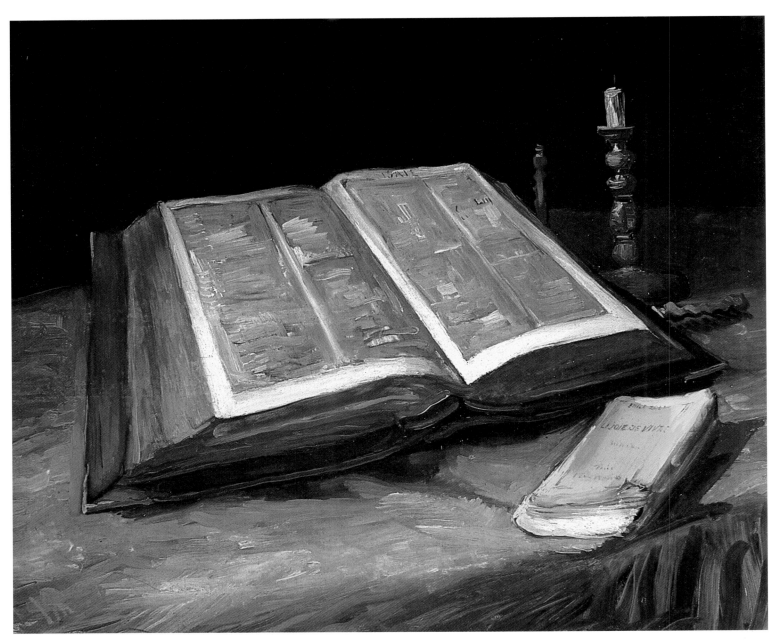

Still Life with Bible
Nuenen, April 1885
Oil on canvas, 65 x 78 cm
F 117, JH 946
Amsterdam, Rijksmuseum Vincent van
Gogh, Vincent van Gogh Foundation

THE YEARS IN NUENEN
1883-1885

An Artist Pure and Simple
The First Year

"If a man is not in a mental asylum, and has not shot or hanged himself either, we must take comfort in the fact, and conclude that he is one of two things: either an evil dog in human form, a lamentable creature that needs a muzzle and is distinctly amazing; or a real human being and therefore not without a morality which should either be reformed or approved of." The rather crude notion of a human soul and a dog's dwelling in the individual's breast derives from the influential English historian and theorist Thomas Carlyle, whose works van Gogh regularly read throughout his life. During the two years he spent at his parents' home, in particular, he regularly dwelt upon Carlyle's views on coming to terms with life and the past. He had hardly arrived but he felt like a dog that well-bred people would prefer to muzzle: "I sense the

Peasant Woman Sitting on a Chair
Nuenen, June 1885
Oil on panel, 34 x 26 cm
F 126, JH 800
Whereabouts unknown

Peasant Woman by the Fireplace
Nuenen, June 1885
Oil on canvas, 44 x 38 cm
F 176, JH 799
New York, The Metropolitan Museum
of Art

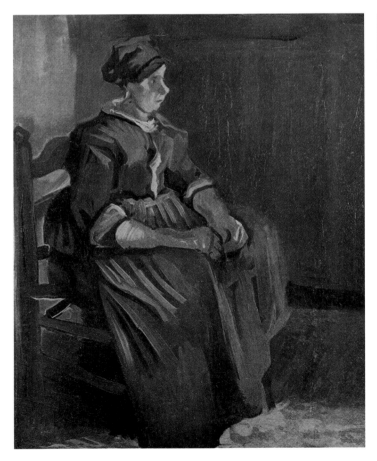

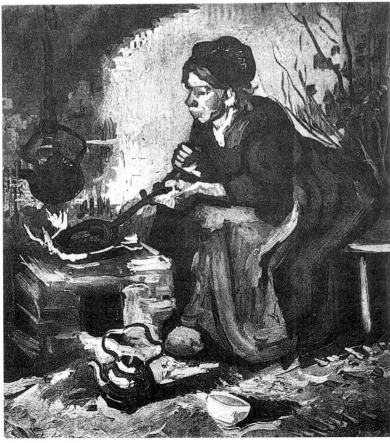

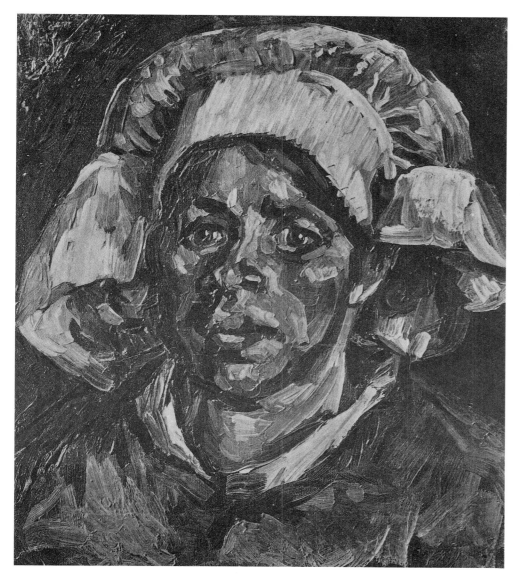

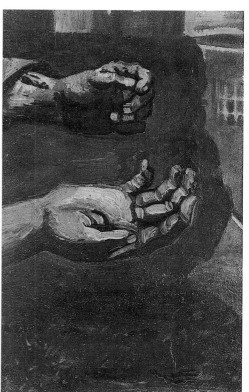

Head of a Peasant Woman with White Cap
Nuenen, May 1885
Oil on canvas, 41 x 34.5 cm
F 141, JH 783
Private collection
(Sotheby's Auction, London, 5. 12. 1979)

Two Hands
Nuenen, April 1885
Oil on canvas on panel, 29.5 x 19 cm
F 66, JH 743
Netherlands, Private collection

thoughts Pa and Ma instinctively have about me", he wrote to Theo (Letter 346). "They are as reluctant to let me into the house as they would be to let in a big shaggy dog. Into the parlour he comes, with his wet paws – and how shaggy and wild he is! He gets in everybody's way. And how loudly he barks. In a word – he's a filthy creature." Dignified and mannerly, they did not penetrate to the heart within the repellent exterior: "But the creature has a human history and (though it's a dog) a human soul, and a sensitive one at that." These reservations notwithstanding, Vincent stayed at the Nuenen vicarage longer than at any other single place in his entire life as an artist. He was constantly at loggerheads with his father, and even vented his unrelenting mockery of society on his long-suffering brother Theo. But van Gogh could now devote himself entirely to painting, using oil on canvas, which he had previously been mostly unable to afford. He tried to perfect his command of the three types of picture he had hitherto been concentrating on: still lifes, landscapes and genre paintings. Working on various series at the same time, he used up all the suitable subjects he could find around the village where his parents were living. During the first year at

Cottage with Trees
Nuenen, June 1885
Oil on canvas on panel, 32 x 46 cm
F 93, JH 805
Private collection
(Christie's Auction, London, 29. 6. 1976)

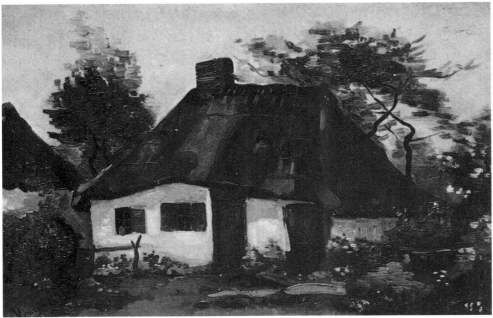

Cottage with Trees
Nuenen, June 1885
Oil on canvas, 44 x 59.5 cm
F 92, JH 810
Whereabouts unknown
(Sotheby's Auction, London, 28. 6. 1961)

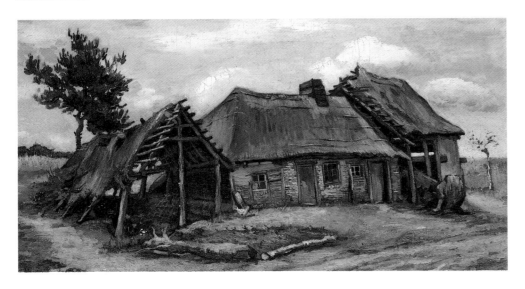

**Cottage with Decrepit Barn and Stooping
Woman**
Nuenen, July 1885
Oil on canvas, 62 x 113 cm
F 1669, JH 825
Private collection
(Sotheby's Auction, London, 3. 12. 1985)

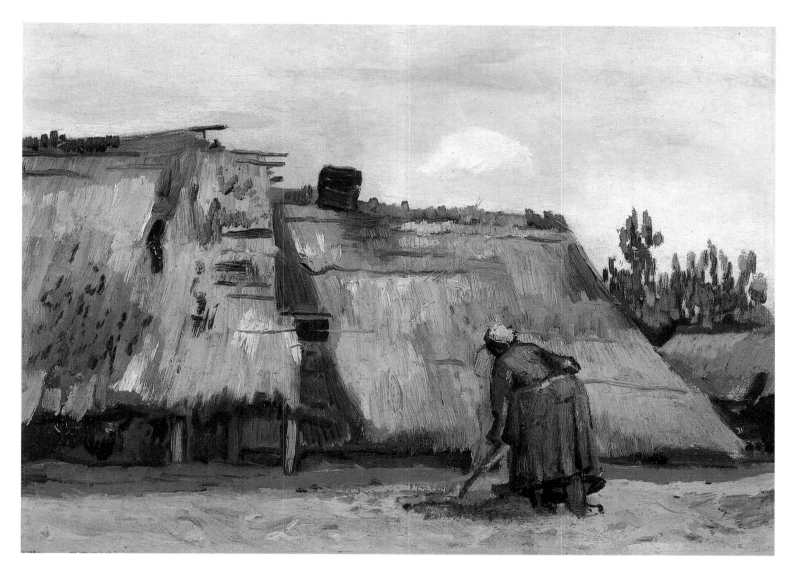

Cottage with Woman Digging
Nuenen, June 1885
Oil on canvas on cardboard, 31.3 x 42 cm
F 142, JH 807
Chicago, The Art Institute of Chicago,
Bequest of Dr. John J. Ireland

Cottage with Trees
Nuenen, June 1885
Oil on canvas, 22.5 x 34 cm
F 92a, JH 806
Whereabouts unknown

Nuenen he produced a number of everyday scenes from the life of weavers (which will be discussed in a separate chapter), paintings of the surrounding countryside, and a number of still lifes that harked back to his earliest ventures into art. In addition there was one commissioned work, the only one he ever did.

One of the first scenes van Gogh painted in Nuenen, *Chapel at Nuenen with Churchgoers* (p. 53), introduces us to the milieu he was now living in. For Vincent's father, this was the place of his spiritual ministry; in van Gogh's treatment it looks like a place of work, where goods are manufactured and a certain output achieved, as at the looms in the poor weavers' homes. Van Gogh painted this detached view of the village church for his parents, and he chose Sunday churchgoing as his subject, adopting an angle reminiscent of the figural compositions he had painted in The Hague. The simple chapel is seen close; yet the artist himself is far enough from the scene to avoid any kind of identification. His approach can be seen as a reaction to his parents' wish that he accompany them to church. In painting, he was serving "what some people call God, others the Supreme Being, and still others Nature" (Letter 133) in his own way.

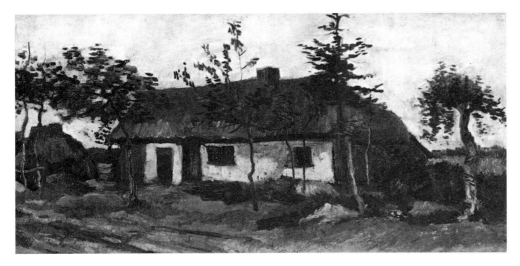

Cottage
Nuenen, June 1885
Oil on canvas, 35.5 x 67 cm
F 91, JH 809
Harrison (N. Y.), Collection John P.
Natanson

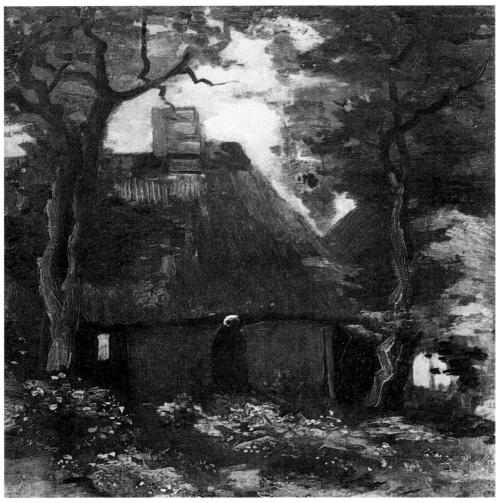

Cottage with Trees and Peasant Woman
Nuenen, June 1885
Oil on canvas, 47.5 x 46 cm
F 187, JH 808
Los Angeles, Los Angeles County
Museum of Art

Van Gogh moved closer to his subject when he painted the water mills along the Brabant canal-banks. *Water Mill at Kollen near Nuenen* (p. 40), painted in May 1884, was the first in a series of mill scenes which he continued that autumn with four more paintings (pp. 54-55). Throughout the series he was essaying picturesque showpieces; his rendering of a seasonal atmosphere, with the light reflected in the flowing water, was more ambitious than anything he had previously attempted. He was also interested in the way the solid contours of the barn-like buildings related to the lines of the millwheels themselves.

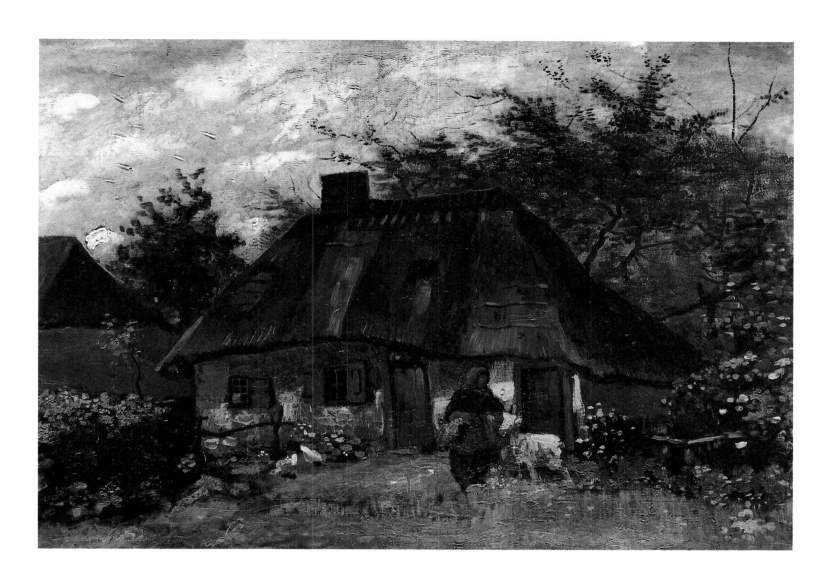

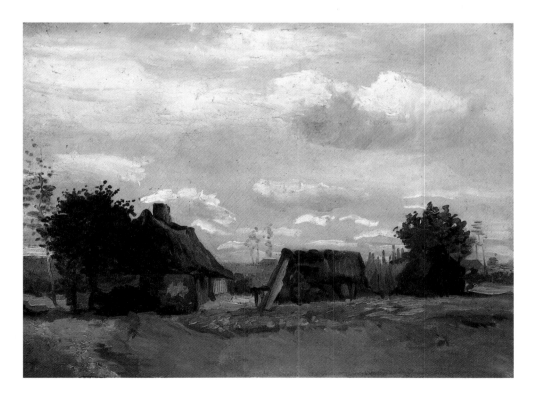

Cottage and Woman with Goat
Nuenen, June-July 1885
Oil on canvas, 60 x 85 cm
F 90, JH 823
Frankfurt am Main, Städelsches
Kunstinstitut und Städtische Galerie

Cottage
Nuenen, July 1885
Oil on canvas, 33 x 43 cm
Not included in F or JH
Private collection
(Sotheby's Auction, London, 30. 3. 1988)

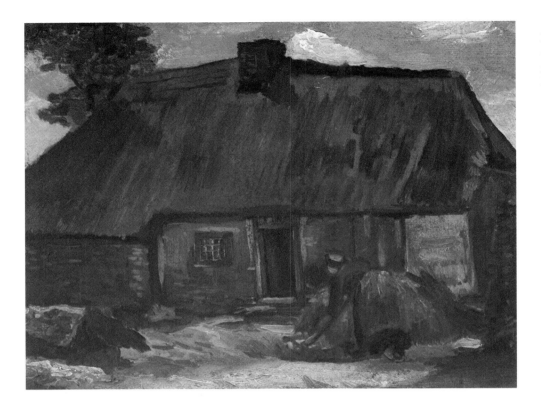

Cottage with Peasant Woman Digging
Nuenen, June 1885
Oil on canvas on panel, 30.5 x 40 cm
F 89, JH 803
Private collection
(Christie's Auction, London, 29. 6. 1976)

The impact of these paintings draws equally upon draughtsman skills (symmetry in the composition, use of silhouettes, the contrast of light open spaces and the dark huddled clusters of mill buildings) and painterly creation of mood and atmospherics. At times, van Gogh's ambitions do not quite come off, of course. In *Water Mill at Gennep* (p. 55), for instance, a doughy mass of hatching obliterates any contrasts that might have brought the scene effectively to life.

Doubtless, van Gogh chose the mills for iconographic reasons, too. The Christian metaphor of the mills of God that grind slowly was probably in his mind; and van Gogh had always been interested in sowing and reaping – a process that ends in the miller's labours. Still, the

Peasant Woman Laundering
Nuenen, August 1885
Oil on canvas, 29.5 x 36 cm
F 148, JH 908. Private collection

Two Peasant Women Digging
Nuenen, July 1885
Oil on canvas on panel, 39 x 55 cm
F 96, JH 878
Whereabouts unknown

views have a posed, detached, even uninterested flavour; the mills are clearly being foregrounded as simple objects. Art historian Erwin Panofsky, writing on the loving use of close-up detail in old Dutch art, coined the term 'disguised symbolism' to describe that hidden dimension beyond the mere surface of things, and van Gogh's water mills may

Peasant Woman by the Fireplace
Nuenen, June 1885
Oil on canvas on panel, 29.5 x 40 cm
F 158, JH 792
Paris, Musée d'Orsay

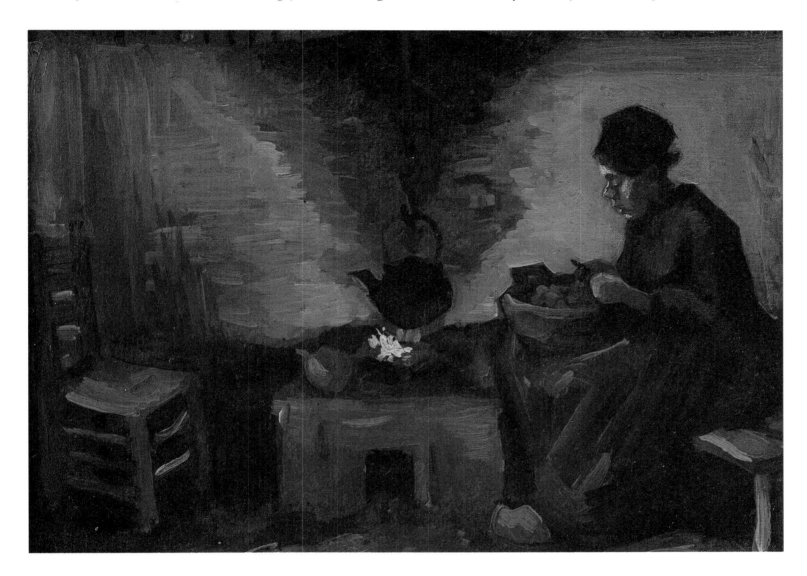

be seen as a further step in that use of extra dimensions of meaning. More than anything else in his whole oeuvre they highlight a detached lack of interest, free of intention, simple in form, that defies the quest for deeper significance.

The landscapes featuring the old tower on the outskirts of the village, on the other hand, seem far more loaded with meaning. The striking tower was all that was left of a Gothic church; the graveyard clustered about it. The metaphoric investigation of death is obvious. In the background of *Parsonage Garden* (p. 41) the tower rises impressively on the horizon, commanding that we meditate upon last things when we see spring burgeoning in the beds. In this painting, the rather dull arrangement of parallel levels (the fence-posts, a hedge, and the trees) is lent expressive dignity by the presence at the vanishing point of the squat

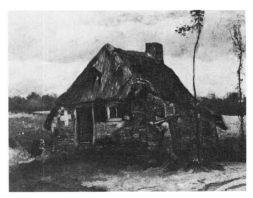

Cottage with Peasant Coming Home
Nuenen, July 1885
Oil on canvas, 63.5 x 76 cm
F 170, JH 824. Private collection
(Sotheby's Auction, London, 2. 4. 1974)

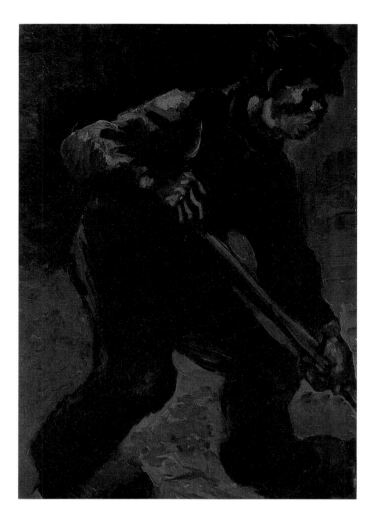
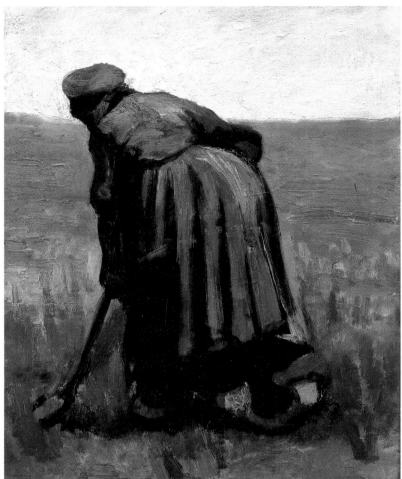

mass of the old tower. At times van Gogh still needed to use striking motifs in order to generate interest in his work.

The Old Tower in the Fields (p. 45) makes a more coherent, unified impression because van Gogh has skilfully deployed his melancholy props to create a Romantic mood with maximum efficiency. The sun, low in the sky and swathed in drapes of mist, seems to add to the hazy mystery of the woman clad in black. Her figure echoes the shape of the tower (in a way that was prefigured in the parsonage view). The sense of menace derives not so much from the awesome immensity of the elements, before which the individual is helpless, as from the dark, mighty silhouette of the tower, built by Man to express the promise of spiritual support. In this picture van Gogh is again distancing himself from typical Romantic landscapes. His tower has none of that eloquent detail that a Caspar David Friedrich so liked in a ruin. For van Gogh, the humanized landscape – Nature kept within seemingly peaceful bounds by Civilization – is enough to express feelings of anxiety and isolation. Once again a sense of paradox that eschews any kind of unambiguous statement is apparent.

Nuenen was extremely provincial, in every respect; and this son of the parson's who had appeared from nowhere struck the local people as a

Peasant Digging
Nuenen, July-August 1885
Oil on canvas, 45.5 x 31.5 cm
F 166, JH 850
Otterlo, Rijksmuseum Kröller-Müller

Peasant Woman Digging
Nuenen, July 1885
Oil on canvas on panel, 41.5 x 32 cm
F 95, JH 827
Private collection
(Sotheby's Auction, London, 2. 12. 1981)

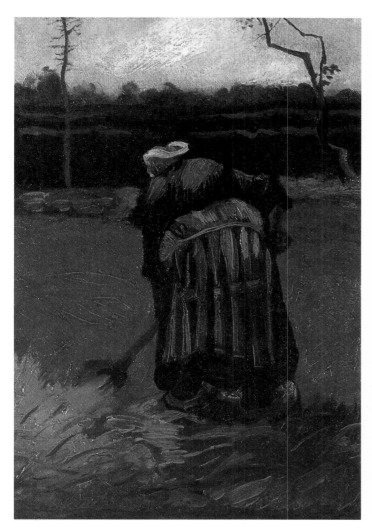

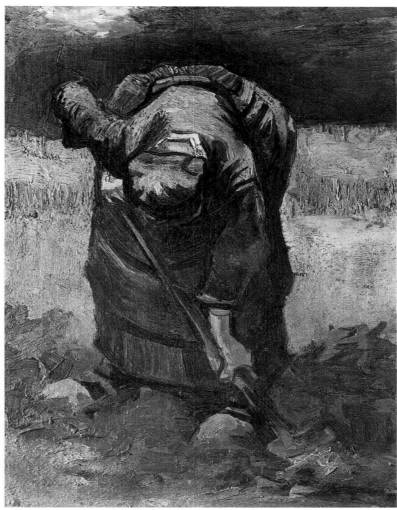

Peasant Woman Digging
Nuenen, July-August 1885
Oil on canvas on panel, 37.5 x 25.7 cm
F 94, JH 893
s'-Hertogenbosch, Noordbrabants Museum

Peasant Woman Digging
Nuenen, August 1885
Oil on canvas on panel, 42 x 32 cm
F 95a, JH 899
Birmingham, Barber Institute of Fine Arts,
University of Birmingham

little odd. Yet no one troubled him. Indeed, the stares van Gogh attracted were due not only to his unusual appearance but also to the awe in which artists were held. At this period, van Gogh even had pupils, of sorts – amateur painters who were gratified if he took a look at their work in progress. In nearby Eindhoven, the only town that had any kind of claims to urbanity, he got to know a tanner by the name of Anton Kerssemakers; and soon van Gogh was teaching the tanner and his acquaintances, in particular Charles Hermans, what he himself knew about art. Hermans was a man of means. Van Gogh started to call on him with some frequency, to use the utensils the goldsmith had in his home.

"Hermans possesses so many beautiful things", Vincent wrote to Theo (Letter 387), "old pitchers and other antiques, and I am wondering if you might be pleased with a still life of some of these articles, for instance Gothic things, to hang in your room." In autumn 1883 van Gogh did indeed paint a number of still lifes, using the earthenware vessels and bottles Hermans had (pp. 56-63). In Etten his compositions had been loose, but now the jugs, bottles and bowls jostled close together, giving the pictures a tectonic feel: every object had its place, even if its physical, material qualities almost vanished in the crush.

Sheaves of Wheat in a Field
Nuenen, August 1885
Oil on canvas, 40 x 30 cm
F 193, JH 914
Otterlo, Rijksmuseum Kröller-Müller

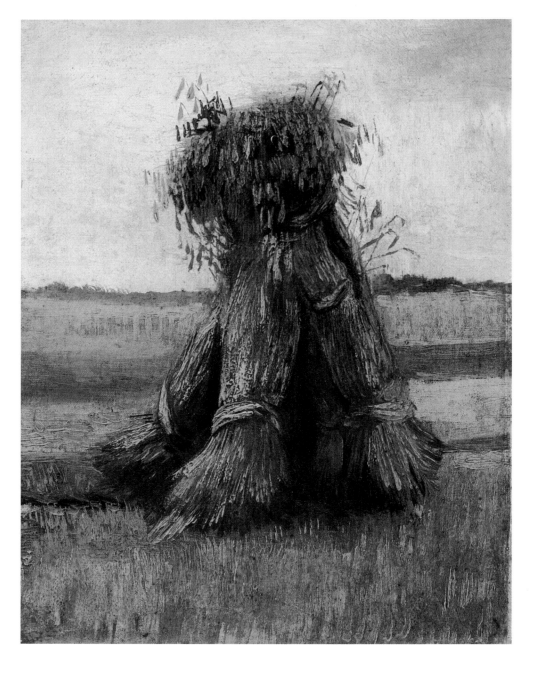

Peasant Woman Raking
Nuenen, August 1885
Oil on canvas, 38.5 x 26.5 cm
F 139, JH 905
New York, Private collection

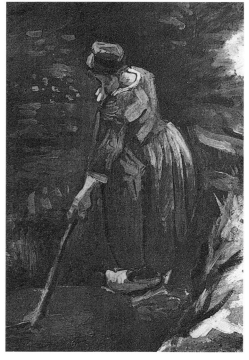

Again we are reminded of the watercolours with several figures crowded into anonymous huddles which van Gogh had done in The Hague.

What is plain is that in the preceding years van Gogh had been acquiring an eye for the arresting impact the organic unity of a composition could make. Admittedly he was still somewhat clumsy in arranging the objects at times: merely toppling a bottle on its side was no way to redeem the monotony of a row of stoneware bottles (p. 57), nor could detailed close-up rendering of ornamental faience save unimaginative positioning of vessels beside or even *in* each other (p. 62). Later, van Gogh was to re-use some of these canvases to paint self-portraits on their backs, and he well knew the loss was not great. After the progress he was to make in Paris he found that these still lifes lacked that sufficient measure of autonomy that would justify preserving them – still lifes such as *Still Life with Pots, Jar and Bottle* (p. 56; on the reverse,

Two Peasant Women Digging Potatoes
Nuenen, August 1885
Oil on canvas on panel, 31.5 x 42.5 cm
F 97, JH 876
Otterlo, Rijksmuseum Kröller-Müller

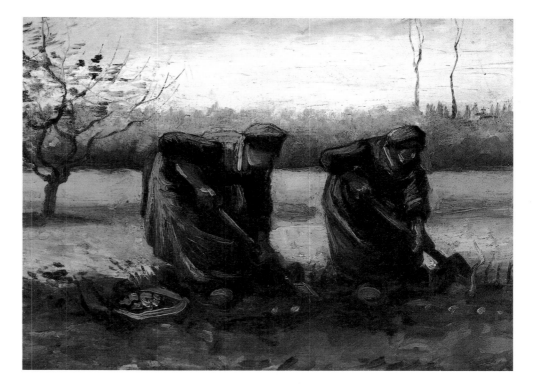

Peasant Woman Digging Up Potatoes
Nuenen, August 1885
Oil on paper on panel, 31.5 x 38 cm
F 98, JH 901
Antwerp, Koninklijk Museum voor Schone
Kunsten

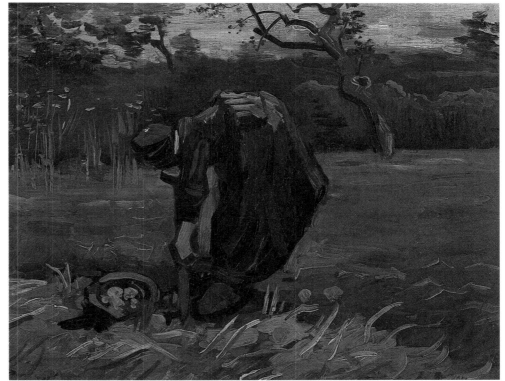

Peasant Woman Digging Up Potatoes
Nuenen, August 1885
Oil on canvas on panel, 41 x 32 cm
F 147, JH 891
Private collection

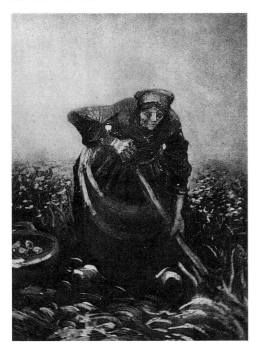

Still Life with a Basket of Vegetables
Nuenen, September 1885
Oil on canvas, 35.5 x 45 cm
F 212a, JH 929
Landsberg/Lech, Collection Anneliese Brand

F178V, JH 1198) or *Still Life with Pottery, Bottles and a Box* (p. 59; on the reverse, F61V, JH 1302). That said, though, there are occasional gems as well, where the subjects are not submerged in a monochrome slush of earthy colours, the lighting effects are not limited to a few bright highlights, and where the objects are neither squashed up tight nor come adrift from the backgrounds and the surfaces they are on.

Arguably the finest example of his successful still-life work at this time is *Still Life with Three Bottles and Earthenware Vessel* (p. 60), traditional in spirit though it naturally is. In it, van Gogh succeeds in establishing spatial values with only a few objects. The things in the still life do not conflict with the format; rather, there is a natural air to the way they are grouped about the round bowl in the middle. The different kinds of material and different sizes of object have their own kinds of lighting; one bowl gives a mellow gleam, another is almost

Still Life with Two Birds' Nests
Nuenen, September-October 1885
Oil on canvas, 31.5 x 42.5 cm
F 109r, JH 942
Amsterdam, Rijksmuseum Vincent van Gogh, Vincent van Gogh Foundation

Still Life with a Basket of Apples
Nuenen, September 1885
Oil on canvas, 30 x 47 cm
F 115, JH 935
Whereabouts unknown

dazzling. Some critics, impressed by the conviction in this still life, have dated it to the middle of the following year (1885); but this chronological revisionism implies viewing van Gogh's progress as one of consistent technical maturing, and seeing it as a long-term development ignores the speed van Gogh worked at and also underestimates his tendency to think of paintings in series – a still life featuring earthenware would be completely on its own in his output for 1885. The simple truth is that, after a brief experimental period, the artist was now altogether capable of creating a 'classical' picture – though this does not mean the quality of every painting was as high. Every artist's oeuvre has its duds along with the masterpieces. Van Gogh was no exception.

Still Life with Earthenware, Bottle and Clogs
Nuenen, September 1885
Oil on canvas on panel, 39 x 41.5 cm
F 63, JH 920
Otterlo, Rijksmuseum Kröller-Müller

Still Life with Two Jars and Two Pumpkins
Nuenen, September 1885
Oil on canvas on panel, 58 x 85 cm
F 59, JH 921
Switzerland, Private collection

Still Life with a Basket of Potatoes
Nuenen, September 1885
Oil on canvas, 44.5 x 60 cm
F 100, JH 931
Amsterdam, Rijksmuseum Vincent van
Gogh, Vincent van Gogh Foundation

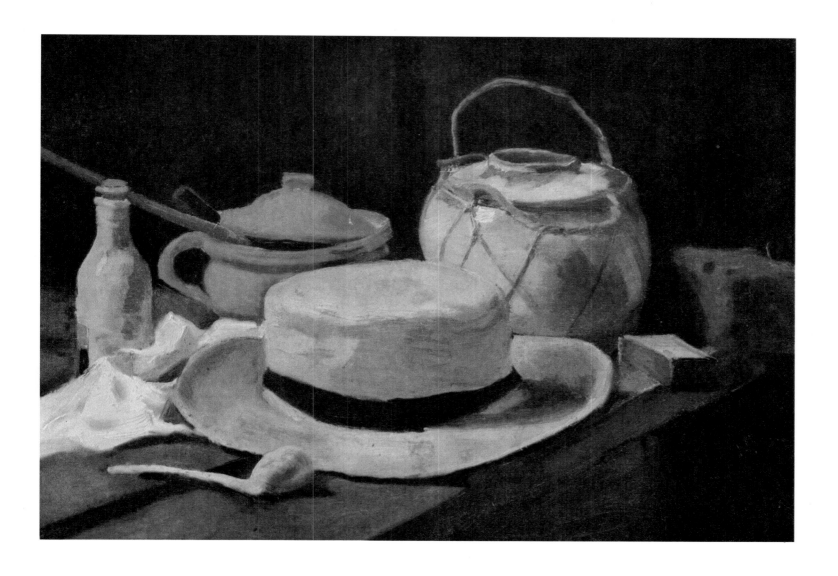

Still Life with Yellow Straw Hat
Nuenen, September 1885
Oil on canvas, 36.5 x 53.5 cm
F 62, JH 922
Otterlo, Rijksmuseum Kröller-Müller

Still Life with an Earthen Bowl and Potatoes
Nuenen, September 1885
Oil on canvas, 44 x 57 cm
F 118, JH 932
Private collection
(Mak van Waay Auction, Amsterdam,
15. 4. 1975)

Still Life with a Basket of Potatoes, Surrounded by Autumn Leaves and Vegetables
Nuenen, September 1885
Oil on canvas, 75 x 93 cm
F 102, JH 937
Liège, Private collection

It was also Hermans the jeweller who gave van Gogh the only commission of his artistic career – or rather, to be exact, allowed himself to be persuaded to place the job in van Gogh's hands. A typical *nouveau riche*, Hermans was out to copy aristocratic ways, and wanted his dining room decorated by an artist. "He wanted compositions depicting various saints", wrote van Gogh in Letter 374. "I suggested that half a dozen scenes of farm life, symbolizing the four seasons, might give the good people at table more of an appetite than the aforesaid mystical gentlemen. Now that he has visited the studio the man is very taken with the idea." In the end they compromised: Vincent was to supply sketches, like a painter at court, and Hermans the dilettante would then transfer

Still Life with Two Baskets of Potatoes
Nuenen, September 1885
Oil on canvas, 65.5 x 78.5 cm
F 107, JH 933
Amsterdam, Rijksmuseum Vincent van Gogh, Vincent van Gogh Foundation

Still Life with a Basket of Potatoes
Nuenen, September 1885
Oil on canvas, 50.5 x 66 cm
F 116, JH 934
Amsterdam, Rijksmuseum Vincent van Gogh, Vincent van Gogh Foundation

Still Life with Copper Kettle, Jar and Potatoes
Nuenen, September 1885
Oil on canvas, 65.5 x 80.5 cm
F 51, JH 925
Amsterdam, Rijksmuseum Vincent van Gogh, Vincent van Gogh Foundation

Still Life with a Basket of Apples and Two Pumpkins
Nuenen, September-October 1885
Oil on canvas, 59 x 84.5 cm
F 106, JH 936
Otterlo, Rijksmuseum Kröller-Müller

Still Life with an Earthen Bowl and Pears
Nuenen, September 1885
Oil on canvas, 33 x 43.5 cm
F 105, JH 926
Utrecht, Centraal Museum
(on loan from the van Baaren Museum Foundation, Utrecht)

the scenes to the panelling on the walls himself. As van Gogh told Rappart (Letter R48), the following scenes were to be included: "potato planting, ploughing with oxen, the harvest, the sower, the shepherd in a storm, people gathering firewood in the snow." In other words: contrary to tradition, six scenes (the number had been fixed by Hermans) were to represent the four seasons. Van Gogh, who saw himself as an expert on farm life, ambitiously aimed at an allegorical cycle: the paintings would not only show the kind of work that was done in the country but would also communicate the ways people thought – in terms of the weather and of the natural rhythm of the solar year, which dictated that certain work be done at certain times.

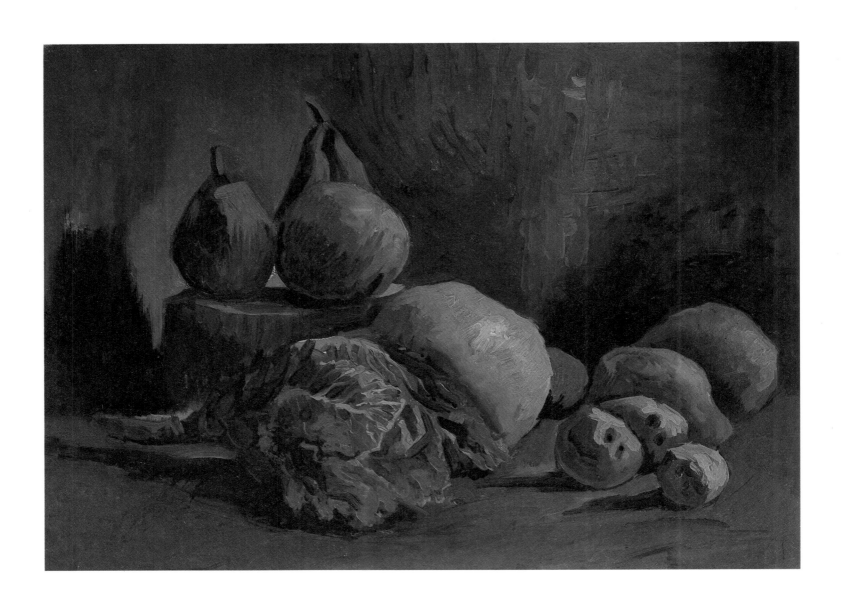

Still Life with Vegetables and Fruit
Nuenen, September 1885
Oil on canvas, 32.5 x 43 cm
F 103, JH 928
Amsterdam, Rijksmuseum Vincent van
Gogh, Vincent van Gogh Foundation

Still Life with Basket of Apples
Nuenen, September 1885
Oil on canvas, 45 x 60 cm
F 99, JH 930
Amsterdam, Rijksmuseum Vincent van
Gogh, Vincent van Gogh Foundation

Still Life with Basket of Apples
Nuenen, September 1885
Oil on canvas, 33 x 43.5 cm
F 101, JH 927
Amsterdam, Rijksmuseum Vincent van
Gogh, Vincent van Gogh Foundation

Still Life with Ginger Jar and Onions
Nuenen, September 1885
Oil on canvas, 39.3 x 49.6 cm
F 104a, JH 924
Hamilton (Canada), McMaster University,
Gift of Herman Levy Esq., O.B.E.

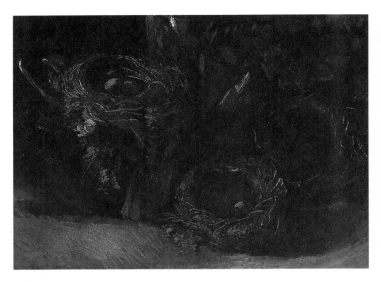

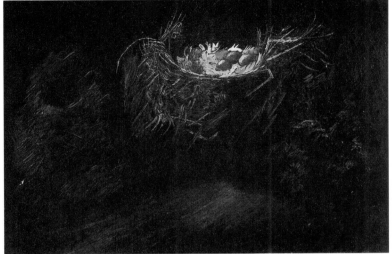

Still Life with Three Birds' Nests
Nuenen, October 1885
Oil on canvas on panel, 43 x 57 cm
F 110, JH 941
The Hague, Haags Gemeentemuseum, on
loan from the Wibbina Foundation

Still Life with Three Birds' Nests
Nuenen, September-October 1885
Oil on canvas, 33.5 x 50.5 cm
F 108, JH 940
Otterlo, Rijksmuseum Kröller-Müller

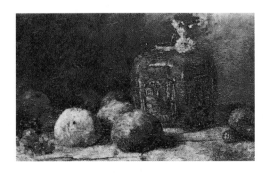

Still Life with Ginger Jar and Apples
Nuenen, September 1885
Oil on canvas on panel, 30.5 x 47 cm
F 104, JH 923
Whereabouts unknown
(Sotheby's Auction, 26. 4. 1972)

Van Gogh made paintings of these scenes himself, and four have survived: *Farmers Planting Potatoes* (p. 47), *Potato Planting* (pp. 48-9), *Shepherd with Flock of Sheep* (p. 46) and *Wood Gatherers in the Snow* (p. 46). All of them were done in late summer 1884. Treating the canvas as a stage, van Gogh presents the action unimaginatively. The landscape is flat and dreary and recedes to the horizon innocent of any relief; and against this background the figures are presented as monumental in their dignity. In van Gogh's sketches the silhouettes of a village, church tower or line of trees still marked the horizon, but now our attention is fixed completely on the people at their work. They bow their heads, they stoop, they walk bent beneath their loads and beneath the line of the horizon, and only occasionally does a head stand out against the light of the sky. In foregrounding his figures, van Gogh has also emphasized their rootedness in the soil that affords them a livelihood. It almost looks as if the ground were dropping away at their feet and they were falling into the depths of a grave. Judged by the rulebook, these paintings are little better than dilettantish; yet van Gogh, in his subtle way, has made a virtue of necessity, allowing his own rudimentary manner to be included in the primæval rituals of this work.

This cycle of the seasons constituted the only paintings that van Gogh did not place at his brother's disposal. In February 1884 Vincent had agreed to repay Theo's postal money orders with paintings. So now his works were regularly being sent to Paris; indeed, everything van Gogh produced from this time forth, till the day he died, went to Theo. Vincent considered his brother the owner of his paintings, while Theo, for his part, saw himself as a trustee – though both of them sensibly refrained from dwelling upon the exact details of ownership. The arrangement itself (which they both observed to the letter, without discussing it at any length in their correspondence) was the result of profound differences between the two brothers. Vincent had lost sight of the *alter ego* he had always assumed Theo to be. He blamed his brother for his own alienation from their parental home, and saw him as the

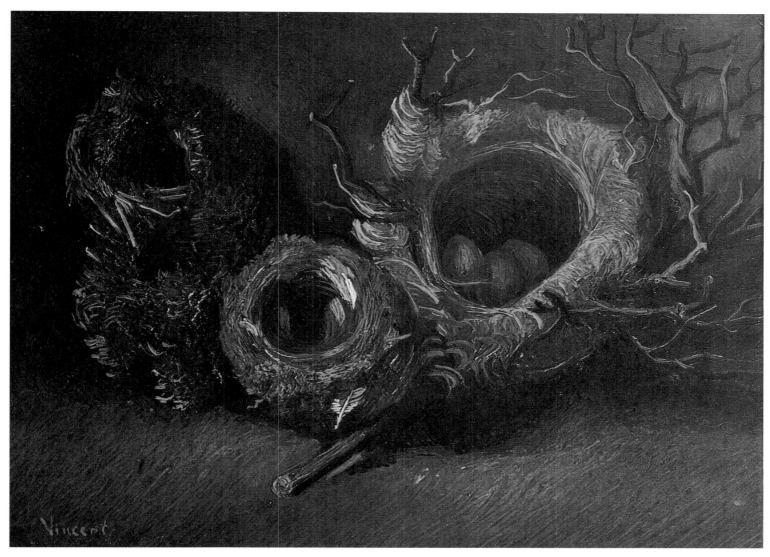

Still Life with Three Birds' Nests
Nuenen, September-October 1885
Oil on canvas, 33 x 42 cm
F 112, JH 938
Otterlo, Rijksmuseum Kröller-Müller

Still Life with Five Birds' Nests
Nuenen, September-October 1885
Oil on canvas, 39.5 x 46 cm
F 111, JH 939
Amsterdam, Rijksmuseum Vincent van
Gogh, Vincent van Gogh Foundation

View of Amsterdam from Central Station
Nuenen, October 1885
Oil on panel, 19 x 25.5 cm
F 113, JH 944
Amsterdam, P. and N. de Boer Foundation

personification of that code of respectability that constantly brought home his own inadequacy to him. The break peaked in a superb passage in Letter 379, in which Vincent discussed Delacroix's famous painting of the 1830 revolution, *Liberty on the Barricades* (in the Louvre in Paris), showing Liberty leading the people onward. Vincent imagined himself in the days of revolutionary fighting in 1830 or 1848, and went on to picture himself meeting his brother on the other side: "If we had both remained true to ourselves, we might – with a sorrow of kinds – have found ourselves enemies, confronting each other, at a barricade like that for instance, you as a government soldier and I behind it, a rebel. Now, in 1884 (by coincidence the numbers are the same, just the other way round) we confront each other once more; there are no barricades, it is true, but our minds cannot agree."

Theo the opportunist and Vincent the rebel: it was van Gogh's way of

Landscape with Windblown Trees
Nuenen, November 1885
Oil on paper on panel, 32 x 50 cm
F 196, JH 957
Whereabouts unknown

The Parsonage at Nuenen by Moonlight
Nuenen, November 1885
Oil on canvas, 41 x 54.5 cm
F 183, JH 952
Private collection

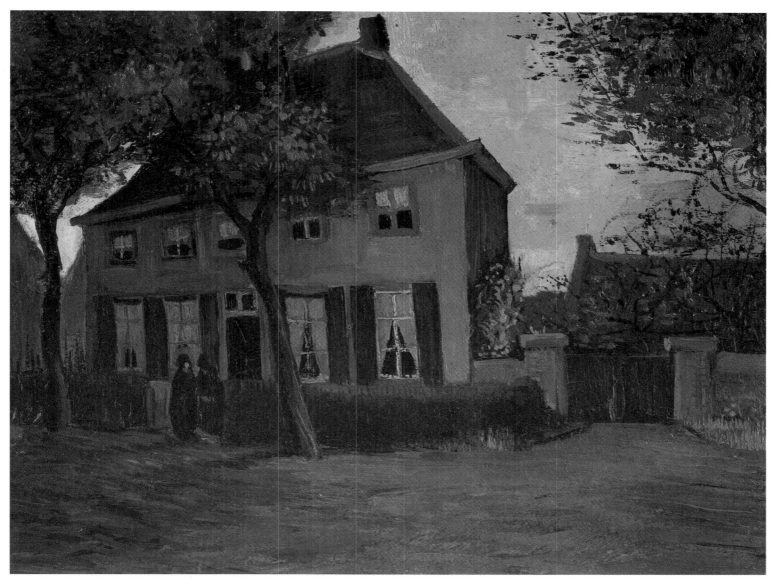

expressing a central polarity in Modernism, between the penniless artistic outsider and the corrupt and obese bourgeois philistine. The row with his brother was soon patched up; but van Gogh's view of the world remained at the very core of his identity. He dreamt the dream of revolution, and indeed he had to do so if he was not to accept the iron indifference of the uncomprehending pillars of society who blithely ignored his art. Van Gogh had to believe that his art was contributing to a better world. Two years before, in his insistence that he had to create something (in Letter 309), he had already pinpointed the problem. The simple folk he was affectionately placing at the centre of his artistic endeavours might not be able to underwrite that changed society of the future he vaguely envisaged, but still he took them as its prototypes. Showing them in their natural dignity was van Gogh's way – the only way open to him – of assisting in that change.

The Parsonage at Nuenen
Nuenen, October 1885
Oil on canvas, 33 x 43 cm
F 182, JH 948
Amsterdam, Rijksmuseum Vincent van Gogh, Vincent van Gogh Foundation

View of Amsterdam
Nuenen, October 1885
Oil on canvas on panel, 35 x 47 cm
F 114, JH 945
Amsterdam, Rijksmuseum Vincent van Gogh, Vincent van Gogh Foundation
(Attribution disputed)

Progress
The *Weavers* Series

View of a Town with Drawbridge
Nuenen, October 1885
Oil on panel, 42 x 49.5 cm
F 210, JH 947
Private collection

Van Gogh tended to be more at home in peasants' cottages than in his parents' house. Only a few weeks after the stranger had appeared in their midst, the villagers (the poor among them in particular) befriended Vincent and adopted him as one of themselves. It is tempting to draw cosy, idyllic conclusions from the fact that his first paintings in Nuenen were interiors, showing weavers at work, busy at their looms. Reality, however, was not altogether so cosy. Van Gogh, relieved of concerns for his daily bread, now had 150 francs a month; Theo's support meant that he had about three times what a weaver family (every generation of the family living together under the same roof) had by way of income. Though van Gogh doubtless felt a sense of solidarity with the weavers, his visits cannot be accounted for on those grounds alone. We should also remember that in the cold winter months it was much better to paint indoors. And above all, he had the money to pay the weavers (who tended to have large families) for posing at their picturesque looms.

Country Lane with Two Figures
Nuenen, October 1885
Oil on canvas on panel, 32 x 39.5 cm
F 191a, JH 950
Private collection
(Christie's Auction, London, 2. 12. 1986)

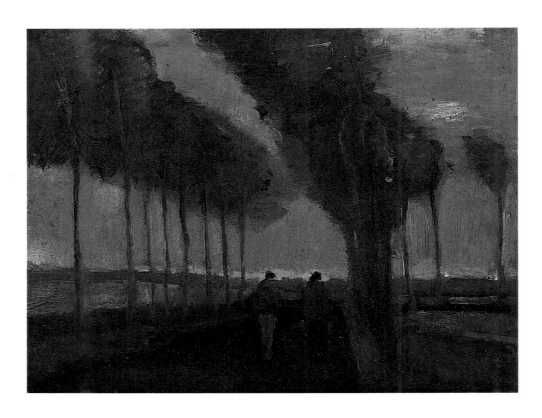

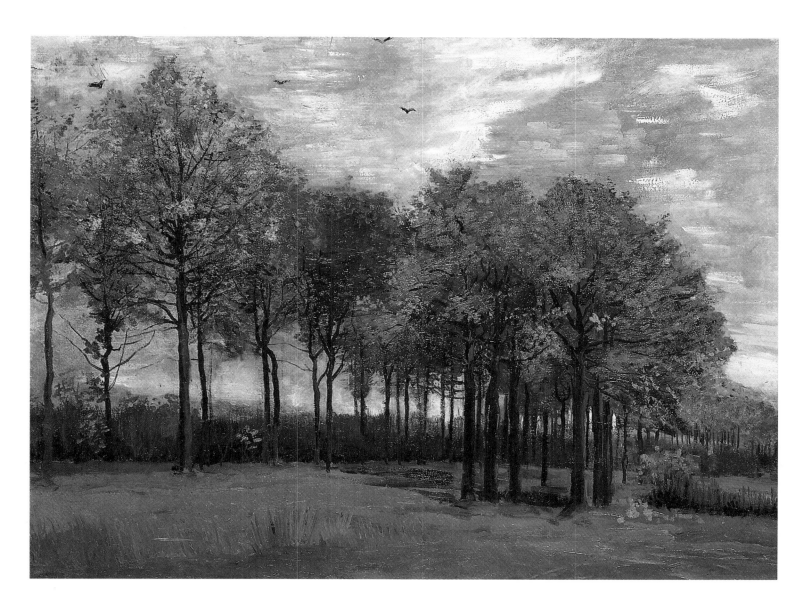

Autumn Landscape
Nuenen, October 1885
Oil on canvas on panel, 64.8 x 86.4 cm
F 119, JH 949
Cambridge (England), Fitzwilliam Museum

Van Gogh ascribed a certain depth to these milieu scenes, feeling they provided insight into his own work too; and indeed it is that depth which lends the series its special quality. Still, the identification of artist with weaver, and vice versa, amounted to precious little in practice. Before he had ever set foot in a weaver's workroom, van Gogh had been full of effusive social romanticism: "A weaver", he wrote from The Hague (Letter 274), "with a great number of threads to weave, has no time to philosophize about how he is to work them all together; rather, he is so absorbed in his work that he does not think, he acts, and he feels how things can and must be arranged rather than being able to explain it." In the weaver's work he had again located a metaphor for his own everyday labours; linen (or canvas), the final product of one man's work, was the starting point of the other's. Once he was on the spot, though, van Gogh had problems finding his pet idyll of the craftsman's life. The series of pictures he presently painted eloquently attest van Gogh's gradual relinquishment of his preconceived notions and his acceptance of the careworn reality of everyday life as a weaver. For the first time in van Gogh's oeuvre we can witness the artist engaging in the process of

Autumn Landscape with Four Trees
Nuenen, November 1885
Oil on canvas, 64 x 89 cm
F 44, JH 962
Otterlo, Rijksmuseum Kröller-Müller

 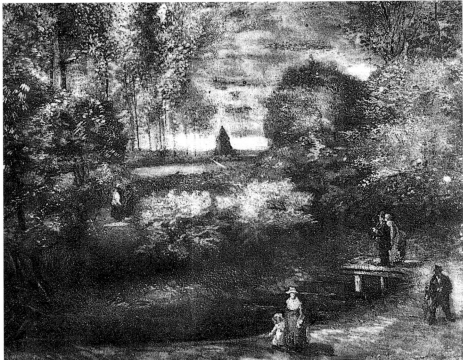

questioning his own subjective attitudes and starting a dialogue with his subjects.

Presumably it was their unanticipated obduracy that led van Gogh to take the weavers as his subject. The series was a kind of pilot project for him. Henceforth his work would typically be conceived in series, and in this way his tireless urge to create (as an end in itself) harmonized with his systematic investigations of the unfamiliar. Carlyle too had stressed the importance of affectionate empathy in accessing the natural laws of series. The soul and conscious needed to be awoken within us, dilettantism ousted in favour of honest endeavour, the heart of stone replaced by the living heart of flesh and blood; and, once that had been accomplished, an endless number of things would be perceived, things that were waiting to be done. And once the first had been done (felt Thomas Carlyle) the second would follow, then the third, and so forth unto infinity.

Weaver, Facing Right, Half-Figure (p. 35) is the only close-up in the series. Van Gogh is trying to gaze into that tensed face, touch those lips tight with concentration, and observe the hand movements the weaver makes at his work. Van Gogh is trying to see himself in this figure, whose gestures and facial expression remind him of his own at the easel – which the loom even distantly resembles. Here, in the first painting in a series of ten, the metaphoric link between the picture and the fabric as products of related activities is effectively stated in the striking geometry of cords which van Gogh's long brushstrokes have overlaid on the surface.

In *Weaver Facing Left, with a Reel* (p. 36) van Gogh has already

The Willow
Nuenen, November 1885
Oil on canvas, 42 x 30 cm
F 195, JH 961
Whereabouts unknown

The Parsonage Garden at Nuenen with Pond and Figures
Nuenen, November 1885
Oil on panel, 92 x 104 cm
F 124, JH 955
Destroyed by fire during World War II

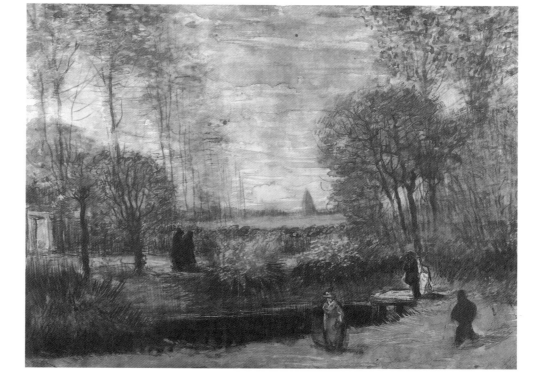

The Parsonage Garden at Nuenen with Pond and Figures
Nuenen, November 1885
Watercolour, 38 x 49 cm
F 1234, JH 954
Wassenaar (Netherlands), Collection
B. Meijer

retreated somewhat. Now he is attempting a kind of reportage, documenting the working atmosphere, trying a new approach to a recalcitrant subject. The light, bright and diffuse, fills a room which merely serves as a space in which to present a highly detailed rendering of the weaver's instruments. Van Gogh has added a reel, a commonplace attribute that confirms the everyday tone of this account of a weaver's existence. The addition shows the artist taking his bearings from the detached, anecdotal manner of the magazine illustrations he had so often admired. He was playing the part of an expert with vast, impartial knowledge of the working world.

"Imagine a black monster made of darkened oak", van Gogh wrote to Rappard (Letter R44), explaining the fascination and horror he felt for the loom, "all its crossbars standing out against the greyness of the

Autumn Landscape at Dusk
Nuenen, October-November 1885
Oil on canvas on panel, 51 x 93 cm
F 121, JH 956
Utrecht, Centraal Museum

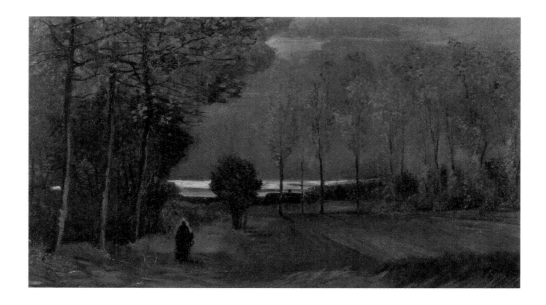

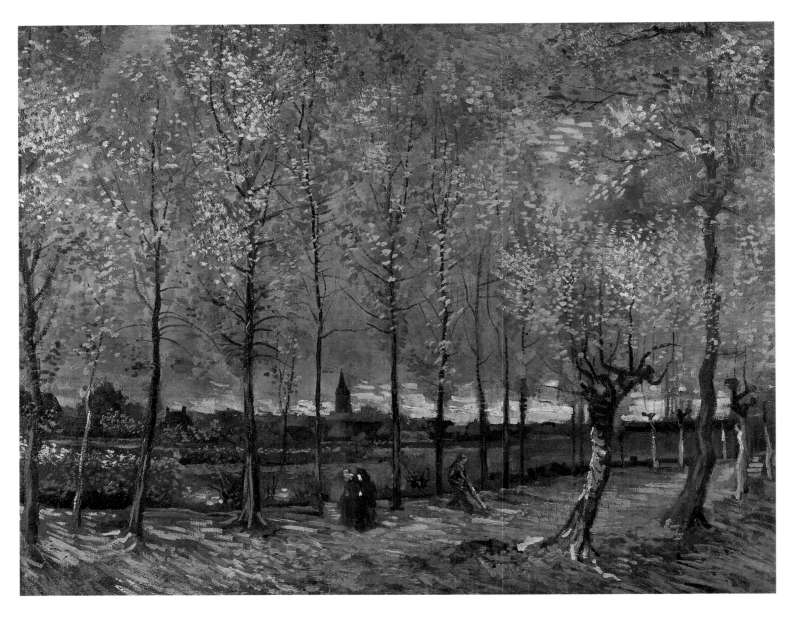

Lane with Poplars
Nuenen, November 1885
Oil on canvas, 78 x 98 cm
F 45, JH 959
Rotterdam, Museum Boymans-van
Beuningen

room, and sitting right inside it a black ape or kobold or ghost, rattling away at the shuttles from dawn till dusk. And I have recorded it by using a few scribbles and splotches to indicate a sort of weaver's figure at the place where I saw him sitting." It was in April 1884 that van Gogh wrote these lines about the ghost in the machine – a quarter of a year after his first contact with the weavers. Plainly he was not totally at ease with his material, and his rhetoric cannot disguise the fact that he had not yet fully come to terms with his subject. However, the way had been paved for an involvement in the lives of working people that accepted the unattainability of total harmony. Indeed, the curious fetishism he developed concerning the mysterious powers at work in the loom's wooden mechanism may well have been the right way to that new insight and acceptance.

Weaver, Seen from the Front (p. 39) places the "black monster's" daunting shape in the foreground. The weaver is scarcely individuated, a mere part of the complex mechanism, a figure in a geometrical construct of bars and shuttles, occupying a place in the incessant bustle of

the loom. No light illuminates his face. No colour highlights him amidst the brown monotony of the wood. Man and machine operate in tandem, not because the man (like the machine) lacks a soul but because the artist's eye has discovered life in both. It is hardly possible to overestimate the importance of this loom for van Gogh's subsequent art: for the very first time a thing or object transcends the status of a mere prop in a still life. The eloquence of his chairs (pp. 9 and 10) or shoes (p. 201) is anticipated here.

After six months of intense work, van Gogh found the solution he needed – to be exact, two solutions, marking the peak and also the finale of the weavers series: *Weaver near an Open Window* (p. 43) and *Weaver, Seen from the Front* (p. 43). In these paintings, van Gogh locates two alternative ways of expressing distance and proximity, identification and remoteness simultaneously. The window and the views it affords offer the artist's own commentary, while the weaver's person and machine confront him in a manner that seems antithetical, no longer personal.

Quayside with Ships in Antwerp
Antwerp, December 1885
Oil on panel, 20.5 x 27 cm
F 211, JH 973
Amsterdam, Rijksmuseum Vincent van Gogh, Vincent van Gogh Foundation

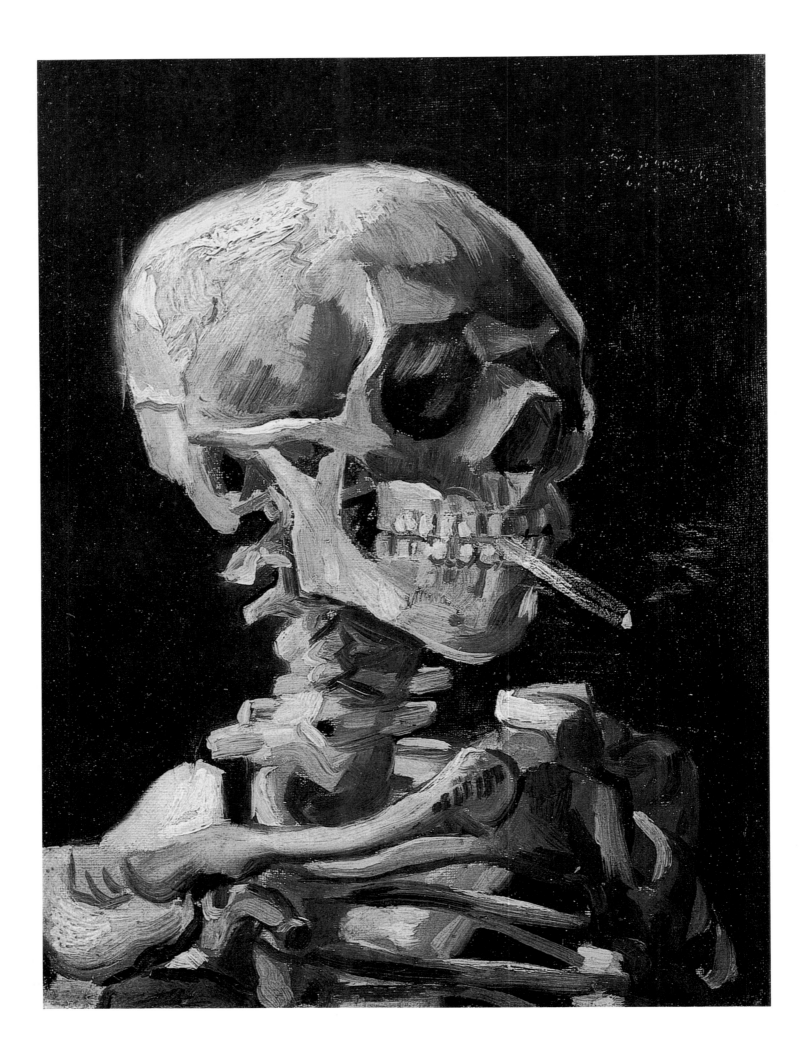

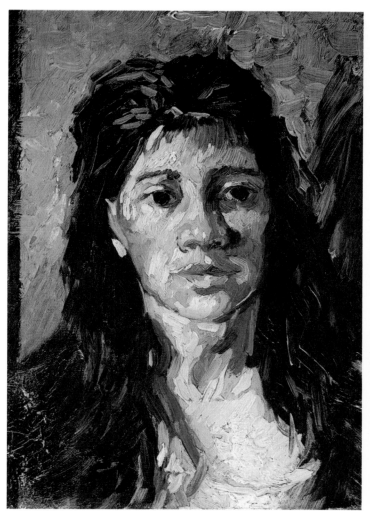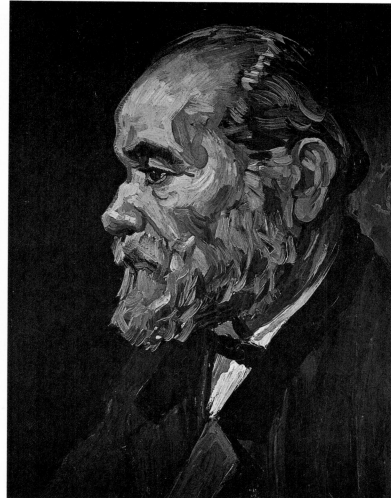

Head of a Woman with her Hair Loose
Antwerp, December 1885
Oil on canvas, 35 x 24 cm
F 206, JH 972
Amsterdam, Rijksmuseum Vincent van
Gogh, Vincent van Gogh Foundation

Portrait of an Old Man with Beard
Antwerp, December 1885
Oil on canvas, 44.5 x 33.5 cm
F 205, JH 971
Amsterdam, Rijksmuseum Vincent van
Gogh, Vincent van Gogh Foundation

Skull with Burning Cigarette
Antwerp, Winter 1885/86
Oil on canvas, 32 x 24.5 cm
F 212, JH 999
Amsterdam, Rijksmuseum Vincent van
Gogh, Vincent van Gogh Foundation

Weaver near an Open Window is the more optimistic of the two paintings. The weaver is getting on with his work, silent, dedicated. He is protected by the higher power that appears symbolically at the perspective vanishing point. As long ago as Letter 250, van Gogh had written enthusiastically of the "little tower in the distance that looks quite small and unimportant but becomes impressive as you approach it." Now he was including it as a way of anchoring the humble, poverty-stricken life of a fellow-being he cared about in a larger context. First and foremost it was to himself that he was offering the promise of transcend-ent authority symbolized by the tower – himself, a man in need of affection, understanding and compassion, a man unable to cope with the social distinctions that gaped wide before him with every new day that dawned. But now he was placing the weaver and the things in the weaver's life in the midst of his own personal symbols: the ruined tower and the greyish blue figure of a woman bending. Though the bare interior might strike him as remote and alien, he had now cradled it in a bright exterior that he knew how to deal with in his art.

Weaver, Seen from the Front is more pessimistic. Awkward and unapproachable, the weaver seems as clumsy and indeed monstrous as his machine. The window is closed, and through it we see a windmill,

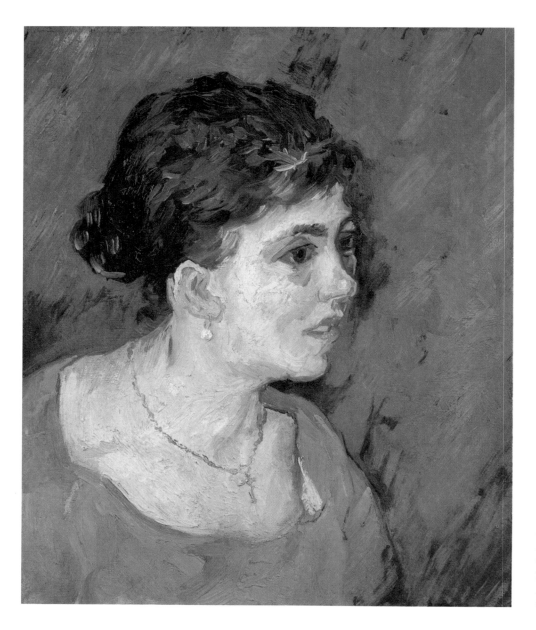

Portrait of a Woman in Blue
Antwerp, December 1885
Oil on canvas, 46 x 38.5 cm
F 207a, JH 1204
Amsterdam, Rijksmuseum Vincent van
Gogh, Vincent van Gogh Foundation

unclearly, some way off, its sails moving ineffectually. The weaver is in a prison, locked into an architectural construct reminiscent of a burial chamber. He is frozen rigid like an icon, remote and monumental, a kind of ghost. It is as if he were mummified; and the reason cannot be artistic incompetence on van Gogh's part. Though he had not yet mastered certain skills by a long way, he was well able to endow his figures with life and vitality. The weaver in this picture is singing a dirge or elegy on the passing of his own way of life. Half a century before, Carlyle had lamented that the living craftsman was everywhere being expelled from his workshop and replaced by a dead machine. Fingers of iron could move the shuttle faster than the weaver's fingers of flesh and blood. In his painting, van Gogh is showing this dismal future, vividly and awfully. Again he has abandoned all intention of making the man a component of his own subjective visual world; again he is aiming at a general presentation in which the individual can acquire symbolic meaning. The angle is different, though: there is no attempt to enter into the

Portrait of a Woman with Red Ribbon
Antwerp, December 1885
Oil on canvas, 60 x 50 cm
F 207, JH 979
New York, Collection Alfred Wyler

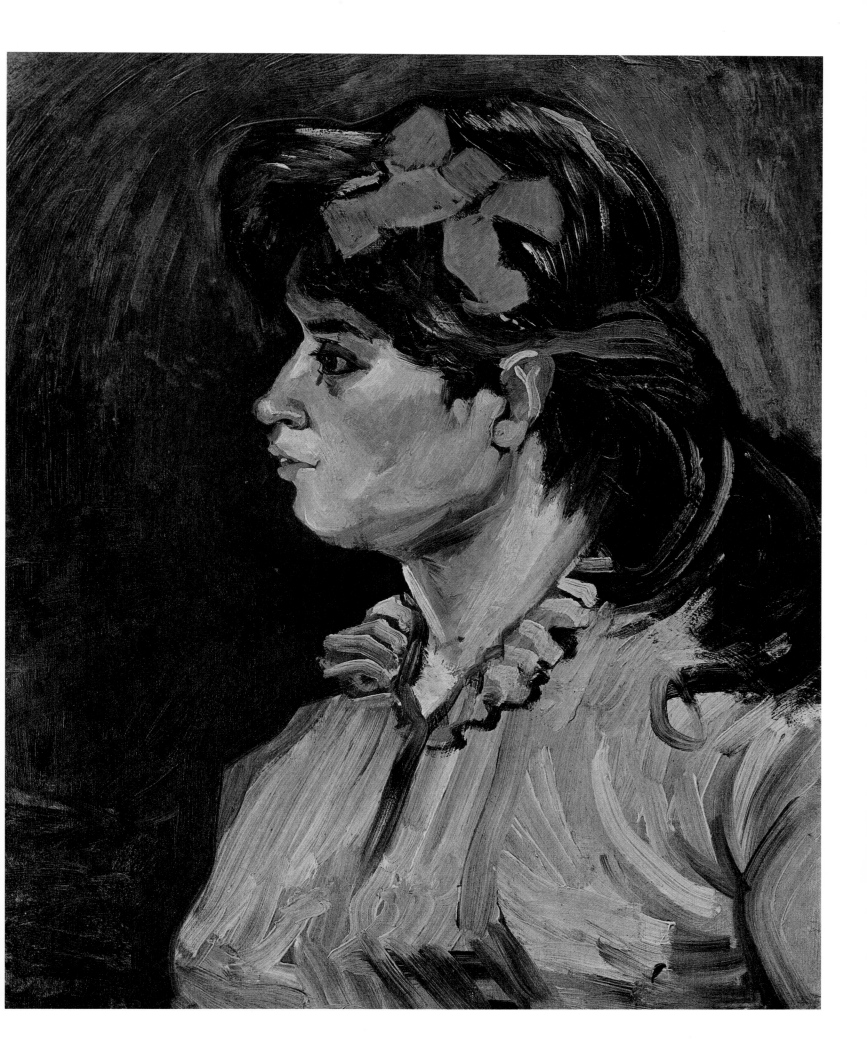

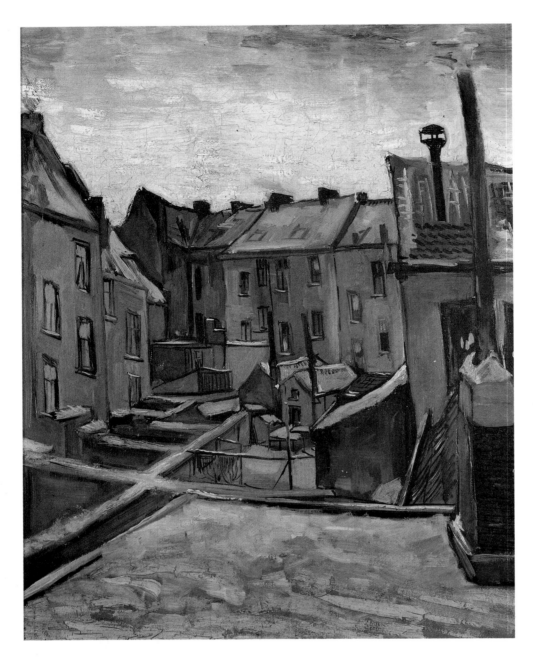

Backyards of Old Houses in Antwerp in the Snow
Antwerp, December 1885
Oil on canvas, 44 x 33.5 cm
F 260, JH 970
Amsterdam, Rijksmuseum Vincent van
Gogh, Vincent van Gogh Foundation

other's life or identify with him; instead, the approach might almost be
called political. Distress at a specific ill has temporarily displaced van
Gogh's general distress at the universal ills of mankind. Shortly after-
wards he was to request his brother to send him reports of the weavers'
uprising in Lyon (Letter 393).

Whether the last two paintings in the weavers series are artistically
the finest is debatable. Their composition, though, neatly illustrates
how van Gogh, at one point in his creative life, would acquire a hold on
subjects that were trying to evade his grip: by juxtaposing his personal
experience with what remained so implacably alien. It may seem a
crude and antithetical method; basically, though, it was to be applied
unaltered throughout van Gogh's career. In due course van Gogh was to
find solutions that made a more sensuous appeal, were more natural,
and enabled him to establish a greater unity of impact. He took the

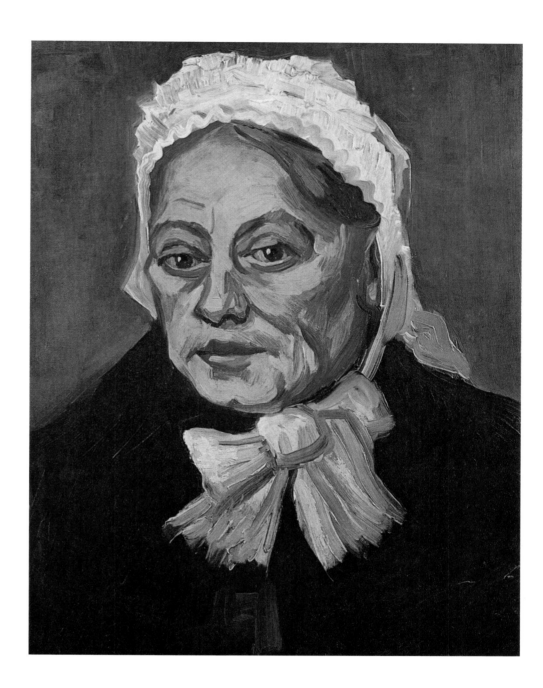

Head of an Old Woman with White Cap (The Midwife)
Antwerp, December 1885
Oil on canvas, 50 x 40 cm
F 174, JH 978
Amsterdam, Rijksmuseum Vincent van Gogh, Vincent van Gogh Foundation

lesson he had learnt from the weavers and applied it to his subjects, approaching them with all his love of paradox, coaxing conflict and inconsistency out of the tiniest details. Ambiguity, which had hitherto been primarily a feature of his reception, now became a hallmark of his creative work.

"With all my strength"
Winter 1884-1885

Hardly any artist's oeuvre harmonizes so thoroughly with the cycle of the seasons as van Gogh's. If critics trying to assign a work its chronological place are at odds, their discussion is likely to centre on determining the year itself rather than the season of the year. Van Gogh rarely leaves us in any doubt as to whether a work was created when the blossom of springtime was flowering, or summer's harvest being made,

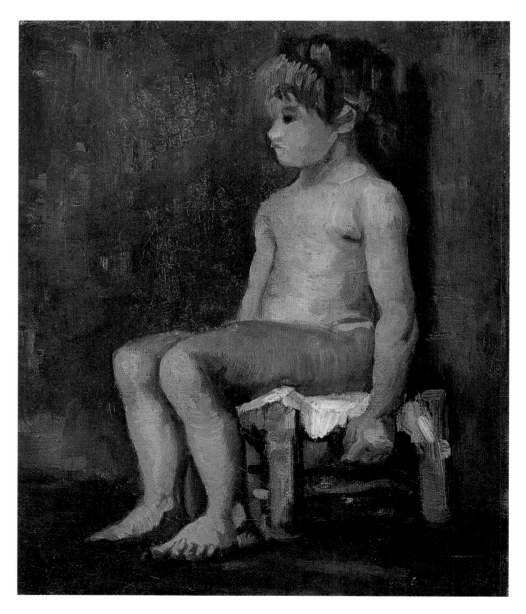

Nude Study of a Little Girl, Seated
Paris, Spring 1886
Oil on canvas, 27 x 22.5 cm
F 215, JH 1045
Amsterdam, Rijksmuseum Vincent van Gogh, Vincent van Gogh Foundation

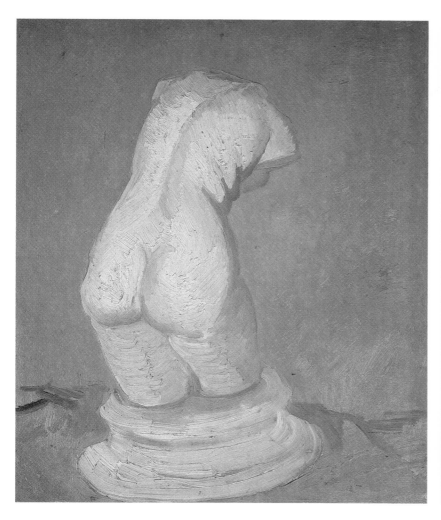
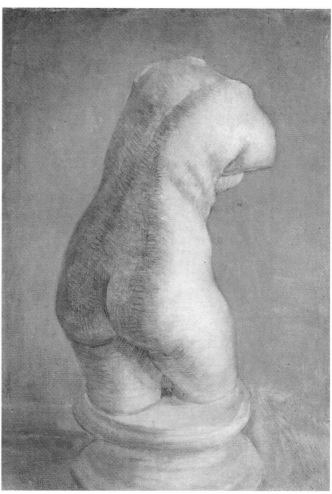

or the leaves of autumn falling, or winter's cold biting so harshly that the painter was driven indoors to his studio. Letters document all this; but so do the indications of season van Gogh liked to include in his pictures. He wanted to live and work like the farmers he lived amidst. His emotional sense of affinity with them was accompanied and indeed almost defined by geographical closeness (they were neighbours) and the closeness of fellow workers (whose labours were timed to suit the wind and rain).

As if the cold was part of some artistic programme, van Gogh set his easel up in the snow. Painting the picture of wood gatherers in the snow for the Hermans cycle, Vincent had done the winter landscape from memory, but now he was out for complete unity of subject and work. *The Old Cemetery Tower at Nuenen in the Snow* (p. 72), *The Old Station at Eindhoven* (p. 72) or the two paintings titled *The Parsonage Garden at Nuenen in the Snow* (pp. 73 and 77) all have a genuine wintry chill about them. The snow shoveller's cold wet feet (and the painter's too), cold noses and numb fingers, snow on the spire of the tower, bare trees: we have a total impression of authenticity and can easily imagine the details we cannot see. Van Gogh bravely trudged off through the snow, thinking that the more fully he engaged with the elements of winter the more their power would fill his canvas. As in the case of the

Plaster Statuette of a Female Torso
(rear view)
Paris, Spring 1886
Oil on cardboard on multiplex board,
47 x 38 cm
F 216a, JH 1054
Amsterdam, Rijksmuseum Vincent van Gogh, Vincent van Gogh Foundation

Plaster Statuette of a Female Torso
(rear view)
Paris, Spring 1886
Oil on canvas, 40.5 x 27 cm
F 216g, JH 1055
Amsterdam, Rijksmuseum Vincent van Gogh, Vincent van Gogh Foundation

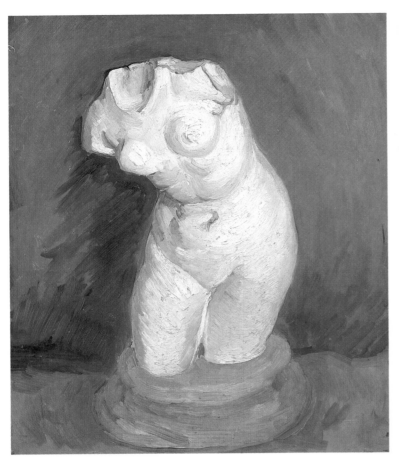
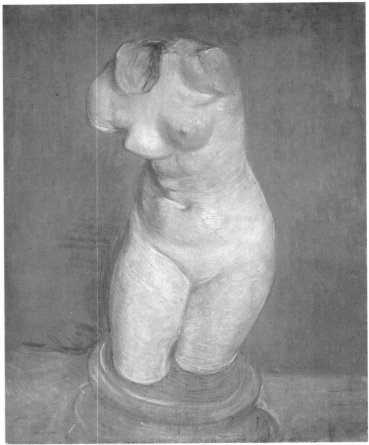

sower and reaper, the artist functioned purely as a medium for Nature's process of creation. It is as if van Gogh were holding out his unbegun picture of Creation, wanting its imprint on his virgin canvas. In this we see van Gogh experiencing the characteristic modern landscape artist's sense of being overwhelmed by the constant flux of natural creation; the artist himself is only intermittently creative and therefore holds himself in low esteem. However strong his subjective responses, the artist must suppress subjectivity if he is to allow those natural forces which are beyond his control to have full, vivid play in his work. Van Gogh, as so often in other respects as well, was more literal about this paradox than other artists. He was perfectly prepared to be self-sacrificing, even at the cost of his health, if the art he produced had a satisfactory immediacy.

The snow scenes are only an intermezzo, though, in the major series of that six-month period, at the end of which van Gogh painted his first true masterpiece. *The Potato Eaters* (p. 96) was a synthesis of countless studies of peasants' heads, of people absorbed in work and handicrafts, which van Gogh painted that winter in the poor cottages in the village. As with the weavers, he had to paint a whole series in order to achieve any real closeness with these intractable people. This time the series approach resulted in a final triumph.

"You see, if I am to get ahead at all I have to paint fifty heads, precisely because it goes so well. As soon as possible, one after the other. I have

Plaster Statuette of a Female Torso
Paris, Spring 1886
Oil on cardboard on multiplex board,
46.5 x 38 cm
F 216b, JH 1060
Amsterdam, Rijksmuseum Vincent van Gogh, Vincent van Gogh Foundation

Plaster Statuette of a Female Torso
Paris, Spring 1886
Oil on canvas, 41 x 32.5 cm
F 216h, JH 1058
Amsterdam, Rijksmuseum Vincent van Gogh, Vincent van Gogh Foundation

Plaster Statuette of a Female Torso
Paris, Spring 1886
Oil on cardboard on multiplex board,
35 x 27 cm
F 216j, JH 1059
Amsterdam, Rijksmuseum Vincent van Gogh, Vincent van Gogh Foundation

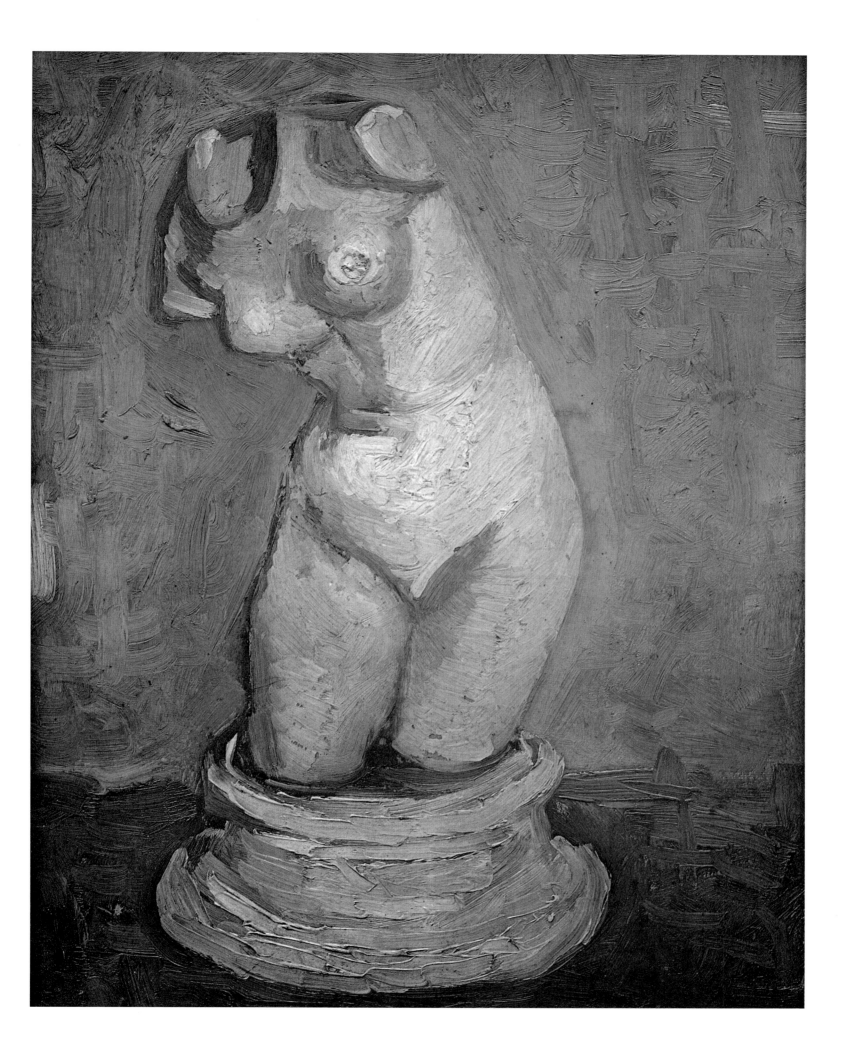

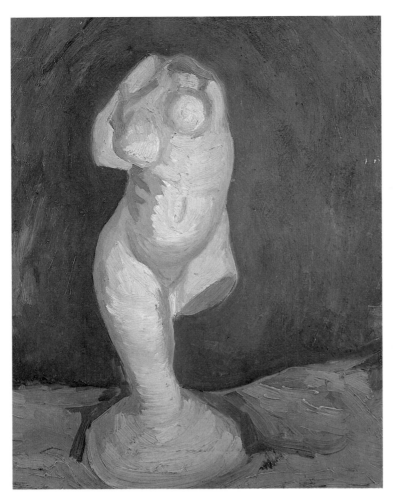

worked it out, but it can't be done, with all my strength (which I shall gladly invest, as far as effort and exertion are concerned), without putting in extra work." In Letter 384 (November 1884) he told Theo of the workload he had set himself and requested more money; after all, the models he was now using had to be paid too. Van Gogh adhered to his work schedule through to April the following year, and over forty paintings of peasants' heads plus two dozen close-up studies of various kinds of cottage work have survived from this time.

It would be difficult to put these pictures in chronological order. In the course of his efforts to include the people of Nuenen in his art, van Gogh himself made only comments of a general nature: "I want the subject to follow from the character", we read in Letter 391, or: "I am even more interested in a figure's proportions, and how the eggshape of the head relates to the whole" (Letter 394). However, if we take our reading of the weavers series as the basis of an approach to these new works, we might outline a rough description of van Gogh's methods as follows. First he would restrict himself to bust portraits. He had a preference for placing figures in profile, their silhouettes (in dark colours) set off against the monochrome gloom of the background; and he would dwell on the material of caps and kerchiefs, the folds and crinkles in the linen (cf. pp. 66-69). In the portraits where the sitters are seen fulface, van Gogh strikingly avoids meeting their careworn gaze and sim-

Plaster Statuette of a Female Torso
Paris, Spring 1886
Oil on cardboard on multiplex board,
35 x 27 cm
F 216d, JH 1071
Amsterdam, Rijksmuseum Vincent van Gogh, Vincent van Gogh Foundation

Plaster Statuette of a Female Torso
Paris, Spring 1886
Oil on cardboard on multiplex board,
32.5 x 24 cm
F 216i, JH 1072
Amsterdam, Rijksmuseum Vincent van Gogh, Vincent van Gogh Foundation

Plaster Statuette of a Kneeling Man
Paris, Spring 1886
Oil on cardboard on multiplex board,
35 x 27 cm
F 216f, JH 1076
Amsterdam, Rijksmuseum Vincent van
Gogh, Vincent van Gogh Foundation

Plaster Statuette of a Male Torso
Paris, Spring 1886
Oil on cardboard on multiplex board,
35 x 27 cm
F 216e, JH 1078
Amsterdam, Rijksmuseum Vincent van
Gogh, Vincent van Gogh Foundation

ply records that the villagers look full of mistrust; they remain in some unfathomable depths of their own, not communicating with their vis-à-vis, gazing straight past at some imaginary world (cf. pp. 69 as well as 75).

As time went by, van Gogh ventured to look his modest subjects in the eye. We can distinguish a second group of portraits in which the sitter meets our gaze; they are *en face* portraits or three-quarter profiles. Their rustic spirits become more open and mischievous, and the painter's growing intimacy with them is reflected in their facial expressions, which are expectant or possibly show a need for help but at any rate are less stubborn and timorous (cf. pp. 70 and 74). Van Gogh even painted sub-series within his series. The same person would be examined five or six times so that every detail of the face could be recorded as it became readier, more accessible. Seen very slightly from below, they are revealed in their true dignity, in the full integrity of a life lived in harmony with Nature. In their authenticity, these pictures afford a contrast to the posed and self-consciously original scenes van Gogh had painted for Hermans's commission. The subjects of his new work emerged from their social anonymity of their own accord, and established their individual personalities so clearly that in due course the critics took pains to identify the sitters. One of the most striking (pp. 87ff.) was Gordina de Groot; she re-appeared in *The Potato Eaters*.

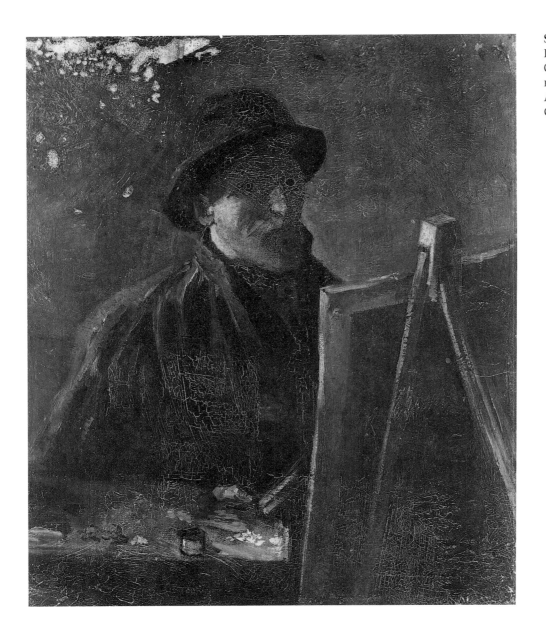

Self-Portrait with Dark Felt Hat at the Easel
Paris, Spring 1886
Oil on canvas, 46.5 x 38.5 cm
F 181, JH 1090
Amsterdam, Rijksmuseum Vincent van
Gogh, Vincent van Gogh Foundation

The third stage in van Gogh's work on this series involved the change from portraits to interiors. He observed his subjects about their domestic chores, peeling potatoes, spinning, weaving baskets. The figures and their settings now received equal attention. The light, from a single source, is now diffuse, now contrastive, and creates an atmosphere of tranquil permanence in which the figures and objects appear interdependent. Van Gogh drew upon tradition for some of his effects, borrowing from the genre scenes of the Dutch baroque, from Jan Steen or Gerard Terborch, in order to lend timeless meaning and relevance to specific views of everyday life. It is no coincidence that *Peasant Woman at the Spinning Wheel* (p. 81) recalls Jan Vermeer's enigmatic interiors. Daylight from a window off-canvas to the left has the curious effect of adding a mysterious note; and van Gogh's peasant woman acquires an almost emblematic quality as she pursues her task, as preoccupied and unknowable as the women in Vermeer's paintings. Now that van Gogh's wish to come closer to these people had been rewarded with success he was beginning to see as much significance in them as had

View of Paris from near Montmartre
Paris, Spring 1886
Oil on canvas, 44.5 x 37 cm
F 265, JH 1100. Private collection

Plaster Statuette of a Horse
Paris, Spring 1886
Oil on cardboard on multiplex board,
33 x 41 cm
F 216c, JH 1082
Amsterdam, Rijksmuseum Vincent van
Gogh, Vincent van Gogh Foundation

once been seen in merchants and scholars. These interiors were the foundation of that social romanticism that van Gogh was soon to articulate, in manifesto style, in *The Potato Eaters*. The people's tools and implements still have something of attributes, the peasants still make a somewhat absent-minded impression as they do their work, their concentration still looks like a pose; but that was all entailed by the laws of series work, and the painter could still look forward to a future picture that would afford the consolation of eliminating these shortcomings.

"I have only one belief, one strength: work. All that kept me going was the immense task I had assigned myself. The work I am telling you of is regular work, a task, a duty I set myself, so that every day, even if it was only a single step, I would move forwards in my labours." In his *Speech to Young People*, Zola placed programmatic value on the idea of a regular quota of work for its own sake. Zola himself did in fact write the same amount every day; this inevitably left traces in his literary output, and it is often easy to see which passages were written on good

days and which on bad. Van Gogh went about things in much the same way. His series spurred him on, just as Zola's contracts spurred the writer on. An untiring urge to get ahead encouraged a belief in both men that they actually would make real progress if only they put pressure on themselves to work on. This belief in progress reveals both Zola and van Gogh to be typical minds of the 19th century, of course; and this professional achiever instinct was in a sense the very opposite of Romantic inwardness, devotion, and profundity of feeling. It would be a mistake to overlook this fact when examining van Gogh's oeuvre.

The painting of *The Potato Eaters* in April, 1885 marked a turning-point in van Gogh's artistic life; his private life also encountered a turning-point at the same time. On 26 March, Pastor Theodorus van

Fritillaries
Paris, Spring 1886
Oil on canvas, 38 x 55 cm
F 214, JH 1092
Whereabouts unknown

View of the Roofs of Paris
Paris, Spring 1886
Oil on cardboard on multiplex board,
30 x 41 cm
F 231, JH 1099
Amsterdam, Rijksmuseum Vincent van Gogh, Vincent van Gogh Foundation

Gogh died suddenly, aged sixty-three, of a stroke. It may be no exaggeration to blame his son Vincent, at least in part. The vicar had been grieving ever since his artist son had come to live at home. Their characters were too different for any harmony to be possible, and the discord made a bitter man of van Gogh *père*. Everyone considered Vincent a failure, too, which did not make family life any easier. The day before he died, Pastor van Gogh had written to the financial bedrock of the family, Theo, to get his pessimism off his chest and lament Vincent's lack of success. Now, following his death, the family were able to stay on at the vicarage for the time being; but Vincent's standing in the eyes of the villagers deteriorated rapidly.

Naturally he commented on his changed circumstances in his art. *Still Life with Bible* (p. 104) is an examination of his relations with his father, whose correct reserve had always troubled Vincent. In the paint-

Self-Portrait with Dark Felt Hat
Paris, Spring 1886
Oil on canvas, 41.5 x 32.5 cm
F 208a, JH 1089
Amsterdam, Rijksmuseum Vincent van Gogh, Vincent van Gogh Foundation

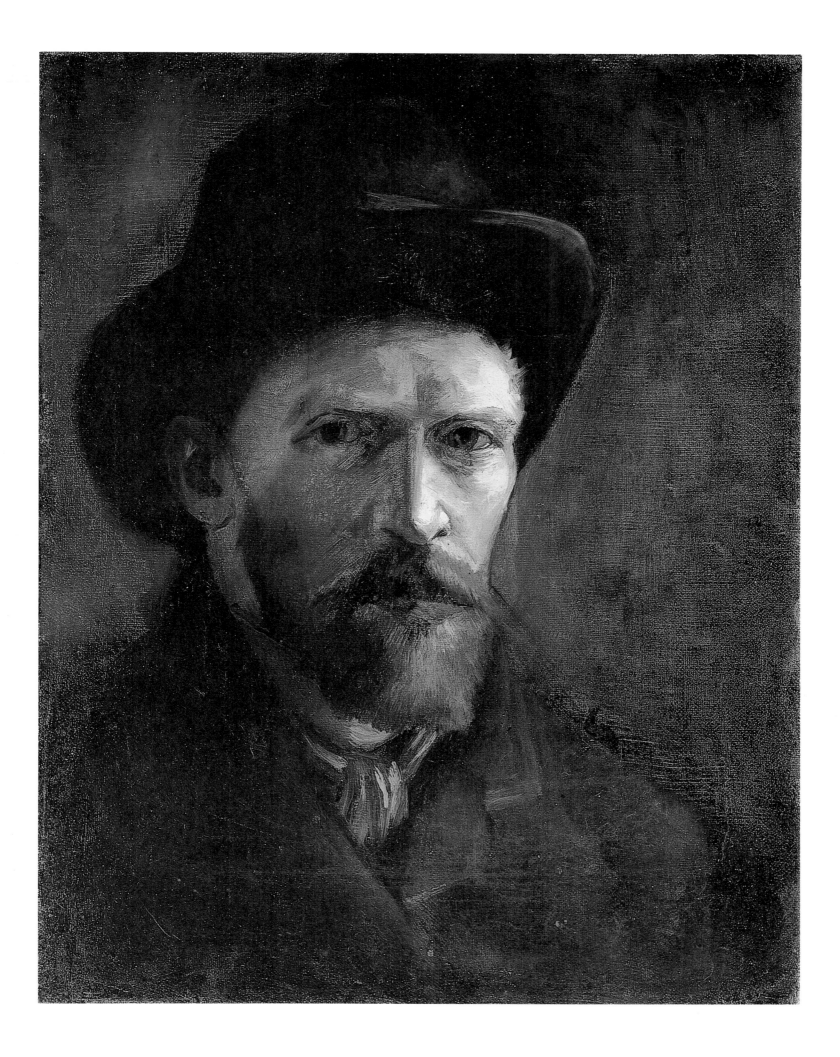

Still Life with a Bottle, Two Glasses, Cheese and Bread
Paris, Spring 1886
Oil on canvas, 37.5 x 46 cm
F 253, JH 1121
Amsterdam, Rijksmuseum Vincent van Gogh, Vincent van Gogh Foundation

ing, objects express his feelings: the books stand for the father and the son. It is no more a genuine still life than the two later paintings of chairs were, which reviewed his time with Gauguin. The painting is dominated by the Holy Scripture, a fine and huge edition, sober, melancholy, leather-bound, pathetic. Beside it is an extinguished candle, a traditional prop in any memento mori picture; this symbol of transience and death is sufficient to link the picture to the death of van Gogh's father. And in the foreground, modest yet insistent too, is a well-thumbed yellow copy of Zola's novel *La joie de vivre*. The metaphoric polarity implied by the juxtaposition of this book with the Bible is plain: the Bible was the father's source of authority in all his well-meant preaching and lecturing, while the novel represented a belief that there are other things in modern life besides wisdom that has been handed down through thousands of years.

Zola's *La joie de vivre* tells of a family in Normandy who squander their fortune, partly through greed, partly through fecklessness. Their money trickles through their fingers; their harmony evaporates; the household is ruined. The maidservant hangs herself, the mother dies of dropsy at the end of the novel, and in the midst of the cataclysm is the gouty, inflexible father, emphatically asserting the value of life, and the devoted niece, trying to keep chaos at arm's length. In the cheerful openness with which these two characters looked forward to the future, van Gogh partly saw himself – that paradoxical need for suffering which would provide a frame for any real awareness of being alive. As for the Bible, it is open at Isaiah 53, where the Old Testament prophet speaks of the exaltation that awaits those who suffer. It is a passage that promises

Glass with Hellebores
Paris, Spring 1886
Oil on canvas on panel, 31 x 22.5 cm
F 199, JH 1091
Whereabouts unknown

Sloping Path in Montmartre
Paris, Spring 1886
Oil on cardboard on multiplex board, 22 x 16 cm
F 232, JH 1113
Amsterdam, Rijksmuseum Vincent van Gogh, Vincent van Gogh Foundation

Tambourine with Pansies
Paris, Spring 1886
Oil on canvas, 46 x 55.5 cm
F 244, JH 1093
Amsterdam, Rijksmuseum Vincent van
Gogh, Vincent van Gogh Foundation

redemption to the servants of God, vicars presumably included. The paradox of suffering and the clear promise of redemption, the inscrutability of life in this world and the clarity of life in the next, the vale of tears and the garden of paradise: van Gogh's ambitious painting is a discussion of worldviews, of hopes and expectations which had been irreconcilable till recently and now, identified as Heaven and Earth, could come closer in a spirit of acceptance.

Hitherto the picture has always been dated on the basis of a passage in Letter 429, written in October 1885: "In response to your account I am sending you a still life with an opened leather-bound Bible . . . I painted it in one go, in a single day." The phrase "in one go" has been interpreted as meaning an immediate response on Vincent's part to something communicated by Theo. But three things weigh against the theory that the painting was not done till six months after Pastor van Gogh's death. First, the expression 'in one go' is a common turn of phrase that occurs frequently in van Gogh's letters and in contemporary writings on art. It was Edouard Manet who provided the remark van Gogh was responding to: "There is only one truth: to do in one go [*au premier coup*] whatever you see." Second, Vincent writes that he is sending the painting; but paintings need time to dry – van Gogh's letters often include discussion of the difficulties of sending paintings that have not properly dried – and the *Still Life with Bible* bears no scratches or scrapes that might have resulted from premature packing. We must conclude that it had been in the painter's keeping for some time. Third, of course, it seems much

Still Life with Scabiosa and Ranunculus
Paris, Spring 1886
Oil on canvas, 26 x 20 cm
F 666, JH 1094
Private collection
(Sotheby's Auction, New York, 12. 11. 1988)

Lane at the Jardin du Luxembourg
Paris, June-July 1886
Oil on canvas, 27.5 x 46 cm
F 223, JH 1111
Williamstown (Mass.), Sterling and
Francine Clark Art Institute

The Pont du Carrousel and the Louvre
Paris, June 1886
Oil on canvas, 31 x 44 cm
F 221, JH 1109
Private Collection

The Bois de Boulogne with People Walking
Paris, Summer 1886
Oil on canvas, 46.5 x 37 cm
F 224, JH 1112
Zurich, Private collection

likelier that the painting would have been done in April 1885, under the full shock of his father's death. At that time he wrote in Letter 399: "That Fortune smiles on the brave is doubtless often true, and however things stand with Fortune, or *joie de vivre*, one must go on working and venturing if one is truly to live." Thus alongside *The Potato Eaters*, overshadowed by it and not mentioned for that reason, another picture that had programmatic value in van Gogh's early work was painted in spring 1885: his *Still Life with Bible*. And it set a classical standard that his subsequent work would have to satisfy.

Painting as Manifesto
The Potato Eaters

The Bois de Boulogne with People Walking
Paris, Autumn 1886
Oil on canvas, 38 x 45.5 cm
No F Number, no JH Number
Private collection

The Bois de Boulogne with People Walking
Paris, Summer 1886
Oil on canvas, 37.5 x 45.5 cm
F 225, JH 1110
United States, Private collection
(Sotheby's Auction, New York, 12. 5. 1980)

Vase with Poppies, Cornflowers, Peonies and Chrysanthemums
Paris, Summer 1886
Oil on canvas, 99 x 79 cm
F 278, JH 1103
Otterlo, Rijksmuseum Kröller-Müller

"I think that the picture of the peasants eating potatoes that I painted in Nuenen is the best of all my work." Writing to his sister two years later from Paris (Letter W1), van Gogh still considered *The Potato Eaters* his most successful painting. Basically it was the only one of his paintings that he considered worth showing in public. It was the only one he could imagine taking its place in the tradition of Millet or Breton, the only one (in his view) that communicated the values that he believed Art ought to communicate; and he insisted that Theo should play the art dealer and hawk the painting about. If he was ever to make a career as an artist it would be as the painter of that picture alone. All van Gogh's ambition was invested in it. And, after all, since he lived in the country this spartan peasant repast put his own artistic authenticity to the test. It was his own life-style – as friend of the people, the passionate peasant, the compassionate ascetic – that would stand or fall by the reception accorded the painting. The man was indistinguishable from the painter,

Still Life with Mackerels, Lemons and Tomatoes
Paris, Summer 1886
Oil on canvas, 39 x 56.5 cm
F 285, JH 1118
Winterthur, Collection Oskar Reinhart

Still Life with Two Herrings, a Cloth and a Glass
Paris, Summer 1886
Oil on canvas, 32.5 x 46 cm
F 1671, JH 1122
United States, Collection Scharenguival

and in this one work his worldview doubled as his fate. Inevitably the theory piled up. A whole bundle of letters deal exclusively with this painting. Every step the work involved is documented, with notes that (in van Gogh's usual syncretist manner) unambiguously forge a unity out of his attitudes to life and his brushstrokes, his social criticism and his use of colour, his analysis of the times and his choice of subject. Away in his village, van Gogh underwent one of the core experiences of modern art: in formulating a manifesto he had to face the dilemma of being accessible only to the initiated few who read the accompanying texts and of needing to supply further texts for the sake of being understood. Van Gogh was still far from the madding gallery crowd. Correspondence with a few confidants still made the nailing of theses to doors unnecessary. But there was already a wide gap between his practice and his theory, between the simple painted canvas and the load of ambitious meanings it was expected to shoulder. What a picture *was* and what it was *supposed* to be were increasingly proving to be two distinct and irreconcilable things.

Van Gogh did countless studies for *The Potato Eaters*, which was procedurally the very opposite of a work done in one go – otherwise his

Still Life with Bloaters
Paris, Summer 1886
Oil on canvas, 45 x 38 cm
F 203, JH 1123
Otterlo, Rijksmuseum Kröller-Müller

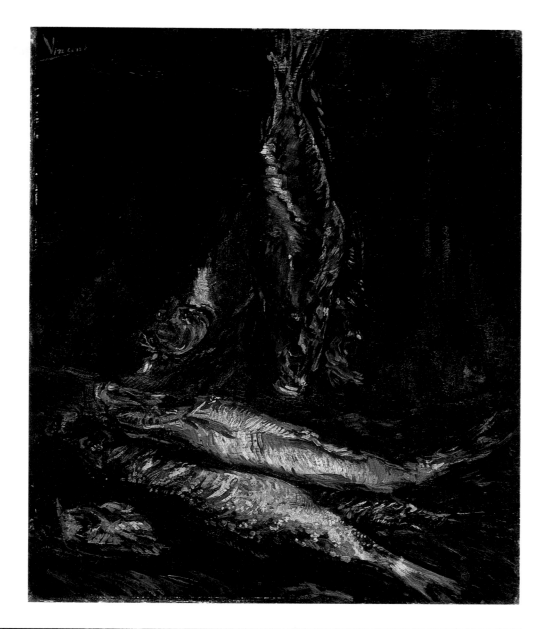

Still Life with Bloaters
Paris, Summer 1886
Oil on canvas, 21 x 42 cm
F 283, JH 1120
Basle, Rudolf Staechelin Family
Foundation

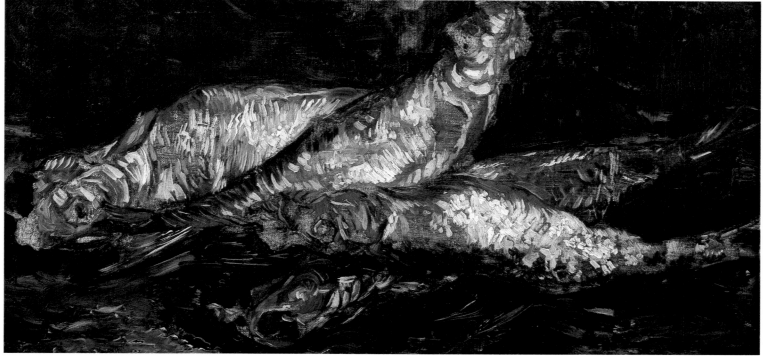

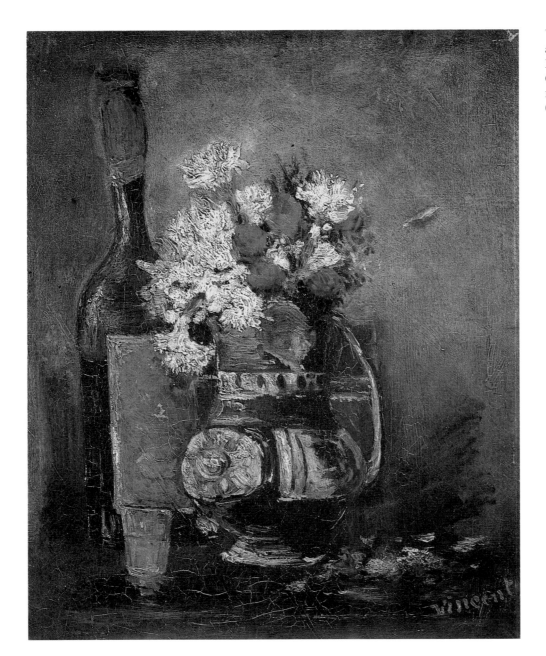

Vase with Carnations and Roses and a Bottle
Paris, Summer 1886
Oil on canvas, 40 x 32 cm
F 246, JH 1133
Otterlo, Rijksmuseum Kröller-Müller

preferred method. The studies included heads, interiors, compositional sketches, and details of hands or the coffee pot. And when he was finally done with his monumental work, van Gogh signed it: "Vincent." Sensibly he painted it in the studio. A professional by now, he felt disturbed by the nervous shifting of amateur models unable to hold a pose. He painted from memory, *par coeur* (as Delacroix taught): "For the second time", he wrote to Theo (Letter 403), "I am finding that something Delacroix said means a great deal to me. The first time it was his theory of colour. Then I read a conversation he had with other painters about the technique of making a picture. He claimed one produced the best pictures out of one's head. *Par coeur!* he said." The sheer distance van Gogh had succeeded in achieving from his hitherto sacred principle of physical closeness to his subject is in itself a measure of his seriousness in attempting a major work.

The painting (p. 96) shows five people – the potato eaters of the title –

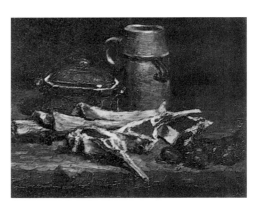

Still Life with Meat, Vegetables and Pottery
Paris, Summer 1886
Oil on canvas, 33.5 x 41 cm
F 1670, JH 1119
Whereabouts unknown

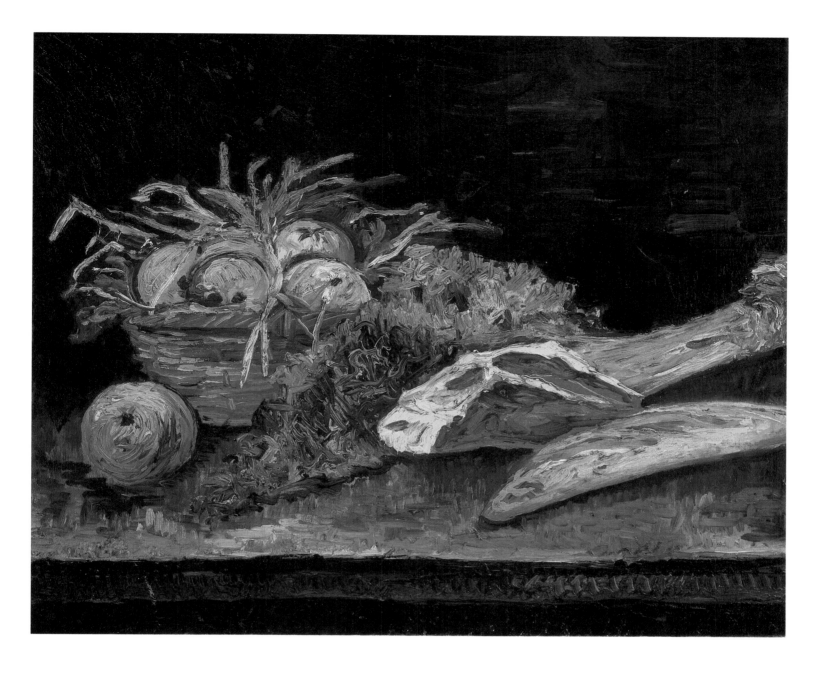

Still Life with Apples, Meat and a Roll
Paris, Summer 1886
Oil on canvas, 46 x 55 cm
F 219, JH 1117
Otterlo, Rijksmuseum Kröller-Müller

seated round a rough wooden table. The younger woman has a bowl of hot, steaming potatoes in front of her and – an interrogative expression on her face – is serving up portions. The old woman opposite her is pouring barley-malt coffee into cups. The three generations of a peasant family living together under one roof are gathered for this frugal meal. An oil lamp sheds a dim light on the scene, showing its plain poverty yet also highlighting an atmosphere of silent thankfulness. This lamp, shedding its weak and flickering light on all of them equally, establishes unity in the appearance of these careworn figures. Daily toil is visible in their faces; but their eyes signal trust, harmony and contentment with their life together, articulating a love that is also apparent in their gestures. It is as if there were no outside world to disturb their tranquil gathering with noise and bustle.

Van Gogh himself is struggling with the idyllic flavour of the scene. The figures still have something of the poses he put them in when

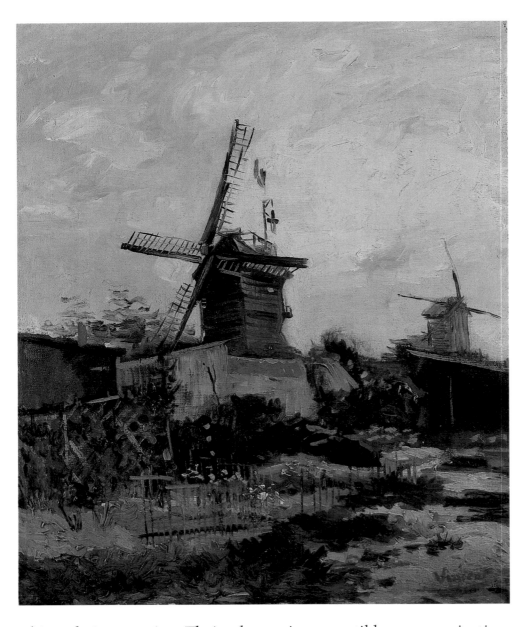

LEFT:
Le Moulin de Blute-Fin
Paris, Summer 1886
Oil on canvas, 46.5 x 38 cm
F 273, JH 1116
Tokyo, Bridgestone Museum of Art

RIGHT:
Le Moulin de la Galette
Paris, Summer 1886
Oil on canvas, 46 x 38 cm
F 274, JH 1115
Glasgow, Glasgow Art Gallery and
Museum

Ginger Jar Filled with Chrysanthemums
Paris, Summer 1886
Oil on canvas on panel, 40 x 29.5 cm
F 198, JH 1125
Private collection
(Sotheby's Auction, London, 5. 12. 1979)

taking their portraits. Their almost imperceptible communication, which seems so eloquent of an atmosphere of wordless harmony, is to some extent the result of insufficient skill in transferring individual studies to a group composition. The people are looking *past* each other, for the simple reason that the painter had never seen them together. The positioning is not altogether happy, either; van Gogh has placed the five figures as if he were composing a still life, but the spatial illusion is at odds with a sense of merely cumulative juxtaposition. The visual symmetry balances the young couple with the potatoes on the left against the older couple with the coffee on the right, with the hardly original rear view of the child in the middle as a kind of axis on which the two halves hinge – a function the figure can only fulfil if it remains anonymous, a faceless and purely formal cipher.

Van Gogh's first attempt at painting a group of potato eaters (p. 82) was compositionally more interesting. It includes only four figures round the table, and the sense of their sitting in a circle is made plausible by the irregularity of the positions they are in. Nor does the lamp have to

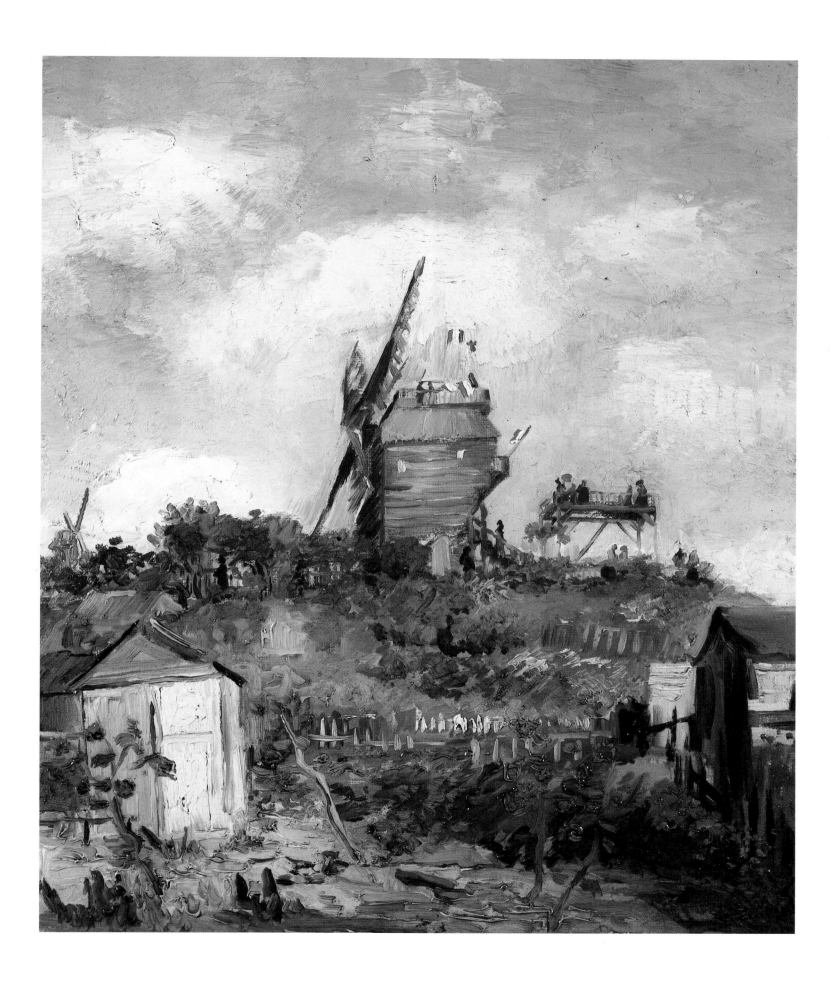

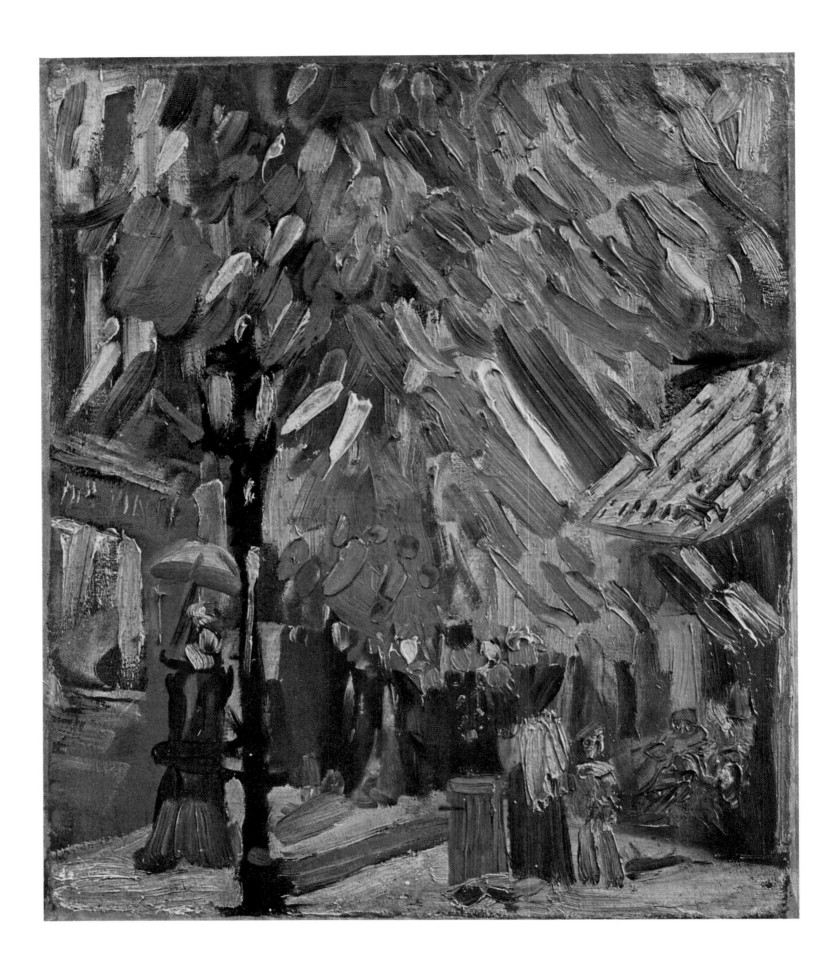

LEFT:
The Fourteenth of July Celebration in Paris
Paris, Summer 1886
Oil on canvas, 44 x 39 cm
F 222, JH 1108
Winterthur, Collection L. Jäggli-Hahnloser

Vase with Carnations
Paris, Summer 1886
Oil on canvas, 46 x 37.5 cm
F 245, JH 1145
Amsterdam, Stedelijk Museum

Vase with Red Gladioli
Paris, Summer 1886
Oil on canvas, 50.5 x 39.5 cm
F 248, JH 1146
Private collection
(Sotheby's Auction, New York, 18. 5. 1983)

illuminate two symmetrical halves with analogous groups of people. The relaxed approach is emphasized by the sketchy brushwork; this picture is of course a preliminary study, but as such it has an unpretentious spontaneity that the final version lacks. The second attempt (p. 97) shows van Gogh already having difficulty preserving that relaxed mood. The figure seen from the rear is already in position and has even less point here than in the final painting, merely looking geometrical and stiff compared with the other four characters in the scene. The sense of a brief moment caught by chance in a cosy parlour and preserved as in a snapshot is still present, but a shift towards universal, emblematic significance is already visible in the balancing of the younger and older couples, the one with food and the other with drink, looking as if they had been conceived uniformly.

The final version now in Amsterdam, meticulously painted and then signed, has eliminated all trace of spontaneous reportage and substituted the forced authority of a historical scene. One detail serves to indicate the way van Gogh had changed his approach. In the second (Otterlo) version the old woman is holding the coffee pot so that we see it side-on, flat against the canvas, as it were, as she pours. But in the final painting she is holding the pot so that it is turned towards us as she pours; this helps create an illusion of spatial depth, and in the demands it makes on the artist's virtuoso brush technique it is evidently the more

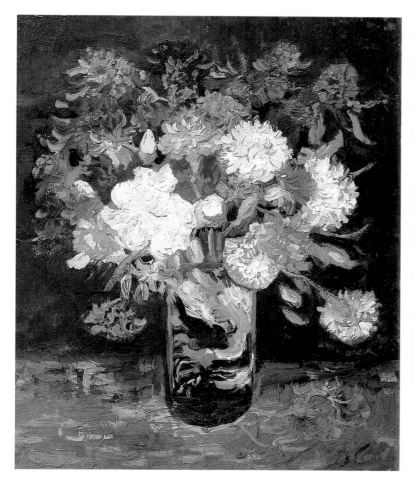

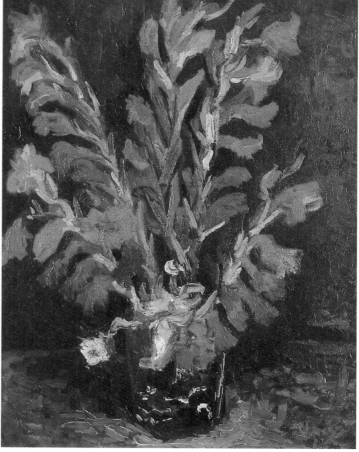

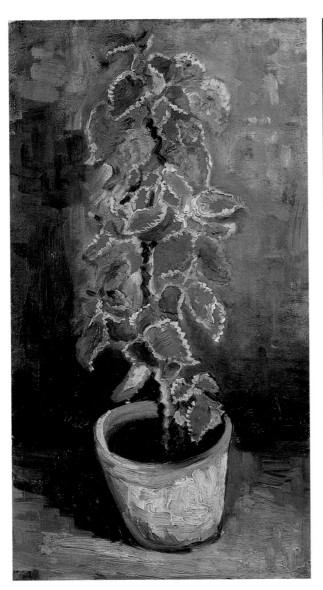

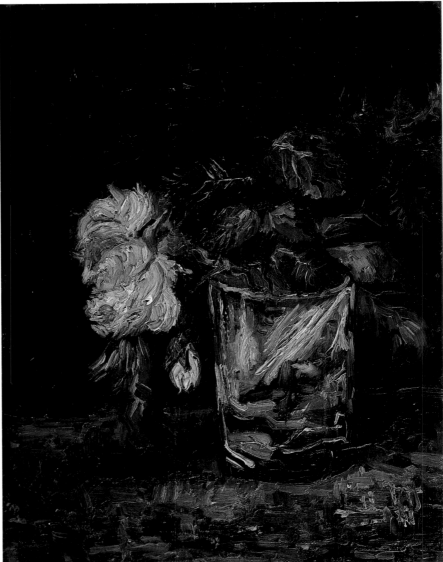

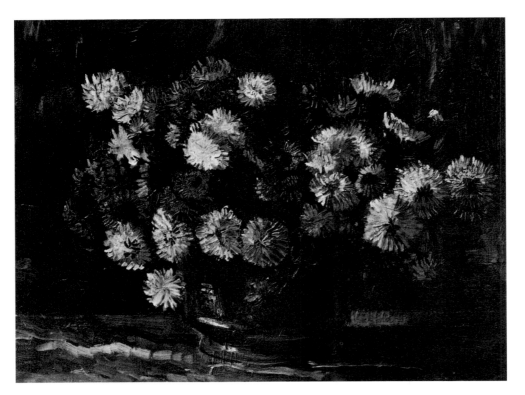

Coleus Plant in a Flowerpot
Paris, Summer 1886
Oil on canvas, 42 x 22 cm
F 281, JH 1143
Amsterdam, Rijksmuseum Vincent van
Gogh, Vincent van Gogh Foundation

Glass with Roses
Paris, Summer 1886
Oil on cardboard on multiplex board,
35 x 27 cm
F 218, JH 1144
Amsterdam, Rijksmuseum Vincent van
Gogh, Vincent van Gogh Foundation

Bowl with Chrysanthemums
Paris, Summer 1886
Oil on canvas, 46 x 61 cm
F 217, JH 1164
United States, Private collection

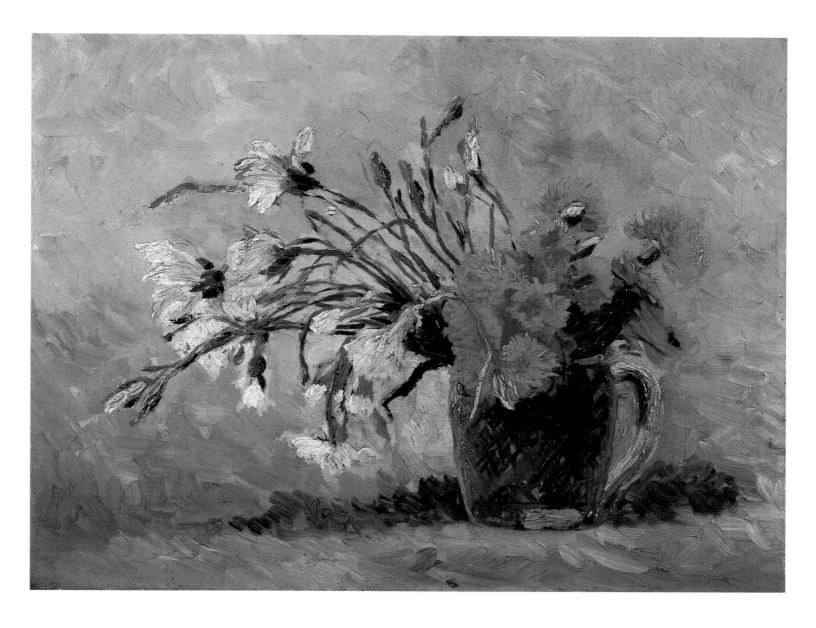

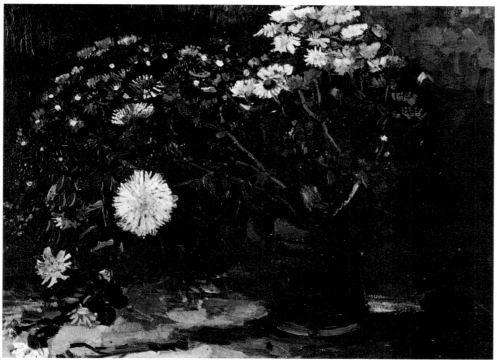

Vase with Red and White Carnations on Yellow Background
Paris, Summer 1886
Oil on canvas, 40 x 52 cm
F 327, JH 1126
Otterlo, Rijksmuseum Kröller-Müller

Vase with Daisies
Paris, Summer 1886
Oil on paper on panel, 40 x 56 cm
F 197, JH 1167
Philadelphia, The Philadelphia Museum of Art

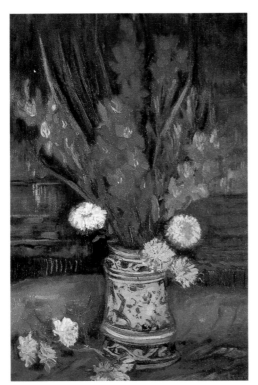

Vase with Red Gladioli
Paris, Summer 1886
Oil on canvas, 65 x 40 cm
F 247, JH 1149. Private collection
(Sotheby's Auction, London, 3. 7. 1973)

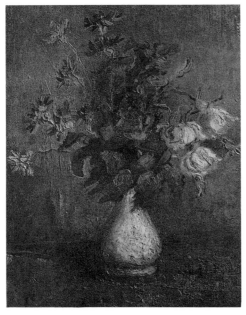

White Vase with Roses and Other Flowers
Paris, Summer 1886
Oil on canvas, 37 x 25.5 cm
F 258, JH 1141. Private collection

Vase with Carnations and Other Flowers
Paris, Summer 1886
Oil on canvas, 61 x 38 cm
F 596, JH 1135
Washington, David Lloyd Kreeger

ambitious solution. But it also betrays his wish to have the whole picture seen as a synthesis or summary of all he had learnt, technically and conceptually, in his life as a painter up till then.

"You will agree that a work like this cannot be meant seriously. Fortunately you are capable of better things; but why ever have you viewed and treated everything in the same superficial way? Why did you not study their movements thoroughly? What you have here are poses." This, and more of a similar nature, was Rappard's criticism. It has come down to us because van Gogh sent the letter (R51a) back by return in a fit of indignation. Rappard had only seen a lithograph based on the Otterlo version. But his comments are not insensitive, nor unjust; and they would have applied all the more to the final version. Of course we must bear in mind that van Gogh's young friend, who had visited Nuenen and had also been sent countless sketches in letters, was thoroughly familiar with Vincent's artistic progress, and had naturally seen work that was stylistically coarser, compositionally clumsier, and less mature in choice of subject than van Gogh's beloved *Potato Eaters*. He was finding fault with a forced quality in the ugliness of the figures, the spartan bareness of the interior, and the violence of the brushwork. He was objecting to van Gogh's sophisticated tone in discussing his own work and trumpeting a manifesto abroad. And Rappard was right: the figures *are* poses. The whole picture is a pose.

This impression is confirmed by the notable degree of success van Gogh critics have had in locating models for *The Potato Eaters*. All of these antecedents, whether by Léon Lhermitte (an imitator of Millet) or Israëls (a painter in The Hague), show groups gathered round a supper table by artificial light. It was a popular subject in the 19th century. It is only when we see van Gogh's painting in the light of his ambition (in appropriating an entire tradition for his own purposes) that we grasp the picture's real significance in his oeuvre. Van Gogh knew of the contemporary debate on the aesthetic issues he broached in the work: ugliness, truthfulness, rustic life, and (including all of this) the question of modernity. Van Gogh followed the intellectual affairs of his times alertly, offering (for example) his own critique of Zola's masterpiece *Germinal* a brief four weeks after the novel was published (in Letter 410); so he would undoubtedly have been familiar with the aesthetic debates relevant to his own art.

In his *Aesthetics*, Georg Wilhelm Friedrich Hegel had stressed that the principle of what is characteristic must include ugliness and the representation of ugliness. It was the most influential work on aesthetic theory in the 19th century; and Hegel continued to state that the artist attempting to tackle his subject without prejudice, value judgement or over-sensitive scruple could go as far as caricature in the interests of precision. Indeed, ugliness of presentation would be certain proof of the artist's commitment to honest treatment. The common folk were of

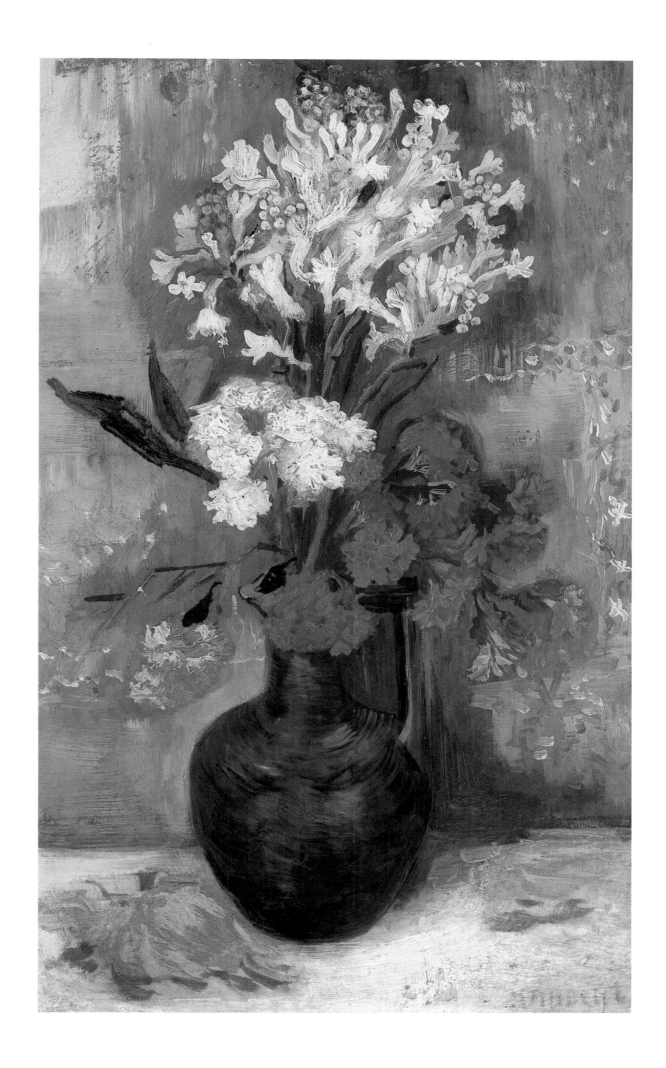

Vase with Zinnias and Geraniums
Paris, Summer 1886
Oil on canvas, 61 x 45.9 cm
F 241, JH 1134
Ottawa, National Gallery of Canada

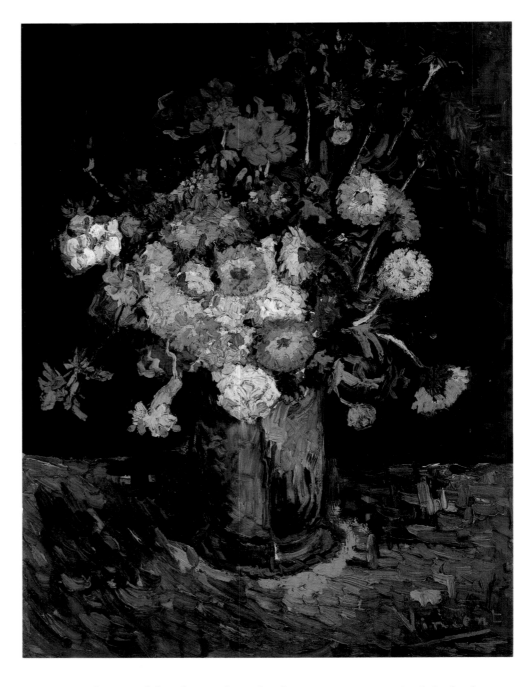

Vase with Viscaria
Paris, Summer 1886
Oil on canvas, 65 x 54 cm
F 324a, JH 1137
Cairo, Museum of Modern Art

course predestined for the realm of ugly presentation; Carlyle had written that the rough, weathered, dirty face of the simple man with his straightforward intelligence was venerable because it was the face of a man living the life that Man was made for. The ill-treated worker or peasant, who had hitherto always got the dirty end of the stick and was society's beast of burden, was in demand again as the hero of democracy. On him were focussed dreams and hopes of a better world that would be uncultured but also unspoilt, simple but truthful, a life integral and entire lived in harmony with the elements: "Do not forget that I intend always to remain an artist, a novelist, in order to present all the creative power of the earth: in the image of the seasons, of work in the fields, of peasant life, of animals, of landscape that is a home to all creatures! Simply report that my presumptuous ambition is to cram the whole of peasant life into my book: work and love, politics and religion, past and

Vase with Zinnias
Paris, Summer 1886
Oil on canvas, 61 x 48 cm
F 252, JH 1140
Washington, Collection David Lloyd
Kreeger

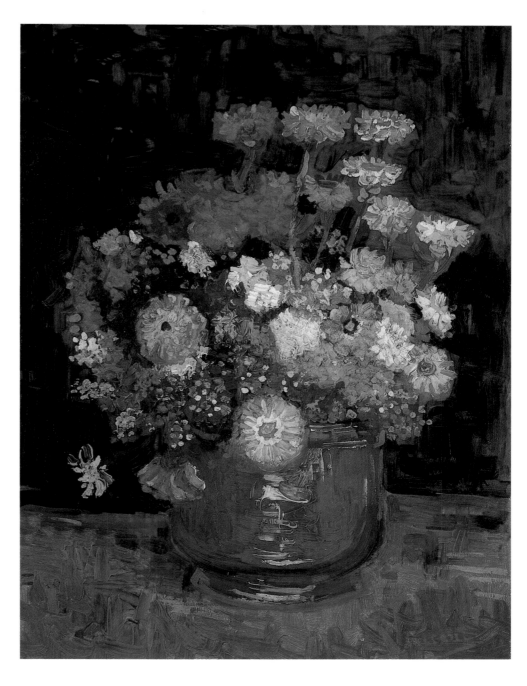

Geranium in a Flowerpot
Paris, Summer 1886
Oil on canvas, 46 x 38 cm
F 201, JH 1139
Private collection
(Sotheby's Auction, London, 4. 7. 1973)

present and future too. It will be nothing but the truth!" Zola's programmatic comments on the origins of his book *La Terre* summed up the artistic creed of an entire generation. Vitality, truth, and the fundamental experiences of life, were their goals. And they could only be reached with the help of the common folk's integrity.

Soon after completing *The Potato Eaters*, van Gogh added a written manifesto to the painted one: Letter 418, in which he reviews the thoughts that guided him while he was working on the picture. Paintings, he declared, needed to be created "with willpower, feeling, passion and love" and not with the hair-splitting subtleties "of these experts who are acting more important than ever nowadays, using that word 'technique' that is so often practically meaningless." Art could meet the world it served in sensitivity towards the simple and of course positive life of the underprivileged. The technology of the machine age and the

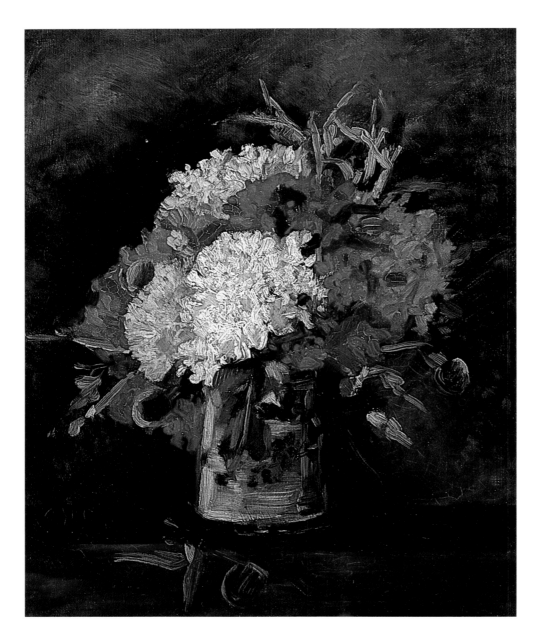

Vase with Carnations
Paris, Summer 1886
Oil on canvas, 40 x 32.5 cm
F 220, JH 1138
Rotterdam, Willem van der Vorm-
Stichting

Vase with Carnations
Paris, Summer 1886
Oil on canvas, 46 x 38 cm
F 243, JH 1129
New York, Collection Charles B. Murphy

Vase with White and Red Carnations
Paris, Summer 1886
Oil on canvas, 58 x 45.5 cm
F 236, JH 1130
Whereabouts unknown

Vase with Carnations and Zinnias
Paris, Summer 1886
Oil on canvas on panel, 61 x 50.2 cm
F 259, JH 1132
Private collection
(Christie's Auction, New York, 10. 11. 1987)

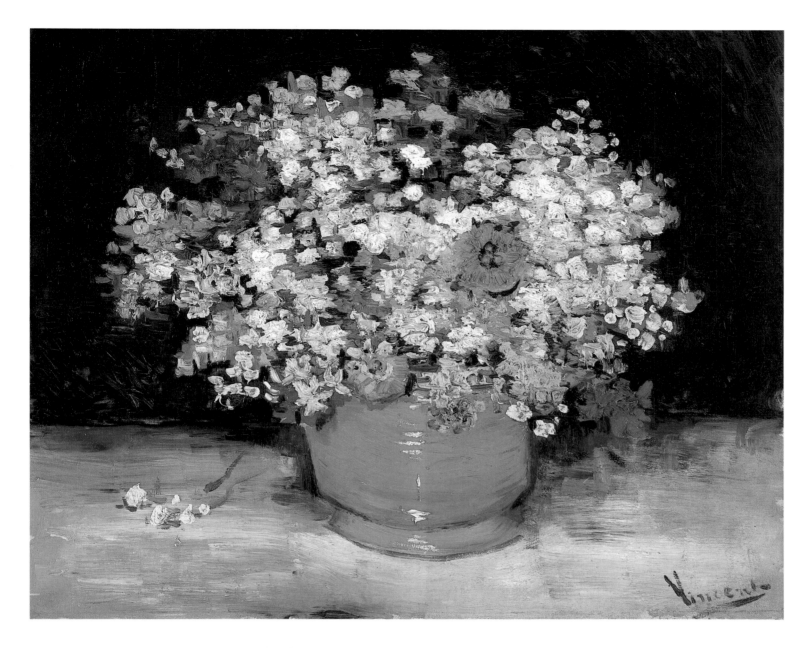

Vase with Zinnias and Other Flowers
Paris, Summer 1886
Oil on canvas, 50.2 x 61 cm
F 251, JH 1142
Ottawa, National Gallery of Canada

technique of academic rules were both aimed at destroying that way of life. Artist and worker could experience solidarity when confronted with faceless mechanisms.

In these theories, a belief in progress is paradoxically linked with hostility towards all things technical. The criticism is directed quite radically at the very roots of communal existence. If a new beginning was to be made at a profound level, the roots first had to be laid bare, cleared of the accretions of the status quo. We shall be returning to these thoughts, which became so central to Modernism. In order to understand what it is that gives *The Potato Eaters* manifesto status it is sufficient to grasp van Gogh's deliberate rejection of virtuoso technique. What Charles Baudelaire wrote in his essay on the "painter of modern life", of the city, Constantin Guys, might just as well have been applied to van Gogh: "He started out by looking at life, and only at a late stage did he go to the trouble of acquiring the means of expressing life. What resulted was striking originality, and whatever barbaric or naive qual-

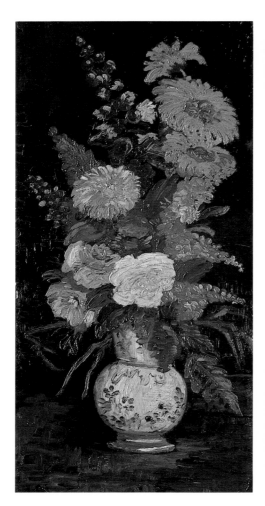 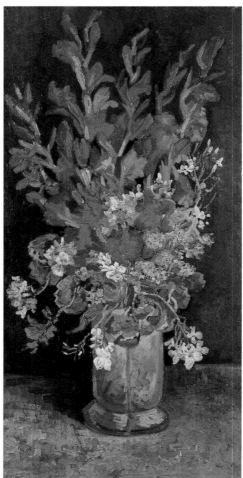 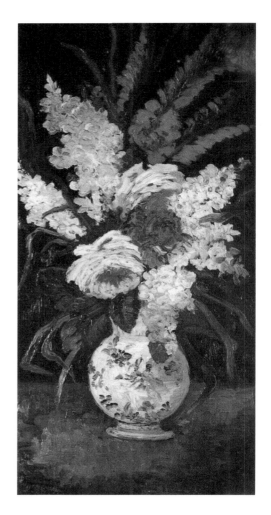

ities still remained now attested his fidelity to his impressions, a kind of flattery offered to Truth." The immemorial function of pictures, to prettify the true image, was replaced by the wish for authenticity: "flattery offered to Truth" is a magnificent euphemism for the fact that modern art was out to record ugliness.

"Instead of saying: a man digging must have character", van Gogh went on in Letter 418, "I prefer to express it in a different way, saying: this peasant must be a peasant, this man digging must be digging. Then there is something in it that is essentially modern." Everyday drudgery had left its mark on the faces of these people. Their backs were bent. Consistently enough, a painting conceived in the modern spirit would have to highlight these facts if it was to give a characteristic account of the times. It was ugly, it was coarse, it was authentic ... it was modern.

Van Gogh authoritatively incorporated all these elements into *The Potato Eaters*. The peasant as hero of a better world, ugliness as proof of verisimilitude, of his reality, and a claim to truthfulness that demanded not only solidarity but a life literally lived side by side – all of this can be seen in the painting. Hitherto van Gogh had taken all of this for granted, and had produced artistic concoctions all of his own that no one wanted to know about. But now he went over to the offensive, with a manifesto on his banner. The German classical sculptor Johann Gottfried Schadow once wrote that Rembrandt was perhaps the biggest liar in the

Vase with Asters, Salvia and Other Flowers
Paris, Summer 1886
Oil on canvas, 70.5 x 34 cm
F 286, JH 1127
The Hague, Haags Gemeentemuseum

Vase with Gladioli and Carnations
Paris, Summer 1886
Oil on canvas, 78.5 x 40.5 cm
F 242, JH 1147
Private collection
(Sotheby's Auction, London, 1. 7. 1970)

Vase with Gladioli and Lilac
Paris, Summer 1886
Oil on canvas, 69 x 33.5 cm
F 286a, JH 1128
Ballwin (Mo.), Collection Edwin McClellan
Johnston

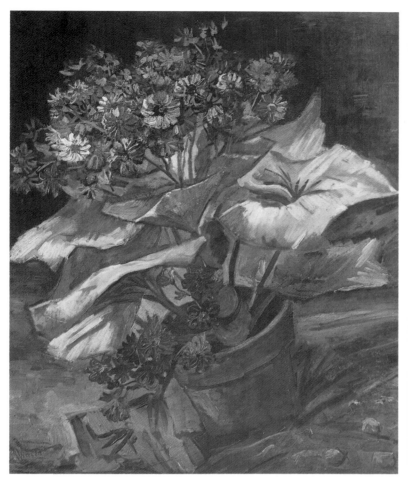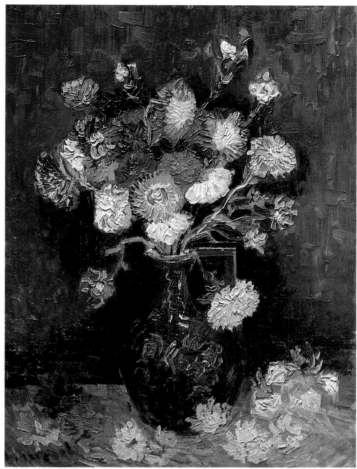

Cineraria in a Flowerpot
Paris, July-August 1886
Oil on canvas, 54.5 x 46 cm
F 282, JH 1165
Rotterdam, Museum Boymans-van
Beuningen

Vase with Asters and Phlox
Paris, late Summer 1886
Oil on canvas, 61 x 46 cm
F 234, JH 1168
Amsterdam, Rijksmuseum Vincent van
Gogh, Vincent van Gogh Foundation

history of art, but he never contradicted himself, and kept to a consistent story. In Letter 418 van Gogh addressed himself to this comment: "Tell him I long more than anything to learn how to do things wrong, how to create discrepancies, adaptations, changes to reality, so that it all becomes – well, lies if you like, but truer than literal truth." In *The Potato Eaters* van Gogh told a deliberate, posed lie – in the profound hope of articulating the truer truth all the more forcefully.

Understanding and Suspicion
Summer and Autumn 1885

"The party Vincent Willem van Gogh departed during the inventory proceedings without giving any reasons." Thus the bureaucratic version of van Gogh's sudden departure while Pastor Theodorus van Gogh's last will was being executed. In May 1885, apparently revolted by the bureaucratic arrangements that had accompanied the death of his father, and at odds with his mother and siblings, van Gogh left the

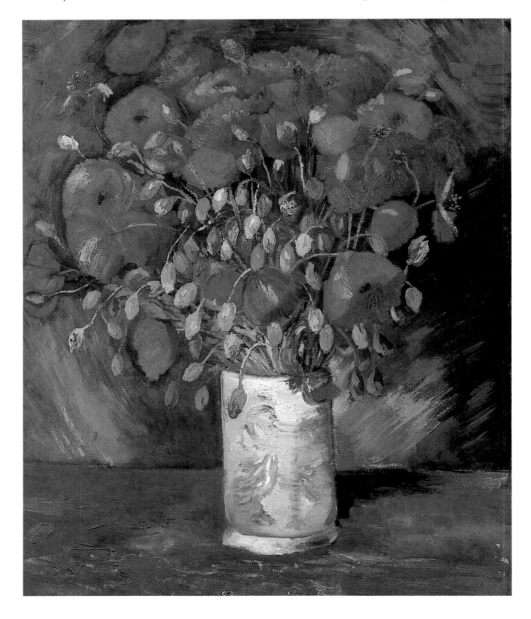

Vase with Red Poppies
Paris, Summer 1886
Oil on canvas, 56 x 46.5 cm
F 279, JH 1104
Hartford (Conn.), Wadsworth Atheneum

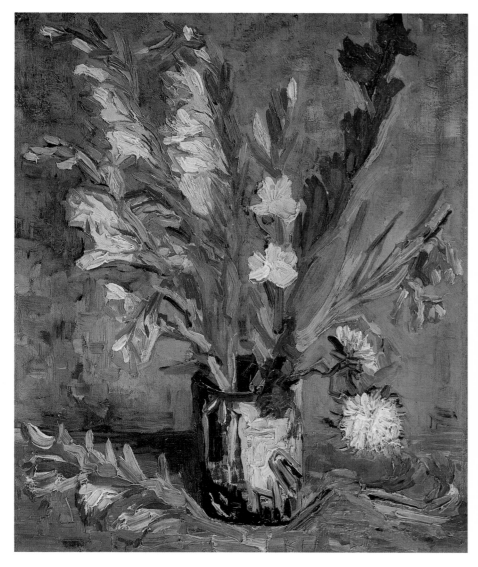

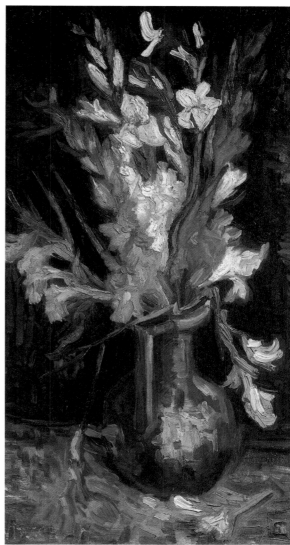

vicarage. He rented a studio from the sexton of Nuenen's Catholic community – that is to say, again from a man of the church, as if he needed the daily confrontation with his own longing for spiritual well-being. In the course of the next six months, four series were done in this studio: one showing peasants at work in the fields, one showing cottages in the vicinity, one set of still lifes, and finally – the last series of his Dutch period – a number of subtle studies of the autumn landscape.

Van Gogh's main subject in 1885 was perhaps the potato. He not only painted the eating of potatoes. He also did a number of still lifes of potatoes in baskets or crates. Furthermore, he followed the growing of potatoes, from the planting to the lifting, in a series showing people digging. *Peasant and Peasant Woman Planting Potatoes* (p. 101), for instance, was painted at about the same time as *The Potato Eaters*, in April 1885. The style and format suggest that this painting was only a preliminary study. In subject it returns to the thematic concerns of van Gogh's period in The Hague. "Peasants digging", he had written at that time (Letter 286), "are closer to my heart, and I have found things better outside paradise, where the literal meaning of 'the sweat of his brow' becomes apparent." Rural folk toiling to live off the fruits of the land

Vase with Gladioli
Paris, late Summer 1886
Oil on canvas, 46.5 x 38.5 cm
F 248a, JH 1148
Amsterdam, Rijksmuseum Vincent van Gogh, Vincent van Gogh Foundation

Vase with Red Gladioli
Paris, Summer 1886
Oil on canvas, 65 x 35 cm
F 248b, JH 1150
Morges (Switzerland), Collection J. Planque

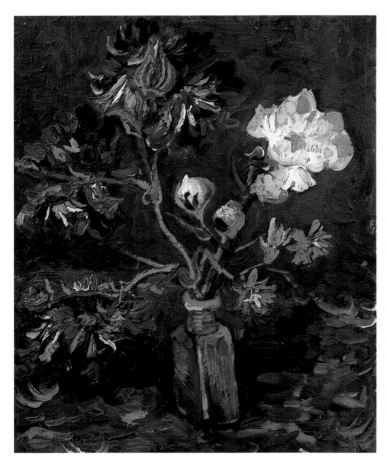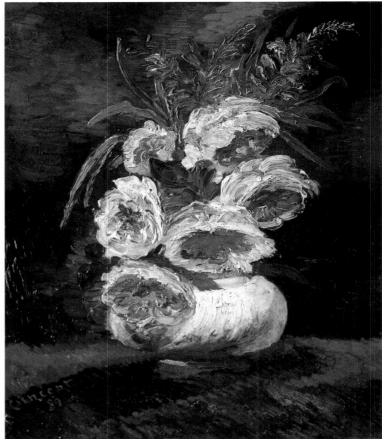

Vase with Myosotis and Peonies
Paris, June 1886
Oil on cardboard, 34.5 x 27.5 cm
F 243a, JH 1106
Amsterdam, Rijksmuseum Vincent van
Gogh, Vincent van Gogh Foundation

Vase with Peonies
Paris, Summer 1886
Oil on canvas, 54 x 45 cm
F 666a, JH 1107
Private collection
(Sotheby's Auction, London, 3. 12. 1985)

provided van Gogh with a metaphor for his own endeavours even at that date – and also with a metaphoric way of expressing his hope that one day he would be able to earn a modest living with his art. Now in Nuenen, van Gogh was all the better able to see a Biblical dignity in the labours of the poor peasantry, having seen at close quarters what was previously little more than a tenet of faith. His way of seeing, guided by allegorical concepts, discovered in rural life a realm onto which, irrespective of fashion, he could project all his own needs for comfort and consolation.

Two Peasant Women Digging Potatoes (p. 117), a summer scene, shows the fruits of toil being gathered in, and is thus a companion piece to the April painting. One simple insight makes these pictures minor masterpieces of their kind: the realization that at the beginning and the end of the process the same torture is involved – back-breaking bending, calluses on the hands, hard and stony earth to struggle with. "The sweat of his brow" is a perpetual fact of life. In this work, van Gogh has also enriched his series principle by a further quality. The motif appears unchanged and we might conclude that van Gogh had made no progress as an artist, but we should not interpret the lack of change as a sign of incompetence; the series is unchanging because the reality it describes is also inexorably and unchangingly the same. The motif, programmatically constant, underwent significant technical renewal as the series evolved. The figures in the later work have an arresting physical pres-

ence compared with those in the Zurich picture (p. 101). These peasant women's corporeal presence is heavy and emphatic, quite unlike the earlier dependence on line in their solidity. Van Gogh was abandoning the line fixation that automatically accompanied his training in drawing and in his case took the place of a thorough grounding in his craft. And again it was Delacroix who was his guide: "Currently, when I draw a hand or an arm, I am trying to practise what Delacroix says about drawing: *ne pas prendre par la ligne, mais par le milieu* [start not with the line but with the middle]", he wrote in Letter 408 (May 1885). "What I am out to establish is not that I can draw a hand but that I can capture the gesture, not that I can render a head with mathematical precision but that I can show deep feelings in an expression. For inst-

Vase with Hollyhocks
Paris, August-September 1886
Oil on canvas, 91 x 50.5 cm
F 235, JH 1136
Zurich, Kunsthaus Zürich

Vase with Gladioli and Carnations
Paris, Summer 1886
Oil on canvas, 65.5 x 35 cm
F 237, JH 1131
Rotterdam, Museum Boymans-van Beuningen

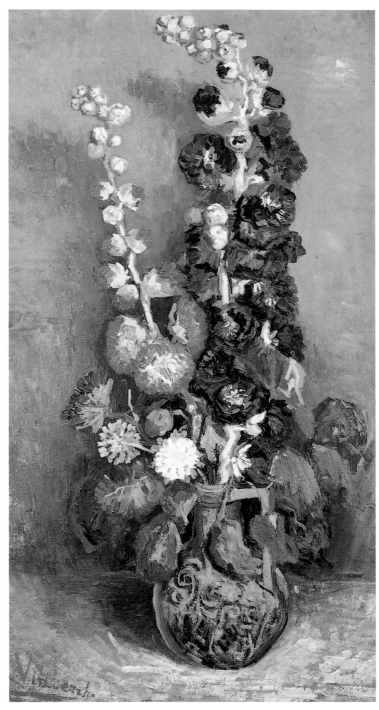

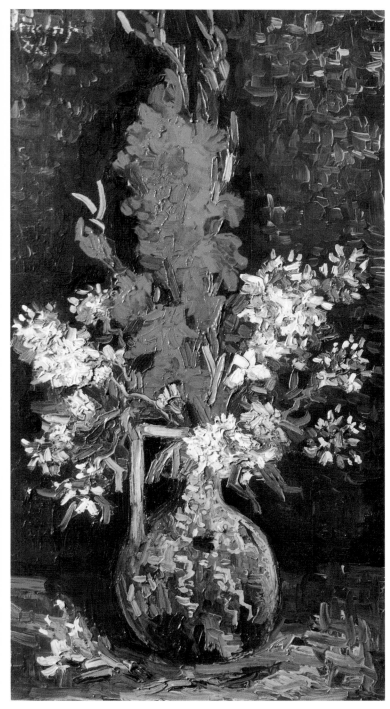

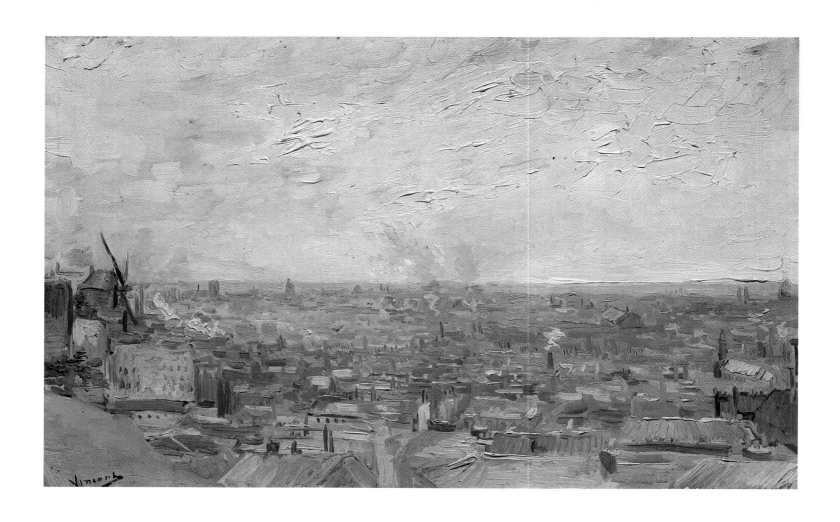

View of Paris from Montmartre
Paris, late Summer 1886
Oil on canvas, 38.5 x 61.5 cm
F 262, JH 1102
Basle, Öffentliche Kunstsammlung,
Kunstmuseum Basel

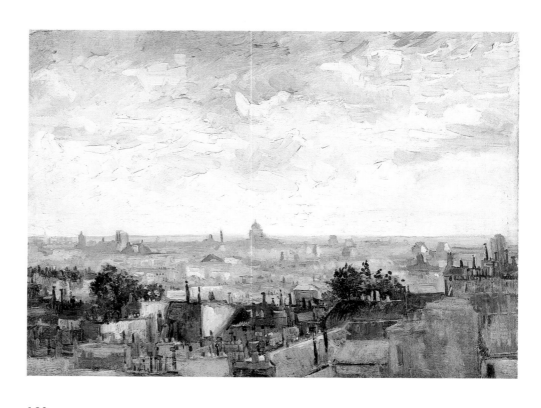

View of the Roofs of Paris
Paris, late Summer 1886
Oil on canvas, 54 x 72.5 cm
F 261, JH 1101
Amsterdam, Rijksmuseum Vincent van
Gogh, Vincent van Gogh Foundation

ance, when a man digging looks up to draw a deep breath; or speaking –
in a word, life." His whole endeavour as an artist was focussed on the
vitality in things. And he had chosen his side in the age-old debate
between the advocates of line and the advocates of colour, a debate
fought out in his own era by Jean Auguste Dominique Ingres and
Delacroix. In making his choice, van Gogh also made possible the wild
and unexpectedly powerful uses of colour which we nowadays associate
with his name; though of course in the short term he was simply
making up ground that a thoroughly-trained art student would already
have covered.

"In point of fact I intend to paint the cottage picture again. I found the
subject particularly absorbing: the two tumbledown cottages under one
and the same thatched roof reminded me of a weary old couple that have
become a single being and lend each other mutual support" (Letter 410).
The change in technique and the instinct to tackle the cottages in the
vicinity sprang from the same need to create a feel of vitality. Unlike

A Pair of Shoes
Paris, second half of 1886
Oil on canvas, 37.5 x 45 cm
F 255, JH 1124
Amsterdam, Rijksmuseum Vincent van
Gogh, Vincent van Gogh Foundation

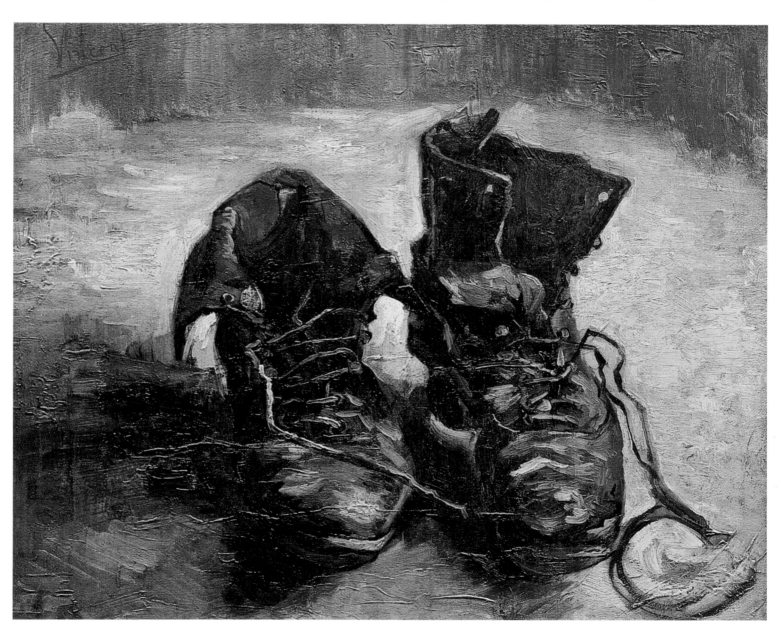

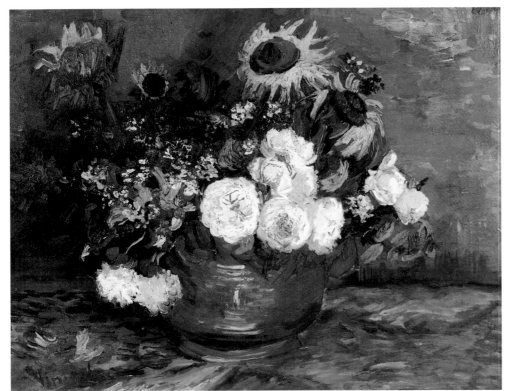

Bowl with Sunflowers, Roses and Other Flowers
Paris, August-September 1886
Oil on canvas, 50 x 61 cm
F 250, JH 1166
Mannheim, Städtische Kunsthalle

Still Life with Mussels and Shrimps
Paris, Autumn 1886
Oil on canvas, 26.5 x 34.5 cm
F 256, JH 1169
Amsterdam, Rijksmuseum Vincent van
Gogh, Vincent van Gogh Foundation

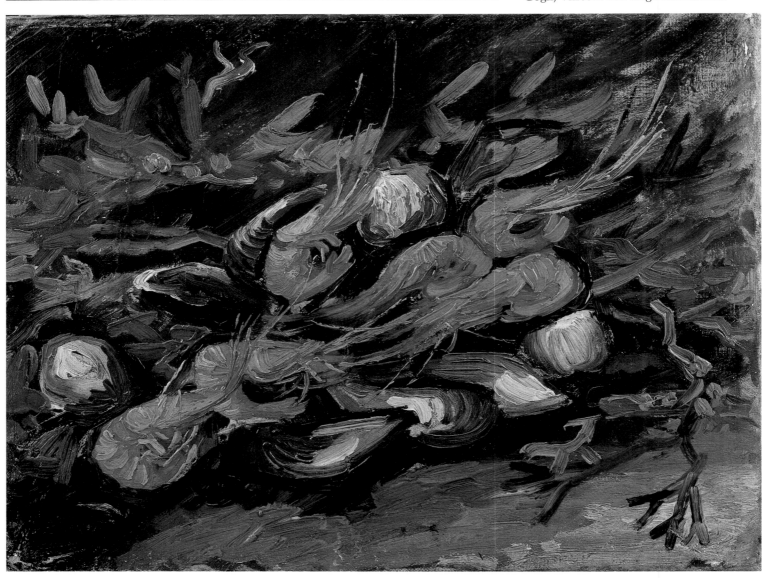

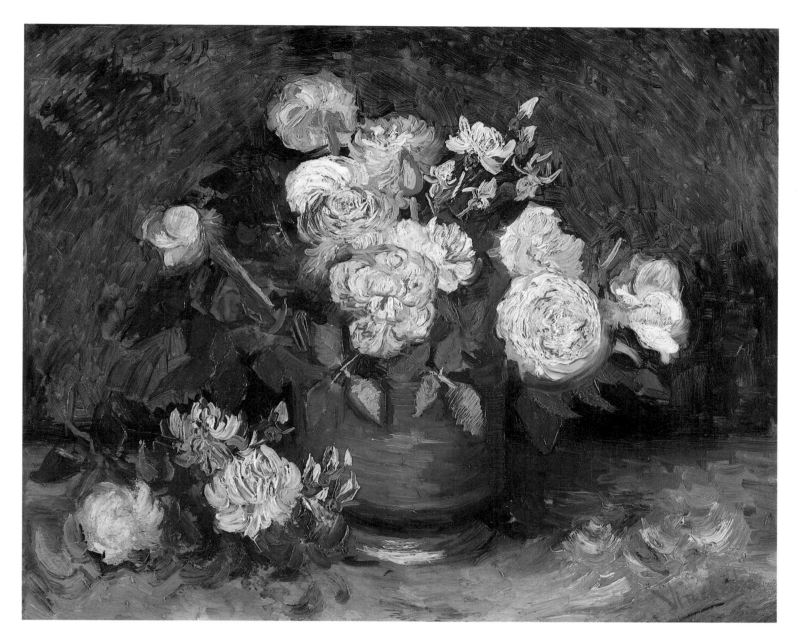

Bowl with Peonies and Roses
Paris, Autumn 1886
Oil on canvas, 59 x 71 cm
F 249, JH 1105
Otterlo, Rijksmuseum Kröller-Müller

those in Drente, these homesteads have individual personalities, and are as straightforward and self-assured as those who dwell in them. Thatched, and surrounded by trees, they form an organic unity with their natural environment and, like the peasants' work in the fields, they record the presence of human activity. Like their owners they are rustic and natural; they are like open air summer portraits following upon the studio work of the winter. The cottages are van Gogh's protagonists, and the people seen near them are like attributes. The woman, goat and hens in *Cottage and Woman with Goat* (p. 111) have no value in their own right; there is no distinction between them, and they merely serve to point up the farming milieu of the cottage. They supply the story, so to speak, and the modest building's personal background.

"The cottage with the mossy roof reminds me of a wren's nest", wrote van Gogh in Letter 411. It is no longer a very great step from this association to the series of still lifes with birds' nests that he painted the following autumn (pp. 118 and 126-7). They are indeed *nature morte*;

van Gogh's respect for living things was too great for him to disturb a nest, and he did not find them locally himself. Instead he started a collection. His detached approach, valuing the artistic arrangement above authentic portrayal of Nature, was very different from that of the English artist William Henry Hunt, who had specialized in the subject with an eye to the new life amidst the burgeoning twigs. Quite uncharacteristically, van Gogh approached these beautifully-worked objects in the same way as he was viewing fruit and potatoes in *Still Life with an Earthen Bowl and Pears* (p. 123) or *Still Life with a Basket of Potatoes* (p. 122) at the same period. He stacked them up against a dark, monochrome background, with only one or two scattered highlights to alleviate the gloom, in his quest for a way of balancing weighty solidity and lightness, amassed quantities and individual items, surface and detailed depth.

Up to this point, he had painted still lifes in the winter. Why did van Gogh retreat to his studio on those fine late summer days to agonize over artistic arrangements? The peasants who lived in the cottages were familiar to him from countless portrait sittings – why did they now appear so curiously faceless, compared with their charismatic abodes? Of course van Gogh's subjects are related to the people who live in them, who built them and take pleasure in them. Of course these pictures are

Self-Portrait with Pipe
Paris, Spring 1886
Oil on canvas, 27 x 19 cm
F 208, JH 1195
Amsterdam, Rijksmuseum Vincent van
Gogh, Vincent van Gogh Foundation

Two Self-Portraits and Several Details
Paris, Autumn 1886
Pencil, pen, 31.5 x 24.5 cm
F 1378r, JH 1197
Amsterdam, Rijksmuseum Vincent van
Gogh, Vincent van Gogh Foundation

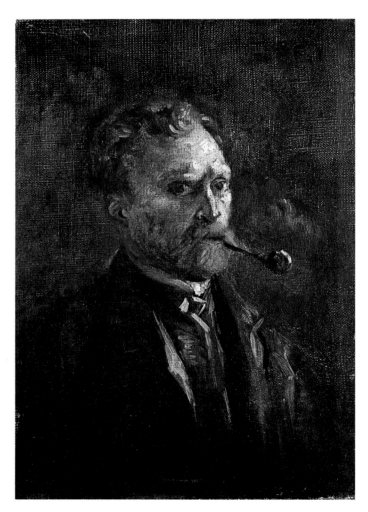

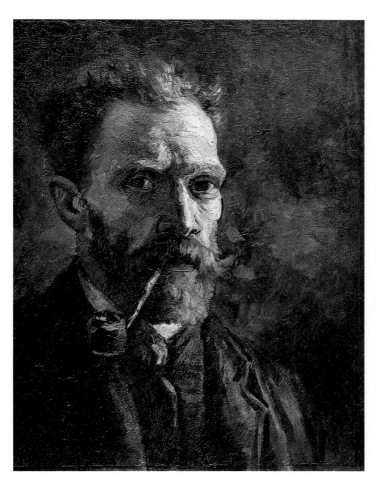

metaphoric ways of examining feelings of contentment or security. Nonetheless, the rustic pathos of the cottages and the cornucopia of fruit and vegetables seem almost too positive and assertive for them to be easily accommodated in van Gogh's oeuvre. We begin to suspect that first and foremost the artist needed the optimism these paintings express for his own purposes, to compensate for his own wrecked hopes.

After his father's death, Vincent had realized how vital a part the pastor's protecting hand and natural authority had played in his life. He had hardly moved out of the vicarage before becoming a target of hostility that soon soured his life in Nuenen. The year before he had already occasioned a local scandal when an unmarried village woman who had fallen in love with him, and could not cope with the conflict between her feelings and the pressure her family brought to bear, tried to kill herself. She had swallowed poison and then collapsed while out walking with Vincent – unfortunate timing. Her life was saved, but the blame was heaped on the artist. When there was more bad news he was blamed again: a peasant girl who had posed for him got pregnant, and, since his name had already been ruined, it was easy to see him as the guilty party. At all events, the Catholic priest had a field day, forbidding his flock to associate with the painter. The friendship with these simple people, which van Gogh (as the paintings attest) had arduously been establishing, step by step, disappeared at the behest of the churlish priest. Not

Self-Portrait with Pipe
Paris, Spring 1886
Oil on canvas, 46 x 38 cm
F 180, JH 1194
Amsterdam, Rijksmuseum Vincent van Gogh, Vincent van Gogh Foundation

Self-Portrait
Paris, Autumn 1886
Oil on canvas, 39.5 x 29.5 cm
F 178v, JH 1198
The Hague, Haags Gemeentemuseum

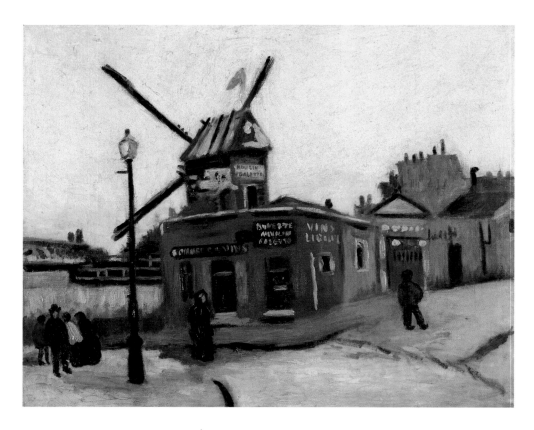

Le Moulin de la Galette
Paris, Autumn 1886
Oil on canvas, 38 x 46 cm
F 226, JH 1172
Baden (Switzerland), L. S. and J. Brown
Foundation

that there was ever any risk that his disapproval would have fallen on stony ground; several of van Gogh's neighbours already found the artist rather odd.

So the pictures of people digging, done in summer 1885, were van Gogh's last opportunity to indulge his belief that he was a figure painter. The crowning achievement and the finale of his Dutch period were the autumn landscapes painted in October and November 1885. It seems

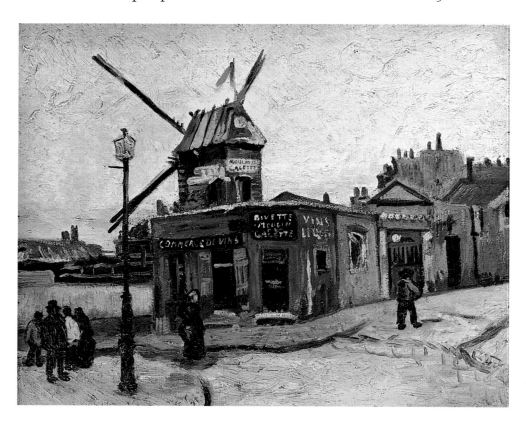

Le Moulin de la Galette
Paris, Autumn 1886
Oil on canvas, 38 x 46.5 cm
F 228, JH 1171
West Berlin, Nationalgalerie SMPK

fair to describe them as his crowning achievement if we take mimetic competence or time-honoured strategies in composition and use of colour as our criteria – that is, if we view them with an eye schooled by the academies. Paintings such as *Autumn Landscape* (p. 131) or *Autumn Landscape with Four Trees* (pp. 132-3) would doubtless appeal to any academician. Van Gogh has chosen his position with care, finding a happy midpoint between proximity and remoteness. In so doing he avoids being overwhelmed by the sheer power of Nature, as often happens with him; his motifs, though, retain their vivid immediacy, maintaining a kind of direct contact with the artist and at the same time preserving their metaphoric impact. Van Gogh's gaze is neither detached nor slavish – it is well-balanced. If we consider his early work as a whole as deriving from the premise that realism (the artist's objective) consists in matching the visual impressions conveyed by the object with the visual impressions conveyed by the painting, then this work represents the sum and peak of what was then within van Gogh's power.

Le Moulin de la Galette
Paris, Autumn 1886
Oil on canvas, 38.5 x 46 cm
F 227, JH 1170
Otterlo, Rijksmuseum Kröller-Müller

**Terrace of a Café on Montmartre
(La Guinguette)**
Paris, October 1886
Oil on canvas, 49 x 64 cm
F 238, JH 1178
Paris, Musée d'Orsay

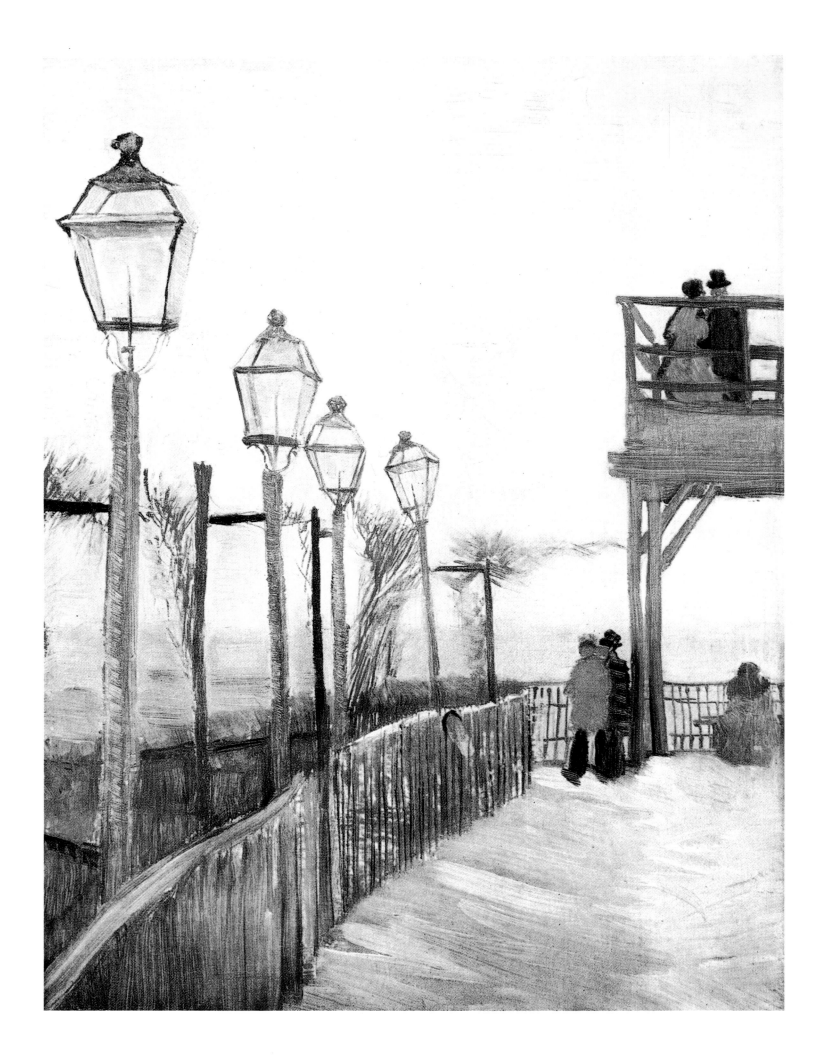

He had perfected an idiom of understanding and rapprochement, and (as the autumn landscapes prove) had learnt whatever he could learn in the province. And van Gogh was shortly to make radical changes both in his place of residence and in his artistic idiom.

Given the way his standing with the villagers had changed, departure was inevitable. In any case, van Gogh was also growing increasingly aware of a need to experience city life again. The pleasure he took in the simple life had obscured this need; but now he realized that his knowledge of the art world was all hearsay culled from Theo's Paris letters and the visits of friends. His information was all second-hand. He had never even set eyes on an Impressionist painting. And as a result his work tended to be overburdened with theory: he had to milk Nuenen's modest resources of all the subjects the village had to offer, and articulate everything he had resolved to say. We often find that there is a discrepancy between the sensuous visual impact of his pictures and that forced symbolism which his letters (rather than the works themselves) induce us to infer. The time had now come for van Gogh to enter the art world proper. Doubtlessly he had sufficient confidence in his abilities to face the confrontation with equanimity. Indeed, his confidence had been such that he had already produced a manifesto picture, *The Potato Eaters*. He now had his qualifications, and could go out into the fight for recognition. Millet, his *alter ego*, whose paintings of peasants (which he supposed could only have been done amidst simple folk) had always been a model and inspiration to him, had ventured into the capital cities too. In October, van Gogh went to Amsterdam for a few days, for the first time since moving to the country. There he wandered about the great museums, and realized that the old masters still had a great deal to tell him. And he in turn had questions to put to them. He decided to do so, starting in Antwerp, city of Peter Paul Rubens.

Windmill on Montmartre
Paris, Autumn 1886
Oil on canvas, 46.5 x 38 cm
F 271, JH 1186
Destroyed by fire in 1967

Twilight, before the Storm: Montmartre
Paris, Summer 1886
Oil on cardboard, 15 x 10 cm
F 1672, JH 1114. Private collection

LEFT:
Montmartre near the Upper Mill
Paris, Autumn 1886
Oil on canvas, 44 x 33.5 cm
F 272, JH 1183
Chicago, The Art Institute of Chicago

Colour and the Finished Work
Evolving a Theory of Art

"His art had greater depth and scope than he ever consciously realized. To a certain extent, indeed, his theories obscured his practice." Thus Kurt Badt in his study of van Gogh's theory of colour. Badt is thinking not only of the obvious difference between visual and verbal articulation of an insight; more than that, he believes van Gogh's work centres upon something essentially inexpressible. This interpretation naturally confines the work within the worldview van Gogh himself espoused: the Romantic. But in fact van Gogh wrote more eloquently than any other artist about his guiding principles in painting; and frequently the ideas he set down on paper anticipated procedures he would adopt in pictures as yet unpainted. The foundation was not the inexpressible; it was the unpaintable. Distress at his own lack of talent in converting his

View of Montmartre with Windmills
Paris, Autumn 1886
Oil on canvas, 36 x 61 cm
F 266, JH 1175
Otterlo, Rijksmuseum Kröller-Müller

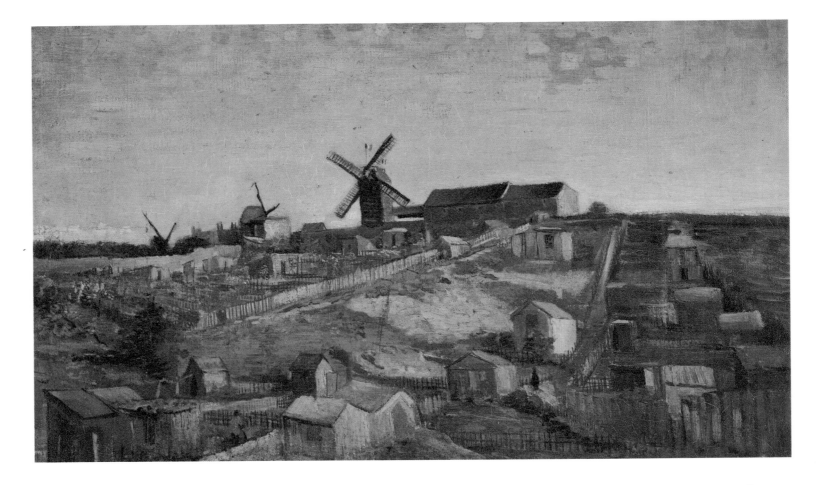

Le Moulin de la Galette
Paris, Autumn 1886
Oil on canvas, 55 x 38.5 cm
F 349, JH 1184
Newark (N.J.), Collection Charles W.
Engelhard

Le Moulin de la Galette
Paris, Autumn 1886
Oil on canvas, 61 x 50 cm
F 348, JH 1182
Buenos Aires, Museo Nacional de Bellas
Artes

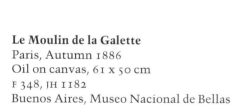

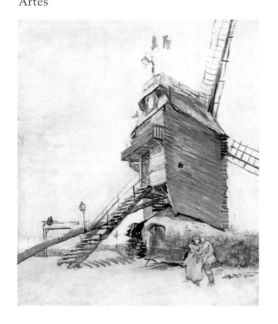

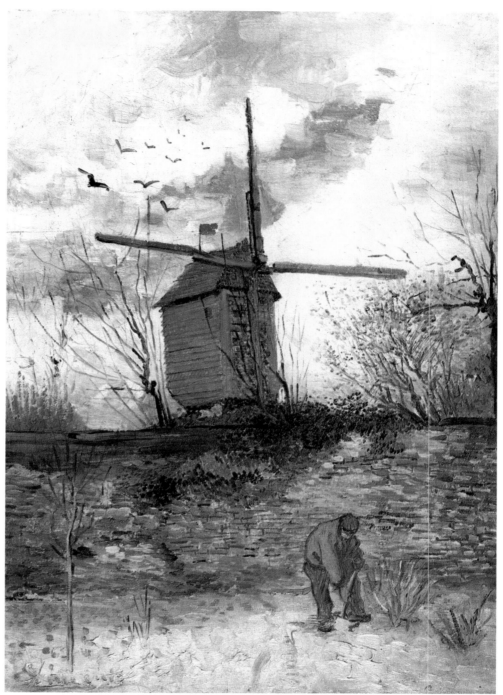

concepts into artistic practice spoilt many a day at the easel. It is time we took a closer look at the theory of art he expressed in his letters and tried to articulate in his paintings.

There was nothing provincial in his main ideas. Though he lived away from the mainstream, he was thoroughly familiar with the aesthetic preoccupations of the day, as we see from his interest in two of the central concerns of contemporary artists: firstly, how does the motif in the picture relate to its original in Nature, and (following from this) when can a painting be considered "finished"? Secondly, what part does the use of colour play? In his sensitivity to these two problems, van Gogh showed a greater affinity to his age than he did in his works. Indeed, it was that great sensitivity that had really driven him out of his

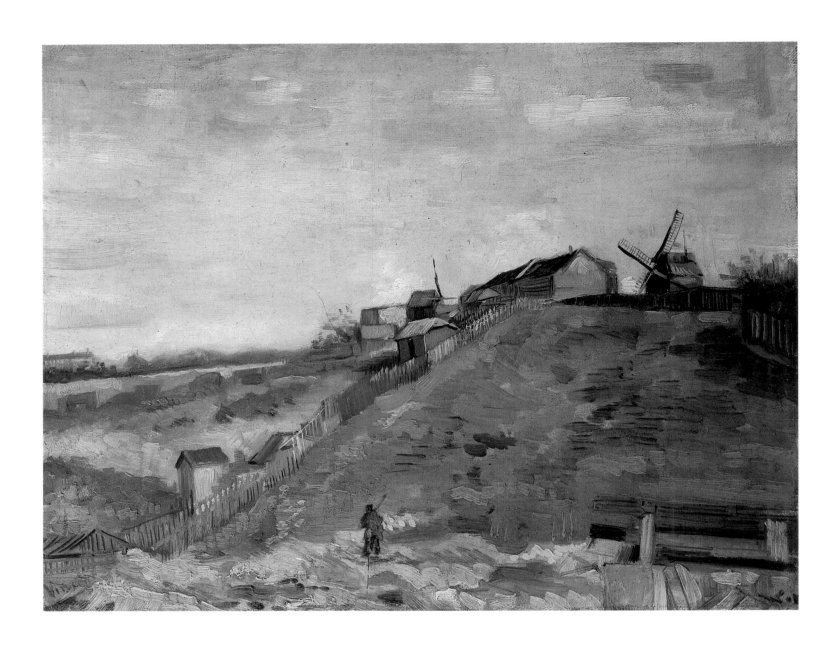

Montmartre: Quarry, the Mills
Paris, Autumn 1886
Oil on canvas, 32 x 41 cm
F 229, JH 1176
Amsterdam, Rijksmuseum Vincent van
Gogh, Vincent van Gogh Foundation

View of Montmartre with Quarry
Paris, late 1886
Oil on canvas, 22 x 33 cm
F 233, JH 1180
Amsterdam, Rijksmuseum Vincent van
Gogh, Vincent van Gogh Foundation
(Attribution disputed)

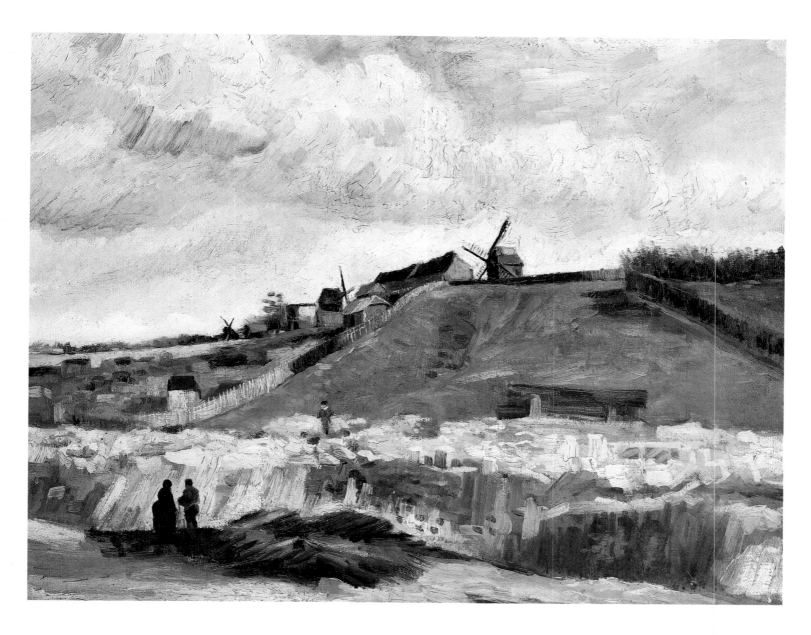

Montmartre: Quarry, the Mills
Paris, Autumn 1886
Oil on canvas, 56 x 62.5 cm
F 230, JH 1177
Amsterdam, Rijksmuseum Vincent van
Gogh, Vincent van Gogh Foundation

Nuenen retreat; books and magazines reached him in the country, but
as long as he stayed there he could never look at new paintings.

"As I walked home with Grzymala we talked about Chopin. He told
me that his improvisations were far more daring than his finished
compositions. Doubtless this is much the same as comparing a sketch
with the finished painting." In this passage in his diary, Delacroix was
suggesting that a hasty study might be more effective and alive than the
finished product. A sketch was spontaneous and close to real life, to
Nature; it had no truck with the dignity and complacency of the per-
fected work. But then, a sketch was by its very nature a different artistic
genre. A sketch expressed the artist's subjective view and for that reason
alone could not be compared with a picture submitted to public discus-
sion, to the critics, to a Salon jury. In the 19th century, extensive debate
centred upon this question. Experts clung to their academic rules, rating
decorative values above the vivid impression of life, rating traditional
themes above vitality in the motif, rating an immaculate finish above a
personal touch. Those who opposed the dogmatism of self-appointed

197 PAINTINGS: PARIS 1886

The Green Parrot
Paris, Autumn 1886
Oil on canvas on panel, 48 x 43 cm
F 14, JH 1193
Private collection
(Christie's Auction, London, 1. 12. 1987)

arbiters of taste necessarily became partisans for the sketch, since it was a more direct record of reality. Hence the uproars occasioned by the Impressionists. It was not their subjects that offended; these were largely drawn from the idyllic realm of middle-class sunny afternoons. What prompted anger was their way of dabbing and brushing patches of paint onto the canvas. Their work had a power that was provocative in its day; and this inevitably prompted the question of the relation of study to painting.

"What has impressed me most on seeing paintings by the old Dutch masters again is the fact that they were generally painted quickly. Not only that: if the effect was good, it stood. Above all, I admired hands painted by Rembrandt and Hals, hands that were alive though they were not finished in the sense that is being insisted on nowadays." Indeed, as van Gogh hazards in Letter 427, a Frans Hals would have found little favour with a Salon jury in the 1880s. But the painters of the 17th century had been incomparably successful at breathing life into their figures. Van Gogh had taken his bearings from them from the outset, and had gone on to an impulsive, crude art of vitality and energy that was so sketchy in character that there was surely a point in wondering

The Kingfisher
Paris, second half of 1886
Oil on canvas, 19 x 26.5 cm
F 28, JH 1191
Amsterdam, Rijksmuseum Vincent van Gogh, Vincent van Gogh Foundation

Stuffed Kalong
Paris, second half of 1886
Oil on canvas, 41 x 79 cm
F 177a, JH 1192
Amsterdam, Rijksmuseum Vincent van Gogh, Vincent van Gogh Foundation

whether his canvases were finished products. Van Gogh engaged with the question, and the answers he came up with were to influence the whole of modern art.

The Impressionists had found a solution that still accorded with Delacroix's view. "The original idea", he had written, "the sketch, which is in a sense the egg or embryo of the idea, is usually far from perfect. It contains the whole, in a manner of speaking, but that whole, which is no more than a unison of all the parts, needs to be coaxed forth." A picture is finished or perfect when it presents a whole unity. Totality of impact derives from homogeneity of style rather than from choice of subject and colour. In a rapidly-worked canvas, the objective presence of the motif and the subjective view of the artist become one.

It is not hard to see what van Gogh considered finished. If he considered a painting was more than a study, he signed it. There are not a great many of them; in his Dutch period they amount to a scant five per cent. *Head of a Peasant Woman with White Cap* (p. 87), for instance, bears his

Outskirts of Paris
Paris, Autumn 1886
Oil on canvas on cardboard, 45.7 x 54.6 cm
F 264, JH 1179
Private collection
(Christie's Auction, New York,
10. 11. 1987)

"Vincent". But how does that painting differ from the *Head of a Peasant Woman with Dark Cap* (p. 90), which he apparently felt to be only a character study? Both are thickly pastose, both are vehement, both were done at speed, and both evidence the affection with which the artist approached his subjects. Both were done in the same environment, for the same purpose, as part of the same work programme. It is difficult to see how van Gogh decided which work was superior. Yet he himself put a name to the essential quality: 'soul'. "It is the highest thing in Art, and in this Art is sometimes superior to Nature [...] just as, for example, there is more soul in Millet's sower than in an average sower in the field", he had written in The Hague (Letter 257). The study is plainly close to the real model; the finished picture goes beyond it, penetrating to a deeper level and examining the essential nature of the subject. Only work that succeeds in capturing 'soul' can be considered 'finished'. In espousing this view, van Gogh assigned to his private inner self the role of ultimate arbiter in Art, and thus effectively removed his work from the public arena. This anticipated the purely subjective approach that is characteristic of modern art, and also made manifestoes necessary if debate such as could once have been taken for granted was to be possible.

According to van Gogh, a painting with 'soul' is superior to natural

Three Pairs of Shoes
Paris, December 1886
Oil on canvas, 49 x 72 cm
F 332, JH 1234
Cambridge (Mass.), Fogg Art Museum,
Harvard University

Creation. From its higher vantage point, the work of art abstracts the essential in the world's phenomena in order to present a lasting impression. Though a painter may be far removed from Nature in the process, he also needs to remain close to Nature, because only Nature can correct the products of his scrutiny of the depths within. Dialogue between Nature and the work (with the painter eavesdropping, as it were) takes the place of dialogue between artist and critic.

This holds good for the second main point in van Gogh's theory of art, too: his discussion of colour. "Studies after Nature, the tussle with

Nude Woman on a Bed
Paris, early 1887
Oil on canvas (oval), 59.5 x 73 cm
F 330, JH 1214
Merion Station (Pa.), The Barnes
Foundation
(Reproduction in colour not permitted)

Reality", he wrote in Letter 429, "I won't deny it, for years I approached the business well-nigh fruitlessly and with all manner of dismal results. I wouldn't want to have avoided the mistake ... One starts with fruitless labours, trying to copy Nature, and nothing works out, and one ends up creating in peace and quiet using only the palette and Nature is in agreement and follows from it." This is reminiscent of Paul Cézanne's famous saying that "Art runs parallel to Nature". Van Gogh had formulated the idea before the Frenchman: "That is truly painting. And what results is something more beautiful than a faithful copy of things themselves. To have one's eye on one thing so that everything else around is part of it, proceeds from this." These ideas (while very advanced in terms of colour) were still merely theoretical; van Gogh's technical skill lagged behind his theorizing. The passage from Letter 429 established the basic principles of autonomous colour – colour that is used according to its visual impact in the picture rather than its fidelity to Nature; but it would be a while yet before van Gogh was able to paint as he

Portrait of a Man with a Moustache
Paris, Winter 1886/87
Oil on canvas, 55 x 41 cm
F 288, JH 1200
Whereabouts unknown

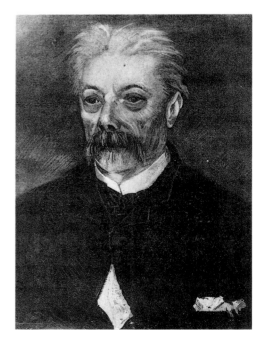

Nude Woman Reclining
Paris, early 1887
Oil on canvas, 24 x 41 cm
F 329, JH 1215
De Steeg (Netherlands), Collection Mrs.
van Deventer

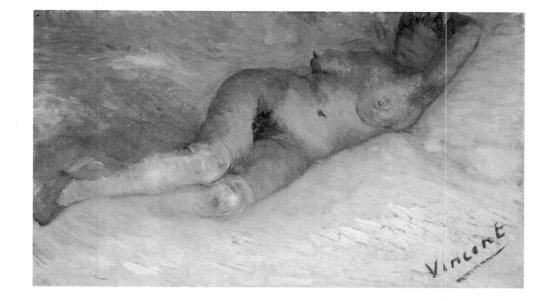

Nude Woman Reclining, Seen from the Back
Paris, early 1887
Oil on canvas, 38 x 61 cm
F 328, JH 1212
Paris, Private collection

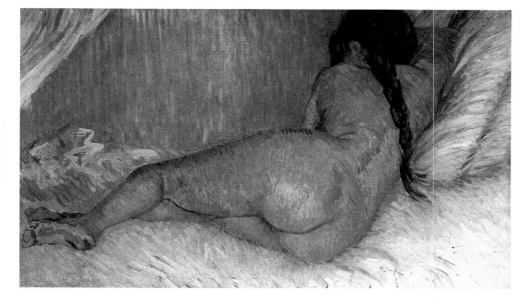

Portrait of the Art Dealer Alexander Reid, Sitting in an Easy Chair
Paris, Winter 1886/87
Oil on cardboard, 41 x 33 cm
F 270, JH 1207
Oklahoma City, Collection A. M.
Weitzenhoffer

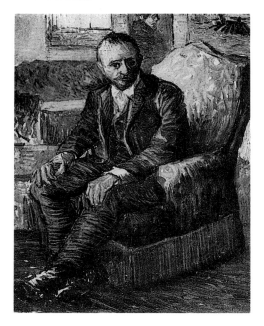

thought. For the time being he had evolved a sort of hierarchy to govern his use of colour (Letter 428): "The most serious question concerns complementary colours, contrast, and the way complementary colours cancel each other out; next in importance is the effect two related colours have on each other, say carmine on vermilion, or a red shade of purple on a blue purple. The third question concerns the effect of a pale blue on the same kind of dark blue, pink on reddish brown, etc. But the first of these questions is the most important."

Van Gogh's approach to colour in his own practice had proceeded the opposite way round. In the autumn still lifes with their laden baskets of potatoes he had been concerned with the third and least important of these issues, the interaction of lighter and darker shades of the same colours. His earliest paintings had used chiaroscuro, dwelling on the effect of light on a foregrounded motif seen against a background of deep shadow. An artificial insistence on only slightly variegated shades of brown resulted in colour stimulus being reduced almost to non-existence – an inevitable consequence of experimenting in diminished light.

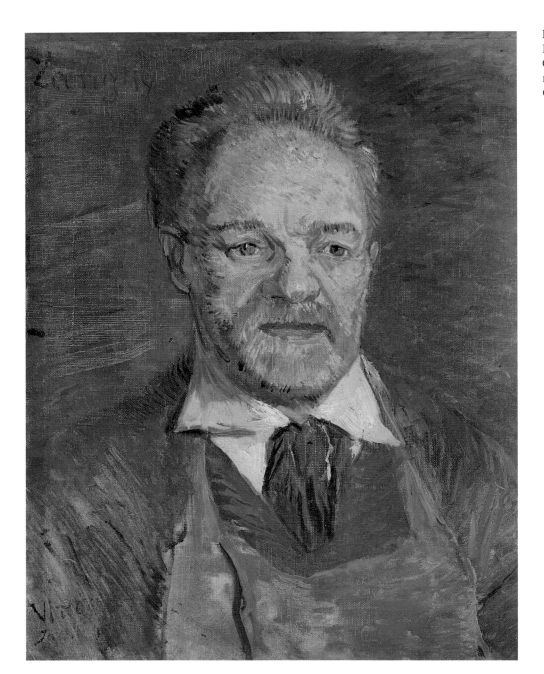

Portrait of Père Tanguy
Paris, Winter 1886/87
Oil on canvas, 47 x 38.5 cm
F 263, JH 1202
Copenhagen, Ny Carlsberg Glyptotek

One of the most striking Nuenen pictures involves van Gogh's second principle. *Sheaves of Wheat in a Field* (p. 116) examines the effects various related yellows have on each other; that is, it explores colour analogies. The melancholy, earthy reportage pictures done in Drente had already done something of the kind; their marshy brown was the product of other considerations than the still lifes' principle of neutral lighting. The wheatsheaves have of course been done in more cheerful colours; and they dominate the canvas so thoroughly that we are inclined to overlook the fact that a colour scheme has taken precedence over the motif, the multiplicity of tonal values over the single, central status of the subject.

By far the most important principle of van Gogh's palette, a principle that was later to become a dogma with him, was that of complementary colours. This too had been taken from Delacroix, during his second year

Portrait of a Man
Paris, Winter 1886/87
Oil on canvas on panel, 31 x 39.5 cm
F 209, JH 1201
Melbourne, National Gallery of Victoria

in Nuenen. Complementary colours are colours that heighten their mutual effects most intensively if they are placed contrastively: blue and orange, red and green, yellow and violet. Initially van Gogh added a fourth contrast, white and black. He had found that the principle was at work in Nature, in the cycle of the seasons, so dear to him: "Spring is tender young shoots of wheat and pink apple blossom. Autumn is the contrast of yellow leaves with shades of violet. Winter is snow, with black silhouettes. If summer is taken to be a contrast of blues with the orange of golden, bronze grain, it is possible to paint a picture in complementary colours for every one of the contrasts." (Letter 372).

In spite of his sophisticated theory, van Gogh remained a realist in his use of colours. True, his ideas abstracted away from the immediate impression made by Nature; but in practice a look at the subject sufficed to guide his use of the palette. Van Gogh was alert to complementary colours, but was satisfied if he saw them in the contrast of yellow leaves with a violet sky or red flowers with a green field. His theory paved the way for autonomous colour, but in his practice he remained close to the old masters and his solitary hero Millet. It would be another year before he shook off this fidelity.

Self-Portrait with Pipe and Glass
Paris, early 1887
Oil on canvas, 61 x 50 cm
F 263a, JH 1199
Amsterdam, Rijksmuseum Vincent van Gogh, Vincent van Gogh Foundation

Portrait of a Man with a Skull Cap
Paris, Winter 1886/87 (or 1887/88?)
Oil on canvas, 65.5 x 54.5 cm
F 289, JH 1203
Amsterdam, Rijksmuseum Vincent van Gogh, Vincent van Gogh Foundation

PAGE 206:
Agostina Segatori Sitting in the Café du Tambourin
Paris, February-March 1887
Oil on canvas, 55.5 x 46.5 cm
F 370, JH 1208
Amsterdam, Rijksmuseum Vincent van Gogh, Vincent van Gogh Foundation

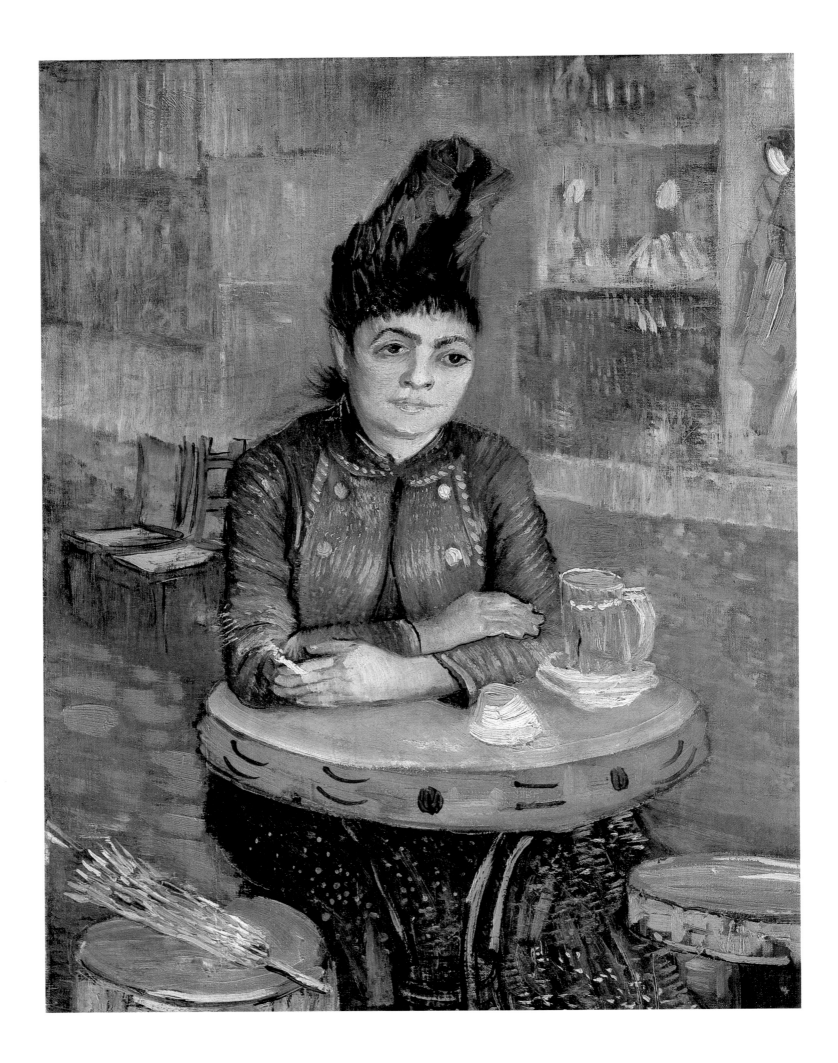

CITY LIFE
1885-1888

The Antwerp Interlude
Winter 1885-86

"It is quite certain that I shall be without a place to work in Antwerp. But I have to choose between a place to work but no work here and work without a place to do it there. I have opted for the latter. And with such joy and delight", wrote van Gogh in Letter 435, "that it feels like returning from exile." He felt that, after the past few years, he urgently

Portrait of a Woman
Paris, Winter 1886/87
Oil on canvas, 27 x 22 cm
F 215b, JH 1205
Amsterdam, Rijksmuseum Vincent van Gogh, Vincent van Gogh Foundation
(Attribution disputed)

needed to return home – to rediscover that homeground that a city provides. His concept of artistic truth, borrowed from Millet and Breton, had led him to live in the same rustic, rural environment he liked to paint; but now he felt compelled to satisfy society's notions of the artistic life. *The Potato Eaters* had heralded a new, programmatic ambition, and he was now out to present a confident public image and an urbane personality – and to succeed.

From the very start, van Gogh saw his time in Antwerp as an intermezzo before he moved on to the great metropolis, Paris, capital of the 19th century. Antwerp served as a kind of training, to prepare him for what might otherwise (after the intimacy of village life) be the rude shock of the faceless city. And Theo first needed persuading to have his brother. Van Gogh tried to give his correspondent an honest account of his progress in questions of civilized conduct. He believed he might still need improvement in three respects: first, he simply wanted to dive into the sea of people and houses and forget the everyday feuding of the

Portrait of a Woman (Madame Tanguy?)
Paris, Winter 1886/87
Oil on canvas, 40.5 x 32.5 cm
F 357, JH 1216
Basle, Kunstmuseum Basel, on loan from
the Rudolf Staechelin Family Foundation

A Pair of Shoes
Paris, early 1887
Oil on canvas, 34 x 41.5 cm
F 333, JH 1236
Baltimore, The Baltimore Museum of Art,
The Cone Collection

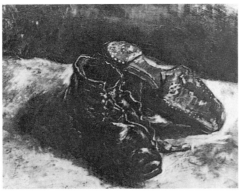

A Pair of Shoes
Paris, Spring 1887
Oil on canvas, 37.5 x 45.5 cm
F 332a, JH 1233
Brussels, Collection Emil Schumacher

A Pair of Shoes
Paris, first half of 1887
Oil on paper on cardboard, 33 x 41 cm
F 331, JH 1235
Amsterdam, Rijksmuseum Vincent van
Gogh, Vincent van Gogh Foundation

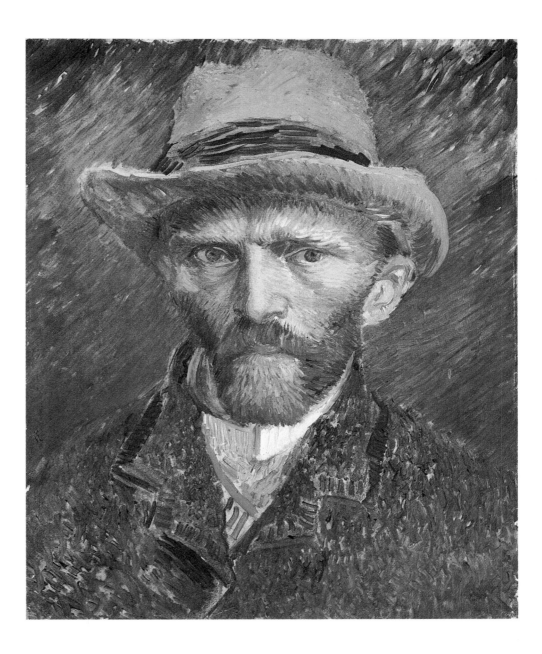

Self-Portrait with Grey Felt Hat
Paris, Winter 1886/87
Oil on cardboard, 41 x 32 cm
F 295, JH 1211
Amsterdam, Stedelijk Museum (on loan
from the Rijksmuseum)

village; second, he felt he might profit from further instruction at the
Academy, in order to have the technical means to tackle his new
subjects; and third, he thought that after years of neglecting his outer
appearance he might be in need of a little advice in that respect.

He spent three months in the Belgian port. Rubens was the presiding
spirit in this period. Van Gogh, as a follower of Delacroix, was of course
destined to discover the baroque painter. Having done so, he appropri-
ated Rubens's subtlety and allusiveness with the same energetic
thoroughness as he had borrowed Millet's simple devotion to Nature
years before. "Studying Rubens is extremely interesting", he wrote in
Letter 444, in an attempt to locate his own interests in the old master,
"precisely because he is so very simple in technique, or – to be more
exact – seems to be. Because he achieves his effect with such modest
means and with so swift a touch, because he paints without any kind of
hesitation and above all draws as well. But portraits, heads of women
and female figures are his strong points. In these areas he is profound,

 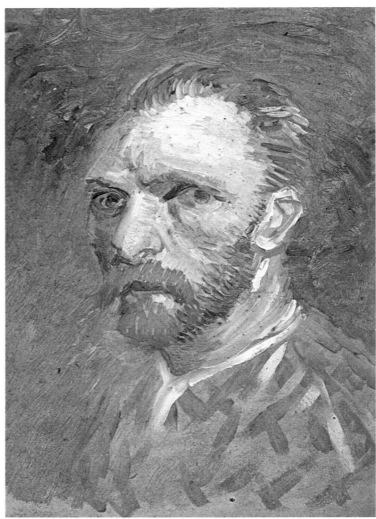

Self-Portrait
Paris, Spring 1887
Oil on paper, 32 x 23 cm
F 380, JH 1225
Otterlo, Rijksmuseum Kröller-Müller

Self-Portrait
Paris, Spring-Summer 1887
Oil an cardboard, 19 x 14 cm
F 267, JH 1224
Amsterdam, Rijksmuseum Vincent van
Gogh, Vincent van Gogh Foundation

and sensitive too. And how fresh his paintings have stayed, because of that very simplicity of technique." To paint swiftly and establish a likeness with a very few well-placed strokes had never been something he found difficult; but what he wanted to learn from Rubens was the subtlety of impeccable *hautgout*, which had been inaccessible to him in the village – delicacy and distinction.

In *Head of a Woman with her Hair Loose* (p. 139) van Gogh achieved a degree of artistic sensitivity that had hitherto been beyond him. The portrait is still vigorous, if not indeed violent, in its brushwork, but the colouring is exquisite. Sensitively patterned brushstrokes create a beautifully nuanced, detailed image in which the virtuoso technique has perhaps become more important than the subject. The woman is not rustic or picturesque like the Nuenen women in their caps. In fact, van Gogh has dispensed with everything that might tie the woman specifi-cally to one walk of life. It is simply some woman or other, a town girl whose beauty does not last long and whose dignity will come or go, just depending, a hired model who will pose for anyone who will pay. The picture is superficial in the sense that it does not aim to explore pro-found depths in the woman but instead anticipates the rapid brushwork and strong colours of the Paris period. A rich red is juxtaposed with the

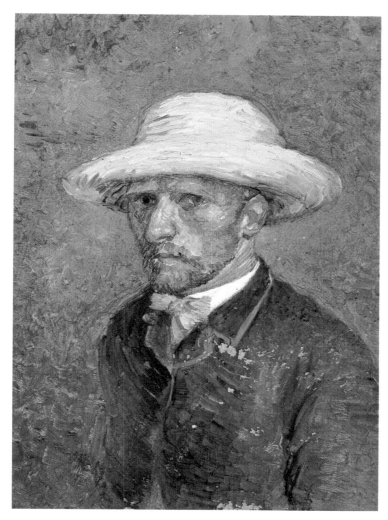
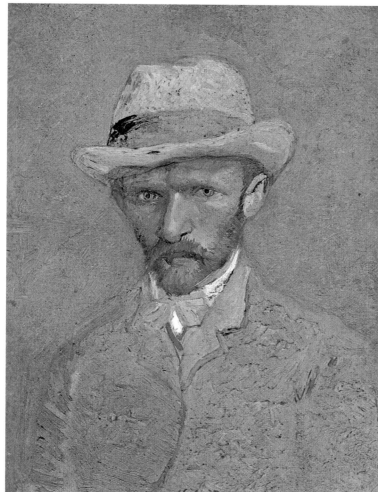

cool whitish shades of the flesh – an impressive effect that is supposed to be delicate rather than descriptive, to highlight the picture's colours without appearing to represent make-up. Van Gogh, in other words, was becoming fully aware of the opportunities open to the palette, and the new freedom was allowing him to put documentary presentation of subjects behind him.

"What colour is in a picture, enthusiasm is in life, in other words no mean thing if one is trying to keep a hold on it", he wrote in Letter 443, explaining his new interest in colour. Increasingly, the violent tonal clashes, streaks of colour, and patches of paint applied directly from the tube took over the function that his motifs had previously had: to reconcile the painter's subjective view of the world with the objective state of phenomena. Previously van Gogh had been offering the better life – better because lived in harmony with Nature. Now he withdrew somewhat from natural plurality, as it were, and tried to present a synthesis, his own interpretation, on canvas. The world in his pictures became more artificial because it was more consciously filtered by the perceptions and mind of an artist. "I think that in order to draw figures of peasants, for example, it is very good to draw ancient sculptures, always assuming it is not done as it normally is." (Letter 445). At the

Self-Portrait with Straw Hat
Paris, March-April 1887
Oil on cardboard, 19 x 14 cm
F 294, JH 1209
Amsterdam, Rijksmuseum Vincent van Gogh, Vincent van Gogh Foundation

Self-Portrait with Grey Felt Hat
Paris, March-April 1887
Oil on cardboard, 19 x 14 cm
F 296, JH 1210
Amsterdam, Rijksmuseum Vincent van Gogh, Vincent van Gogh Foundation

PAGE 214/215:
Street Scene in Montmartre: Le Moulin à Poivre
Paris, February-March 1887
Oil on canvas, 34.5 x 64.5 cm
F 347, JH 1241
Amsterdam, Rijksmuseum Vincent van Gogh, Vincent van Gogh Foundation

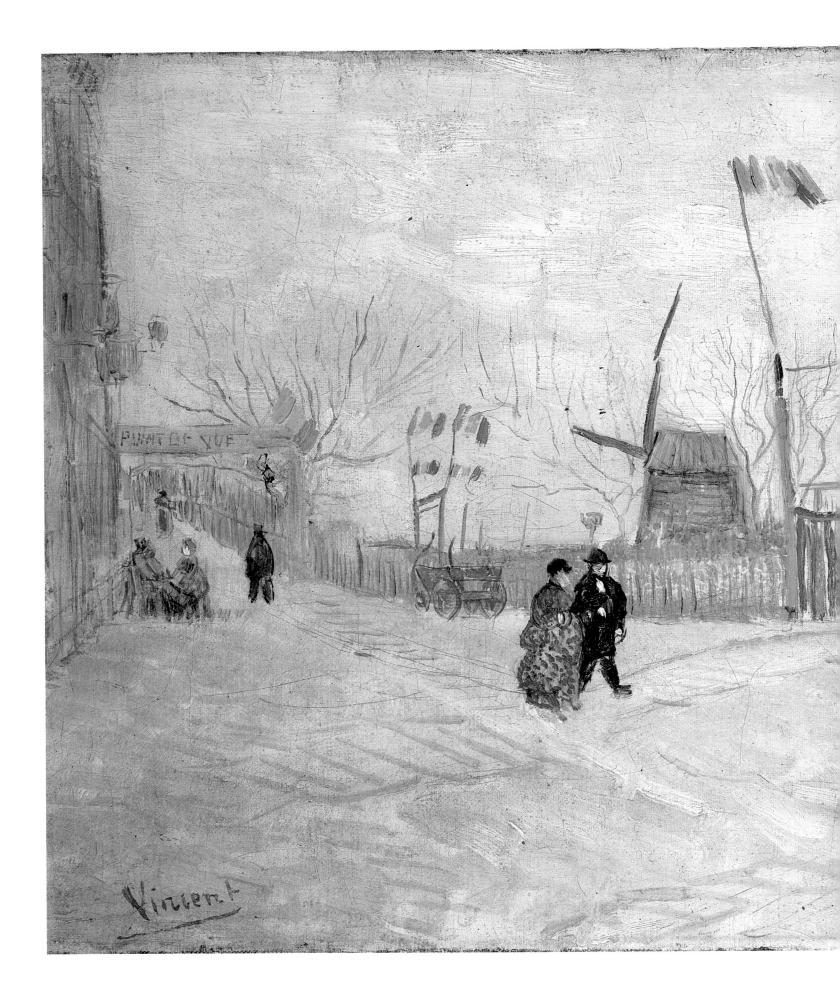

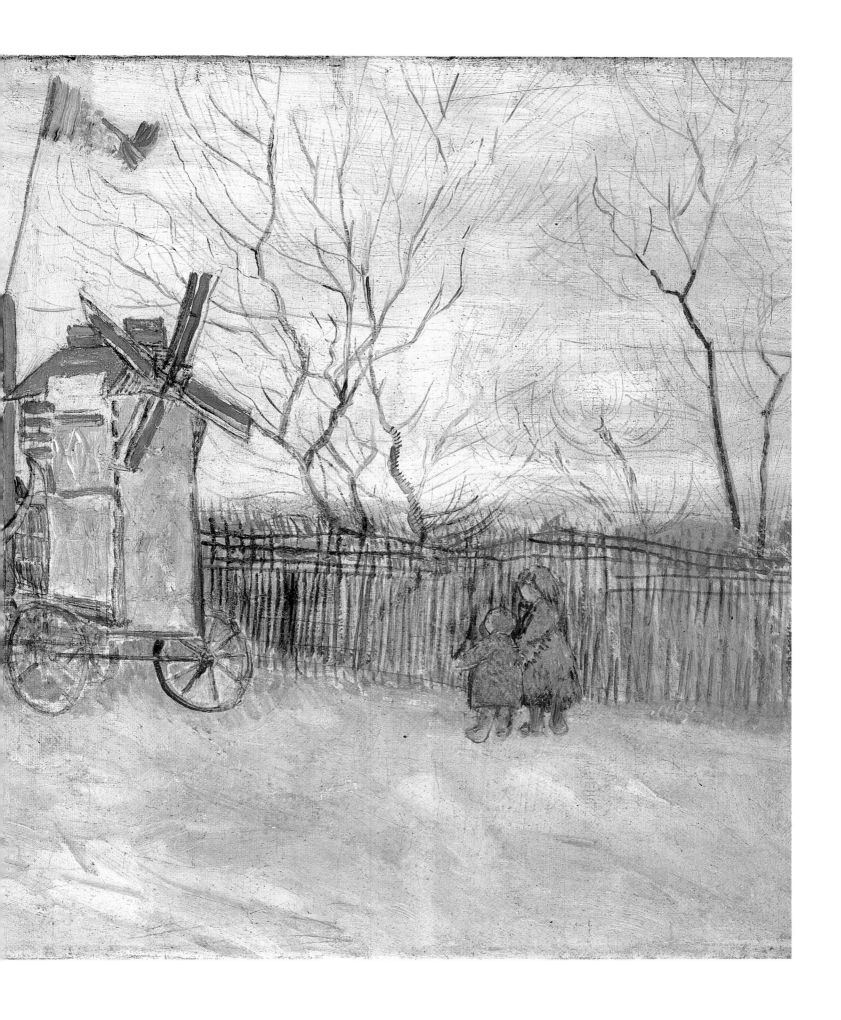

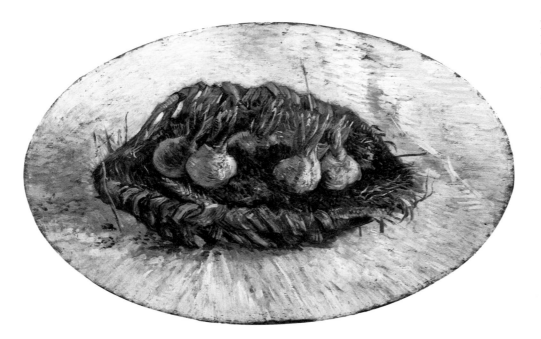

Basket of Sprouting Bulbs
Paris, March-April 1887
Oil on panel (oval), 31.5 x 48 cm
F 336, JH 1227
Amsterdam, Rijksmuseum Vincent van
Gogh, Vincent van Gogh Foundation

time of *The Potato Eaters*, van Gogh would have abhorred this idea because it was the sort of thing done in academies, which were out of touch with reality. But now he too tried his hand at painting copies of classical sculptures; what counted was the unusual approach, not the subject itself.

Consistently enough, van Gogh applied to the Academy of Fine Arts. He rapidly passed a number of courses; none of the professors quite knew what to make of this Dutchman's abstruse views. Van Gogh's concept of art had by now gained depth and weight and was incompatible with academic pedantry and didacticism, which could do nothing but assess the handling of line and contour. The categories of 'enthusiasm' and 'vitality', which van Gogh rated supreme, were dismissed

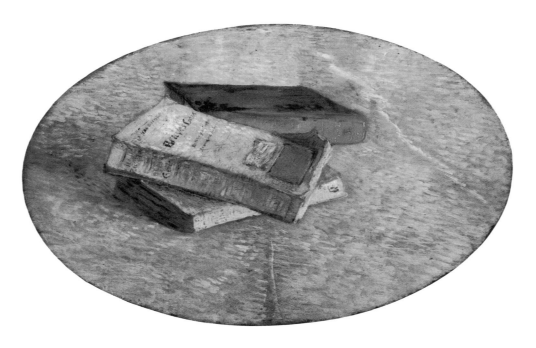

Still Life with Three Books
Paris, March-April 1887
Oil on panel (oval), 31 x 48.5 cm
F 335, JH 1226
Amsterdam, Rijksmuseum Vincent van
Gogh, Vincent van Gogh Foundation

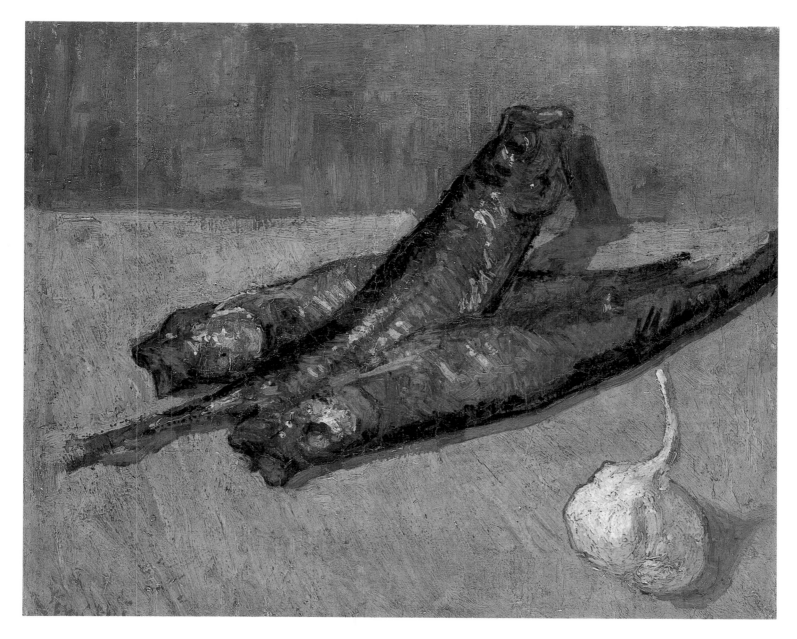

as expressions of inflated self-esteem. In three short months, Vincent travelled the typical Modernist road, repelled by the dogmatic inflexibility of the official custodians of art and seeking some goal of his own, off the beaten track. In February 1886 he entered a competition at the academy. The result was not announced until after he had left for Paris – and perhaps that was just as well, because the experts had apparently decided that van Gogh might join a class for 13-to-15-year-olds.

Skull with Burning Cigarette (p. 138) is in many ways the key Antwerp picture. Van Gogh was mocking the procedure in drawing classes, where a skeleton invariably served as the basis of anatomical studies, considered by the teachers to be the artist's indispensable aid in figuring out physical proportions and anatomical structure. The lifelessness of the skeleton represented the very opposite of what van Gogh wanted a picture to express. With the burning cigarette jammed in its teeth, the skeleton, though still nothing but dead bones, has acquired a grotesquely funny hint of life.

Still Life with Bloaters and Garlic
Paris, Spring 1887
Oil on canvas, 37 x 44.5 cm
F 283b, JH 1230
Tokyo, Bridgestone Museum of Art

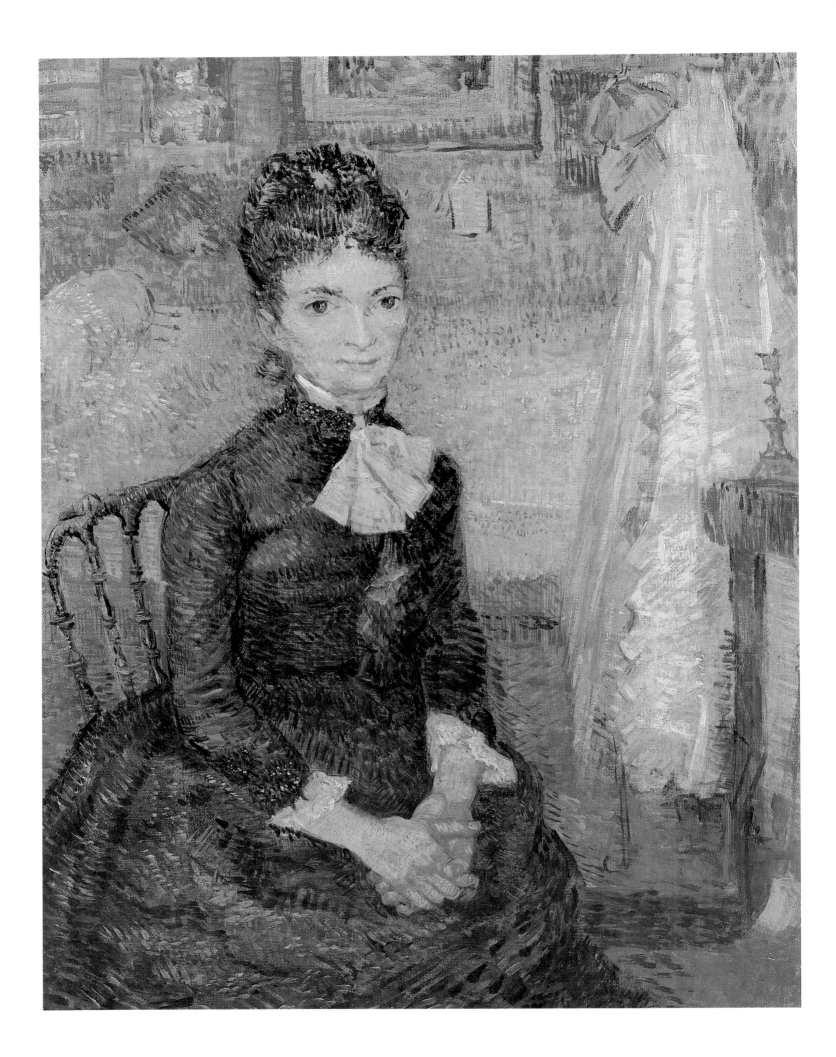

Factories Seen from a Hillside in Moonlight
Paris, first half of 1887
Oil on canvas, 21 x 46.5 cm
F 266a, JH 1223
Amsterdam, Rijksmuseum Vincent van
Gogh, Vincent van Gogh Foundation

The painting is less amusing if we bear in mind van Gogh's feeling
that he needed to make his outer appearance more attractive. He had
just had major dental treatment. In Nuenen he had painted no self-
portraits, but in Paris he tackled the task head-on – and the reason for
this may well have been that van Gogh had recently acquired a touch of
the upright citizen's vanity, and that he did not think himself present-
able until his gap-teeth had been fixed. On the other hand, of course, if
he now saw himself as a man about town, he would have developed the
self-confidence needed to think he merited a self-portrait (and first some
improvement of his facial appearance, which was sunken and weary).
His health was not in the best of conditions: "The doctor tells me I
absolutely have to keep my strength up", he wrote in Letter 449, "and
until I have built it up I am to take it easy with my work. But now I have
made things worse by smoking, which I did because one doesn't feel the
emptiness of one's stomach then." With this in mind we can see the
skull as van Gogh's first self-portrait – a cynical, merciless comment on
an unkempt and unattractive appearance that had been a sign of solidar-
ity with the peasants back in Nuenen but was now an embarrassment
and a problem in the city.

Finally, we should not forget the contemporary penchant for the
motif of the living dead. Fifteen years before, Arnold Böcklin had
painted a *Self-Portrait with Death Playing a Fiddle*; and not long after
the turn of the century the dance-of-death theme was to peak in Hugo
von Hofmannsthal's play *Everyman*. It was a game the *fin de siècle*
played, holding up an artificial mirror to its own eschatological fears.
What did it mean to Vincent van Gogh, the hallmark of whose work
tends to be a paradoxically optimistic view of progress? His death's-head
represented a serious attempt to keep pace with the artistic debates of
the times. The authorial ambition the picture betrays was a dead end for
him, though; the exaggerated focus on a motif that did not stand for any
reality but was simply available as an iconographical prop highlights the
problems van Gogh was having with his repertoire of subjects. In
Antwerp he explored both the extremes that were accessible to his art:

Woman Sitting by a Cradle
Paris, Spring 1887
Oil on canvas, 61 x 45.5 cm
F 369, JH 1206
Amsterdam, Rijksmuseum Vincent van
Gogh, Vincent van Gogh Foundation

on the one hand the sheer pleasure of exuberant brushwork, on the other the highly-charged melancholy of a literary man's motif. Somehow he had to put an end to his irresolution. Earlier than planned, van Gogh left for Paris.

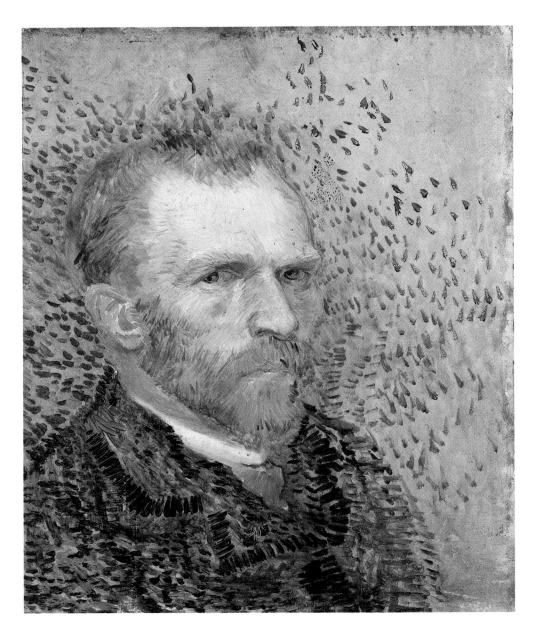

Self-Portrait
Paris, Spring-Summer 1887
Oil on canvas, 41 x 33 cm
F 356, JH 1248
Amsterdam, Rijksmuseum Vincent van Gogh, Vincent van Gogh Foundation

A Dutchman in Paris
1886-1888

For centuries artists had gone on pilgrimages to Italy, where they could find their idealized antiquity, the architectural and sculptural remains with which they pieced together an image of human perfection, literally in the streets. In the 19th century, artists who found their times too bustling, loud and obsessed with ephemera would still escape to Italy --

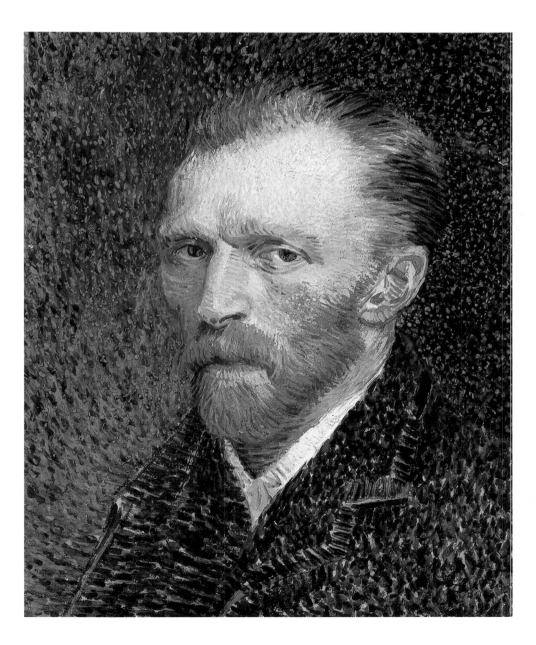

Self-Portrait
Paris, Spring 1887
Oil on cardboard, 42 x 33.7 cm
F 345, JH 1249
Chicago, The Art Institute of Chicago

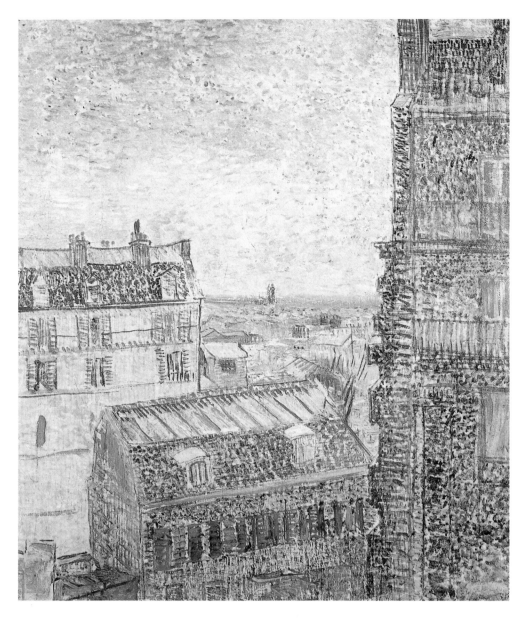

**View of Paris from Vincent's Room
in the Rue Lepic**
Paris, Spring 1887
Oil on canvas, 46 x 38 cm
F 341, JH 1242
Amsterdam, Rijksmuseum Vincent van
Gogh, Vincent van Gogh Foundation

artists such as Böcklin, Max Klinger or Hans von Marées. Perhaps in
their longing for a timeless Arcadia there was at core litle more than
love of a country that was underdeveloped when compared with other
European countries.

The cutting edge of modernity was certainly not in Italy. It was in
Paris, where the Revolution had placed the city in the European van-
guard. And the problems of the age had become aesthetic problems.
Back in the period around 1700 there had been an argumentative
Querelle des anciens et des modernes, a debate that Swift had spoofed
in Britain: was Beauty to be evaluated by some eternal standard, or by
the evanescent taste of the times? The watchword 'modern' had become
controversial, and remained controversial in subsequent aesthetic dis-
putes; by the 19th century it was a kind of article of faith, pathetically
recited by artists frantic for an identity. The front ran through Paris. On
the one side were the historically-minded advocates of great subjects
sanctioned by the past, the painters of historical scenes, all those who
paid lip service to the consummate skill of the old masters; and on the

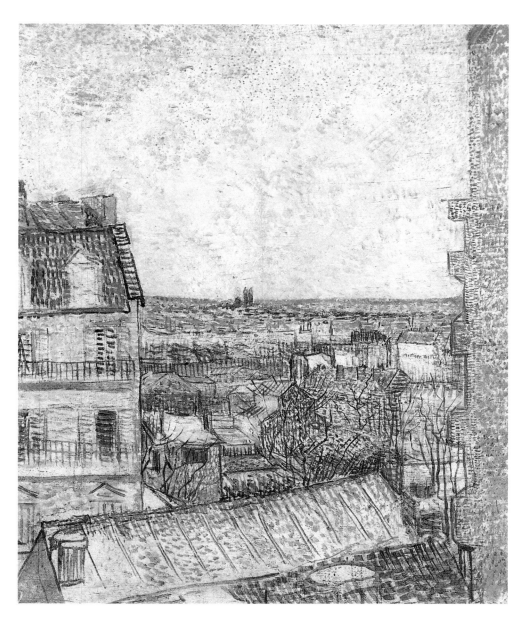

**View of Paris from Vincent's Room
in the Rue Lepic**
Paris, Spring 1887
Oil on cardboard, 46 x 38.2 cm
F 341a, JH 1243
Private collection
(Sotheby's Auction, New York, 14. 5. 1985)

other side were those who documented contemporary life with their brush and preferred the flux of passing moods, glimpses of everyday life, and freedom in the use of shape and colour. One of the things that made Paris a modern city was the very fact that the debates were fought out there; the fierceness of the fighting was an indicator of the new pluralism in Art. So they all were drawn to Paris: Max Liebermann from Germany, James Abbott McNeill Whistler and Mary Cassatt from the United States, Félicien Rops from Belgium. And of course a Dutchman, Vincent van Gogh, whose brother lived in the great metropolis. (This was important to him, but to see it as his main reason for moving to Paris would be to underestimate his commitment to his art.)

"And do not forget, my dear fellow, that Paris is Paris. There is only one Paris, and, hard as it may be to live here, even if it were to grow harder and worse – French air clears the head and does one good, tremendously good." Van Gogh is rarely as uninhibitedly enthusiastic as in this passage from Letter 459a to a young fellow-artist, Horace Lievens. Vincent had fallen under the city's spell. His customary exis-

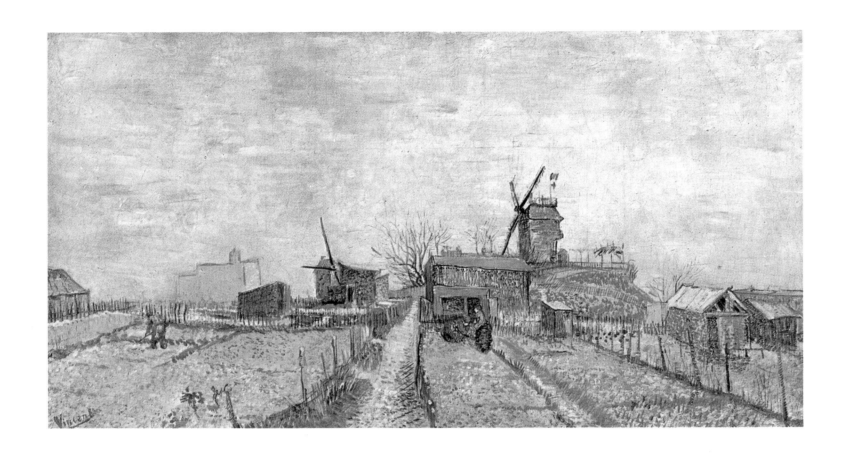

Vegetable Gardens in Montmartre
Paris, February-March 1887
Oil on canvas, 44.8 x 81 cm
F 346, JH 1244
Amsterdam, Rijksmuseum Vincent van
Gogh, Vincent van Gogh Foundation

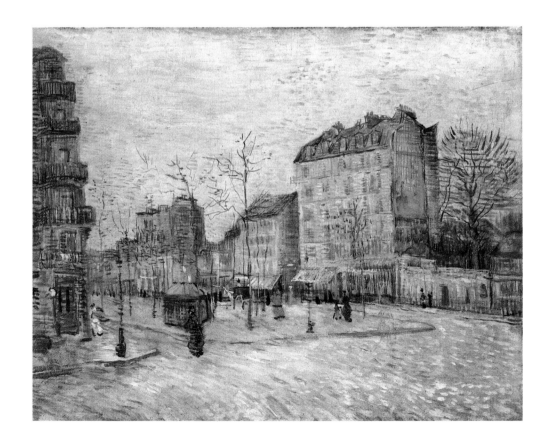

Boulevard de Clichy
Paris, February-March 1887
Oil on canvas, 45.5 x 55 cm
F 292, JH 1219
Amsterdam, Rijksmuseum Vincent van
Gogh, Vincent van Gogh Foundation

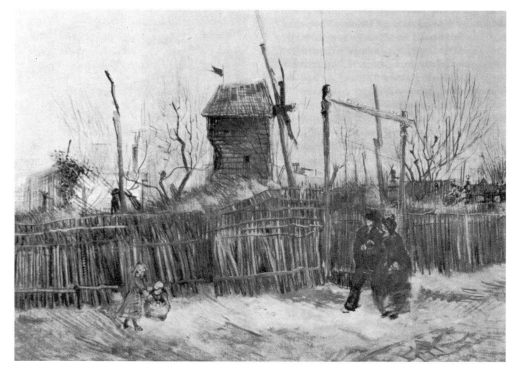

Street Scene in Montmartre
Paris, Spring 1887
Oil on canvas, 46 x 61 cm
No F Number, JH 1240
Copenhagen, Private collection

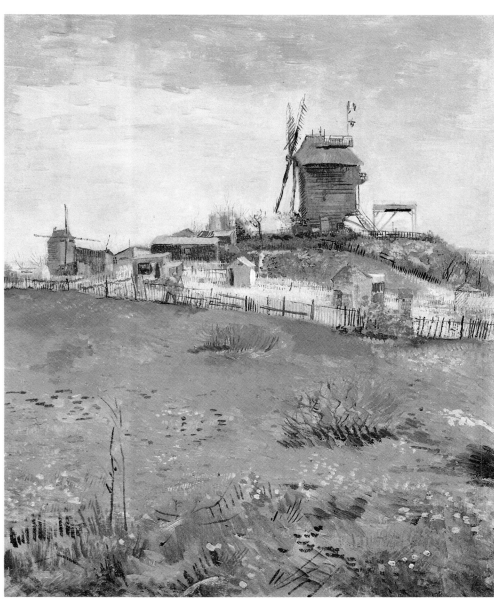

Le Moulin de la Galette
Paris, March 1887
Oil on canvas, 46 x 38 cm
F 348a, JH 1221
Pittsburgh, Museum of Art,
Carnegie Institute

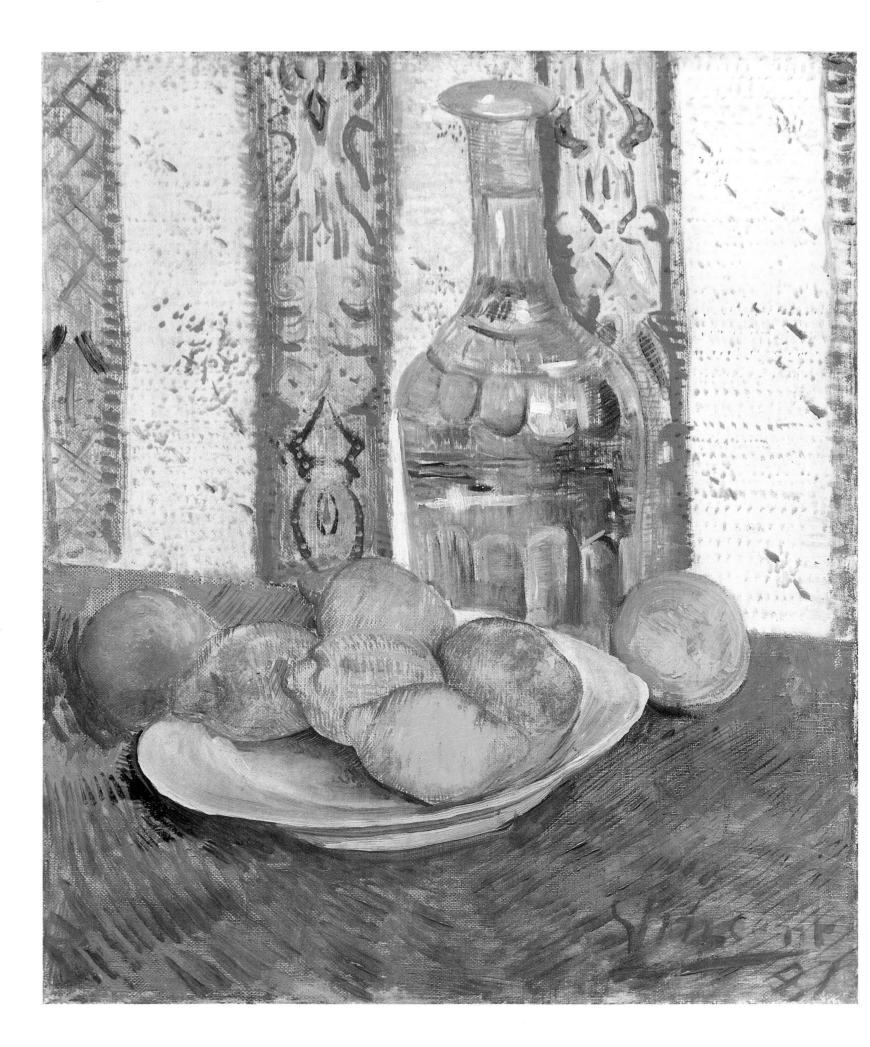

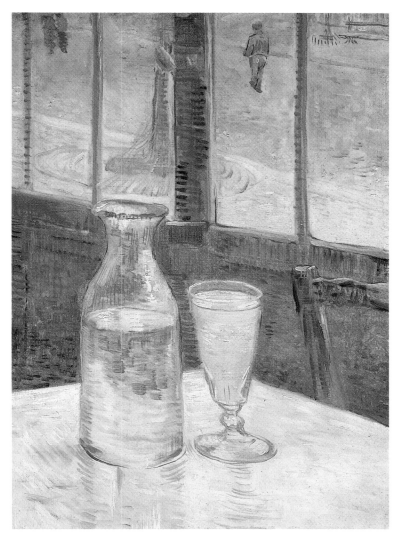

Still Life with Absinthe
Paris, Spring 1887
Oil on canvas, 46.5 x 33 cm
F 339, JH 1238
Amsterdam, Rijksmuseum Vincent van
Gogh, Vincent van Gogh Foundation

Flowerpot with Chives
Paris, March-April 1887
Oil on canvas, 31.5 x 22 cm
F 337, JH 1229
Amsterdam, Rijksmuseum Vincent van
Gogh, Vincent van Gogh Foundation

**Still Life with Decanter and Lemons on
a Plate**
Paris, Spring 1887
Oil on canvas, 46.5 x 38.5 cm
F 340, JH 1239
Amsterdam, Rijksmuseum Vincent van
Gogh, Vincent van Gogh Foundation

tential unease had not left him, but perhaps because of that he was all
the readier to enter into the spirit of bright, urbane rationalism. His
weltschmerz cast aside for the moment, he opened his heart to all the
new impressions. Only seven letters survive from the two years in Paris,
for the obvious reason that his principal addressee, Theo, no longer
needed to be written to – they could talk again at last. But there was
another reason, too: van Gogh's existential compulsion to account for
himself and thus reassure himself had slackened. Now, he was deriving
his sense of identity simply from making his own distinctive contribu-
tion to the life of Paris. The hymn-like tone of his letter to Lievens bears
eloquent witness to his sense of belonging, his new sense of security.

For exactly two years, from February 1886 to 1888, Vincent went
about the business of catching up on modern times. He learnt the ways
of the city as rapidly as the new aesthetics; his human qualities and
cognitive powers were both considerable. When he finally left, Theo
wrote sadly to his sister: "When he arrived here two years ago I would
never have thought that we could become so close. Now that I am on my
own again I feel the emptiness in my home all the more. It is not easy to
fill the place of a man like Vincent. His knowledge is vast and he has a
very clear view of the world. I am convinced that if he has a few more

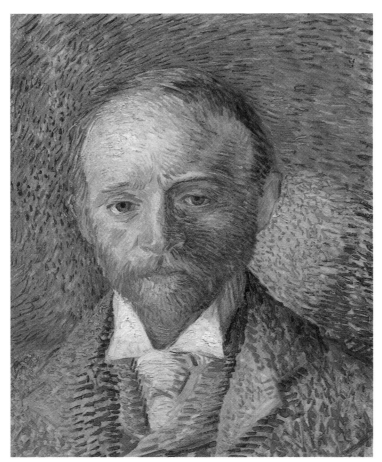

years he will make a name for himself. Through him I got to know a number of painters who value him highly. He is one of the pioneers of the new ideas, or rather he is trying to revive ideas that have been falsified in routine everyday life and have lost their lustre. And he has such a good heart, too, and is forever trying to do things for others. All the worse for those who do not want to know or understand him."

For years, Theo had felt a sense of family responsibility for Vincent; he had taken for granted that he should help his needy brother. It was only when he was carrying out this duty within the same four walls, with Vincent living at his home, that he truly began to see Vincent's personality. In the process a caring paternalism was replaced by closer personal relations; he discovered a man of integrity, and they became intimates. His brother's moods fascinated him, and he saw them as the mark of an artistic temperament. "It is as if two people dwelt within him", Theo had complained a year previously, "one of them marvellously talented, refined and tender, the other selfish and hard-hearted! They appear alternately, and in consequence he can be heard expressing one opinion one time and a quite different one the next – always with arguments for and against." What looked like inconsistency in Vincent could be seen as a paradoxical streak once his artistic nature had been accepted. After a number of disputes, Theo came to recognise this streak as an integral part of his brother's worldview – fundamentally the only view that could cope with modern times.

Portrait of the Art Dealer Alexander Reid
Paris, Spring 1887
Oil on cardboard, 41.5 x 33.5 cm
F 343, JH 1250
Glasgow, Glasgow Art Gallery and Museum

Woman Sitting in the Grass
Paris, Spring 1887
Oil on cardboard, 41.5 x 34.5 cm
F 367, JH 1261
New York, Private collection

Fritillaries in a Copper Vase
Paris, April-May 1887
Oil on canvas, 73.5 x 60.5 cm
F 213, JH 1247
Paris, Musée d'Orsay

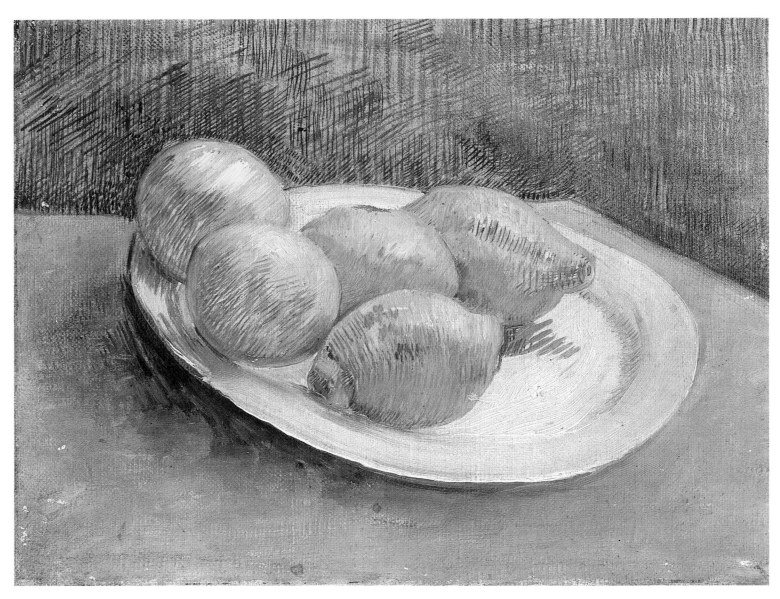

Still Life with Lemons on a Plate
Paris, March-April 1887
Oil on canvas, 21 x 26.5 cm
F 338, JH 1237
Amsterdam, Rijksmuseum Vincent van
Gogh, Vincent van Gogh Foundation

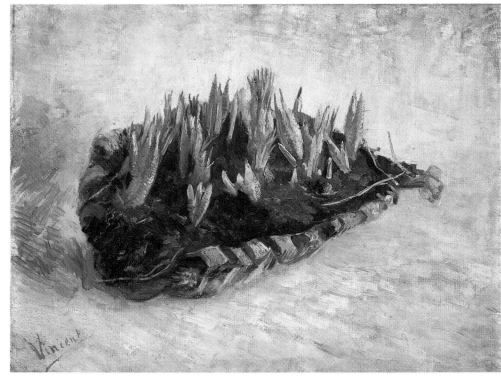

Still Life with a Basket of Crocuses
Paris, March-April 1887
Oil on canvas, 32.5 x 41 cm
F 334, JH 1228
Amsterdam, Rijksmuseum Vincent van
Gogh, Vincent van Gogh Foundation

A Plate of Rolls
Paris, first half of 1887
Oil on canvas, 31.5 x 40 cm
F 253a, JH 1232
Amsterdam, Rijksmuseum Vincent van
Gogh, Vincent van Gogh Foundation

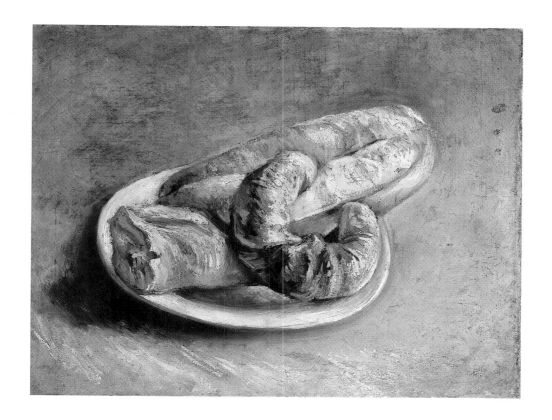

Vase with Flowers, Coffeepot and Fruit
Paris, Spring 1887
Oil on canvas, 41 x 38 cm
F 287, JH 1231
Wuppertal, Von der Heydt-Museum

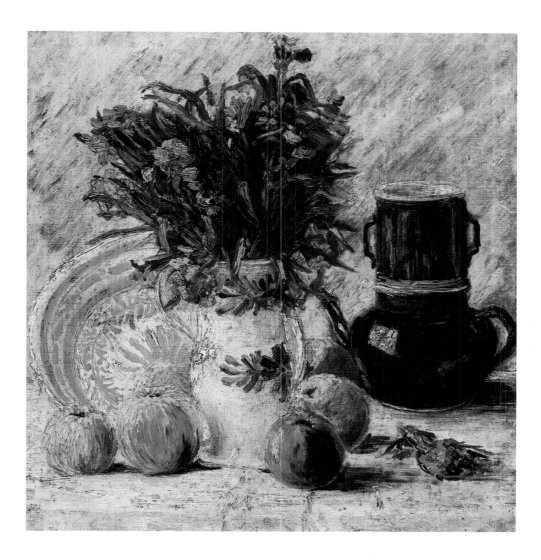

Theo was the person to whom Vincent related most closely. Once he had Theo's approval, he felt strengthened; and the pictures he painted were more cheerful and accessible. He knew he had quirky ways, but it now seemed that they were a kind of badge, and he fitted the societal stereotype of the difficult, temperamental artist perfectly. He also found support among the dreamers and reformers out to change the world, who were every bit as eccentric, enthusiastic and unknown as he was. He entered artistic circles, debating till the small hours, and proclaimed his opinions even if no one had asked them. Everyone who was still waiting for the breakthrough believed himself really one of the elite; and in Paris van Gogh saw the necessity of the outsider's life if a man was to achieve greatness as an artist.

Initially, Paris was merely the sequel to Antwerp. Some time in 1886 (the exact date is disputed) he matriculated at a private art college run by Fernand-Anne Piestre, called Cormon. Cormon was a history painter

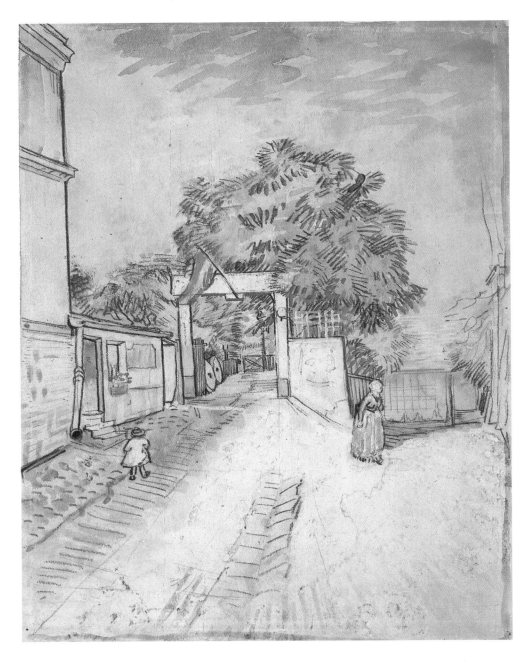

The Entrance of a Belvedere
Paris, Spring 1887
Watercolour, 31.5 x 24 cm
F 1406, JH 1277
Amsterdam, Rijksmuseum Vincent van Gogh, Vincent van Gogh Foundation

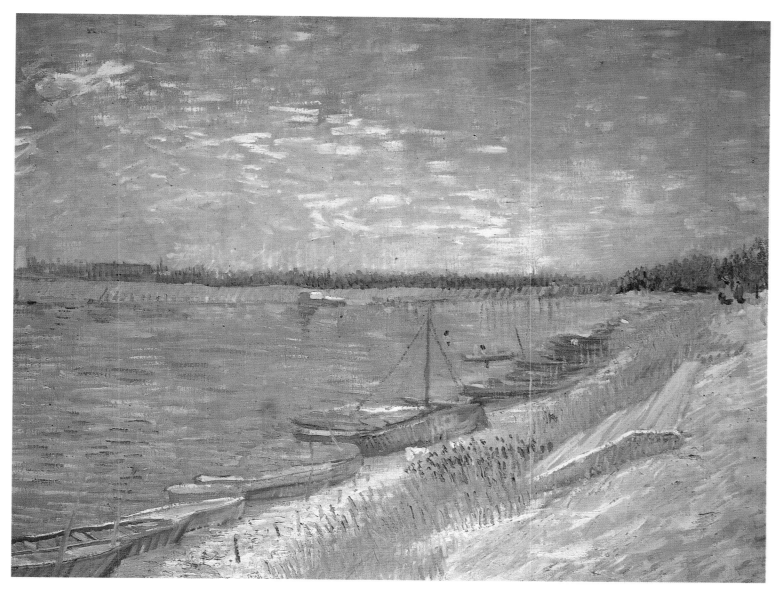

View of a River with Rowing Boats
Paris, Spring 1887
Oil on canvas, 52 x 65 cm
F 300, JH 1275
Aberdeen, Collection William Middleton

whose archaeological detail could be seen as an evasion (by substituting scholarly precision) of the debate on the contemporaneity of Art. In 1880 his monumental painting of Cain fleeing (now in the Musée d'Orsay, Paris) had caused a sensation; it showed a group of ragged vagabonds in a desolate region – but these people were not tramps, they were Biblical characters. This man would certainly be able to teach van Gogh how to work in a conventional, craftsmanlike way and still attract attention ...

Of greater importance for van Gogh, though, were the friendships he presently struck up with fellow-students who were admittedly a full ten years younger and lacked his experience of life but nevertheless were at a comparable level in their artistic training. Louis Anquetin, Emile Bernard and Henri de Toulouse-Lautrec were among them. They smoothed van Gogh's access to the art world, and soon he found theorizing more interesting than the dull routine of drawing plaster figures. Cormon's art school was van Gogh's last chance to acquire a basic grounding in the academic mysteries; but he did not stay long. Van Gogh chose not to bother with the corrective value of time-honoured

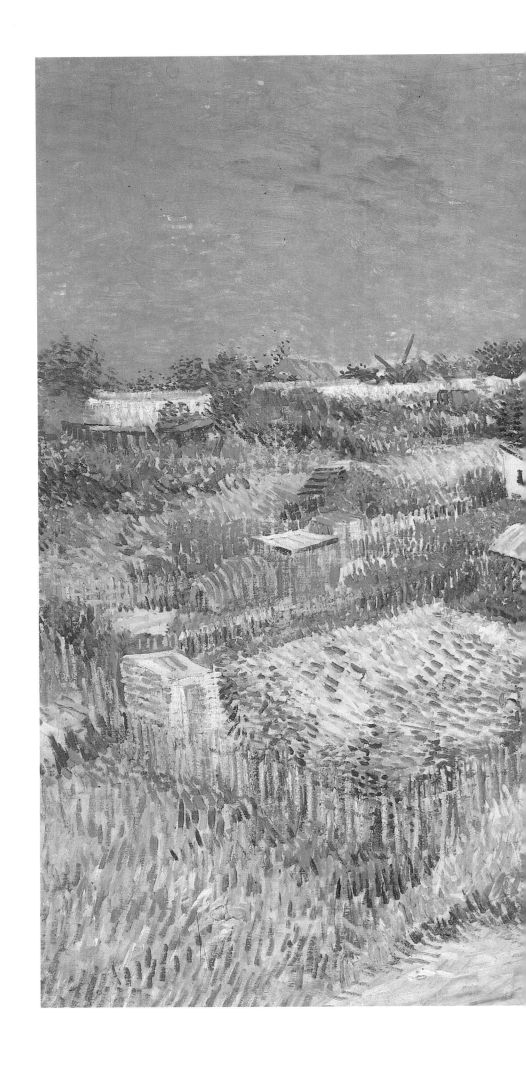

Vegetable Gardens in Montmartre:
La Butte Montmartre
Paris, June-July 1887
Oil on canvas, 96 x 120 cm
F 350, JH 1245
Amsterdam, Stedelijk Museum

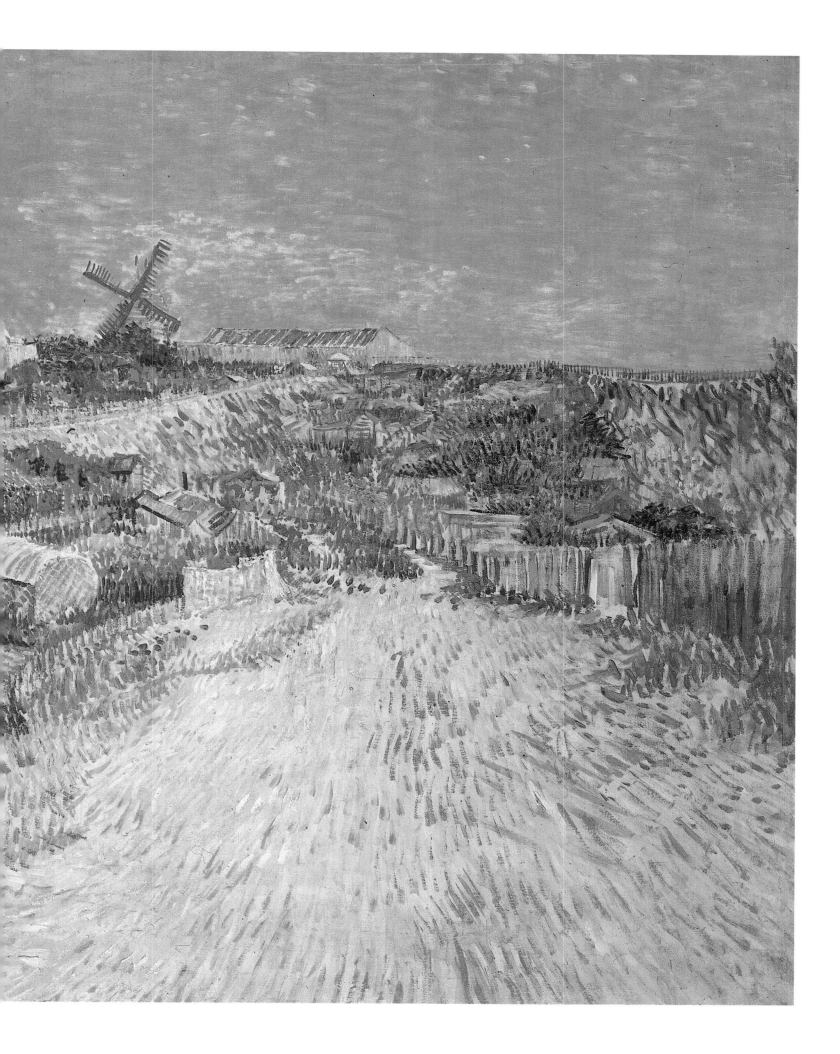

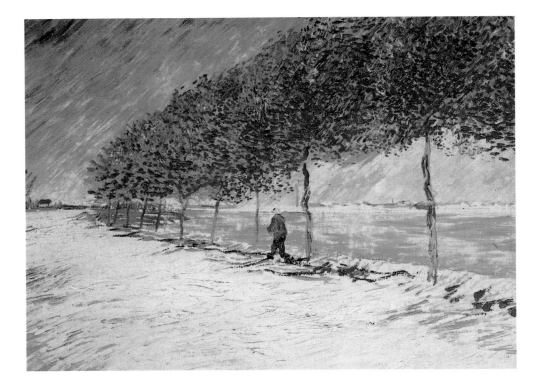

**Walk along the Banks of the
Seine near Asnières**
Paris, June-July 1887
Oil on canvas, 49 x 65.5 cm
F 299, JH 1254
Amsterdam, Rijksmuseum Vincent van
Gogh, Vincent van Gogh Foundation

technique, a corrective which his youthful friends were accepting and
which left them, after the late-night café discussions, in the conven-
tional craftsman's rut. Van Gogh preferred to take his bearings from
theory again. He was too much a part of the art scene for his ideas to be
labelled those of an autodidact; rather, in acquiring a grip on modern
thought he was quite simply capable of assimilating more rapidly than
others. And he wanted to paint in the way he knew how, the way he had
learnt from all his discussions and all the exhibitions. As for his techni-

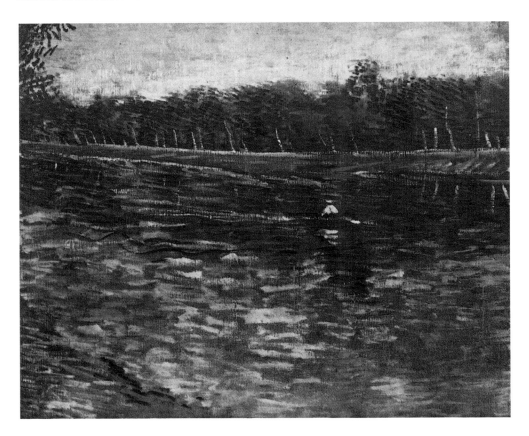

The Seine with a Rowing Boat
Paris, Spring 1887
Oil on canvas, 55 x 65 cm
F 298, JH 1257
Paris, Private collection

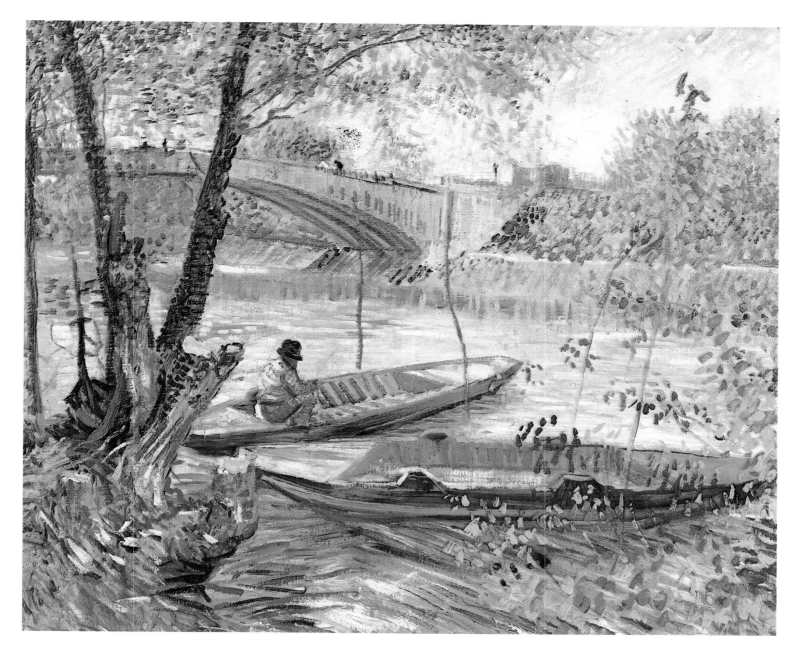

Fishing in the Spring, Pont de Clichy
Paris, Spring 1887
Oil on canvas, 49 x 58 cm
F 354, JH 1270
Chicago, The Art Institute of Chicago

cal skills, his strength was not so much a steady hand as a forceful will and a clear eye. So all his works are ad hoc creations, impetuously done, scarcely finished, and often bearing telltale signs of effort. When van Gogh adapted the various styles that were currently in vogue, he did so (it seems fair to say) without the charm or distinction that a Claude Monet or a Paul Gauguin, a Georges Seurat or a Toulouse-Lautrec all had in common, wilful as they might sometimes be.

"If you wish", Theo wrote to his brother after Vincent had departed for the south (Letter T3), "you can do something for me: you can continue doing what you have already done, and establish a circle of artists and friends, which I am quite incapable of doing on my own; since you came to France you have succeeded, more or less, in establishing a circle of that kind." Apparently Vincent was able to help Theo in his career as an art dealer. Theo's reputation as a specialist in the work of young artists, one of whom was his own brother, was growing. "Theo

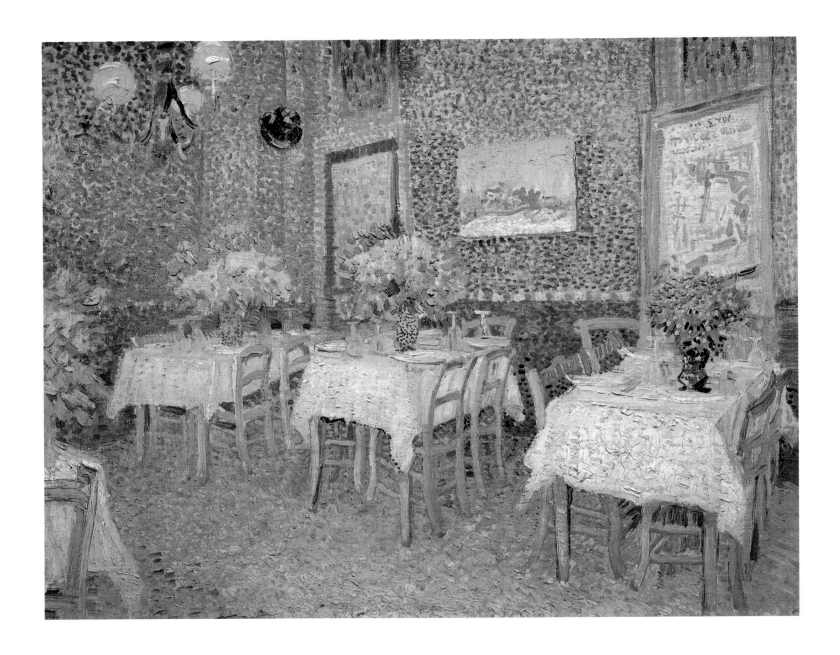

van Gogh", Gustave Kahn, one of their major theorists, later wrote, "was pale, fair-haired and melancholy. There was nothing loud in his ways. But this dealer was an excellent critic, and as an art expert would join in discussions with painters and writers." Gauguin was one of those who benefitted from the newly outward-going optimism of the brothers as they went their way amidst the throngs of would-be artists, lending each other support; it was Theo who first made a name for their mutual acquaintance.

It was Vincent's job to make contacts. His success in this cannot be accounted for by the exotic appeal of his out-of-town appearance alone. Experienced fellow-artists found him likable, and he established friendships with Bernard and with Paul Signac that lasted beyond the Paris years; there must have been a deeper reason for this. Van Gogh had quite intuitively (that is, in a less *voulu* manner than his friends) adopted a lifestyle that was then *de rigueur* for avant-garde artists. Naively (as it

Interior of a Restaurant
Paris, June-July 1887
Oil on canvas, 45.5 x 56.5 cm
F 342, JH 1256
Otterlo, Rijksmuseum Kröller-Müller

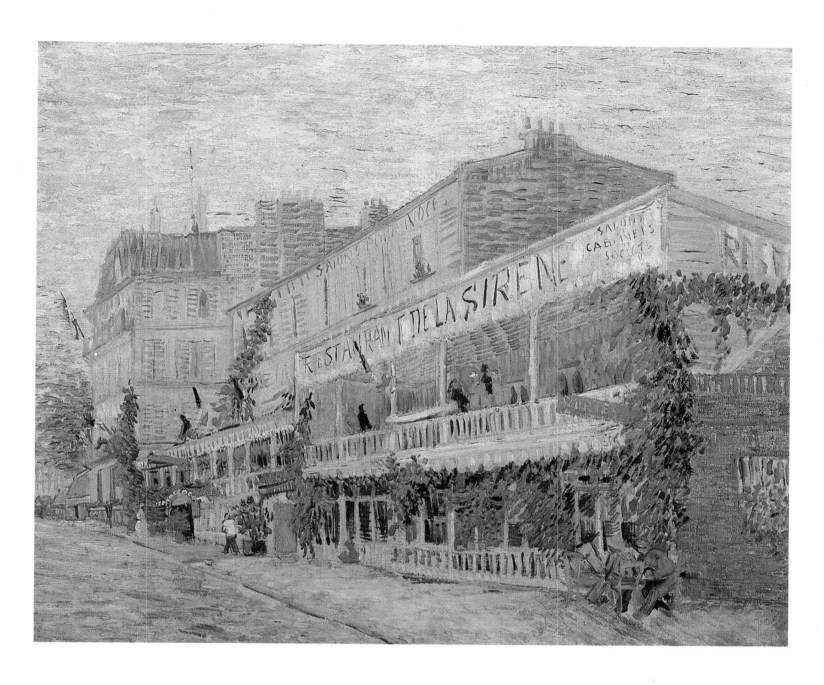

Restaurant de la Sirène at Asnières
Paris, Summer 1887
Oil on canvas, 54 x 65 cm
F 313, JH 1251
Paris, Musée d'Orsay

seemed) van Gogh had harmonized in his own behaviour traits that seemed forced or over the top when others tried them: he had reconciled artificiality and day-to-day ordinariness, the sense of vocation and life on the social periphery, conviction and playfulness, Art and Life. For two years, van Gogh was in the artistic swim, watching a scene that was infatuated with itself; and if he did not produce paintings of extraordinary importance during that time, at least his effortless ability to personify that scene's ideal of natural and deliberately aestheticized life at one and the same time made a vital contribution to the progress of modern art.

The Rispal Restaurant at Asnières
Paris, Summer 1887
Oil on canvas, 72 x 60 cm
F 355, JH 1266
Shanwee Mission (Kans.), Collection
Henry W. Bloch

Lane in Voyer d'Argenson Park at Asnières
Paris, Spring 1887
Oil on canvas, 59 x 81 cm
F 276, JH 1259
New Haven (Conn.), Yale University Art
Gallery

Through the Window
1886

Van Gogh painted almost 230 paintings during his stay in Paris, more than in any other comparable period of his life. This work is more diverse in character, the frank record of two years of continual experiment. In Paris, van Gogh put the rootedness of his apprentice years behind him. In terms of energy, what he accomplished is amazing; though of course speed, and ingenious touches, could not be as important as steady work. The theories van Gogh had adumbrated in the last letters he wrote from Nuenen were still far from being visible in his practice, and he was to spend the whole of 1886 putting the finishing touches to his early work. It took him several months before he could launch off in a new artistic direction. Van Gogh was still travelling with a good deal of the baggage he had picked up as he started on the artist's life, and could not simply throw it away in his new milieu. The main features of his Dutch output remained.

Those features might be characterized, in a word, as 'realistic'. Realism was a label that covered a multitude of artistic approaches, and still

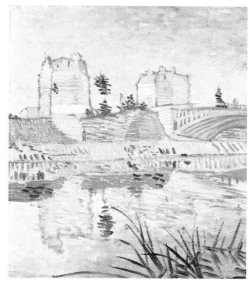

The Seine with the Pont de Clichy
Paris, Summer 1887
Oil on canvas, 54 x 46 cm
F 303, JH 1323
Private collection
(Sotheby's Auction, New York, 10. 5. 1988)

Vegetable Gardens at Montmartre
Paris, Summer 1887
Oil on canvas, 81 x 100 cm
F 316, JH 1246
Amsterdam, Rijksmuseum Vincent van Gogh, Vincent van Gogh Foundation

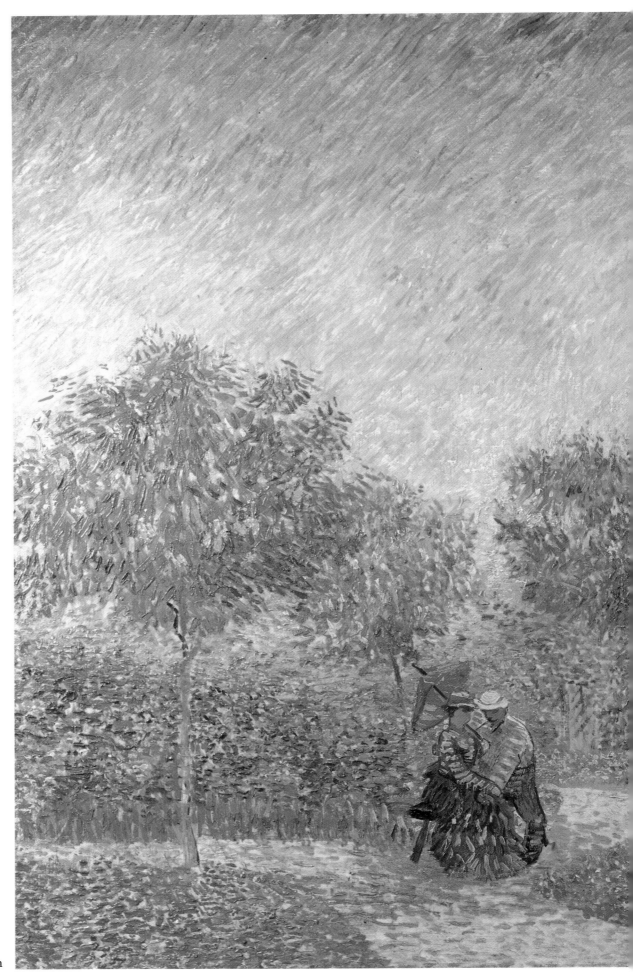

**Couples in the
Voyer d'Argenson
Park at Asnières**
Paris, June-July 1887
Oil on canvas,
75 x 112.5 cm
F 314, JH 1258
Amsterdam, Rijksmuseum
Vincent van Gogh,
Vincent van Gogh Foundation

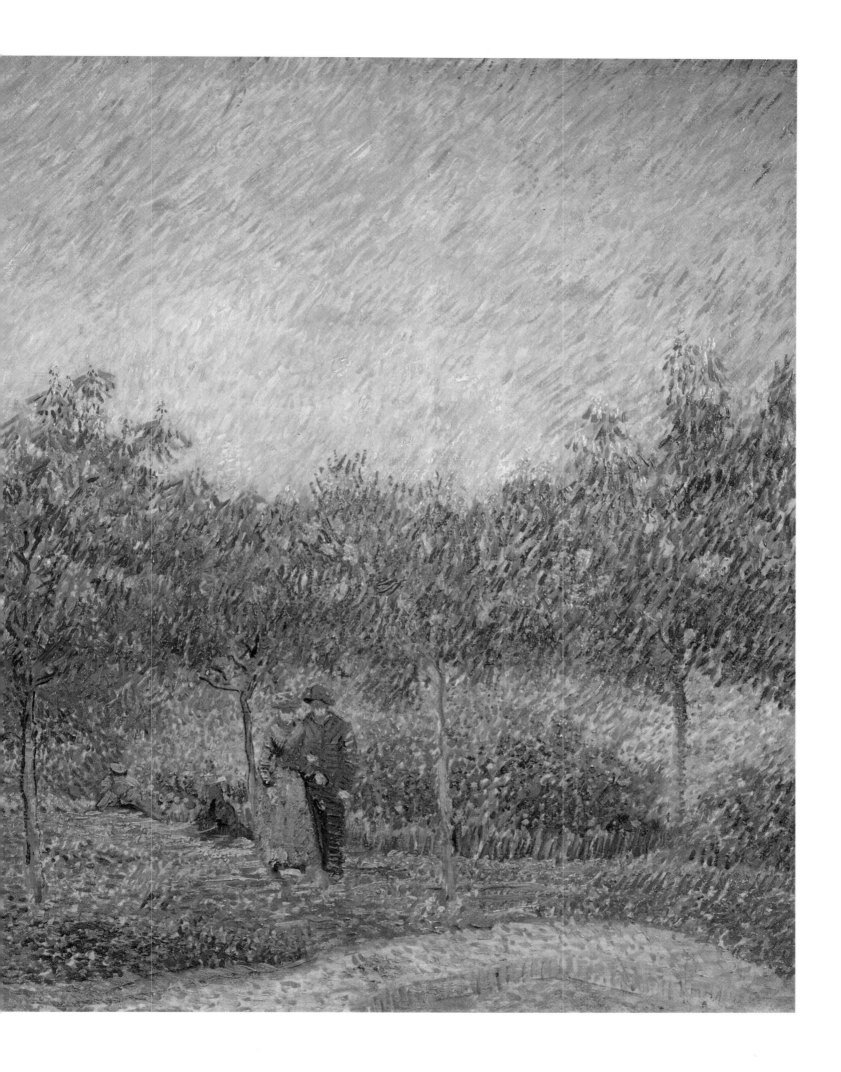

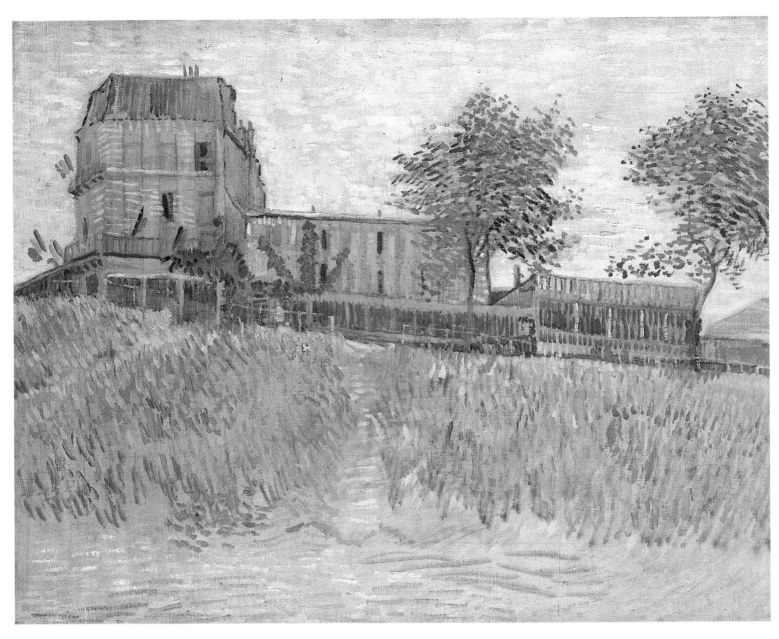

The Restaurant de la Sirène at Asnières
Paris, Spring 1887
Oil on canvas, 51.5 x 64 cm
F 312, JH 1253
Oxford, Ashmolean Museum

is; but, vague as the term may be, it can be helpful in trying to assess the diversity of van Gogh's oeuvre. Realism implies first and foremost a willingness to trust what is out there, what can be seen by the eye in everyday life. "First I draw a rectangle, of any size at all, on the surface where I am going to paint, and this I see as a window through which I can see what is to be painted." Trust in what the eye could see was the cornerstone of all painting according to *Della pittura* [*On painting*] (1435), a treatise by the Italian architect and aesthetics theorist Leon Battista Alberti. Ever since, the image of pictures as windows onto life had been used to vindicate inclusive presentation of the sheer plurality of phenomena and equally to sensitize responses to the near and the far, both the horizon and the detail seen close-up. Alberti was the first to formulate a principle that applied to all art after the Middle Ages: pictures were directly linked to the natural appearance of the world, and their qualities were to be assessed in proportion to their mimetic success. In this sense, van Gogh was a realist. His paintings were windows

The Seine Bridge at Asnières
Paris, Summer 1887
Oil on canvas, 53 x 73 cm
F 240, JH 1268
Houston, Collection Dominique de Menil

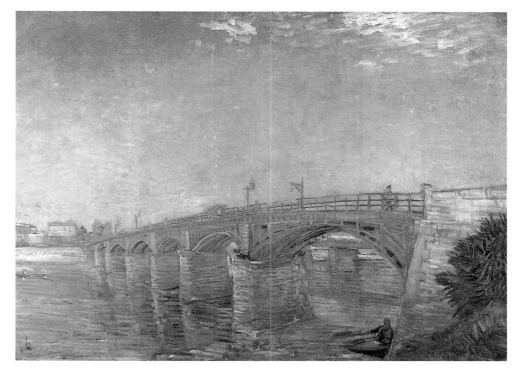

onto the visible world. But increasingly (this is a point we shall be returning to) he was to be looking through tinted, darkened glass.

In the mid-19th century, the sociocritical pathos of Courbet and his disciples had made realism a programmatic position. The artist's eye was merciless; the reality he saw was rendered without any prettifying. Art took the side of the awkward angles of life that academic ornamentalism had smoothed out of existence. The new heroes were workers, beggars, and all the have-nots – the masses who had been given worthy literary treatment in Victor Hugo's *Les Misérables* for the first time. The Realist School (so said their principal propagandist Jules-Antoine Castagnary) "sees Art as an expression of every aspect and every level of Life; its pre-eminent aim is to reproduce the power and vividness of

The Banks of the Seine
Paris, May-June 1887
Oil on canvas, 32 x 46 cm
F 293, JH 1269
Amsterdam, Rijksmuseum Vincent van Gogh, Vincent van Gogh Foundation

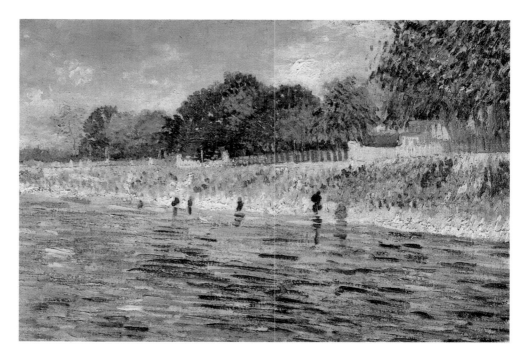

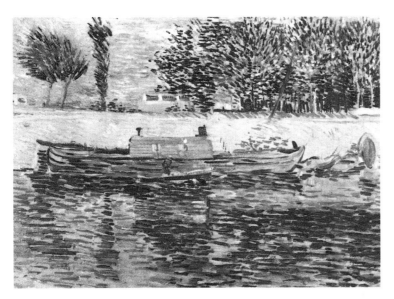

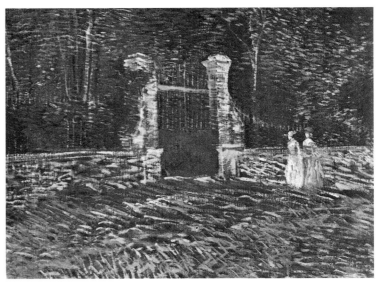

The Banks of the Seine with Boats
Paris, Spring 1887
Oil on canvas, 48 x 55 cm
F 353, JH 1271
Private collection
(Christie's Auction, New York, 15. 5. 1979)

Entrance of Voyer d'Argenson Park at Asnières
Paris, Spring 1887
Oil on canvas, 55 x 67 cm
F 305, JH 1265
Private collection

A Woman Walking in a Garden
Paris, June-July 1887
Oil on canvas, 48 x 60 cm
F 368, JH 1262
United States, Collection E. J. Bowes

Edge of a Wheatfield with Poppies
Paris, Spring 1887
Oil on canvas on cardboard, 40 x 32.5 cm
F 310a, JH 1273
Japan, Private collection

BOTTOM LEFT:
Lane in Voyer d'Argenson Park at Asnières
Paris, June-July 1887
Oil on canvas on cardboard, 33 x 42 cm
F 275, JH 1278
Amsterdam, Rijksmuseum Vincent van
Gogh, Vincent van Gogh Foundation

Nature as forcefully as possible; it is Truth allied to Knowledge. Through its interest in rural life (which it has already proved able to present strikingly) and city life (which promises triumphs for the future), it is attempting to encompass every aspect of the visible world. In placing the artist squarely at the heart of his times and requesting him to mirror them, it is defining the true meaning and thus the moral mission of Art."

The same moral earnest, the same emphatic directness, was apparent in the manifesto van Gogh had already painted, *The Potato Eaters*. Ugliness was a token of involvement, expressive élan a means of locating the truth. Some of the best works done in his Dutch period show van Gogh to have been a committed realist. His devotion to the soil and above all to the simple, careworn people who lived off the land, and their poor homes, was essential to the dignity that is in these portraits and interiors. Courbet's creed might have been penned by van Gogh in one of his letters: "In this civilized society of ours I need to sense what the life of a savage is like; I even have to shake free of governments. My feelings are with the people; it is to the people that I must turn, and from them that I must draw my knowledge and my vitality." Courbet's practice established the concept of the *peintre ouvrier*, the painter as worker, as wage-earner. Van Gogh surely lived ont the role far more thoroughly than Courbet, though, and more expressively than other realists of the Millet or Breton brand, too – more expressively, yet in the total obscurity of the provinces.

If realism meant mimetic imitation of the given world of phenomena, and was by extension an aesthetic programme, the concept also em-

Trees in a Field on a Sunny Day
Paris, Summer 1887
Oil on canvas, 37.5 x 46 cm
F 291, JH 1314
Amsterdam, P. and N. de Boer Foundation

braced a third area: a method of direct approach to objects, a certain immediacy in the painter's confrontation of his subject. Realism, in this sense of an artistic method, remained van Gogh's watchword after he moved to the city. Seen in these terms, his entire output of 1886 was realistic.

In *Lane at the Jardin du Luxembourg* (p. 157) we find the artist among people out for a stroll on a summer's day. The scene is a tranquil one, flooded with bright sunlight. The people are strolling along the shady lane or sitting on the park benches watching the world go by. The painter can feel quite at home in this environment; there is room for his easel and he can expect to remain undisturbed as he observes people at

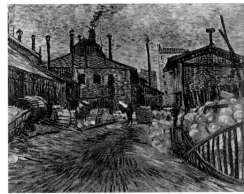

The Factory at Asnières
Paris, Summer 1887
Oil on canvas, 46.5 x 54 cm
F 318, JH 1288
Merion Station (Pa.), The Barnes
Foundation
(Reproduction in colour not permitted)

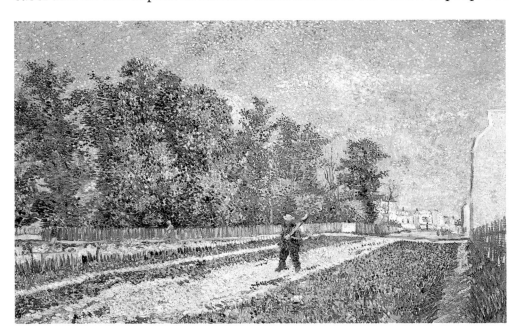

**Outskirts of Paris: Road with Peasant
Shouldering a Spade**
Paris, June-July 1887
Oil on canvas, 48 x 73 cm
F 361, JH 1260
Fort Worth (Tex.), Collection Karen Carter
Johnson

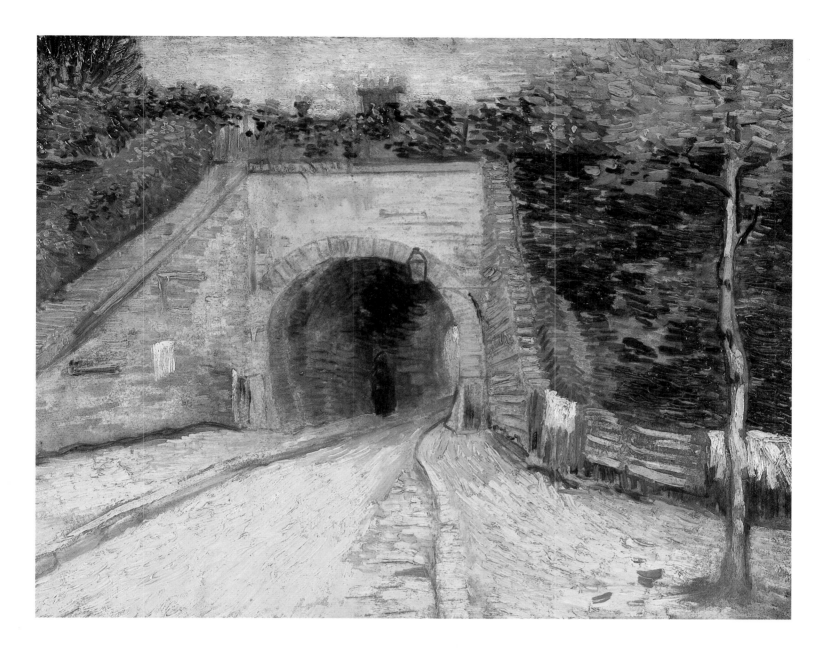

their Sunday pleasures. Even the seemingly inevitable woman in black (at left) is carrying a cheerful red parasol; she is simply a woman out for a stroll, conceived in that unforced, impartial spirit that can so often be the first casualty when van Gogh tries to inject significance into his subjects. Van Gogh has gladly acquiesced in the visual stimuli of the scene, taking his own pleasure in the colourful given world. His gaze is a semi-distant one, rendered in cheerful tones that have an Impressionist immediacy.

Trusting in what he saw with his own eyes, and believing that what he saw could be transferred with scarcely any reworking to the canvas, van Gogh created in this Jardin du Luxembourg scene one of his most attractive 'realistic' paintings. His symbolism, which could often seem forced, is still present in the picture, but it seems to have been quietly absorbed into it, without fuss, to create a new organic unity. "This hermit", Baudelaire had written about his painter of modern life, Guys, "gifted with an active imagination, forever travelling the 'great desert of

Roadway with Underpass (The Viaduct)
Paris, Spring 1887
Oil on canvas, 31.5 x 40.5 cm
F 239, JH 1267
New York, The Solomon R. Guggenheim Museum, Justin K. Thannhauser Collection

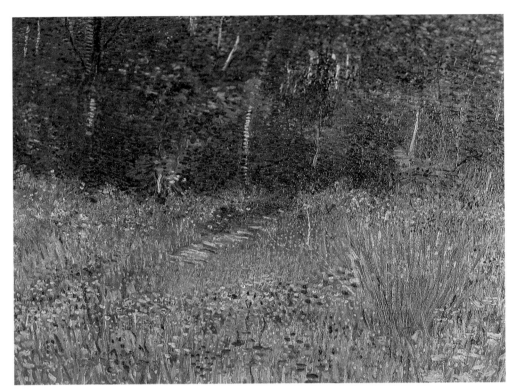

Park at Asnières in Spring
Paris, Spring 1887
Oil on canvas, 50 x 65 cm
F 362, JH 1264
Laren (Netherlands), Singer Museum (on loan from private collection)

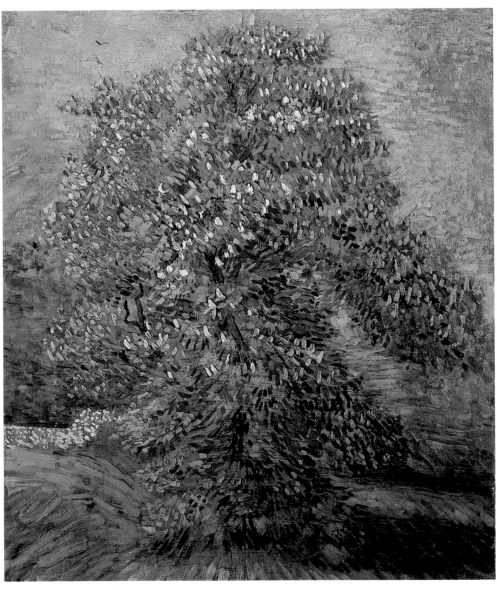

Chestnut Tree in Blossom
Paris, May 1887
Oil on canvas, 56 x 46.5 cm
F 270a, JH 1272
Amsterdam, Rijksmuseum Vincent van Gogh, Vincent van Gogh Foundation

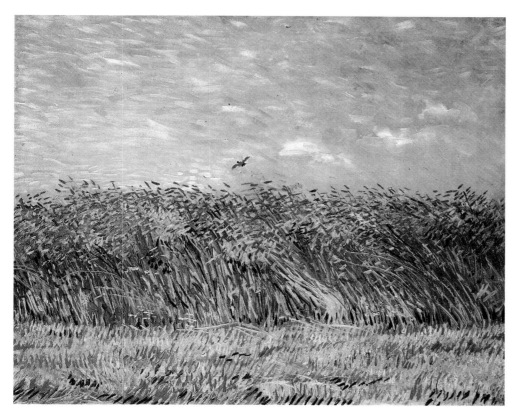

Wheat Field with a Lark
Paris, Summer 1887
Oil on canvas, 54 x 65.5 cm
F 310, JH 1274
Amsterdam, Rijksmuseum Vincent van
Gogh, Vincent van Gogh Foundation

Pasture in Bloom
Paris, Spring 1887
Oil on canvas, 31.5 x 40.5 cm
F 583, JH 1263
Otterlo, Rijksmuseum Kröller-Müller

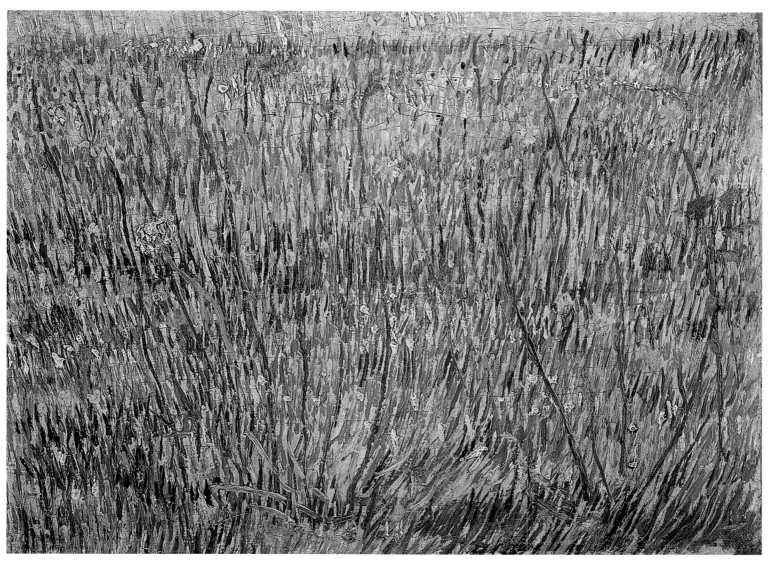

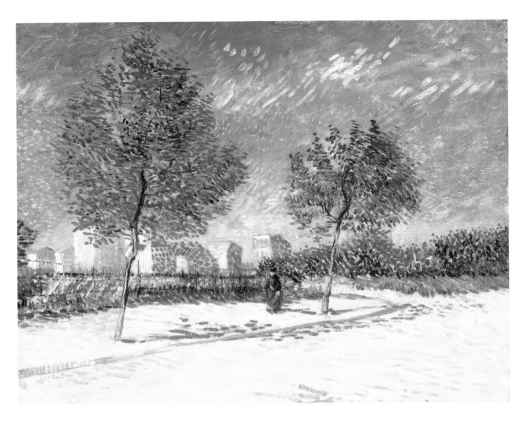

On the Outskirts of Paris
Paris, Spring 1887
Oil on canvas, 38 x 46 cm
F 351, JH 1255
United States, Private collection
(Sotheby's Auction, New York, 18.11.1986)

mankind', has a loftier goal than some idler, a different and broader aim than the fleeting pleasures of the moment. He is after that something which I shall venture to call 'modernity'.

For him, the issue at stake is to isolate the poetic quality in the merely historical, the eternal in the passing." Van Gogh had always made his approach from an eternal, poetic angle. Now (rapidly travelling the artistic line of evolution from Romanticism to Impressionism) he discovered the expressive power of the fleeting moment, of the flux of life. These pictures are not without depth; but it becomes increasingly

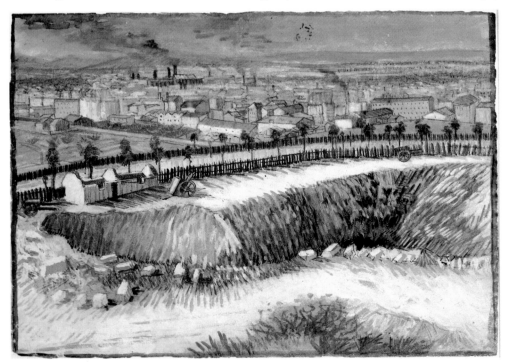

Outskirts of Paris near Montmartre
Paris, Summer 1887
Watercolour, 39.5 x 53.5 cm
F 1410, JH 1286
Amsterdam, Stedelijk Museum

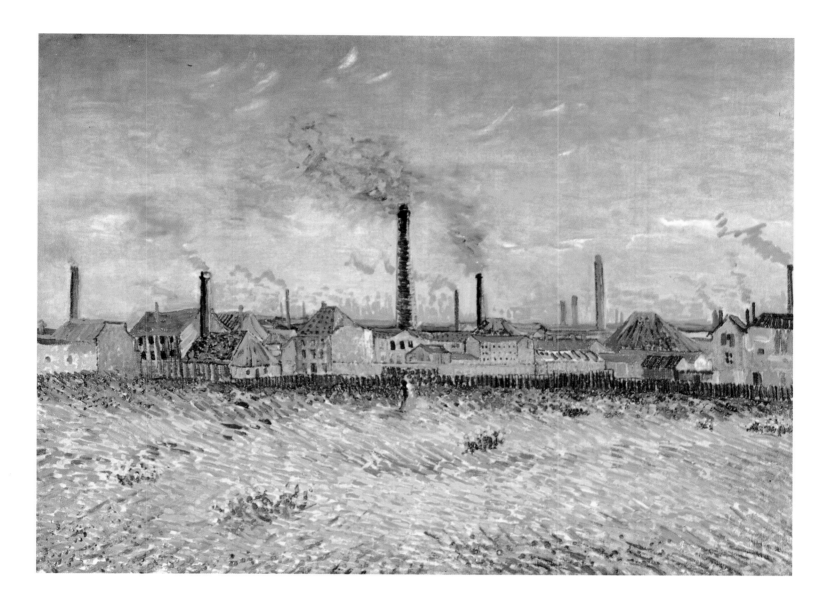

difficult to see past the recording of the moment to the timeless depths
beyond. Baudelaire had called this 'modern'. And that was the very
quality van Gogh was trying to make his own during 1886.

 He also found symbols in the evidence of his eyes when he saw the
three mills on Montmartre. Anomalous relics of a rural age within the
city limits, the mills had become a popular place to go on public
holidays; but doubtless they also reminded van Gogh of his homeland.
One was the Moulin de la Galette, the garden restaurant immortalized
by Pierre Auguste Renoir. Van Gogh's approach was altogether differ-
ent. His attention was fixed not on the coffee-drinkers and dancers but
on plain topography and architecture. In *Montmartre: Quarry, the Mills*
(pp. 196 and 197) he offers a panoramic view of a moment of almost rural
seclusion; his treatment emphasizes the mills' proud position atop the
hill and directs our gaze away from the encroachments of the city. Van
Gogh and his brother were living in a flat not far from the spot where
Vincent made this attempt to see into the distance.

 There are two scarcely noticeable figures deep in conversation in the
second of these deserted landscapes – van Gogh's typically significant

**Factories at Asnières Seen from the Quai de
Clichy**
Paris, Summer 1887
Oil on canvas, 54 x 72 cm
F 317, JH 1287
St. Louis, The Saint Louis Art Museum

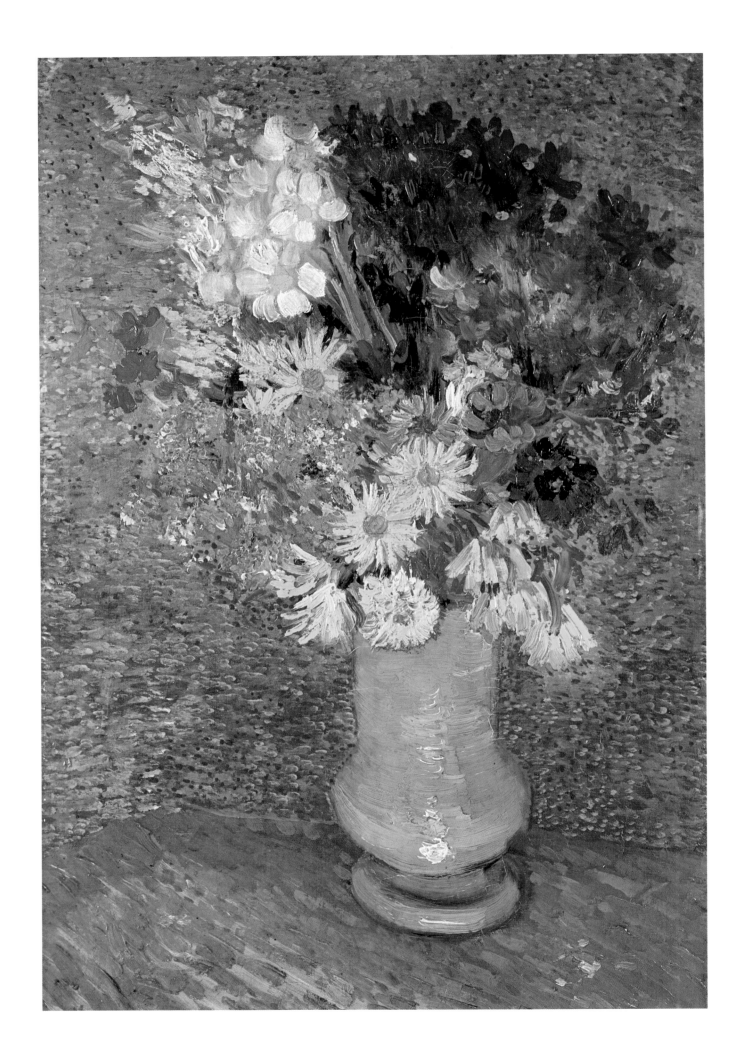

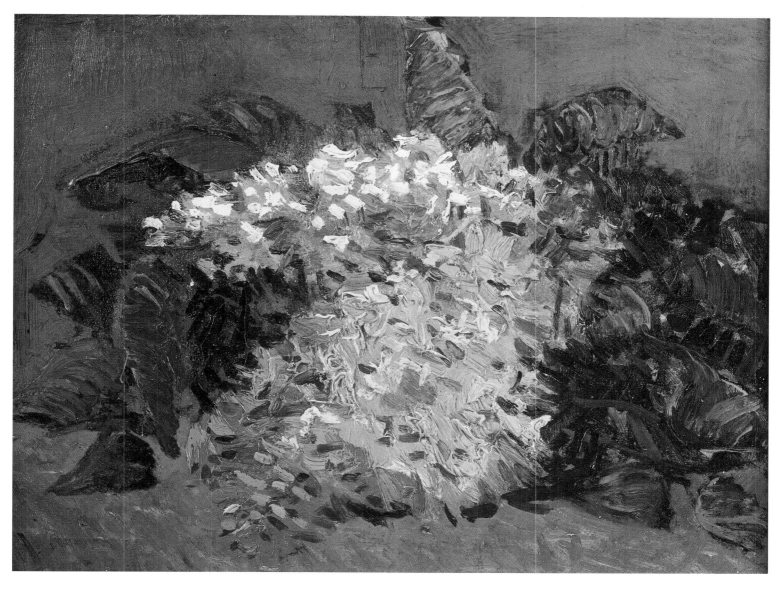

Lilacs
Paris, Summer 1887
Oil on canvas, 27.3 x 35.3 cm
F 286b, JH 1294
Los Angeles, The Armand Hammer
Museum of Art

Vase with Daisies and Anemones
Paris, Summer 1887
Oil on canvas, 61 x 38 cm
F 323, JH 1295
Otterlo, Rijksmuseum Kröller-Müller

personae, dark and anonymous, lending a touch of the mysterious to familiar surroundings. "When a painter goes out into the open country to do a study he tries to copy what he sees as exactly as possible. It is only later, in his studio, that he permits himself to rearrange Nature and introduce attributes that may be to some extent absurd. Realism leaves it at the first of these steps and disapproves of compositions that do not tell the truth." This account of 'realistic' treatment of Nature (by Hippolyte Castille, one of the spokesmen of the new response to the world) can serve as a yardstick to assess van Gogh's position. Undoubtedly he agreed with Castille in disapproving of "compositions that do not tell the truth", that used studies made on the spot as if they were more props, choosing whatever happened to suit the required effect. Van Gogh left his landscapes as the motif demanded they be painted. A *plein air* painter of a purist kind, he trusted in the fundamental effects of the light and air implicitly, and worked the atmospherics into the colours that filled his canvas. But there were times when the fascinating optical results he obtained did not satisfy him; his fondness for deep content would suspect that pleasures offered to the eye were merely superficial.

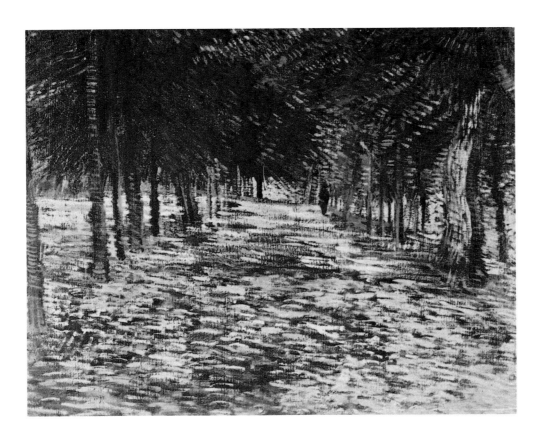

Avenue in Voyer d'Argenson Park at Asnières
Paris, Summer 1887
Oil on canvas, 55 x 67 cm
F 277, JH 1316
New York, Collection Mrs. Charles Gilman

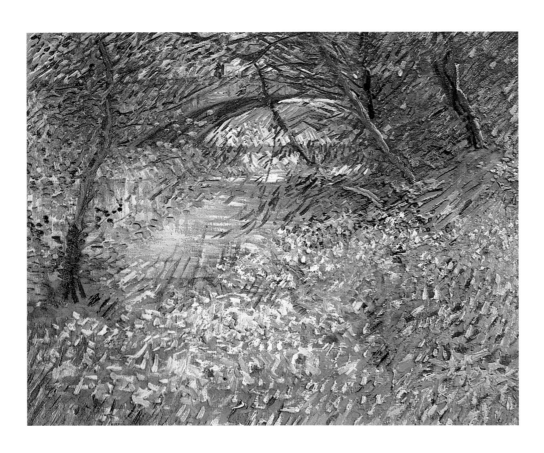

Banks of the Seine with Pont de Clichy in the Spring
Paris, June 1887
Oil on canvas, 50 x 60 cm
F 352, JH 1321
Dallas, Dallas Museum of Fine Arts

And so he would place two black figures in the quarry, or position the forebodingly dark figure of a woman outside the Moulin de la Galette (cf. pp. 188 and 189). These iconographic afterthoughts were usually added in the studio. Castille might have damned them as absurd attributes. They appear from nowhere and are of marginal or negligible importance for the overall effect; but they keep the Romantic flag flying in the trim, open, clearly-lit world of the Realists.

That world is described, or recounted, in the picture. Van Gogh's imagination was unable to kick free; instead, he shackled it with strictly mimetic rules. These rules applied principally to the brushwork and the use of colour. It was not until after 1886 that van Gogh shed his reticence about departing from a faithful, descriptive account of his subject. If we turn once more to *Montmartre: Quarry, the Mills* (p. 197) we see that van Gogh's brushwork dutifully follows the optical impression conveyed by the motif. For the sails of the windmills he uses long, thin strokes; the heaps of stone in the foreground, by contrast, are done in broad, firm strokes; the rendering of the earthy slope is streaky and looks undisciplined; and for the intangible atmospherics of the sky van Gogh resorts to swirling brushstrokes. In all of this he is trying to capture the texture and consistency of things. This represents a development in his grasp of technique if we compare the work of his Dutch period, when a sophisticated textural approach of this kind would still

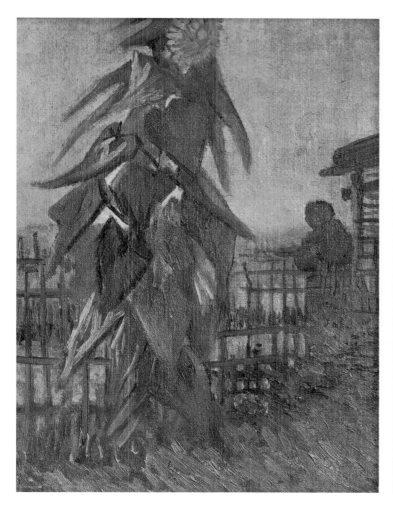

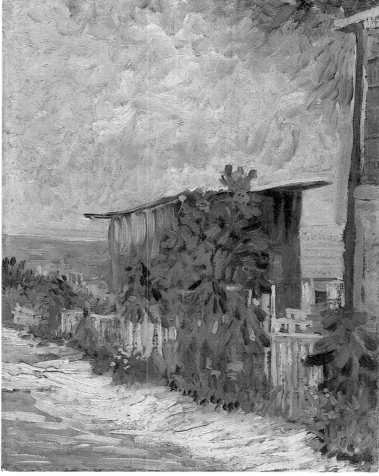

Path in the Woods
Paris, Summer 1887
Oil on canvas, 46 x 38.5 cm
F 309, JH 1315
Amsterdam, Rijksmuseum Vincent van
Gogh, Vincent van Gogh Foundation

**Corner of Voyer d'Argenson Park at
Asnières**
Paris, Summer 1887
Oil on canvas, 49 x 65 cm
F 315, JH 1320
Private collection

Undergrowth
Paris, Summer 1887
Oil on canvas, 46 x 38 cm
F 308, JH 1313
Amsterdam, Rijksmuseum Vincent van
Gogh, Vincent van Gogh Foundation

have been beyond him. Van Gogh's 'realism' peaked in his first Paris
phase. And it was only because he had grown confident of his command
that he was able to shrug off virtuoso technique in the way he did in the
years ahead.

He made the greatest leap in his use of colour. In Nuenen he had
written of "creating in peace and quiet using only the palette, and
Nature is in agreement" (Letter 429). Yet in 1886 he did nothing of the
kind. His colours remained far from the autonomy he had envisaged;
indeed, van Gogh still abided faithfully by local colour, by the appear-
ance of his subject. His first self-portraits (pp. 153 and 187) indulged in
browns reminiscent of the old masters, without a single highlight of
pure, forthright colour to enliven them. It was as if the fascination of his
own face crowded out all possibility of experiment with colour.

Yet van Gogh's entire attention was on colour. He painted a series of
flower still lifes, setting himself the task much as he had with the series
of peasants' portraits. He produced over forty of them; they are not
exactly among his greatest masterpieces, but they certainly prove his

Vase with Cornflowers and Poppies
Paris, Summer 1887
Oil on canvas, 80 x 67 cm
F 324, JH 1293
Whereabouts unknown

Vase with Lilacs, Daisies and Anemones
Paris, Summer 1887
Oil on canvas, 46.5 x 37.5 cm
F 322, JH 1292
Geneva, Private collection

determination to master colour. Theo described the painting of these still lifes to their mother: "He is far more open-minded than he used to be, and very popular; for example, he has acquaintances who send him a fine bunch of flowers to paint every week. His main reason for painting flowers is that he wants to freshen his colours for later work." The still lifes represented a transitional phase for van Gogh, at the end of which he was to be profoundly aware of the power of different tones. Afterwards he would indeed be able to create using only the palette – but not before. *Vase with Hollyhocks* (p. 181) is an attempt to summarize the aims he had articulated in Nuenen. The red of the flowers contrasts with the green of the leaves. The greenish buds, though, are seen against a background only slightly different in tone. The picture is an exercise in the analogies of colours and colour contrasts; in this it is not alone in van Gogh's output at the time. However, the arrangement is a problem. Van Gogh has chosen the flowers carefully, selected a suitable vase, and positioned the whole in front of a background which, though not quite identifiable, gives a definitely spatial impression; the colours and the line of shadow clearly suggest a surface and a wall. Vincent was still painting what was out there. His fidelity to realism was as yet unwavering.

These still lifes nevertheless represent his furthest progress to date. Van Gogh might have started improvising freely from the palette, adding colour for its own sake, were it not for a figure of authority who confirmed him in his attachment to the subject: Adolphe Monticelli. Monticelli was a French painter of Italian extraction. His pictures of flowers were extremely pastose. And he was van Gogh's first artistic discovery in Paris; Vincent was to value Monticelli till the end of his days. Theo and Vincent owned one or two of the Provençal artist's impetuously painted canvases, works which made Vincent's own brushwork look tame. But Monticelli, of course, was painting mimetic copies of flowers, even trying to use thick paint as a kind of relief to convey the tactile, physical dimension of his subject as well as the visual. "I have been trying to convey intensity of colour", van Gogh wrote to Lievens (Letter 459a), referring to the flower still lifes. That was precisely it. The work he painted in 1886 was out to "convey"; it was still looking for (and in need of) the corrective reality would supply.

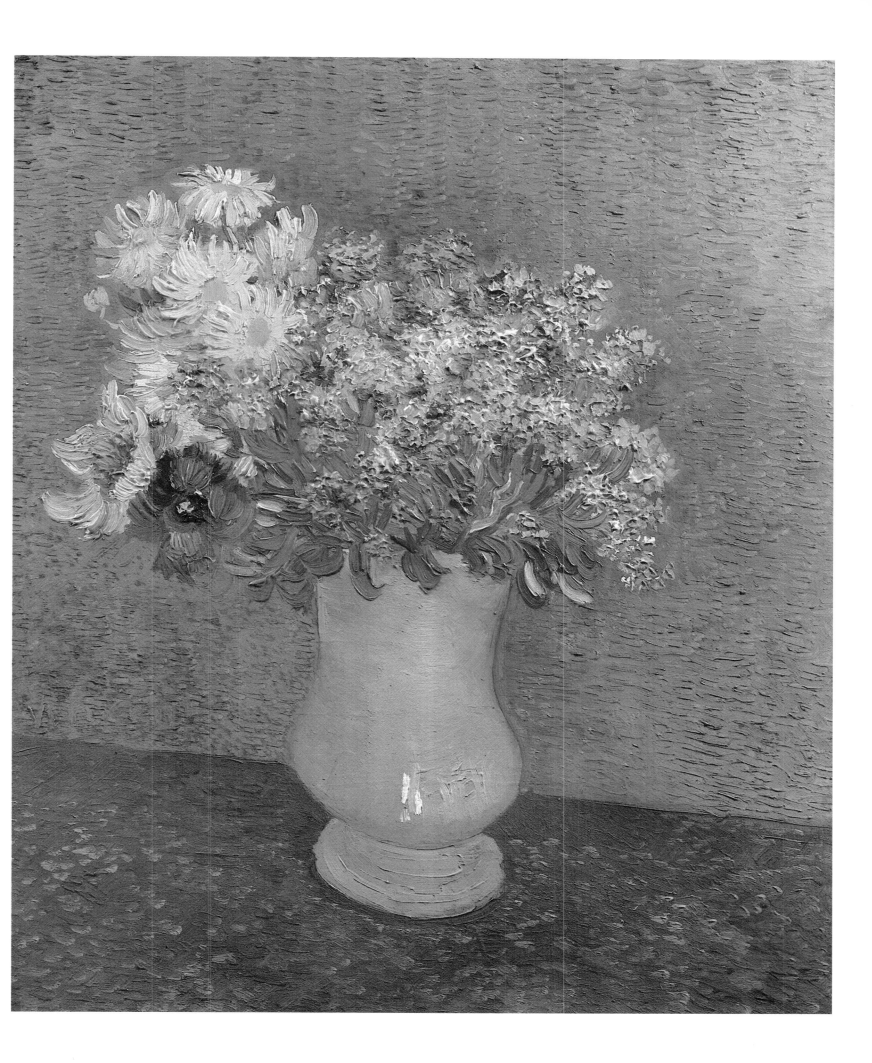

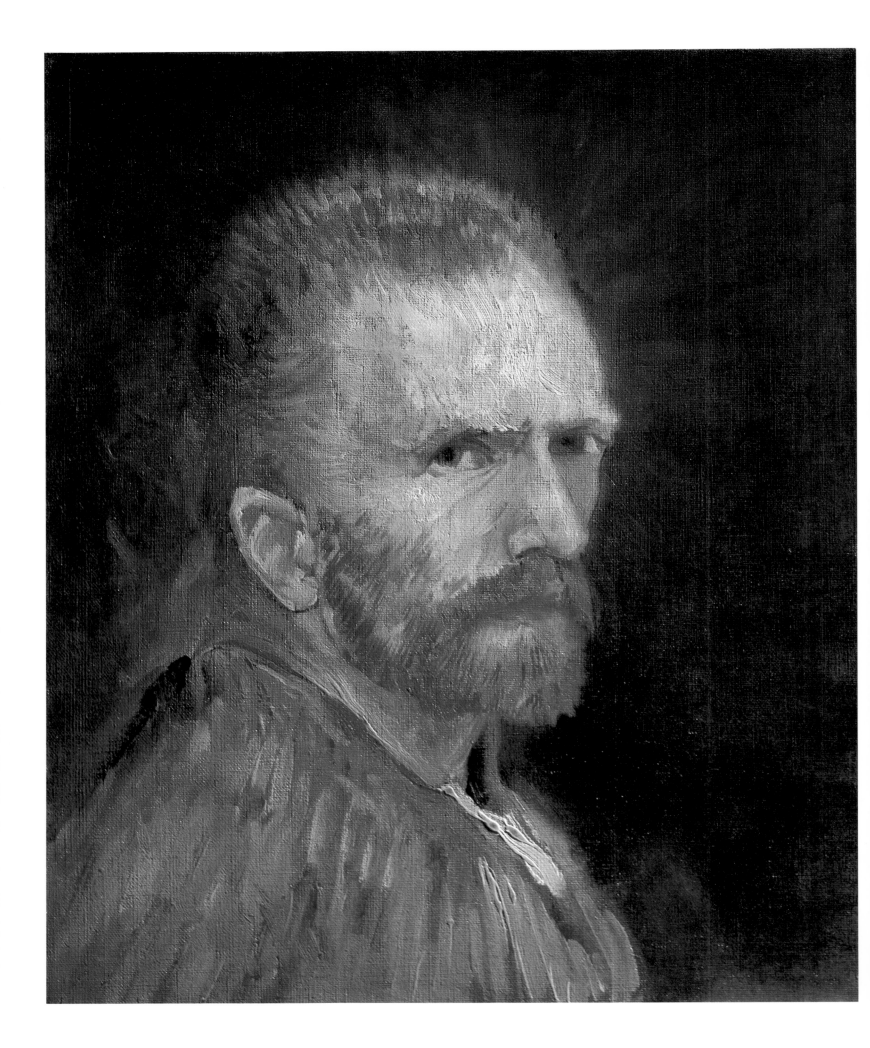

Isms, Isms, Isms
The 1887 Watershed

There they are, on a yellowish cloth: *Three Pairs of Shoes* (p. 201), well-worn footwear as the trademark of an artist who has travelled a long way. Van Gogh's attention is on the signs of heavy use. The worn leather, the ragged sole, the turned-back upper and the toe of the welt parting from the sole, are all emphatic indications of wear and tear. The shoes are seen without any illusions – a still life of fanatical mimetic fidelity. Similarly, the halfboots in *A Pair of Shoes* (p. 210, top) are by no means fashionable footwear. These, though, have a warmer orange tint and are seen contrasting against the blue of some indefinable background. White dots are used to convey the hobnails in the visible sole – though these dots also have a purely aesthetic function, as have the seemingly endless brushstrokes that do service as shoelaces. Vincent signed and (this is rare) dated the painting. He was making it quite clear that this picture was done in 1887, unlike another (p. 183) which probably dated from summer 1886. The artist's approach to colour and brushwork was now in the foreground. The earlier painting, with its love of detail, was losing the battle to a more individual approach that was unafraid of ornamental use of lines and loud colours. The two still lifes of shoes define the 1887 watershed: van Gogh was questioning his previous use of local colour and his purely descriptive style. He was quitting the analytic approach to his subjects which the 'realistic' method had impelled him to take. The *Self-Portrait with Straw Hat* (p. 271), done in summer 1887, similarly departs from the approach of earlier work. Now it is colour analogy that engages the painter's main interest, and the picture contains a cheerful, summery abundance of yellows in the shirt, face, hat and even the background. Carefully-deployed violet strokes add a subtle contrastive note. It is only in the ginger of the beard that van Gogh still retains the principle of local colour; but even here the red is used too sporadically to rate as altogether descriptive. The artist's familiar face has become a terrain for visual experiment. The basic features of his face have naturally been retained, and van Gogh's quirky blend of shyness and severity is readily identifiable. But it is no longer a portrait done merely by looking in the mirror. It records an appearance in a form created for the sake of the

Self-Portrait
Paris, Summer 1887
Oil on canvas, 41 x 33.5 cm
F 268, JH 1299
Hartford (Conn.), Wadsworth Atheneum

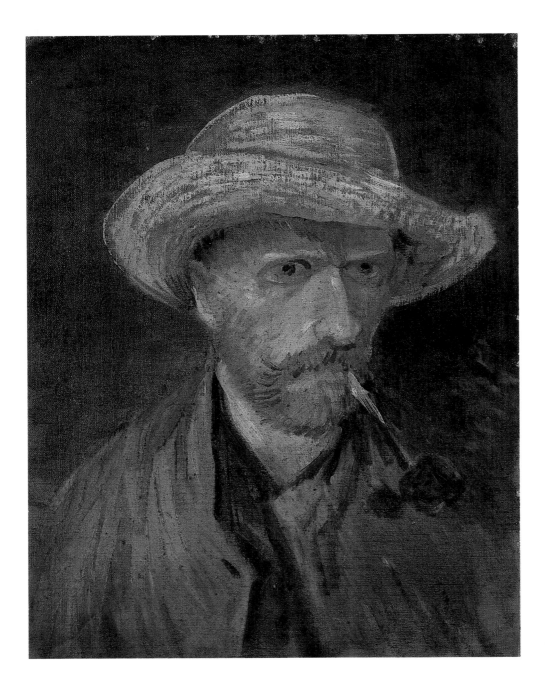

Self-Portrait with Straw Hat and Pipe
Paris, Summer 1887
Oil on canvas, 41.5 x 31.5 cm
F 179v, JH 1300
Amsterdam, Rijksmuseum Vincent van
Gogh, Vincent van Gogh Foundation

painting's effect. If we now turn to *Vegetable Gardens in Montmartre: La Butte Montmartre* (pp. 234-5) we find the canvas covered in colourful brushstrokes: the fences and sheds are treated in the same way, so that they are stylistically integrated into the overall visual effect. The landscape itself has become an excuse for spectacular stylistic showmanship which tends to obscure the subject. The lines are like iron filings being drawn to a magnet: critics have aptly referred to this chaotic approach as van Gogh's magnetic field method. As if on remote control, the brush flits about the canvas, adding here a stroke and there a stroke. "I see that Nature has spoken to me, has told me something that I have written down in shorthand. My shorthand may contain words that are indecipherable – but some of what the forest or shore or figure said still remains." Van Gogh had used this shorthand metaphor to describe his brushwork back in The Hague (Letter 228). But it was only now, six

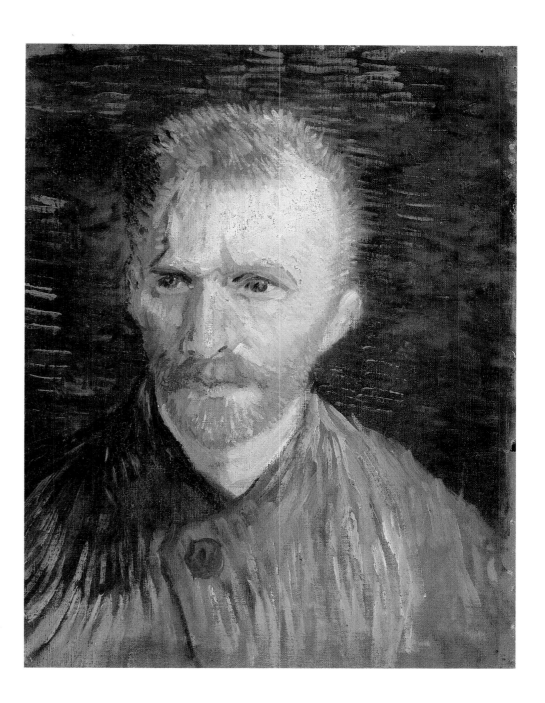

Self-Portrait
Paris, Summer 1887
Oil on canvas, 41 x 33 cm
F 77V, JH 1304
Amsterdam, Rijksmuseum Vincent van
Gogh, Vincent van Gogh Foundation

years later, that his virtuosity was such that rapidity, method and a clearly individual touch all merged. Nature used to show things to van Gogh and he would describe them; now, it told him things, and he re-created the language, the syntax, the melody of the words.

In 1887 van Gogh finally discovered that autonomous value of a painting that Cézanne referred to as a "harmony parallel to Nature." The change did not happen with explosive abruptness; rather, it happened without deliberate volition in the wake of Impressionism. They too were fundamentally 'realists'. They had indeed defined fidelity to the phenomena of the world in radical terms by trying to eliminate the influence of the subjective artistic personality. Reality (they believed) should enter by the eye, directly, without any interference from thought, and should leave a pure, visual impression in the resulting picture. The main thing was speed: only speed could prevent conceptual

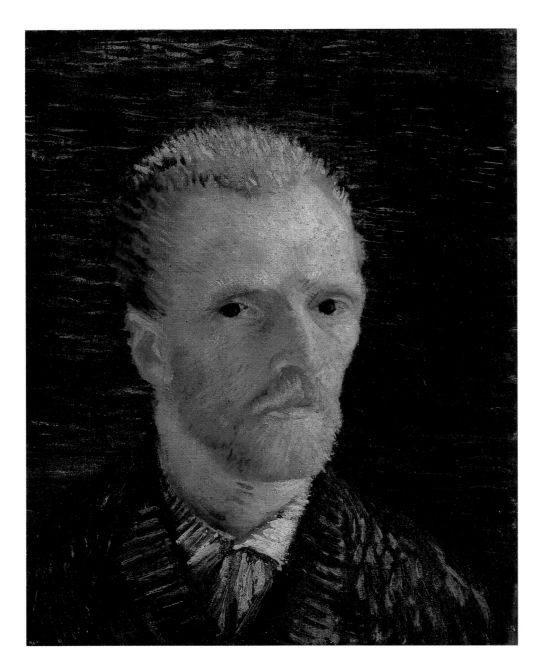

Self-Portrait
Paris, Summer 1887
Oil on canvas, 42 x 34 cm
F 269V, JH 1301
Amsterdam, Rijksmuseum Vincent van
Gogh, Vincent van Gogh Foundation

knowledge from hijacking the natural subject. To spend time and effort re-creating the colours of things on the palette, and to establish their contours on the canvas, would only have diminished the vitality of the work. The characteristic sketchy style of the Impressionists was an inevitable consequence of this attitude. Ironically, though, the method evolved into its own opposite, using its engaging patterns of lines and colours to interpose a veil between the world and the picture far more than faithful realism ever did. The dabs and strokes and colourful dots highlighted the two-dimensionality of the canvas, which came to develop its own unsuspected qualities in a material sense. The painting no longer represented Nature, it simply presented itself: it became essential to bear this obvious fact in mind. In 1887 van Gogh, too, perceived it as a problem.

It was rarely, of course, that he painted a genuinely Impressionist painting. *Trees and Undergrowth* (p. 277), for instance, done in summer

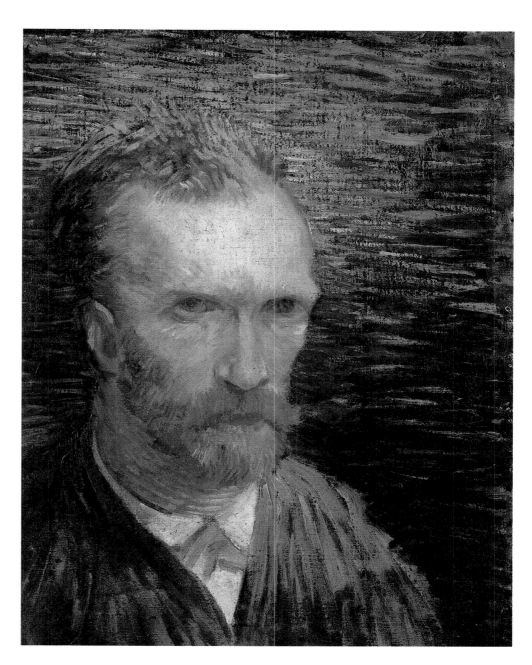

Self-Portrait
Paris, Summer 1887
Oil on canvas on cardboard, 42.5 x 31.5 cm
F 109V, JH 1303
Amsterdam, Rijksmuseum Vincent van
Gogh, Vincent van Gogh Foundation

1887, plainly picks up from work of Monet's such as the painting of an apple tree in blossom (Paris, private collection). Like the French artist, whose 1874 *Impression, soleil levant* (Paris, Musée Marmottan) had given the movement its name, the Dutchman was in a sense trying to convey a feeling of Nature. This green infinity with dabs of bright yellows and whites is not a faithful copy of a wood. Yet the sense of growth fills the canvas all the more powerfully: there is vitality in this burgeoning greenery, and the work becomes a kind of Creation in its own right. The artist is the instrument of the creative energy demanded by Nature, and witnesses with astonishment the process he is himself caught up in. His work is Nature's. His work, like Nature's, is a process of continual production, attesting evolution. The method of immediacy has become a philosophy, or at least a hymn to the power of change. The concept of art that developed from this was to need a great deal of elucidation in the times to come.

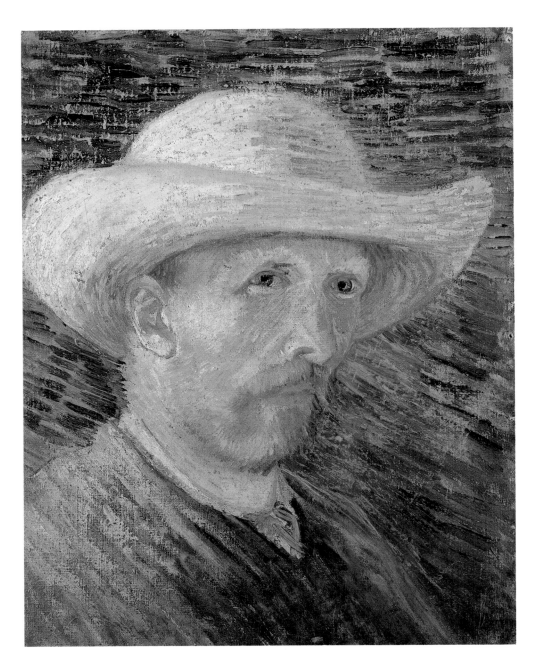

Self-Portrait with Straw Hat
Paris, Summer 1887
Oil on canvas, 41 x 31 cm
F 61V, JH 1302
Amsterdam, Rijksmuseum Vincent van
Gogh, Vincent van Gogh Foundation

The pleasure van Gogh was here sharing in the plant world, the realm of vegetative growth, presently came under attack for neglecting immutable universals and objectivity. What Impressionism had plainly achieved was now expected to make way for Post-Impressionism's goal of harmonizing flux and stasis, change and constancy. In 1887 the Pointillists had occupied all the strategic positions, which meant that van Gogh was registering the sequential progress of two different movements at the same time. No doubt he was basically uninterested in the divergences of their programmes; but the Pointillists had a leading spokesman who also happened to have become a good friend of van Gogh's – Paul Signac, the right-hand-man of the movement's leader Seurat and one of the few fellow-painters van Gogh was close to.

Self-Portrait (p. 221) was done early in 1887. The liveliness of the visual effect is not of a physical nature, as it was in the Impressionist view of trees and undergrowth; the basis is physiological. Charles Henry

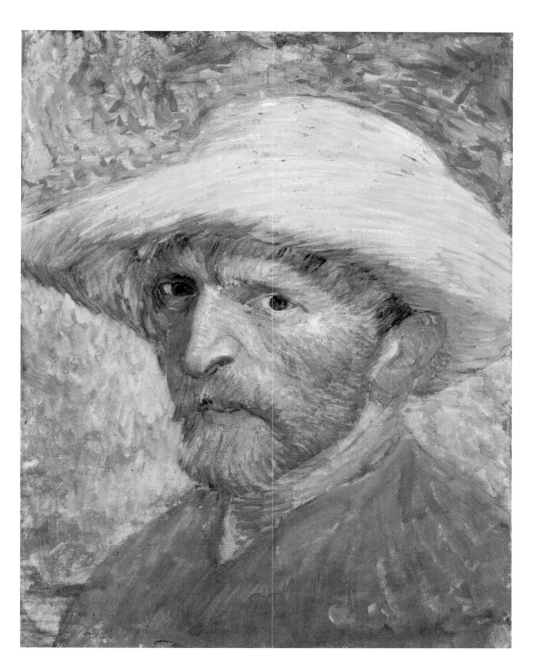

Self-Portrait with Straw Hat
Paris, Summer 1887
Oil on canvas on panel, 35.5 x 27 cm
F 526, JH 1309
Detroit, The Detroit Institute of Arts

and Charles Blanc, the Pointillists' foremost theorists, had found that juxtaposed dots of pure colour provoke a kind of visual panic: the eye compulsively tries to mix the distinct tones and see the staccato of dots as an even surface, as usual. The principle of optical mixing really does work – but it involves a constant sense of agitation. Now artists were trying to cool the overheated excitement of the dots by choosing static subjects: the timeless dignity of still lifes or portraits would help freeze matters. The plural meanings of the present moment (a truism in all modern world views) had been rendered by Impressionism in the polarity of the picture as window and the picture as surface. Pointillism expanded this polarity by adding the conflict of static and dynamic. In his self-portrait, van Gogh found a less radical way of expressing this conflict. Consistently enough, the lucid dabs of colour are used for the jacket cloth and the background but not for the living flesh of his face. Nevertheless, this painting – and the portrait of the art dealer Alexander

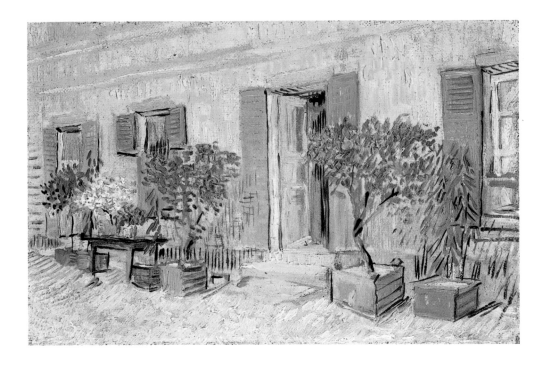

Exterior of a Restaurant at Asnières
Paris, Summer 1887
Oil on canvas, 18.5 x 27 cm
F 321, JH 1311
Amsterdam, Rijksmuseum Vincent van
Gogh, Vincent van Gogh Foundation

Reid (p. 228), done at the same time – were the closest van Gogh came to espousing the principles of Seurat and his group.

He borrowed another aspect of their programme in the two paintings titled *View from Vincent's Room in the Rue Lepic* (pp. 222 and 223). If dabs provide visual dynamics, a carefully calculated balance of verticals and horizontals can provide a static stability. We see this idea at work in van Gogh's panorama. A year before, in *View of Paris from Montmartre* (p. 182), his vision of the city's houses had been of an infinite sea; but now the sea had been dammed by walls, roofs and the horizon. To find the distance, our gaze must first negotiate a set of geometrical obstacles.

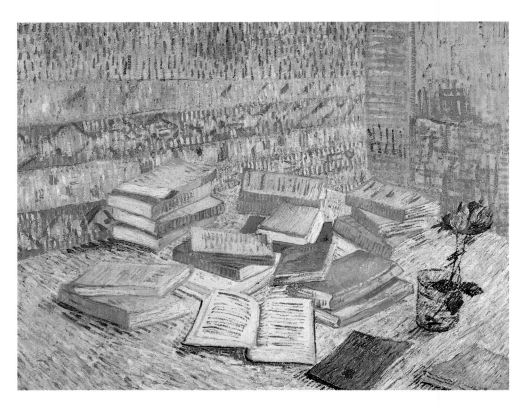

Still Life with French Novels and a Rose
Paris, Autumn 1887
Oil on canvas, 73 x 93 cm
F 359, JH 1332
Japan, Private collection
(Christie's Auction, London, 27. 6. 1988)

RIGHT:
Self-Portrait with Straw Hat
Paris, Summer 1887
Oil on cardboard, 40.5 x 32.5 cm
F 469, JH 1310
Amsterdam, Rijksmuseum Vincent van
Gogh, Vincent van Gogh Foundation

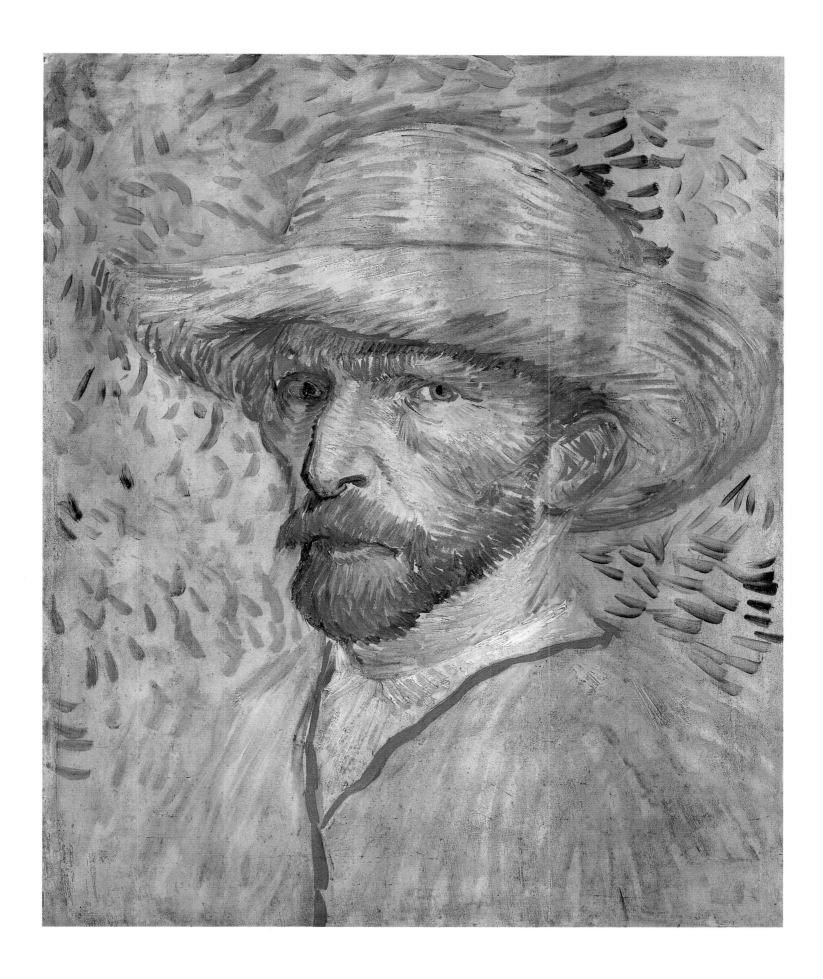

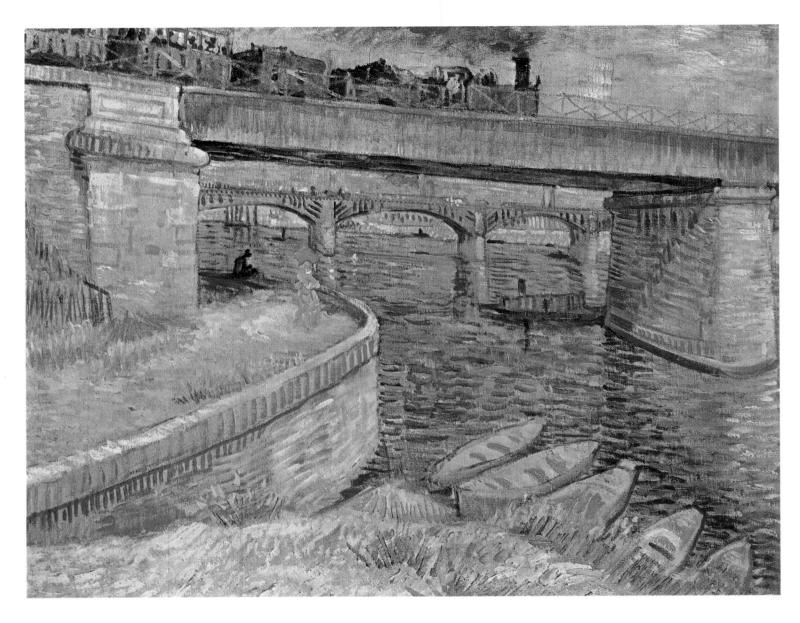

Bridges across the Seine at Asnières
Paris, Summer 1887
Oil on canvas, 52 x 65 cm
F 301, JH 1327
Zurich, Collection E. G. Bührle

Beyond, of course, lies the promise of freedom, the richness of Life. And in that beyond van Gogh has again abandoned pointillist technique.

"There is no single school", declared the Belgian writer Emile Verhaeren, considering the multiplicity of artistic persuasions in Paris at that time, "hardly even groups any more, since they are forever splitting up. The diverse tendencies remind me of movable geometrical patterns, as in a kaleidoscope, one moment opposed and the next united, merging then separating again and then crumbling, but nonetheless moving within a constant circle, that of modern art." Van Gogh was caught in this movement too, adrift in circles where everyone was hunting for the utterly new and convinced that he alone had found it. A standardized approach to Art had become as impossible as an unambiguous view of the world; so everyone was creating a language of his own, his own projects and manifestoes, and everyone subscribed to one style or another that he could believe to be universally valid. The metropolis was flooded with isms: Impressionism, Symbolism, Cloisonnism, Synthetism, Pointillism and more beside. This plurality signalled the

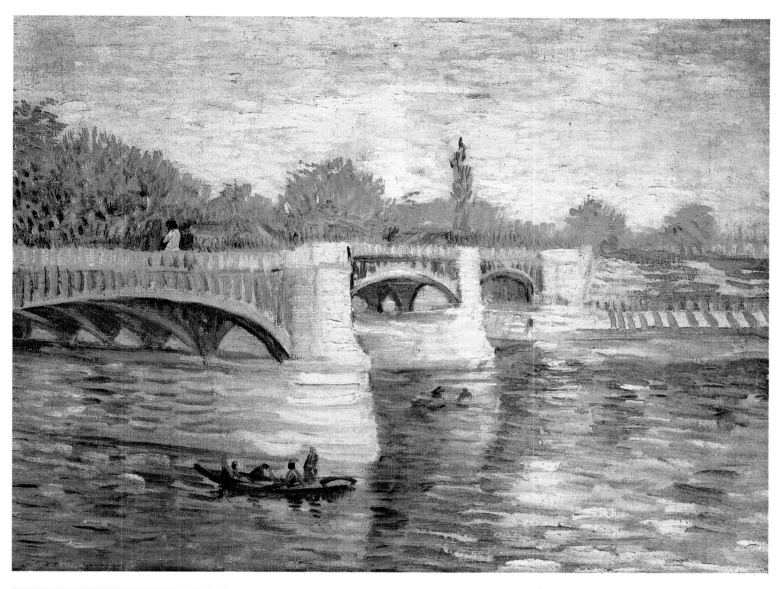

The Seine with the Pont de la Grande Jatte
Paris, Summer 1887
Oil on canvas, 32 x 40.5 cm
F 304, JH 1326
Amsterdam, Rijksmuseum Vincent van
Gogh, Vincent van Gogh Foundation

Banks of the Seine with the Pont de Clichy
Paris, Summer 1887
Oil on cardboard, 30.5 x 39 cm
F 302, JH 1322
Collection Stavros S. Niarchos

revolutionary vitality of modern art, but also the marginal role it was increasingly having to accept.

There was one thing they all had in common, as well as a conviction that they were the chosen ones: the custodians of traditional art considered them all crazy. The defamatory responses modern artists met with only fuelled their convictions. Van Gogh, for example, wrote to his sister (in Letter W4): "The dreary schoolmasters now on the Salon jury will not even admit the Impressionists. Not that the latter will be so intent on having the doors opened; they will put on their own exhibition. If you now bear in mind that by then I want to have at least fifty paintings ready, you will perhaps understand that even if I am not exhibiting I am quietly playing my part in a battle where there is at least one good thing to be said for fighting: that one needn't be afraid of receiving a prize or medal like a good little boy." The "good little boys" were the Establishment artists who pocketed the awards at the annual salons and were lionized by smart society. The isms were a product of another, excluded world. Those who had been recognised could go about their work in a liberated spirit and had little need to rely on a theoretically constructed style that was not out to account for the past but rather to enlist support for the future.

Undergrowth
Paris, Summer 1887
Oil on canvas, 32 x 46 cm
F 306, JH 1317
Utrecht, Centraal Museum
(on loan from the van Baaren Museum
Foundation, Utrecht

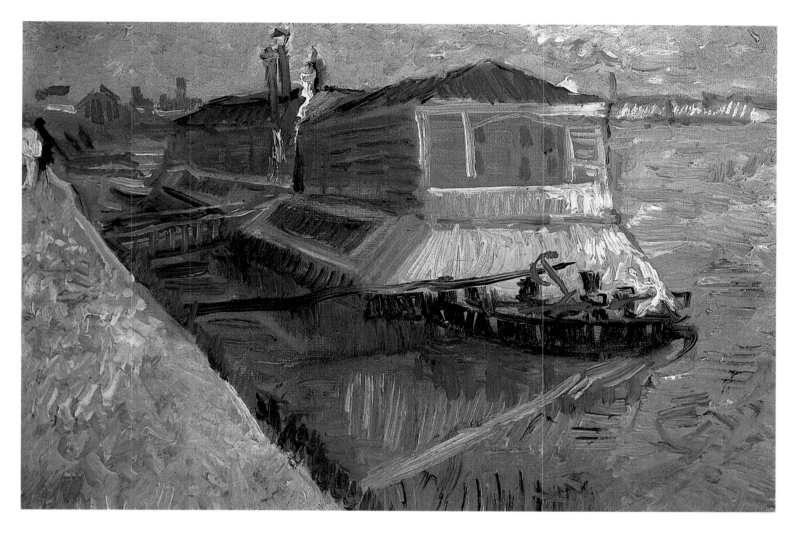

Bathing Float on the Seine at Asnières
Paris, Summer 1887
Oil on canvas, 19 x 27 cm
F 311, JH 1325
Richmond (Va.), Virginia Museum of Fine
Arts, Collection of Mr. and Mrs. Paul Mellon

The association of independent artists (the Indépendants) had been founded in June 1884. "This society", its constitution stated, "is fighting for the abolition of juries and means to help artists submit their work to the opinion of the public without hindrance." A new ism was being born: Secessionism. A profoundly democratic faith in the power of public opinion was out to end the authority of cavilling critics and replace it with the persuasive strength of discussion. Anyone who saw himself as an artist was expected to submit to it. In this there was a hint of what van Gogh termed 'soul' at the same period; though the corrective power of public opinion, by which the Secessionists set such great store, did not feature in van Gogh's thinking – and Modernism was to disavow this belief before too long, when it turned out that the people's expertise in matters artistic left much to be desired (they preferred cheap decorative art to the products of the isms).

An exhibition in November 1887, which van Gogh organized, nicely illustrated what was necessarily the semi-private character of these events. The show was at the Restaurant du Chalet in Montmartre and included about a hundred works by himself and his friends Toulouse-Lautrec, Bernard and Anquetin – artists for whom he had coined the joking label *peintres du Petit Boulevard* in contrast to the artists of the great boulevards, the Impressionists, who were now gradually reaping

Trees and Undergrowth
Paris, Summer 1887
Oil on canvas, 46.5 x 55.5 cm
F 309a, JH 1312
Amsterdam, Rijksmuseum Vincent van
Gogh, Vincent van Gogh Foundation

Trees and Undergrowth
Paris, Summer 1887
Oil on canvas, 46 x 36 cm
F 307, JH 1318
Amsterdam, Rijksmuseum Vincent van
Gogh, Vincent van Gogh Foundation

their recognition. Bernard sold his first picture at the show, and Vincent was very proud of this modest success. The energy and commitment with which van Gogh joined the debate equipped him to reconcile warring factions, and he sounded a call to unity in a letter to Bernard (Letter B1): "Once you have reflected that Signac and the other pointillists often paint things of considerable beauty you will see that instead of attacking these pictures it is better to recognise their value and speak of them with respect, particularly if one is at loggerheads with the artists. Otherwise one will become a bigotted sectarian oneself, and be no better than the people who can see no virtue in others and believe they are the only ones who have understood what's what."

Van Gogh himself had never subscribed entirely to any one trend. He tried things out and borrowed whatever suited his artistic repertoire. He had gone to Paris to learn, and he knew there were many who had something to teach him. To the burgeoning art of Modernism, van Gogh

Two Cut Sunflowers
Paris, August-September 1887
Oil on canvas on triplex board, 21 x 27 cm
F 377, JH 1328
Amsterdam, Rijksmuseum Vincent van
Gogh, Vincent van Gogh Foundation

applied an ism that had been characteristic of the entire 19th century: eclecticism. Unlike the academics who had not scrupled to rummage in the traditional box of tricks, though, he did not stop there. He stirred the Parisian brew and fished out what he found to his taste. The ism that made the strongest appeal to him will be dealt with in the next chapter: Japonism.

"A work of art", Zola had famously asserted, "is a corner of creation seen through a temperament. The picture we see on this screen new to us consists in a reproduction of things and people on the other side of the screen from where we are; and that reproduction, which can never be completely faithful, is changed whenever a new screen is interposed between our eye and the world. In exactly the same way, differently tinted panes of glass make things appear different colours, and concave or convex lenses distort objects." To pursue Zola's terms: in Paris, van Gogh saw that there were an infinite number of tinted panes at his disposal when it came to that window known as a painting. Nevertheless (and this is of central importance in his entire oeuvre), he never

Still Life with Grapes, Pears and Lemons
Paris, Autumn 1887
Oil on canvas, 48.5 x 65 cm
F 383, JH 1339
Amsterdam, Rijksmuseum Vincent van
Gogh, Vincent van Gogh Foundation

pulled down that blind that blocks the view of the outside world and leaves pictures totally dependent on the artist's memory and imagination. Van Gogh remained a 'realist' who needed a world out there in order to paint. The subjects he tackled in Paris were typically Parisian. His windmills were not Dutch, they were on Montmartre; the women whose portraits he painted were not peasants, they were acquaintances met in restaurants and boulevards. Nor could the great Millet exhibi-

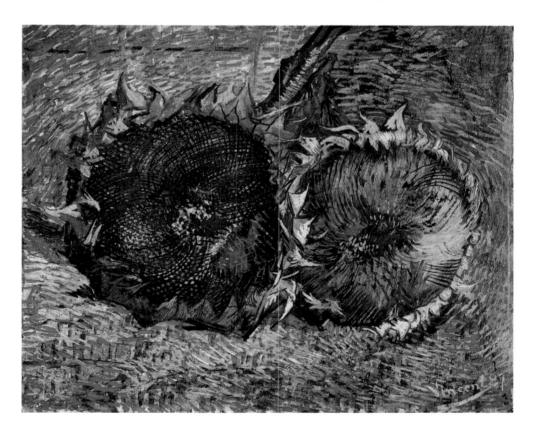

Two Cut Sunflowers
Paris, August-September 1887
Oil on canvas, 50 x 60 cm
F 376, JH 1331
Berne, Kunstmuseum Bern

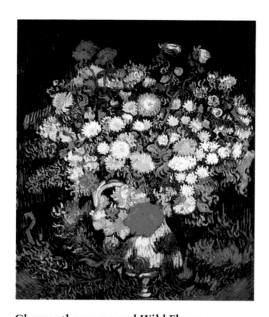

**Chrysanthemums and Wild Flowers
in a Vase**
Paris, Autumn 1887
Oil on canvas, 65 x 54 cm
F 588, JH 1335
Rancho Mirage (Cal.), Collection Mr. and
Mrs. Walter H. Annenberg

Four Cut Sunflowers
Paris, August-September 1887
Oil on canvas, 60 x 100 cm
F 452, JH 1330
Otterlo, Rijksmuseum Kröller-Müller

Two Cut Sunflowers
Paris, August-September 1887
Oil on canvas, 43.2 x 61 cm
F 375, JH 1329
New York, The Metropolitan Museum of Art

tion of spring 1887 move him to an emphatic espousal of peasant painting any longer.

Van Gogh tried his hand at new subjects. For the first time he painted the sunflowers which were to become the symbol of his artistic self *par excellence*. He placed their fiery yellow against a familiar blue contrast (cf. right) and used short strokes and dabs for the seeds; but these borrowings from the isms leave no disagreeable aftertaste of imitativeness with us. Van Gogh's way of seeing – through his own tinted panes – was committed and caring. The ragged petals, cut stems and robust close-up suggest metaphors in plenty: metaphors of menace but also of solidarity with a living thing about to wither and die. The casual atmospherics of Impressionism have been left behind, and authoritatively so. In that one year of 1887, van Gogh occasionally did seem about to be overwhelmed by the sheer mass of artistic conceptions that bombarded him, though; and some of his pictures – such as *The Seine Bridge at Asnières* (p. 245) or *The Seine with the Pont de la Grande Jatte* (p. 273) – are rather second-rate. They are studies using the perspective frame, struggling with the picturesqueness of reflections in the water and succeeding only in establishing a monochrome haze of blues.

Undoubtedly having minor masters as his mentors was an advantage. One friend was the tolerant Signac (rather than the over-theoretical Seurat); another friend was Bernard, just turned twenty (and not the obstinate Gauguin); he was unable to make the acquaintance of Monet. A Monticelli, Charles Angrand or Jean François Raffaelli (hardly the main names in the history of the avant-garde) remained with him longer than the truly eminent. It was the only way van Gogh could reach his goals. And the distance he had travelled from the well-meant emotionalism of his early period can be seen in a single statement written to his sister in summer 1887 (Letter W1): "What I find so splendid in the moderns is that they do not moralize like the old guard."

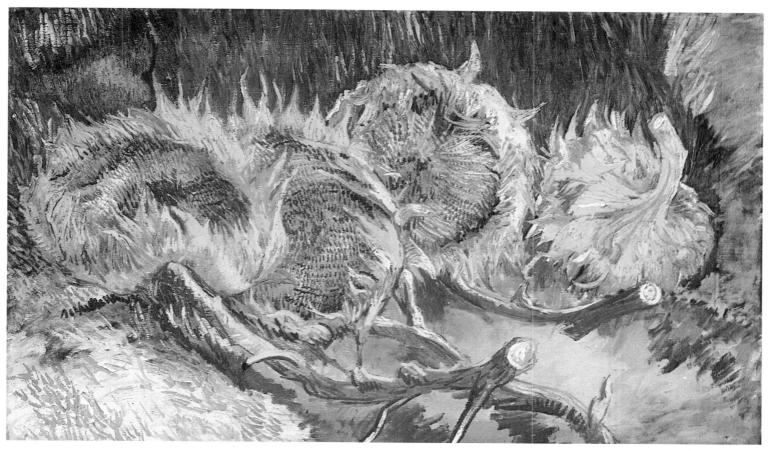

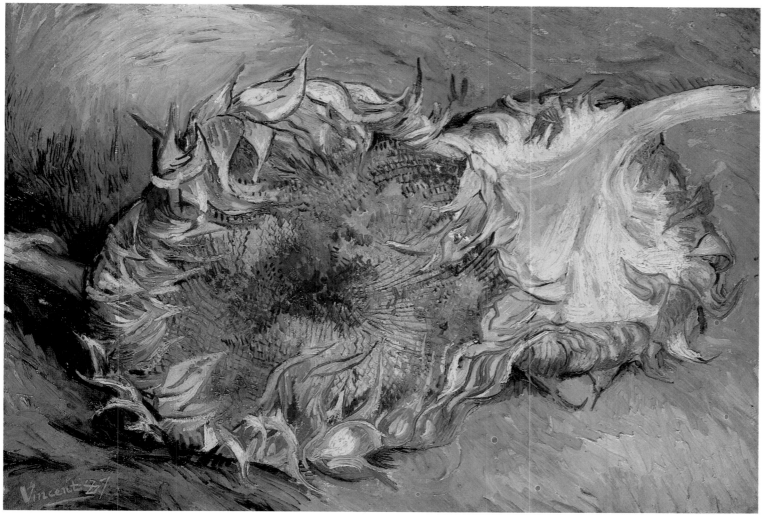

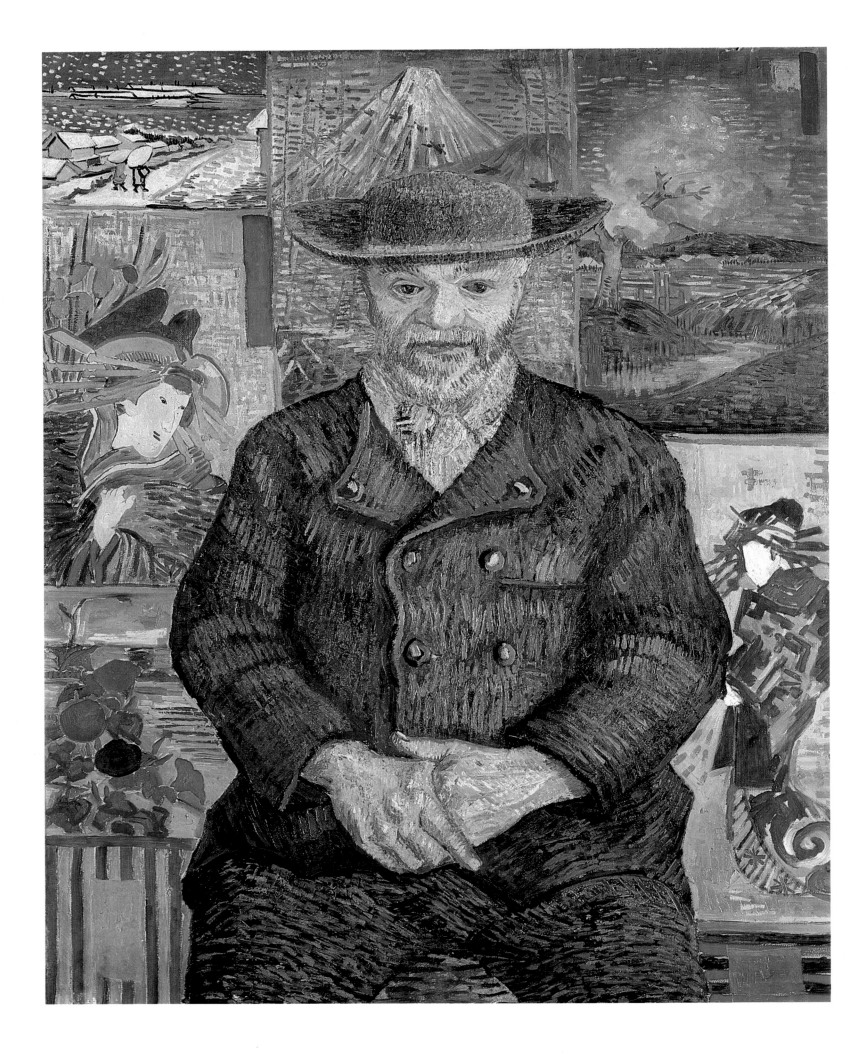

The Far East on his Doorstep
Van Gogh and Japonism

In 1891 the influential critic Roger Marx declared that Japan had been as important for modern art as classical antiquity had been for the Renaissance. Thirteen years earlier, Ernest Chesneau (in his article 'Japan in Paris') had already noted the wildfire that had been spreading throughout the studios, stores and cosmetic parlours of the city: "One was inevitably amazed at the impartiality of composition, the skill with form, the wealth of colour values, the originality of effects and at the same time the simplicity of the means used to achieve the various results." Japan meant more than the merely exotic. The Far East had conquered Europe by peaceful means, quite unlike the Occident, which was then engaged in forcibly subjugating other peoples. Japan had made its impact on 19th century culture.

In the age of the shoguns, Japan had been isolated and xenophobic. But at the 1867 Paris World Fair, Japan burst upon the scene like a bombshell, so to speak. The Japanese made skilful use of western notions of oriental mystery – and Paris gladly took object lessons from the articles

Still Life with Red Cabbages and Onions
Paris, Autumn 1887
Oil on canvas, 50 x 64.5 cm
F 374, JH 1338
Amsterdam, Rijksmuseum Vincent van Gogh, Vincent van Gogh Foundation

Portrait of Père Tanguy
Paris, Autumn 1887
Oil on canvas, 92 x 75 cm
F 363, JH 1351
Paris, Musée Rodin

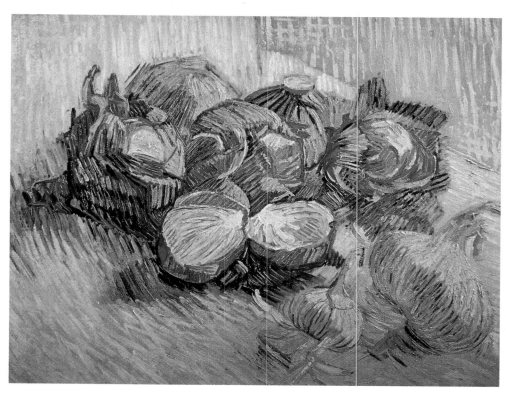

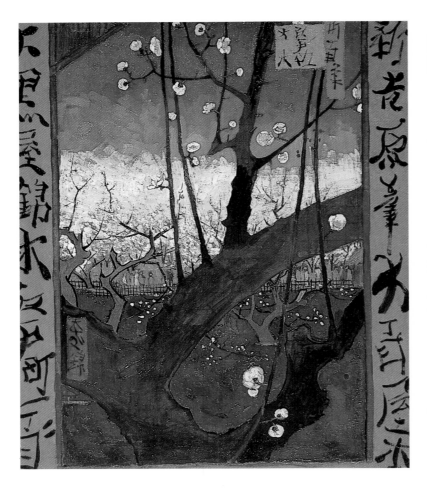

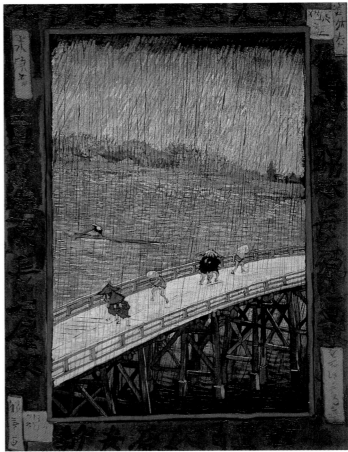

Japonaiserie: Flowering Plum Tree
(after Hiroshige)
Paris, September-October 1887
Oil on canvas, 55 x 46 cm
F 371, JH 1296
Amsterdam, Rijksmuseum Vincent van
Gogh, Vincent van Gogh Foundation

Japonaiserie: Bridge in the Rain
(after Hiroshige)
Paris, September-October 1887
Oil on canvas, 73 x 54 cm
F 372, JH 1297
Amsterdam, Rijksmuseum Vincent van
Gogh, Vincent van Gogh Foundation

that were offered. Novelty always prompts a vogue; and Japan was fashionable. Society ladies wore kimonos, placed screens in their salons, and adored the tea ceremony. In the course of time the vogue evaporated and was replaced by a profounder understanding of Japan, which involved fewer people but also implied a more sensitive acquisition of knowledge. Looking back, we can distinguish four stages in the reception: firstly Japan was a treasure chest where anyone might find a few novel accessories; then the indulgence became a taste that decreed that only the Far East was acceptable and tried to reconstruct the oriental world in local homes; in the third phase people tried to reproduce that world, making their preferences a basis for a repertoire of their own making; and finally, a worldview was distilled from the language of forms and its principles followed.

These four stages of discovery, appropriation, adaptation and re-creation can be explained quite simply if we bear in mind that what was originally sequential struck the westerner far from Japan as juxtaposed and simultaneous. There were artists who were satisfied with the lure of the exotic and added conspicuous, kitschy props such as a low-level table or a woodcut to their pictures. Others stripped their scenes of genre ingredients in imitation of the purity of Japanese interiors which (in their view) were properly devoid of anything superfluous. Yet others, few in number, adopted a lifestyle modelled on that of Japan. Van Gogh was one of these few, though naturally he passed through the other

Japonaiserie: Oiran (after Kesaï Eisen)
Paris, September-October 1887
Oil on canvas, 105 x 60.5 cm
F 373, JH 1298
Amsterdam, Rijksmuseum Vincent van
Gogh, Vincent van Gogh Foundation

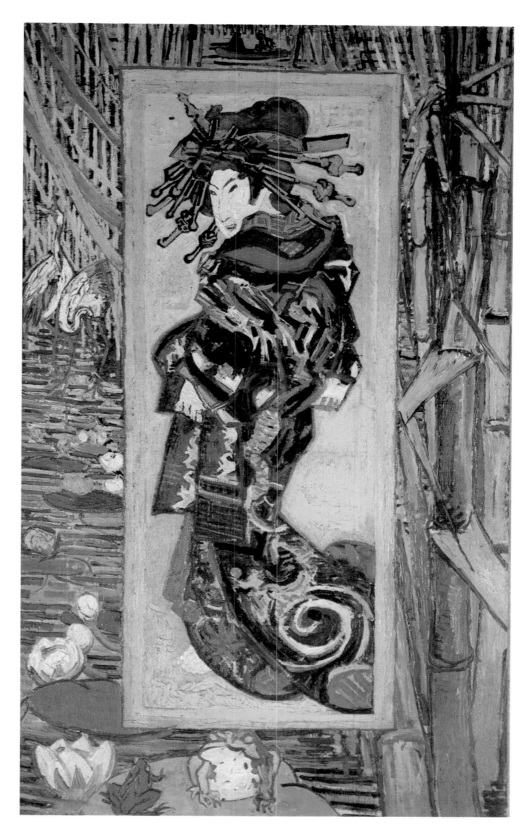

stages in the reception first. In Paris he went through the first three
stages; and his decision to go south signalled his wish to find a true Japan
of his own.

Back in Antwerp, van Gogh had already been decorating his walls
with prints of the Ukiyoye (Popular) School. These scenes of everyday
life were sold cheaply in thousands by a growing number of western
dealers in Japanese work. From time to time there would be an Ukiyoye

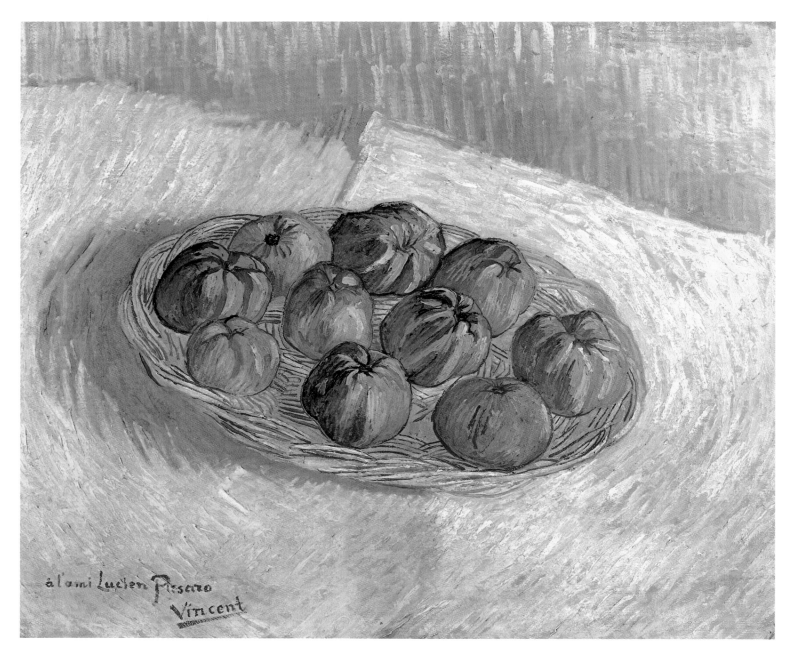

masterpiece by Hokusai, Hiroshige or Utamaro among these prints of woodcuts. Their landscapes, portraits, and pictures of flowers and animals suited western ways of seeing (and indeed had themselves been influenced by European art taken to Japan by traders). In Letter 437 (written from Antwerp in November 1885) we even find van Gogh exclaiming, "Japonaiserie for ever" – quoting the brothers Jules and Edmond de Goncourt, who had been establishing Japan's literary credentials. This is the first we learn of Vincent's new penchant.

Van Gogh practically spent his first Paris winter in Siegfried Bing's shop, a short walk from his Montmartre flat. He was left to browse amongst the mysteries of oriental art to his heart's content; and he started a collection of Japanese woodcuts for Theo and himself that ran into the hundreds. In spring 1887 he included them in an exhibition he organized at the Café du Tambourin in Montmartre. A favourite rendezvous of Parisian artists, the café was happy to show it shared the

Still Life with Basket of Apples
(to Lucien Pissarro)
Paris, Autumn 1887
Oil on canvas, 50 x 61 cm
F 378, JH 1340
Otterlo, Rijksmuseum Kröller-Müller

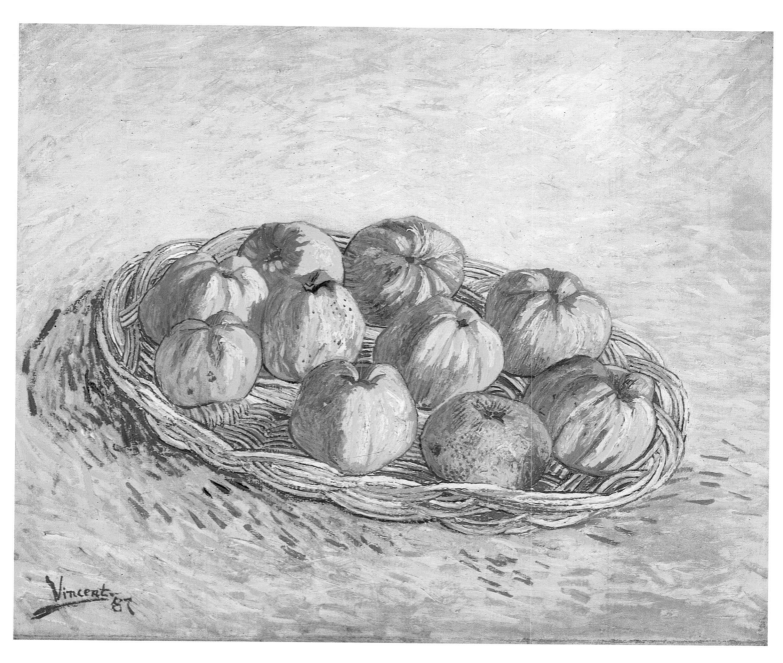

Still Life with Basket of Apples
Paris, Autumn-Winter 1887/88
Oil on canvas, 46.7 x 55.2 cm
F 379, JH 1341
St. Louis, The Saint Louis Art Museum,
Gift of Sydney M. Shoenberg, Sr.

taste of high society. Japan was in. It was still a novel attraction. It was apparently then that van Gogh painted the portrait of the café's owner, Agostina Segatori (p. 206). She had modelled for Corot and for Jean Léon Gérôme and now sat for van Gogh a few times too; the only nudes he ever painted in oil were of her (pp. 202 and 203). We see her sitting at a table in the Tambourin that resembles the musical instrument that gave the café its name.

Edgar Degas's *Absinthe* (Paris, Musée d'Orsay) plainly inspired the setting. But in taking his bearings from Degas, van Gogh was not so much out to record the hopeless solitude of one woman seeking solace in alcohol and a cigarette as to practise an Impressionist eye for a hazy, smoky atmosphere. Van Gogh has invested the full resources of his modesty in painting an unprepossessing documentary picture: merging unclearly with the greenish background are a number of Japanese wood-cuts on the wall panelling, doubtless from the collection of the brothers

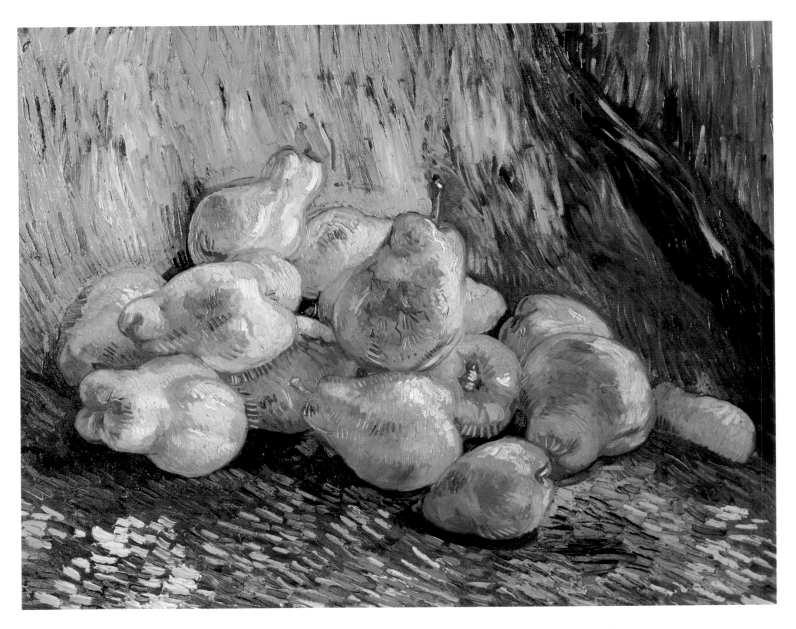

Still Life with Pears
Paris, Winter 1887/88
Oil on canvas, 46 x 59.5 cm
F 602, JH 1343
Dresden, Gemäldegalerie Neue Meister

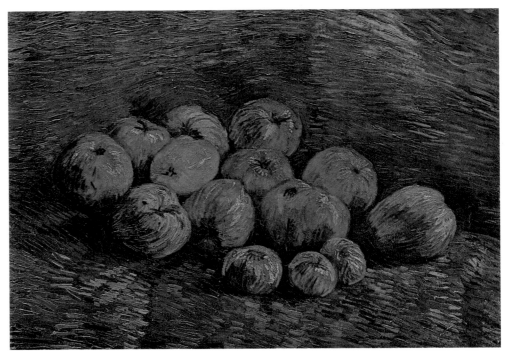

Still Life with Apples
Paris, Autumn-Winter 1887/88
Oil on canvas, 46 x 61.5 cm
F 254, JH 1342
Amsterdam, Rijksmuseum Vincent van
Gogh, Vincent van Gogh Foundation

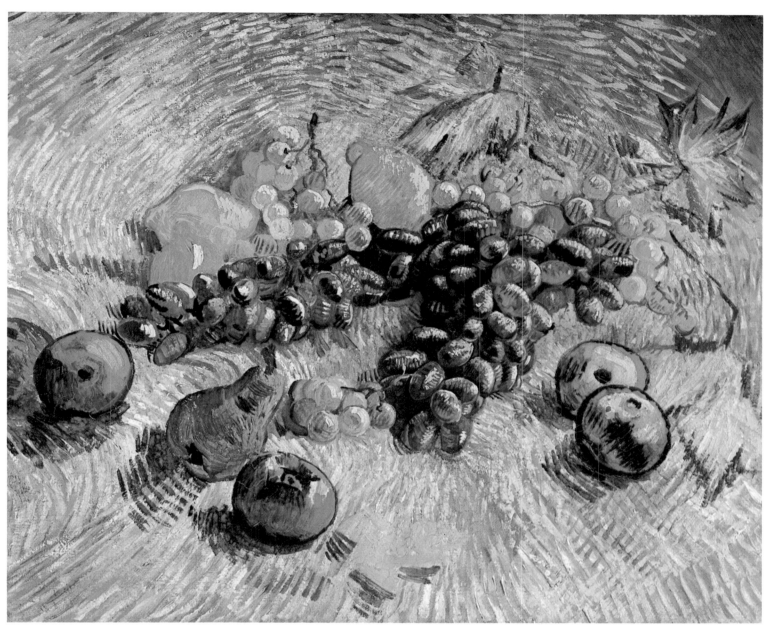

Still Life with Grapes, Apples, Pear and Lemons
Paris, Autumn 1887
Oil on canvas, 44 x 59 cm
F 382, JH 1337
Chicago, The Art Institute of Chicago

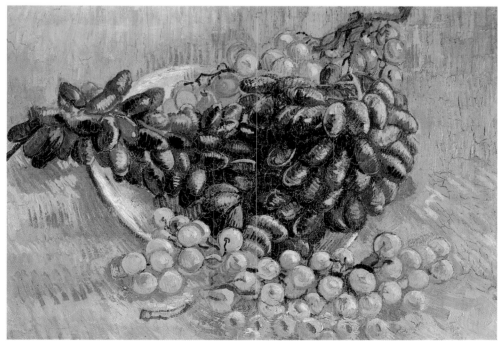

Still Life with Grapes
Paris, Autumn 1887
Oil on canvas, 32.5 x 46 cm
F 603, JH 1336
Amsterdam, Rijksmuseum Vincent van Gogh, Vincent van Gogh Foundation

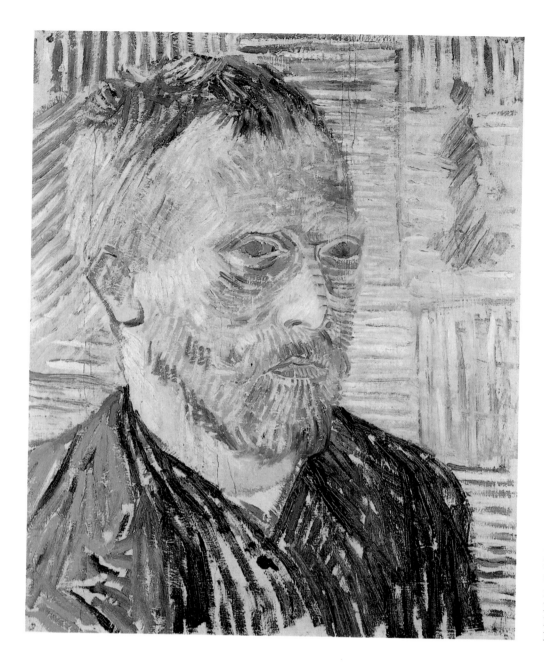

Self-Portrait with a Japanese Print
Paris, December 1887
Oil on canvas, 44 x 35 cm
F 319, JH 1333
Basle, Öffentliche Kunstsammlung,
Kunstmuseum Basel (on loan from the
Emily Dreyfus Foundation)

van Gogh. They lack the laconic eloquence Manet found in them, in his portrait of Zola (Paris, Musée d'Orsay). Van Gogh's prints look lost on the wall; they seem to match the meditative, introspective, lost look of the woman at the table. Like her hat, the prints are exotic accessories. As though ashamed of the impertinent demands being made on them, the artist leaves the prints ill-defined and nebulous, seemingly unable to make pictorial use of them.

A resolve to appropriate Japan became apparent six months later when van Gogh returned to a study method he had used in his early days as an artist: copying. He tackled three Ukiyoye subjects, fitting them into his own repertoire by imitating them – two Hiroshiges from his own collection, *Flowering Plum Tree* (p. 284) and *The Bridge in the Rain* (p. 284), and one by Kesai Eisen, *Oiran* (p. 285), which was on the cover of a Japanese number of *Paris illustré*, published by Theo's company. Copies of this kind are known as japonaiseries. As far as we know, van

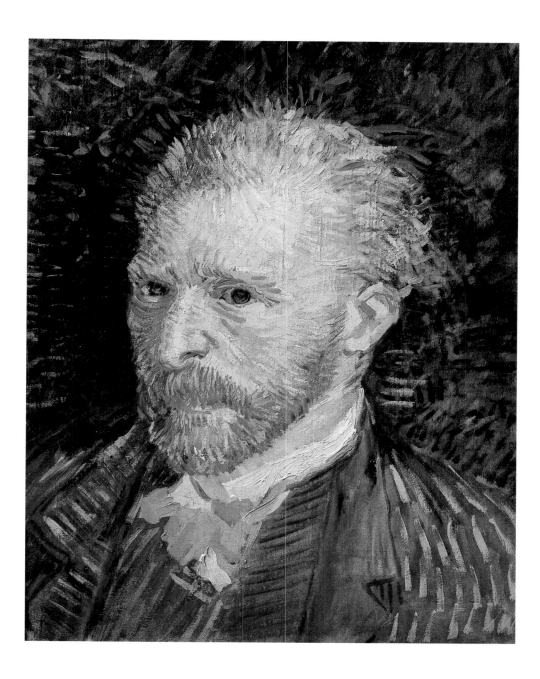

Self-Portrait
Paris, Autumn 1887
Oil on canvas, 47 x 35 cm
F 320, JH 1334
Paris, Musée d'Orsay

Gogh was the first to try his hand at them. And thus he embarked on the second stage in his response to Japanese culture.

"From time immemorial, the Chinese have been familiar with the laws of colour and have made use of them", Blanc had written, "and the tradition of those laws, handed down from generation to generation, has been preserved to this day and has spread throughout Asia, with the result that there is never a weak link in the chain of colour." Van Gogh used these models primarily to perfect his grasp of colour. He was able to juxtapose large areas of unmixed colour, relying on the familiar impact of contrast; and this brought home the full effect of monochrome blocks of colour alongside each other, where previously the setting of yellow beside violet or red beside green had depended on local colour or on small-scale brushwork. This was the first time van Gogh brought himself to use monumental areas of unmixed and unbroken colour, undimmed by questions of light and dark, in their full, vivid, radiant

Plaster Statuette of a Female Torso
Paris, Winter 1887/88
Oil on canvas, 73 x 54 cm
F 216, JH 1348
Tokyo, Private collection

Italian Woman (Agostina Segatori?)
Paris, December 1887
Oil on canvas, 81 x 60 cm
F 381, JH 1355
Paris, Musée d'Orsay

power. He had always valued his fourth, wholly uncanonical contrast very highly too: that between black and white. The Impressionists had exiled black from their palette as a non-colour, but it was vital to the prints, and the Ukiyoye School confirmed his love of the sensuousness and symbolic power of black.

Van Gogh was also attracted by the daring diagonals and jolting shifts in perspective the woodcuts used in order to establish spatial depth. Uninitiated into the greater mysteries of perspective, van Gogh had rigged up a rudimentary frame in the manner we have already described. The angles of vision that resulted from using this crude aid were not unlike those of the Japanese prints. The diagonals van Gogh's frame tended to insist on represent a distinct similarity. His Seine bridge (cf. p. 245) looks like an Impressionist version of Hiroshige's *Bridge in the Rain*; no doubt the resemblance was coincidental and not intended. At all events, van Gogh found his own spatial methods confirmed by the Ukiyoye artists. And their decorative flatness, which counteracted the pull of depth, also impressed him. This afforded an option of staying on the flat surface of the canvas or entering the depths of the picture, as he preferred – and who could say what was incompetence and what an intentional aesthetic effect? One thing was sure: the woodcuts were there as a precedent.

Japanese art provided a universal language of forms that could be used to express new things that were not worn out – modern things. So far van Gogh had imitated, without concern for his own style. There are thick streaks of paint on his canvasses, of course, and in consequence they seem a far cry from the understated originals – but that is first and foremost a question of transferring to the medium of paint. And of course van Gogh invented frames and painted in written characters without any interest whatsoever in whether or not they meant something – but this is primarily a question of the vertical format preferred by the Japanese artists, which van Gogh had to adapt to the sizes of his frames. He was simply curious, anxious to learn. And his eagerness is documented by the work he did in the third stage of his reception of Japan, the adaptation stage.

Those works mark the end of his Paris output. In them we find him engaging with the same problems as Bernard, Anquetin and Toulouse-Lautrec, who were all, in their different ways, trying to come to terms with this new visual world. Their magic masterstrokes were forced spatial depth on the one hand and decorative use of the colourful surface on the other. Each of them made fundamentally different use of these touches; but van Gogh was the only one to draw farreaching conclusions from what he learnt. He was in pursuit of some other reality where he would find the New Japan. It must be outside Paris, because the city afforded the new too few chances. That quest was to be the fourth stage in his reception of Japan; and on the threshold we find three portraits.

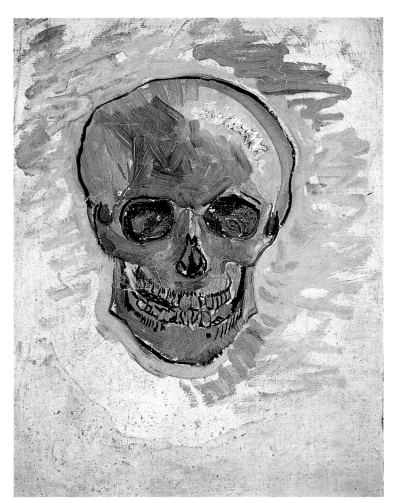
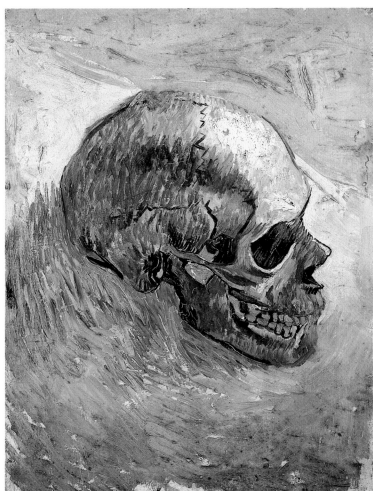

The whole of van Gogh can be found in them, in terms of his ability as a painter. In terms of his personality, the south was yet to coax his total identity into being.

Let us examine the portraits of Père Tanguy (pp. 282 and 296). Julien Tanguy, from whom Vincent bought his paint, deserved his soubriquet. He had seen the glorious days of the Commune and, as a Communard, had been sent to prison. Now, his utopian vision of a better world distinctly faded, he himself was kindness in person, giving credit, presents and support to needy artists. The back rooms of his modest store were a gallery of sorts where their work could be viewed and bought. He saw the artistic idealists of the modern movement as fellow-travellers who had been ignored, misunderstood and despised as he himself had been. Tanguy's premises provided the first opportunity ever to see works by Seurat, Cézanne, Gauguin and van Gogh together in one place: the four precursors of the 20th century who at that time were of little or no interest to anyone. Vincent admired the old man's calm serenity.

His two portraits of Père Tanguy are very similar. The earlier (p. 282) is a shade more conventional, as we might logically expect. The background is covered with woodcuts in memory of the beginnings of van Gogh's Japonism. Now they are so clear we could almost reach over and

Skull
Paris, Winter 1887/88
Oil on canvas on triplex board,
41.5 x 31.5 cm
F 297a, JH 1347
Amsterdam, Rijksmuseum Vincent van Gogh, Vincent van Gogh Foundation

Skull
Paris, Winter 1887/88
Oil on canvas on triplex board, 43 x 31 cm
F 297, JH 1346
Amsterdam, Rijksmuseum Vincent van Gogh, Vincent van Gogh Foundation

Still Life with Plaster Statuette, a Rose and Two Novels
Paris, December 1887
Oil on canvas, 55 x 46.5 cm
F 360, JH 1349
Otterlo, Rijksmuseum Kröller-Müller

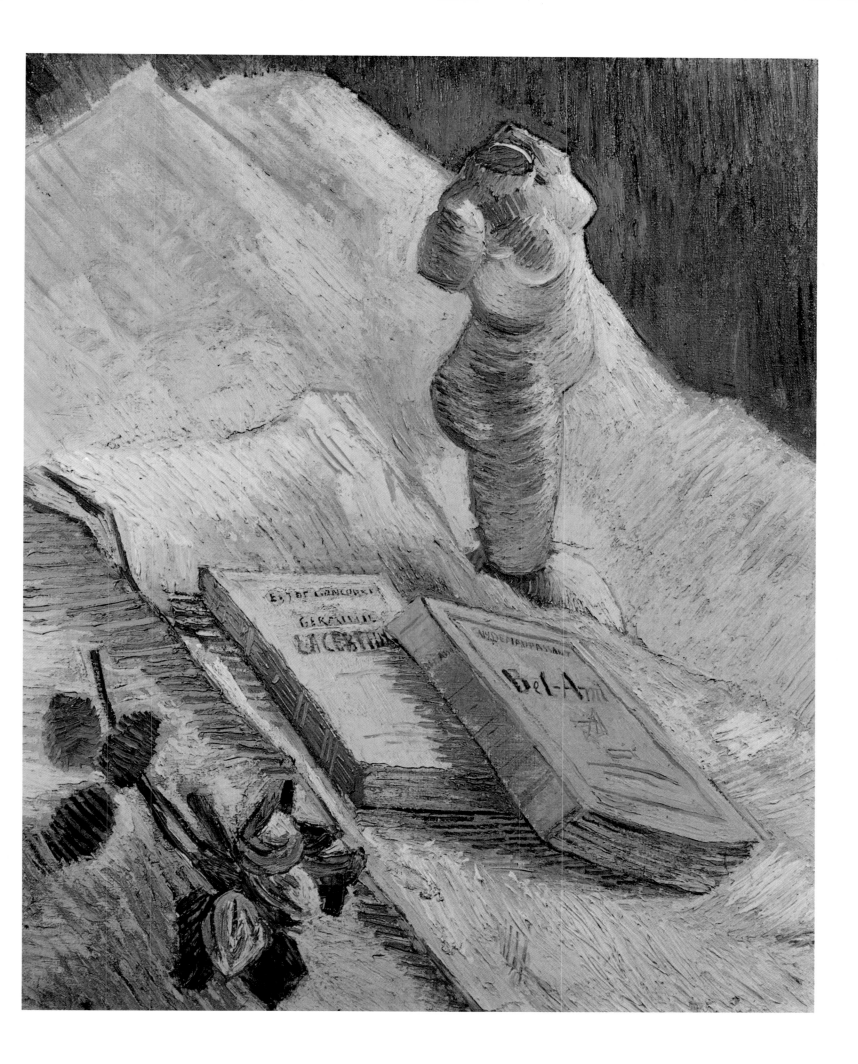

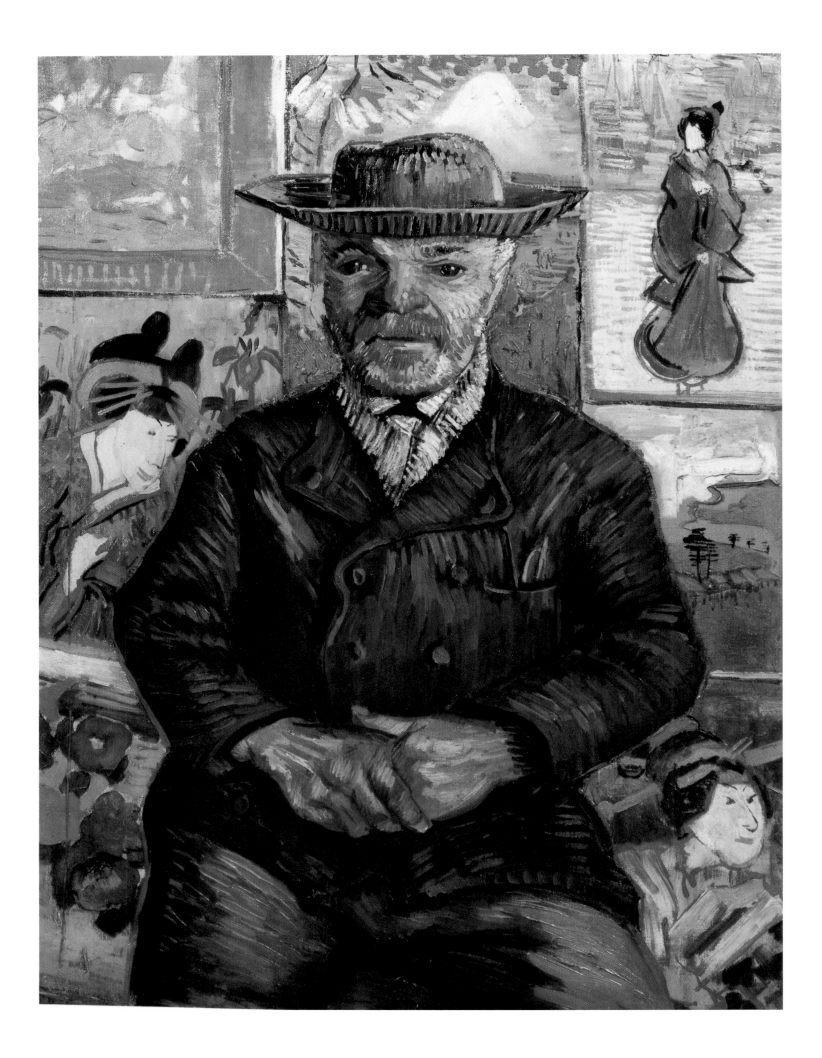

Portrait of Père Tanguy
Paris, Winter 1887/88
Oil on canvas, 65 x 51 cm
F 364, JH 1352
Collection Stavros S. Niarchos

Self-Portrait
Paris, Winter 1887/88
Oil on canvas, 46 x 38 cm
F 1672a, JH 1344
Vienna, Österreichische Galerie in der
Stallburg

Self-Portrait
Paris, Winter 1887/88
Oil on canvas, 46.5 x 35.5 cm
F 366, JH 1345
Zurich, Foundation Collection E. G. Bührle

touch them. Most of them are identifiable as prints from the brothers' collection. What is far more arresting than these visual quotations, though, is the presence of the sitter himself, who has the dominant quality of a figure in an icon. There is not a hint of the spatial to distract his gaze. It is as if he and Japan were one, and the Ukiyoye motifs (actor, courtesan, sacred Mount Fujiyama) were there for him alone. The portrait is not a hesitant approach; on the contrary, van Gogh boldly attempts no less than a synthesis of oriental and western art, and one that is far beyond the syncretism of his early period at that. But he still has to haul out a fine number of motifs in order to guarantee his point. He does not enact or re-create it; he tries to show it thematically.

Without a doubt, van Gogh's most daring venture is *The Italian Woman with Carnations* (p. 293). His model here may have been Agostina Segatori again, as in the Café du Tambourin portrait (p. 206) – the woman's full lips and broad nose (and the title) suggest as much. In this picture van Gogh's Japonism draws upon resources that have little to do with qualities of the sitter. "He especially drew my attention to a number of what he called 'crêpes'", A. S. Hartrick later recalled, "Japanese prints on a kind of crinkly paper that was like crêpe. They quite clearly made a powerful impression on him, and from the way he talked I am certain that in his own work in oils he was trying to achieve a

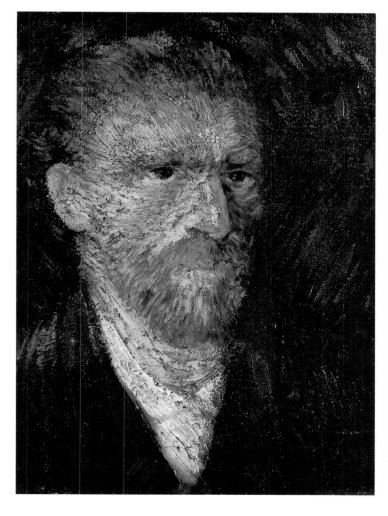
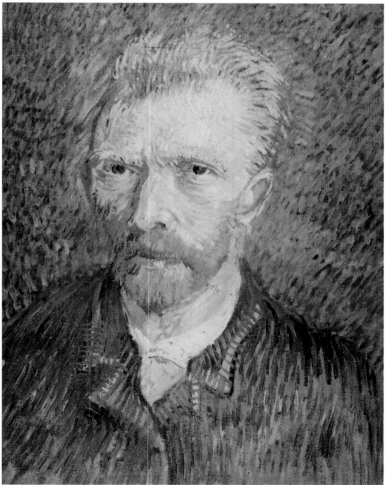

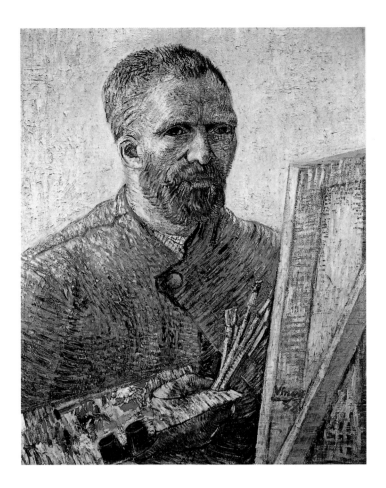

Self-Portrait in Front of the Easel
Paris, early 1888
Oil on canvas, 65.5 x 50.5 cm
F 522, JH 1356
Amsterdam, Rijksmuseum Vincent van
Gogh, Vincent van Gogh Foundation

similar effect of tiny shadows by roughing the surface, an effect he succeeded in achieving." We might add that his most notable success in this was *The Italian Woman*. But it is not only his perfect imitation of the surface effect of what was called Japanese paper that makes this painting a stylistic anticipation of a manner that later matured in Arles. We should also note two other things. One is the thrilling two-dimensionality of the painting, with its ornamental border at the top and right; this is quite simply the narrow side, the threads that attach to the frame. The other feature is the purely decorative quality of the colours, which do not so much describe the woman's skirt as offer a red and green contrast to balance the use of analogous yellow shades. Perhaps the face is not fully realised; van Gogh's parallel streaks of different colours look unmotivated. But if there is one Paris work that points the way forward to the future, it is this. Here, and here alone, van Gogh has removed all trace of the other isms that had influenced him. Even in the portraits of Tanguy his brushwork still had an Impressionist quality.

First he had been impressed. Then he had done his utmost to familiarize himself with the new method. And finally van Gogh had completed the process of assimilation. It was not in his subjects that this adaptation made itself apparent but in his procedure, his technique, his visual approach, and his emotional vigour, all of them central criteria in art, criteria that have always mattered more than questions of mere iconography. In the few years that remained, van Gogh built on

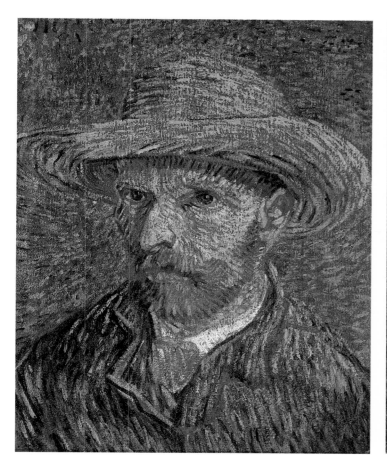
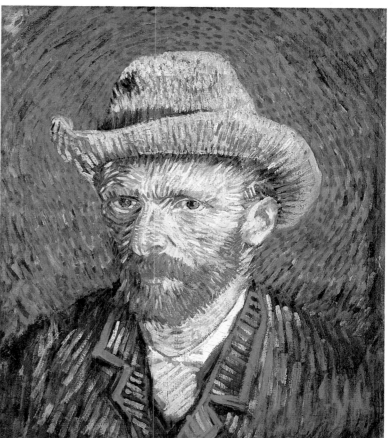

this foundation, and what resulted was a stupendous series of master-pieces arguably unequalled in any other artist's oeuvre. "My whole work is founded on the Japanese, so to speak", he wrote from Arles in summer 1888 (Letter 510), "in its homeland Japanese art is in a state of decline, but it is putting down new roots in French Impressionism." Naturally he was not thinking primarily of a Monet or a Renoir, but of the *Petit Boulevard* painters – Bernard, Toulouse-Lautrec and (modesty aside) himself. He had earned the right to think like this. In van Gogh's case, Roger Marx's observation is absolutely correct: the antiquity behind his Renaissance is Japan.

Self-Portrait with Straw Hat
Paris, Winter 1887/88
Oil on canvas, 40.6 x 31.8 cm
F 365V, JH 1354
New York, The Metropolitan Museum of Art

Self-Portrait with Grey Felt Hat
Paris, Winter 1887/88
Oil on canvas, 44 x 37.5 cm
F 344, JH 1353
Amsterdam, Rijksmuseum Vincent van Gogh, Vincent van Gogh Foundation